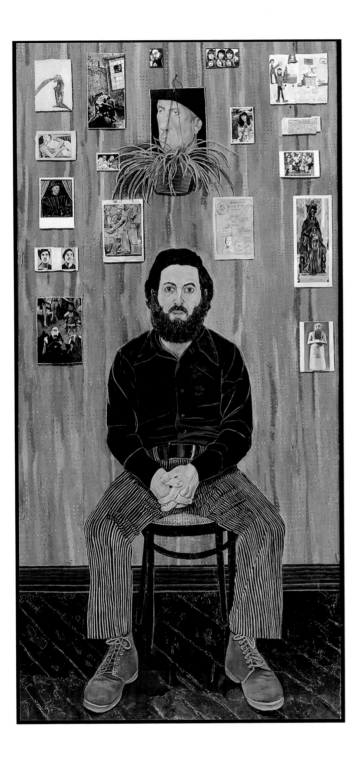

The Suspension of Time

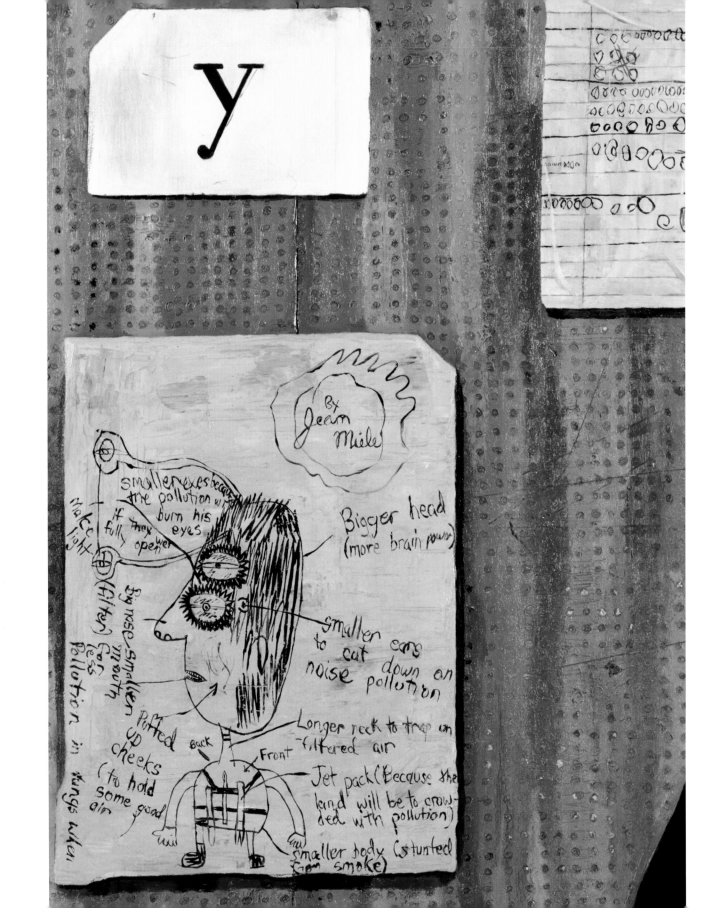

THE SUSPENSION OF TIME

Reflections on

Simon Dinnerstein and *The Fulbright Triptych*

Edited by Daniel Slager

Paintings by Simon Dinnerstein

milkweed
editions

Published 2011 by Milkweed Editions
Printed in Canada
Cover design by Kyle Hunter
Interior design by John Coghlan
The text of this book is set in Bembo.
11 12 13 14 15 5 4 3 2 1
First Edition

Please turn to the back of this book for a list of the sustaining funders of Milkweed Editions.

Library of Congress Cataloging-in-Publication Data

The suspension of time : reflections on Simon Dinnerstein and the Fulbright Triptych / edited by Daniel Slager ; paintings by Simon Dinnerstein. — 1st ed.
 p. cm.
 Includes bibliographical references.
 ISBN 978-1-57131-326-3 (alk. paper)
 1. Dinnerstein, Simon, 1943- Fulbright triptych. 2. Dinnerstein, Simon, 1943—Criticism and interpretation. I. Slager, Daniel.
 ND237.D477A64 2011
 759.13—dc22

2010050097
CIP

For Renée and Alyssa

And to the question which of our worlds will then be *the* world, there is no answer. For the answer would have to be given in a language, and a language must be rooted in some collection of forms of life, and every particular form of life could be other than it is.

—Ludwig Wittgenstein, *Philisophical Investigations*

Anything can happen; everything is possible and probable. Time and space do not exist; on a slight groundwork of reality, imagination spins and weaves new patterns made up of memories, experiences, unfettered fancies, absurdities and improvisations. The characters are split, double, and multiply; they evaporate, crystallize, scatter and converge. But a single consciousness holds sway over them all—that of the dreamer . . .

—August Strindberg, *A Dream Play*

"Solitude"
Grey and sweating
And only one *I* person
Fighting and fretting.
—Gloria Mintz, age 13

All visible objects, man, are but as pasteboard masks. But in each event—in the living act, the undoubted deed—there, some unknown but still reasoning thing puts forth the mouldings of its features from behind the unreasoning mask. If man will strike, strike through the mask! How can the prisoner reach outside except by thrusting through the wall? To me, the white whale is that wall, shoved near to me. Sometimes I think there's naught beyond. But 'tis enough. He tasks me; he heaps me; I see in him outrageous strength, with an inscrutable malice sinewing it. That inscrutable thing is chiefly what I hate; and be the white whale agent, or be the white whale principal, I will wreak that hate upon him.

—Herman Melville, *Moby-Dick*

Simon Dinnerstein paints with a reverence for life that is rare. The radiance of his light can transform reality into a presence that is essential, mythic, and dreamlike.

—George Tooker

Contents

Introduction

In the case of Simon Dinnerstein, I came to the work by way of the man.

I first met him in the summer of 2005. At the time, my wife Alyssa was principal of the Tribeca Learning Center, a public school in lower Manhattan. Simon's wife Renée, a gifted and highly committed educator, was working there as a part-time literacy consultant. And so one Sunday evening, Simon and I were seated beside one another at the Harmony Palace in Chinatown, having accompanied our wives to a banquet celebrating the marriage of one of their colleagues' daughters.

Not knowing his work, I was struck immediately by Simon himself. Observant in an unusually respectful way, deeply curious yet quick with laughter, he made a strong first impression. Over countless courses and sparked by a series of animated entertainments at the Harmony Palace, we began a conversation that has developed in truly wondrous ways.

I was making a living as an editor and translator in those days. A prolific reader, Simon shared many of my interests in literature. And as we talked excitedly about Musil and Wittgenstein, Kafka and Szymborska, it soon became apparent that we were also both particularly interested in the ways—visual and textual, remembered and imagined—we all make sense of experience; more precisely, of the ways we construct meaning of time and experience.

As the four of us shared a cab back to Brooklyn that evening, Simon and Renée invited Alyssa and me to dinner. Not long after, I visited the brownstone row house that functions for the Dinnersteins as home and studio, and saw some of Simon's paintings and drawings.

Over the course of several visits to the house, I was increasingly fascinated with the mysterious sensuality in Simon's work. I was also quite taken by the mystical, otherworldly, yet entirely figurative quality of his compositions, and with the recurring representation of Brooklyn. I am not as knowledgeable about its context and language as I would be were it a novel, but I still found Simon's work refreshingly unfashionable. In fact, if compelled to identify a tradition to associate with it, I would have offered Flemish, Dutch, and German names, most of them from centuries long gone. How

could it be that this work came from a New Yorker whose life had traversed the second half of the twentieth century? It was from the outset, then, that I sensed Simon's disregard for fashions and trends, his exceptionally strong artistic vision.

When I first saw a reproduction of *The Fulbright Triptych* in one of two previously published monographs, I was struck initially by the three human figures. Obviously autobiographical (Simon himself is arguably still recognizable as the artist in the right panel), they were all fully present—or as Simon would say, *completely there*. But there was also some tension, which I associated vaguely with the competing pulls between the togetherness and unity of family (the notion of a secular trinity came to me only later) on one hand, and on the other the solitary pursuit—the brashly ambitious, fiercely single-minded pursuit—of artistic expression. There was also a strikingly sacral quality to the whole composition, and while I did not—I still do not—understand this entirely, I remember thinking initially that the triptych was somehow Jewish in a profoundly illuminating way; that it was, as Guy Davenport puts it in a letter to Simon included in this volume, "a perfect register [...] of the Jewish soul." And yet there was a provincial German landscape out the window (if rendered, I thought, with a degree of ambivalence), in this painting begun not three decades after the worst ravages of the Shoah.

As I studied the details—it is difficult to imagine the scale of the painting's three panels, to be sure, and yet somehow seeing it even in detail is surprisingly rewarding—I wondered at the richly dialogical nature of the work, its own reproduction of paintings by artists such as Holbein, Vermeer, and Degas alongside the drawings of children, its fragments of history and memory, its evidence of exile and migration, and its citations of Melville and Wittgenstein. Here, I thought, was a painting that worked almost more like a symphony or a large-scale literary work, combining an extraordinarily wide range of discursive levels with a disarmingly straightforward figurative representation.

A few months after Simon and I met, I was named editor in chief at Milkweed Editions, an independent literary press. By the end of the year, Alyssa and I had moved our own young family from Brooklyn to Minneapolis, and I feared that the friendship developing between Simon and myself would be curtailed.

It was then that Simon approached me with an idea. Over the years, he said, a number of writers and artists in various disciplines had responded in highly interesting ways to his art, and especially to *The Fulbright Triptych*. And as he had read somewhere that Milkweed published work exploring dialogue between the visual and literary arts (the source proved to be an outdated advertisement for a contest, one of many fortuitous if inexplicable developments along the way), he wondered if I would consider publishing a collection of writings reflecting on his triptych, ideally by an unusually diverse set of contributors that would include poets and scholars, essayists and curators, musicians and composers, actors and filmmakers.

Our hope was that the resulting book would reflect the richly allusive and allegorical qualities of the triptych itself. And as happens with Simon, this original vision was richly rewarded. Over the course of the following two years, an astonishing range of contributors emerged, often—and I can't help but think that this diversity of perspectives reflects *The Fulbright Triptych* itself—in wonderfully mysterious and enigmatic ways. When I approached potential contributors, the response was often unlike anything I had experienced before. I remember sitting in my office with Dan Beachy-Quick, and showing him a reproduction of the triptych for the first time. I said only that we were thinking of assembling a highly unusual book, a book consisting of reflections by widely various writers on a painting of great complexity and accomplishment. He studied the triptych intensely for several minutes, remarking on its extraordinary range of reference, before smiling broadly and answering affirmatively.

And respond he did—respond all the contributors did—in wonderfully creative, intelligent ways. Indeed, while each of the forty or so pieces of writing in this collection offers a rich and highly expressive perspective on *The Fulbright Triptych* and Simon Dinnerstein, taken together they develop what I now see as a collaborative dialogue that directly reflects the painting's inherent message of symphonic connectivity. Such that, as I had hoped from the outset, a contemporary American masterpiece is illuminated anew, in a way that could only be accomplished in this medium.

Looking back from my own perspective, it is hard to believe that this journey began with Simon and my initial exchange in Chinatown. But then perhaps the story of this

book's creation is itself suggestive of another inherent message in *The Fulbright Triptych*. For if, to evoke the lines from Wittgenstein's *Philosophical Investigations* that are cited in the painting, "every particular form of life could be other than it is," the possibilities—in art as in life—are truly endless.

Daniel Slager
Minneapolis, 2011

The Suspension of Time

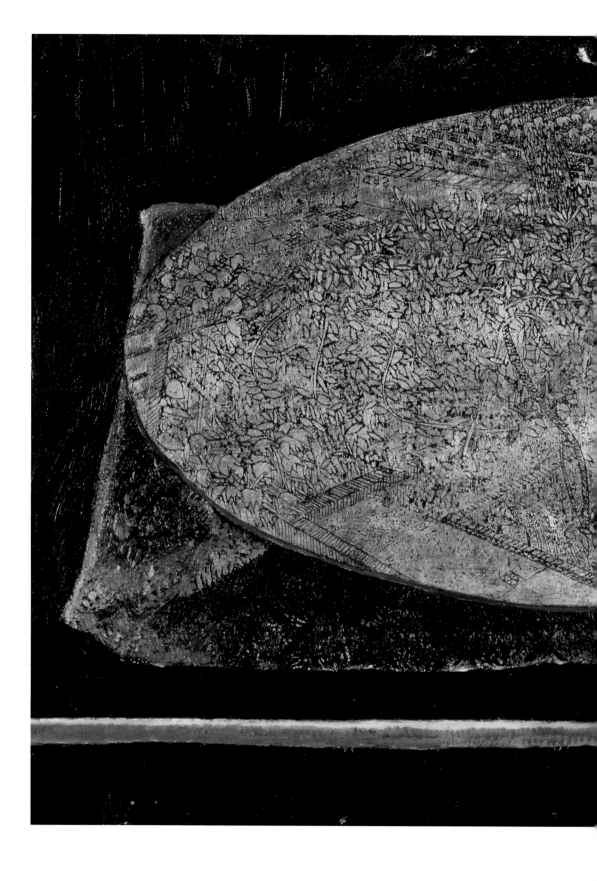

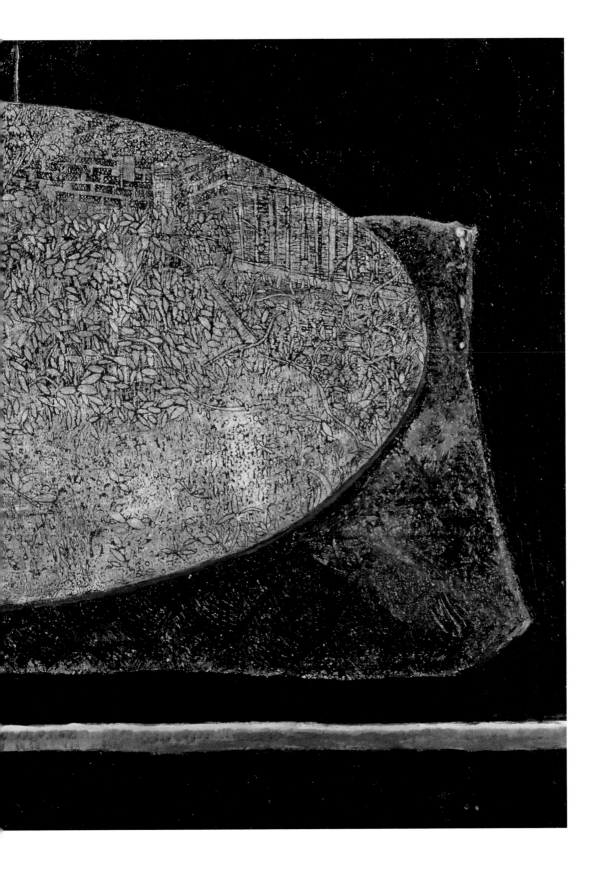

You Are the Printmaker

Anthony Doerr

1. Birds

Here's an experiment: A biologist isolates several dozen two-week-old white-crowned sparrow nestlings in soundproof cages. A first group is left in silence. A second group hears, for three hours a day, complete recordings of adult white-crowned sparrows singing their song. A final group also is allowed to hear the adult song, but only in phrases: a few whistles, some overlapping trills, and long seconds of silence in between. Sometimes the phrases are played in reverse; sometimes the order is mixed up.

Sixty days pass. Which hatchlings learn to sing? The ones left in silence eventually do sing, but their songs are uniformly simple: repeated one-note whistles. Nothing more. The hatchlings who heard the song in its entirety learn to perform it perfectly, trilling away like wild sparrows.

And the group who heard snippets of the song with gaps between the segments? They too, astonishingly, sing perfect adult songs. They *order* the phrases. They take the fragments they are given and assemble them into unified, flawless melodies.

2. Children

One more experiment: A developmental psychologist puts thirty-two twenty-one-month-olds in a waiting room. Sixteen boys, sixteen girls. She makes sure all the children know the following four words: doggy, baby, birdie, and kitty.

One at a time, she sets the toddlers in front of two blank television screens. At regular intervals, a recorded voice asks each child a question. "Where's the doggy?" Or: "Can you see the baby?" As the question is asked, one television displays a picture of a doggy (or a baby, birdie, or kitty). The other television displays something else: a car, a boat, a mouse. The first image is called the "target" picture, and the second is called the "distracter" picture.

Meanwhile the psychologist videotapes the baby's eyes. If the child is looking at the

distracter picture when the target word is spoken, the correct response is for the child to shift his or her fixation immediately to the target picture. If the child is already looking at the target picture, the correct response is to continue looking at that picture.

In a subsequent round, things get tougher. This time the recorded voice doesn't finish her questions. Now the four target words are abbreviated to *bei* (baby), *daw* (doggy), *ki* (kitty), and *ber* (birdie). Rather than hear the entire word, the toddler will only get to hear an extremely short burst of it: the first three hundred microseconds.

So. Here comes a picture of a kitty on one of the screens. Here comes the voice: "Where's the k—?" Again the results are videotaped and tabulated.

Did the toddlers recognize whole words more quickly or more reliably than partial words? No! The psychologist found that there were *no significant differences* in either correct responses *or* reaction times. The children responded reliably to both whole words and abbreviated ones.

This implies that even as babies, we can recognize spoken words using partial phonetic information. Before they are two years old, these little brains can assemble scattered, partial information and transform it into something meaningful.

Give a baby human the hint of a word, and she'll fill in the rest. Give a baby sparrow the broken pieces of a song, and it will make music.

I think we evolved to see structures even when only the faint contours of structures exist. Give us a face and we see a story. Give us brushstrokes and we see apples, pears, skulls, gods. Give us a family, some photographs, some printmaking tools, and a view, and we can re-create the world.

3. Where's the Printmaker?

A scaled-down reproduction of Simon Dinnerstein's fourteen-foot-long, breathtaking painting *The Fulbright Triptych* hangs beside my desk. Every time my eyes drift to it, they get stuck on the table in the center panel. A big, black two-drawer table, covered with tools.

The table stands on a floor that's wrecked and worn—a floor that has known labor, varnish, chemicals, a floor with history. My eyes rise to the twin windows gazing

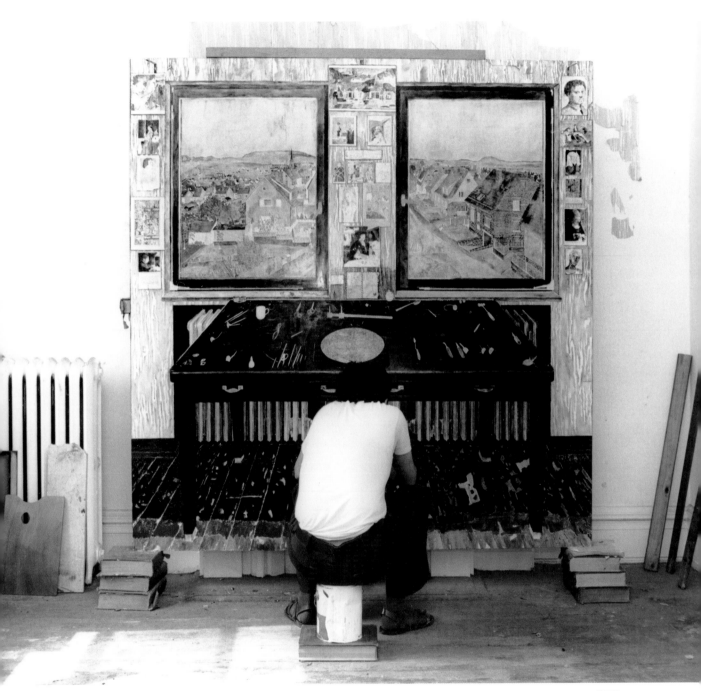

c. 1972

like rectangular eyes onto a town as orderly as the room they peer out from, lived-in, lived-upon, Dutch or German, farmed and tidy, the sky a wash of pale blue, the hills a bucolic green.

Eventually the windows send the eyes back inside, onto broad hardware store pegboard walls, textured and smudged with paint, a spectrum of yellows and reds showing through their holes. An eccentric album of photographs is fixed to these walls, along with letters, postcards of classic paintings, poems, child's drawings, something from Melville, something from Wittgenstein, even matching houseplants; it's as if an artist's memories and influences and aspirations have been turned inside out and slathered, with enigmatic symmetry, in front of us. Everything is framed, everything is a fragment.

My gaze scatters. It skids between an airmail letter, a nude couple kissing, a Russian visa. Always, for some reason, it returns to the table. The table seems to hold its printmaking tools out to the viewer in the way a nurse might hold out a tray of instruments to a surgeon. Here, it seems to say. Here is what you need.

But where's the printmaker? Where's the person for whom these tools are intended? Whose mind is indexed up on that wall; who's going to assemble something meaningful out of all of this? Is it that half-relaxed, half-intense man in the velvet shirt, hands folded, staring at me from the right panel? Or could it be the woman—looking a bit trapped, a bit tired—holding the baby in the left panel? Is *she* the printmaker?

The eye travels back and forth between the man and the table and the woman and the table. Man, table, woman. Father, table, mother. Artist, work, family. One hears the beginning of a word, fragments of a song—one hears a piece of a Phillip Booth poem:

> *I seesaw on the old cliff, trying*
> *to balance things out: job,*
> *wife, children, myself.*

The baby sits on her mother's plaid skirt: alert, intelligent. In the old triptychs the baby was usually given the center panel, wasn't it? God, Jesus, a haloed infant in a manger, drenched in a column of light. The side panels were for shepherds, attendants, supporting actors. In the hierarchy of the triptych, the protagonist should be in the center. Right?

What's in the center of *The Fulbright Triptych*? Tools on a table. Scissors and etching needles, scrapers and scorers, twenty-seven tiny pencils in the back. And in the very center, a copperplate, aswarm with leaves.

In the table I see Booth's seesaw, both chasm and bridge between mother and father, husband and wife, artist and family, and in such a choreography the art-making apparatus seems to swell outward, until the copperplate has become a sun, and the humans in the side panels seem almost provisional, distant planets, as if they too, like the photos and drawings and paintings on the pegboard, have been pinned to the wall, merely three more data points in a great fragmented constellation left to be assembled by the viewer.

Where's the printmaker?

The printmaker is standing in front of the painting.

4. Pegboard

When I'm writing a novel or a short story, I accrue things: photographs, drawings, leaves, pages from books and journals, maps, notes, similes, and I pin them to a big bulletin board in my office. The bigger the project, the more things I tack up. A drawing of a fossil, a photograph of fighter-bombers in formation, a postage stamp, a page copied out of Sebald, a little translucent envelope filled with seashells. To me these disparate things form the dimmest outline of a map. They are the scraps of songs; the beginnings of words; the posts for a long, disorderly pier I'm hoping to cantilever out into the ocean.

Eventually, if things go well, my brain manages to cram many of these seemingly divergent things, gradually and idiosyncratically, into a single narrative. I try to draw lines between the dots. In a sense, a successful project presents a great pastiche of memory and imagination and research, the genesis of which I eventually lose as I press forward into the darkness.

With my bulletin board I map the initial points, and with pen and paper I start to move the points around, dreaming up the connections. In *The Fulbright Triptych,* it is as if Simon Dinnerstein has rendered this process exactly—he has presented the tools and materials with which a storyteller might make meaning out of the world. But he has left it up to you to put it all together.

5. You Are the Printmaker

We each have eighty to one hundred billion neurons in our brains. That's as many stars as there are in the Milky Way. From the ends of each neuron sprout off synapses, slender hairs corkscrewing off into neighboring neurons. A vast, entwined welter of these neural junctions is crammed into our skulls—a private, damp, snarled jungle—from stem to frontal lobes, alive with electricity, soaked in neurochemicals. Each of us has as many as five hundred trillion of those synapses up there, lacing our neurons together into one of the most complicated, dense, and interconnected substances in the universe.

Our brains are meaning-making machines. They seek meaning everywhere, inscribing an intensely idiosyncratic latticework across the landscape. We live in multiple places, lead multiple lives. We stumble into a good book, a dark theater, a rich painting, and the complaints of the day scatter and we fall, we drift, we lose ourselves. We find ourselves looking through the eyes of people we have never met, never could otherwise meet. We ask ourselves: What does this mean?

Look at *The Fulbright Triptych* for a minute and the mind begins to fill in the blanks, sketch lines between data points, assemble a story out of pigment and air. Is this about Judaism and Germany? Is this about family and work? Is this about learning to paint and learning to be a father? Ten million brushstrokes of color touch three huge canvases and we see a woman's eyes, a pair of windows, a baby's cheeks. Two dimensions become three. A table surges into the room, loaded with tools, waiting for you to come and pick one up.

The best paintings are like dreams. They convince you they are real, they fold you into their worlds, and they hold you there. Only then, when you're anchored in the moment-by-moment detail of an experience, when your eyes have extended across the room, when the copperplate is shimmering in front of your hands, can you let yourself reach out into the space between brain and image, into the great mystery of what it means to be viewer and printmaker, reader and writer, listener and singer.

That's where our brains find meaning in the world. That's where art exists.

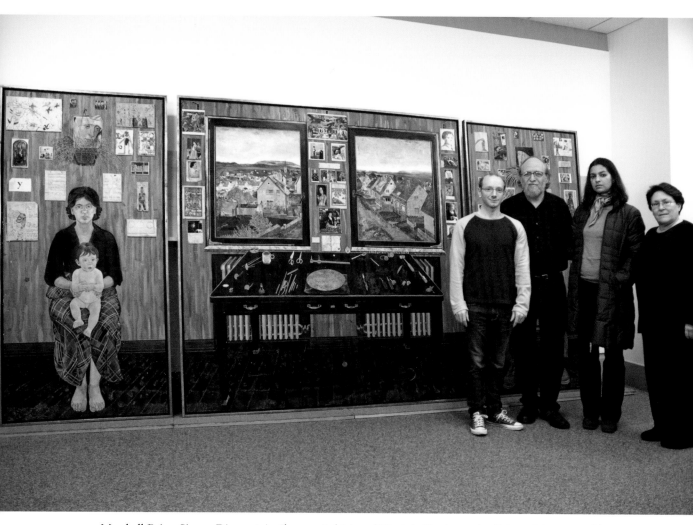

Marshall Price, Simon Dinnerstein, Jhumpa Lahiri, and Virginia Bonito at the Palmer Museum of Art, Penn State University, December 2008

The Space between the Pictures

Jhumpa Lahiri

I first met Simon Dinnerstein in a letter of introduction delivered to me by a mutual friend I'd invited to tea. In the letter, Simon wrote kindly about my writing and, venturing to suggest that I might find his painting *The Fulbright Triptych* "of interest," invited me to contribute an essay for this book. Along with the letter he sent a catalog of his work and a reproduction of the triptych, measuring fourteen-and-a-half by eleven inches. I spent that summer evening looking at the pages of the catalog. There were paintings and drawings of women sleeping and dreaming. Facades of Victorian row houses in Brooklyn, where Simon and I both live, on streets that I'd walked along. I saw a little girl sitting at a piano. A flower market in Rome. One painting, of a nude mother and child lying head to toe in bed against a vivid persimmon wall, reminded me of the portraits of Balthus. A few days later I wrote back to Simon by e-mail, accepting his invitation, and taped the reproduction of *The Fulbright Triptych* to a wall in the room where I write.

The painting depicts an artist's studio, a place where creative work is produced. It is, specifically, a printmaker's workshop. The central panel, about twice the width of the two on either side, contains a black table positioned in front of two radiators set into alcoves in the wall. The table is arrayed with engraving tools, objects vaguely reminiscent of a surgeon's instruments. A copperplate, resembling the solid halos of Giotto's angels, rests ever so slightly off center, on top of a square leather pad. Above the table, a pair of windows reveals a single landscape of homes and hills and sky, the vista divided in equally sized sections by the windows' frames. In the left panel, a barefoot woman with short, dark hair sits with a naked baby girl in her lap. In the right panel, a man sits alone. The man and woman look directly at the viewer. The child's gaze, lighter than those of her parents, strays to one side. Two houseplants, similar but not identical, hang from nails at the same height above the man's and woman's heads. The man's clothing—striped blue-and-white pants, laced work boots, a wide brown belt, a navy shirt with a wide collar—evoke the early 1970s, when I myself was a

child. The painting is both a self-portrait and a family portrait; the man is Simon, the woman is his wife, Renée, and the baby is their daughter, Simone.

There are only three things the three panels have in common. The first is the floor, made of thickly scabbed wooden planks. The second is the wallpaper, which has muddy peach and tan and green stripes seemingly applied with a paintbrush, and is patterned with tiny dots that lend it a perforated quality. The third is an assembly of small images, mostly visual but some consisting of text, decorating these papered walls. There are postcards of paintings, many of which I recognize: Bellini, Ingres, Hans Holbein, Degas. There are family photographs, some playfully taken in a photo booth, along with quotations, letters, things written on sheets of ruled paper, children's drawings. Each of these items, fifty-six in total, appears to be literally pasted to the surface in the manner of a collage, but is, in fact, a painted replica.

I have collected postcards of paintings since I was a teenager. And from the time I first set up a desk and started writing in my early twenties, I have marked my creative territory with a version of the informal, idiosyncratic two-dimensional gallery displayed on the walls of *The Fulbright Triptych*. These are the things that comfort my eyes when they wander from page or screen, that witness my solitary labor day after day. Currently, against the backdrop of teal-blue walls, there is a large map of Massachusetts, the place where I set many of my stories, and a smaller map, recently xeroxed from the New York Public Library, of the neighborhood in Calcutta where my father was raised, a place I am currently struggling to conjure. There are drawings, copied by my own hand from photographs, of the front and back of my paternal grandparents' house. There are photographs of my parents and husband and children, quotations from Nathaniel Hawthorne and from Corinthians 13. There are postcards of work by Piero della Francesca, Giorgio Morandi, and Phillip Guston. Pictures of Virginia Woolf, Anne Sexton, and Hilda Doolittle. A blue-and-orange Joan Mitchell painting I ripped out of a magazine, called *Merci*, the brilliant hues faded from exposure to direct sunlight. A letter, propped up so that I can see it behind the screen of my laptop, sent to me from Paris by Mavis Gallant. As my desks and sources of inspiration have changed over the years, so have the things with which I've chosen to surround myself. But when they are on the walls of the place where I write, they become talismanic; to be

forced to take them down and box them up in the course of a move always feels like a sort of death.

<p style="text-align:center">✳ ✳ ✳</p>

About two months after receiving Simon's letter, I went with my friend Tonuca—the friend who had brought me his letter—to visit him in Park Slope. Located a short distance from the neighborhood I live in now, Park Slope is deeply familiar to me. For five years I lived less than three blocks away from Simon's home, in an apartment where I brought my son, and then my daughter, home from the hospital after they were born. For those years, I probably bought my milk, bagels, and cups of coffee from the same shops along Seventh Avenue, Park Slope's commercial thoroughfare, as Simon.

The man who welcomed us was nearly forty years older than the one sitting in the *Triptych*. His hair and beard were gray, and he wore glasses, black jeans, and a black button-down shirt. Renée was at home that day as well, her hair still short, though no longer the ebony shade Simon had painted it. We stood on the spacious parlor floor which has a large, beautiful kitchen at one end and a gleaming grand piano at the other (Simon and Renée's daughter, the little girl he had drawn at the piano, grew up to be a concert pianist who used to give lessons to Tonuca's daughter).

As we looked at the many paintings and drawings in the room, I was overwhelmed by the personal history of people I barely knew, by the passage of time cycling forward and back. For there was a drawing of Simone, the unclothed infant in the *Triptych*, as a grown woman, eight months pregnant with her son, her shirt unbuttoned to reveal the skin of her swollen belly, her face and body filled with a weary satisfaction. The young couple in the *Triptych*, just setting out on the journey of parenthood, were grandparents now. And just as that brand-new family who had been keeping me company on the wall of my writing room has since spawned another, so the artist in the early years of his creative life now lives in a house chockablock with the work he has produced, hanging up and leaning against just about every wall.

Simon was generous with his time, serious but unassuming. He spoke candidly about his art, his life, his interests, his dreams. He talked about the years he and his fam-

ily had spent in Rome at the American Academy. His love of reading was frequently conveyed. He recommended *Blindness* by José Saramago, and showed me a painting that he feels has a connection with Bulgakov's *The Master and Margarita*. He spoke of Strindberg's *A Dream Play* and of *Tonio Kröger*, a novella by Thomas Mann. I'd read the story over twenty years ago, in college, and remembered it dimly. Simon spoke of it with such enthusiasm that I reread it as soon as I got home.

The visit concluded in Simon's studio. Like mine, it is located on the top floor of a row house. Compared to the other rooms I'd seen, the studio was grittier, untouched by renovation, the plaster walls cracked. Lights were clamped to poles, overlapping blue-and-green tape was stuck to the floorboards, and fluorescent panels hung from the flaking ceiling. On dirtied white walls were hooks from which nothing hung. Midday sun shone into three south-facing windows, one of the panes broken. Through them the colors of autumn were visible, just beginning to grace the leaves of the trees. We could hear the voices of children calling out as they played on the grounds of P.S. 321, the school where Renée taught for many years.

Simon showed us his recent work, a series painted literally onto his palettes, along with something much older—two charcoal drawings he had made of Renée, nude, when she was pregnant with Simone, an uncanny reverse echo of the drawing of Simone, similarly pregnant and bearing distinct resemblance to her mother, downstairs. One of the newer paintings, like the *Triptych*, featured a window. Only instead of revealing the world outside, a self-portrait filled much of the frame, and looked in at the viewer.

I am loath to admit people into the room where I work and was struck by Simon's willingness to allow us to gather there and chat. I saw his curled-up tubes of paint, his easels. Brushes arrayed like beheaded flower stems in an Italian coffee can. Chairs where his models have sat. And tucked into an alcove, taped to one wall, a living continuum of the backdrop of the *Triptych*: a collection of reproduced works of art in the form of postcards and newspaper clippings, many of them faded from sun and age.

In December 2008, two months after meeting Simon in person, I accompanied him to Penn State University, where *The Fulbright Triptych* resides in the Palmer Museum of Art. Along for the ride were Virginia Bonito, an art historian, and a curator at the National Academy, Marshall Price. In the course of the four-hour drive, much of which crosses through the milky, monotonous landscape of northeastern and central Pennsylvania, I asked Simon to talk about the genesis of the painting. He said that he had begun it in 1971, in Germany, when he was twenty-eight years old. He had traveled to Germany the year before, with Renée, thanks to a Fulbright fellowship. He had proposed to study the work of Dürer. After working on the middle panel for six months, drawing forms in black Rapidograph on gessoed wood, he returned to Brooklyn where, after two-and-a-half years, the painting was finished in 1974. He recalled that the apartment in Germany where the painting was conceived came unfurnished. The black table in the central panel was given to him by his landlord and became his subject. It was his first painting. Until then, he had made drawings.

Simon told us that the *Triptych* changed his life before it was even finished. When it was still in progress, when he was struggling to pay a rent of ninety dollars a month and support his wife and child, he walked unbidden into New York's Staempfli Gallery and managed to get the dealer and his co-director, Phillip Bruno, to visit his studio in Brooklyn. After looking at the painting for twenty minutes and not saying a word, the dealer, George Staempfli, told Simon that he wanted to own it. He then proposed an arrangement: he would pay Simon a fixed sum every month until it was finished, and then he would exhibit it. It was an extraordinary stroke of good fortune, a moment that forever altered Simon's life and career. As he recounted the story, it was clear that the memory still overwhelmed him.

I understood his emotion well. Any artist lucky enough to migrate from obscurity to recognition, from poverty to solvency, knows what a miracle it is. Recognition, combined with the ability to support oneself as much as possible on one's creative work, is what aspiring artists dream of. But once achieved, the new reality itself feels like a dream. This is how I have felt for the past dozen years, after a door, against similar odds, opened for me, enabling me to make my living as a writer. Listening to Simon, I realized I would feel this way for the rest of my life. I asked Simon what he'd been

reading when he started the painting. The answer was *Moby-Dick*. He'd read Melville's novel for the entire year he was in Germany, repeatedly renewing it from the library. Still not finished when he was scheduled to sail back to America, he brought the book back with him and finished it, poetically, on the high seas before mailing it back to the library in Europe. He told me another thing: that on the back of the central panel of the *Triptych*, Renée had nailed a five-mark coin to the wood crossbars, corresponding to the gold coin Ahab nails to the mast of the *Pequod*. "Begun in Good Faith and High Hopes on May 3rd, 1971 . . . with the love of Renée" is written in her hand beneath the coin. The benediction touched me; I remembered my own shaky beginnings as a writer, and how much my husband's faith in me meant at the time.

It is striking, and also fitting, that a novel so distinctly American, a novel about appearance and reality, about Ishmael's reflective wandering and Ahab's quest, informs the creation of the *Triptych*. For this is a painting, among other things, about what it means to be an artist: a necessary combination of Ishmael's absorption of the world, fused with Ahab's passion. It is also an intensely personal painting, just as *Moby-Dick*, for all its vastness, is an intensely personal narrative. It is a painting about a young American artist's absorption of northern European art, about his study of Dürer's copper engravings, about his response to that discipline in a new medium, and about his journey home. The triptych-in-progress not only crossed the Atlantic physically along with its creator, but embodies dense layers of crossings between one thing and another: between artistic traditions, between places, between past and present, between the real and the re-created. Between emerging and being, and between conception and birth.

It had been almost nine years since Simon had seen the *Triptych*. It is not the same for writers, who are able to revisit their work simply by pulling it off a shelf. As we sat in a restaurant in University Park, about to head over to the Palmer, I felt a vicarious sense of nervous anticipation. It was as if we were going to visit a child who had both grown unrecognizably old and stayed exactly the same. The people at the museum were expecting us, and the panels had been brought into a special room for us to view, the fourteen inches I'd gotten to know in reproduction now stretched to fourteen feet. The first thing Simon said when he saw it was that the panels needed to be set farther apart. Once they were arranged to his satisfaction, we stood far and close,

taking notes and photographs. For me the pleasure of seeing a real painting has to do with those textures and details that lie dormant in reproduction. Face-to-face, I became aware of the roughness of the subfloor, the seams of the wallpaper. The veins on Renée's feet, the sheen of her plaid skirt. The bold swirls in Simon's hair, the rich velvet of his shirt, the fiery flecks in his beard. With the lights adjusted a particular way, I saw how brightly the copperplate, painted in gold leaf, shone. Most significant was the detail of the windowsills, splattered with paint, turning the windows into easels and thus turning the view they contained into a paradox: something both beyond and within the room, something that is both reality, passively seen, and art, actively re-created.

Another aspect of the painting I was appreciating for the first time was the extent to which the painting represents a compression of real space and time. The room we see, albeit broken into three sections, is neither an apartment in Germany nor a studio in Brooklyn, but an amalgamated realm that is another place altogether. The view through the windows is of the German countryside, but the floor and the wallpaper, the hanging plants, the sycamore fronds scattered on the worktable, are native to Brooklyn. Now that I knew the full story—that Renée was not yet pregnant when Simon started working on the *Triptych*, but that by the time he finished it, Simone had been born—the painting's narrative became apparent. In this sense it is as much a trilogy as it is a triptych, for the painting shows us a life in stages, in parts. It shows what exists, and what does not, and what existed only previously. It reminded me of instances in my writing when, working from the past, I have had to manipulate actual events in order to serve the purpose of fiction. *The Fulbright Triptych* is the first time I appreciated this deliberate rearrangement of reality on a visual level.

Simon talked about many of the items, depicted in astonishing precision, on the walls of the painting. He read a poem written by a thirteen-year-old girl named Gloria Mintz:

Grey and sweating/And only one I person/Fighting and fretting.

He pointed out a ballpoint drawing by one of Renée's students, and reading exercises they had done. He read a quotation about language, and asked us to guess who it was attributed to (I guessed Plato; the answer was Wittgenstein). There was a letter propped

up between the windows, and Simon crouched down, offering to read it, stepping into the world of the painting as if it were a stage set (it is three-quarters life-size). It was a letter to Simon from Renée, who at one point during their years in Germany had gone back to New York to visit her ailing father. She recounted an anxiety dream about being pregnant, a dream she'd had before the painting was conceived.

The things on the wall would be different now, Simon told us, but I saw that his love for them had not waned. Nor had their presence; they were there, an artist's ephemera made permanent, painted into the wood. They were all sacred to him, everything from the work of van Eyck and Seurat to a colorful drawing by two German girls, daughters of a couple the Dinnersteins had befriended in the town, named Simone and Andrea. Simon told us that Simone Dinnerstein (whose name is pronounced Simona) was named after these two girls, and that after she was born, six-year-old Andrea sent them the drawing as a baby gift. As I stood in front of the panel on the right, he pointed, standing directly in front of his painted younger self, to a re-created paragraph torn from the re-created ivory page of a re-created book. "Do you recognize this?" he asked. I shook my head at first, then stopped when I read, "To me, the white whale is that wall, shoved near to me. Sometimes I think there's naught beyond." It was a passage from chapter 36 of *Moby-Dick*.

A painting of an artist's studio is an inherent contradiction, and a profoundly intimate thing. It is a finished work that represents something impossible to represent—the piecemeal, protracted process of making art. To work as an artist is to revisit something day after day, to look at a subject or an experience not twice or twenty times but what easily feels like twenty thousand times. In the course of those repeated visits, the thing seen—or in a writer's case, contemplated—begins necessarily to evolve, to become something other than itself, to become, at times, unrecognizable. The walls of the studio, the floor, the furniture, the scraps taped to the walls are what remain constant, and they are as revealing, as much of a self-portrait, as the depiction of an artist's figure or face. In that sense, *The Fulbright Triptych* is a self-portrait twice over.

One of the postcards on the walls of the *Triptych*, of a painting by Vermeer, is a self-portrait of the artist seated at his easel, his back to the viewer, working with a model who poses in the background. But the artist in *The Fulbright Triptych* sits still, a figure who is both model and artist, his fingers interlaced, the instruments on his worktable untouched. That he is not actively occupied is, of course, an illusion. The completed painting, the enduring distillation of the effort required to create that composed figure, reminds us of this. After getting to know Simon a little bit, I think that his posture in the painting, at once vigilant and relaxed, is appropriate. He is a man who not only paints the world he sees but deeply thinks about and questions it—thoughts and questions that eventually become manifest in his work. His presence in the painting reminds us that the idle moments in one's studio, when one is not actively painting or writing or making anything, when one is perhaps sitting in a chair staring into space, are precisely the moments inspiration tends to strike.

I love *The Fulbright Triptych* and will continue to keep a reproduction of it taped up in my writing room, because it is about the interplay of the two aspects of my life that are the most sacred to me: art and family. When I was first getting to know the painting, I regarded it as a fugue of threes. The three panels, the three figures. The three formal subjects—portrait, still life, landscape. The three levels of representation—the painting, the reproductions of other paintings, the painted renditions of those reproductions. After looking at the painting and thinking about it for nearly six months, I see that it is as much about dyads as triads, and about the primal alchemy of two becoming three. The painting is about a marriage and about the consequence of that marriage: a child. It is also about an individual who, doubly creative as artist and father, exists both in the realm of art and of life; who is devoted to both things but is also sundered by them, occupying a panel of his own. As a writer who is also the mother of two young children, I experience this sense of division on a daily basis. Though the artist's family exists within the *Triptych*, has even participated in its creation by posing for it, the painting is made by him alone, in the studio, outside ordinary life. In *Tonio Kröger* Mann writes: "The artist must be unhuman, extra-human; he must stand in a queer aloof relationship to our humanity; only so is he in a position, I ought to say only so would he be tempted, to represent it, to present it, to portray it to good effect."

As we were getting ready to leave the museum, there was a moment when Simon and I stood alone with his painting. "I believe the meaning of the painting is contained in the space between the pictures," Simon told me. Whether he was referring to the space between the reproductions he'd painted or the space between the panels themselves was not clear to me at the time. But in the process of writing this essay, I began to understand.

The Home and the World

John Turturro

The Fulbright Triptych speaks to me about inspiration. It is a candid reflection on the artist's existence: the tools, and the disjointed visual vocabulary of masterworks and humble doodlings, which any creative person carries in their head and must shuffle through while looking for something truthful, and if they're lucky, beautiful. The studio is a place of refuge, a laboratory of discovery and experimentation—where the forging of an idea happens. The *Triptych* is a meditation on the inner and outer life of an artist, elegantly evoked by the simple but beautiful vista through the window.

As a creative person with a family, this theme also speaks to me; asking into which life, inner or outer, does the family fit? The composition presents the two people as isolated from one another, and also from the world outside. But they seem to me almost ready to stand up and enter the middle panel, where the tools of craft sit waiting to bring these conflicting lives into harmony.

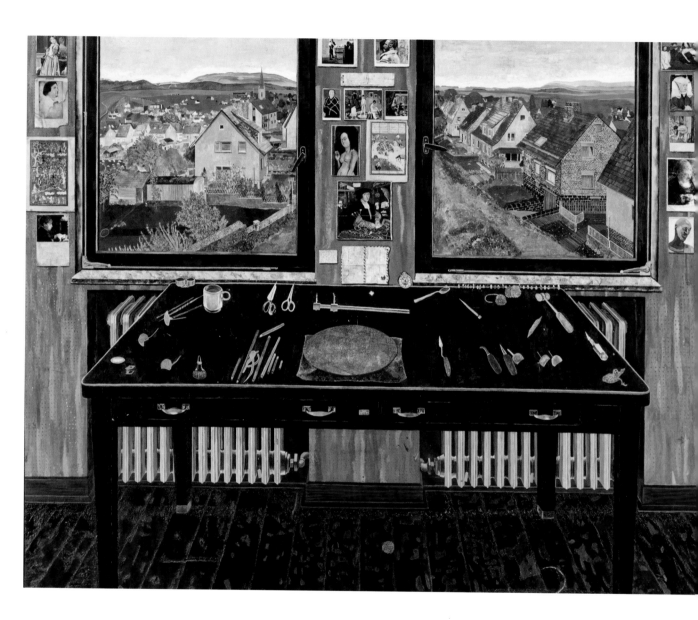

Allegory's Face
Dan Beachy-Quick

My office at work is a blank face: white-washed cinder blocks. On that blank face—a face in front of which I spend many, many hours—I have taped a photographic reproduction of Simon Dinnerstein's *The Fulbright Triptych*. As I did so, I couldn't help but note that I was repeating a process the painting itself records, this hanging of art reproductions on a wall. I have never seen this painting in person; that is, I have never stood in the face of this painting. (I wonder why, even as I write this, to admit so carries within it a tone of confession.) A wall: it is a faceless face. On it we tend to hang faces, portraits of those we love, of those we admire; on the wall we hang the faces our children draw, and in the awkward contortions of those figures, we find our own children's faces. We put faces on walls so that faceless face gains expression. We give them eyes—those walls—with which to see us.

Often, after putting down a book, or finishing my notes, or sending off the latest of the endless e-mails, I look at the *Triptych* for a minute or two, and then I turn away to the next task. A triptych is a curious construction, three panels that tell a single story, but do so through suffering division. As with a nerve, there is a synapse across which the attention must leap—a form that doesn't simply invoke thinking but mimics its structure. I think about those blank spaces between the panels just as I think of those odd moments when the head shifts from one position to another, that transitional turn in which perception occurs unaccounted for, those unconscious, almost imageless moments that stitch our world into cohesiveness—a world that, paradoxically, only seems coherent by ignoring the chaotic moments of which it is constructed. I try to pay attention to those moments that seem to deny the capacity to pay attention, as futile, as almost impossible as it is to do so. When I turn away from the *Triptych*, I have a sudden flash in my head—that museum of the mind—in which I occasionally see the work of another artist. That other artist is Giuseppe Arcimboldo.

Arcimboldo created portraits out of distinct elements, discrete objects. A portrait wasn't of a person but a personification of a season or an element (the old gods).

Summer is given a face by bringing together the summer's bounty; Autumn's portrait is a collection of the fruits of late harvest: gourds, mushrooms, grape tresses, those acorns are his eyes. There is a magical principle lurking in these faces: a self made up of the world in which that self dwells, self created out of that which it also creates.

(Wordsworth: "of all that we behold / From this green earth; of all the mighty

world / Of eye, and ear,—both what they half create, / And what perceive . . .")

There is in these old portraits something addictively lacking in psychology. What makes up the face is the world of which the face is made, not a constructing consciousness, but a consciousness constructed. When such a self says I it is not a word that drops out of his mouth but a leaf. (Gather together those leaves and make a portrait of Spring. When Spring speaks, perhaps you will be the word that drops from his mouth.) Bring together the objects of the world in the right way and you'll find you've made a face; it is a face that is invariably a self-portrait. This is a work we seldom know we do even as we're doing it. (Hold on, hold that thought, I need to check my e-mail.)

When I turn away from the painting, I fear the thought will be gone. Too often, it is.

Let the asterisks mark the division of the thoughts that divide the essay: the gap whose shadow life is connection. The *Triptych* offers itself as a model.

In each panel of the *Triptych* faces abound, and when I stare at it, I find it—always through a different face—staring back at me.

I want to think about faces.

The word is both noun and verb. We must face faces; faces face us. Etymology here is telling. Latinate in source: "*facia* corresponding to form, figure, face, and related to *facere*, make, do, perform."

A face is a form and a function.

Arcimboldo casts a shadow in the mind, creates a suspicion in the eye; one which suggests that as you walk through the day, the world could in a countless variety of ways assemble itself into a face that watches you walk by. This is not the world personified, but capable of persona. In a mind infused with an Arcimboldian vision, the field abutting the road is a face dispersed, the mountains on the horizon with the clouds mountain-like above them are a latent face. This world is also Proust's world, where the young narrator of *Swann's Way* spends his days walking down the winding paths where the hawthorn blooms, suspecting that in each thing there is a soul. This numinous world is also Emerson's world, his invocation an even more ancient idea, in which each person is but a limb or organ, or but a part of those parts, of some vaster one whose body we unwittingly construct with our own partial lives—one, also, whom we can never know. I like this feeling of subjectivity falling down into ignorance. The face here is a curious wisdom: my whole is but a part of the vaster whole, and where I find myself most complete, I am not complete; I'm partly undone, but I'm adhesive. The question is what am I next to and what is next to me? In Arcimboldo's world one must learn to ask: what face is it of which my face is part?

This world is also Simon Dinnerstein's world.

Here is the most simple, most obvious fact about *The Fulbright Triptych*: it is full of faces.

What is the story of a face? It is wounded, and it stares at us through its wounds (eyes). It is wounded, and speaks through its wound (mouth). The face that tells a story is also a story itself. It says: there is no art without damage. Faces: we read them, and we listen.

Facing the Right Panel:
Simon Dinnerstein sits on a wicker-bottomed chair in his own painting. Note: he does not occupy the central panel. He is in the periphery of his own painting, he is not the center; and above his head, as if the embodiment of some thought, hangs a

potted spider plant; and as if springing from the plant's own thinking, is an austere portrait of an austere man; it looks as if the green fronds are his collar's ruff, but where his body should be sits our artist's body, sitting within the absence of the body of the face above him. Other faces surround them: the repeated black-and-white squares of the photo booth; snapshot of a woman holding a dog; postcard of an Assyrian king in stone relief, a child's monster spewing forth fire and destruction (though there is nothing on the page for it to destroy); portrait by a French artist of the early Renaissance in which the curtains' cloth is as exquisite, or more so, than the man painted; the identity photo on a Russian exit visa; a man and woman in erotic embrace. (Let us note, too, that the only face that turns away from us in the entire painting is this man kissing this woman, his hand between her legs, her hand around his penis.) These faces are assembled—I see them almost as a nimbus, aura, or precipitate cloud—around the artist's face.

Facing the Left Panel:
A woman weeps, but she is a painting. To be more accurate to the wonder of the *Triptych*, I should say the woman weeping is a painting of a reproduction of a painting: part of the underlying ethos of the *Triptych* is a radical mimesis in which Dinnerstein replicates not only the grain of the wood on floor and wall, not only the drapery of cloth and how in cloth-folds light catches, but more remarkably, in reproducing reproductions, he returns to them the aura of authenticity that reproduction threatens or denies. In some profound reversal of mechanical reproduction, Dinnerstein inverts the photo of the painting into the painting of the photo. (I might go further and note that the hypnotic quality of the *Triptych*, perhaps the underlying drone of its greatness, is the imperceptible work of the gaze that witnesses a return to origin, to originality—but more on that wonder later.) The weeping woman's portrait is surrounded by children's drawings, by photos, by a typographical *y*, by snapshots, by a spelling test. (They all look real but aren't real, but in the world of the *Triptych* are all the more real, one might even say *ideal*, for the schism a reproduction of a reproduction creates in the gazing mind of the viewer.) Reproduction is not simply here a mechanical means: photo, postcard. Beneath the hanging plant, whose small leaves seem to be the weeping woman's tears stilled in the air and given life, sits the artist's wife, and on her lap, their baby daughter. Reproduction is also a biological fact in the painting, not

simply an issue of craft. One might assume, rightly or wrongly, that the ephemera attached to the particleboard walls are put there as inspiration, (or as reminders of previous inspiration), of those documents whose importance isn't merely in their own formal beauty, but in how that beauty influences what the artist himself must create. Here tradition comes dressed in thumbtacks; here tradition wears a little loop of transparent tape behind its head. This museum, this museum on the wall, is the living one. It is a creative allegory; but it is not the only creative aspect of the *Triptych*. For there sits the daughter on his wife's lap, the physical realization of the erotic photo pinned to the right-hand column, where the question is no longer art but life—except, that division is false. For here, too, all the life is art, all the art is life. If it is vivid it is because it is living.

Note: at the time of painting the baby girl did not yet exist.

Time, it doesn't behave. The *Triptych* has on its walls history. In its lap it has the future.

Art: it links the past to the future. This is the nature of the creative act, that it provides a present tense that cannot cease being present, the poet's holy *is*, the painter's whole *now*, that is so only by virtue of opening within itself, within its own formal life, that creative conduit between differing worlds: what has been done and what will be done. Art is a threshold art.

I have avoided speaking about what I most want to speak about, feeling innately that the complexity of the painting must be set up before its complexity can be explored. Here is what I've ignored—

Facing the Middle Panel:
The middle panel, by definition, separates the left panel from the right. The *Triptych's* middle panel also separates husband from wife and child.

The middle panel is occupied by the artist's table, on it the tools of his artistry, and in the black table's middle, the art piece he's working on—save that we can never here forget the aesthetic remove that is the painting's double-pulsed heart: the art piece, the engraving on which he is in the painting working on, is not the engraving, but a painting—in oil and gold leaf—of the engraving. (Reality in the *Triptych* is Daedalus's labyrinth, at the center of which the Minotaur works on his self-portrait, not from a mirror, but from a photo of himself some other person—ancestor or sacrificial victim—snapped.)

Behind and below the desk are two heaters that run on steam; such heaters sound alive when the steam moves though them, groaning, popping, an arthritic old man anthropomorphized in the room, a tutelary spirit maybe, an ancestor in the pipes, but maybe that goes too far—the painting is silent, after all.

Above the heaters are two windows, and through the windows, the German village this Jewish family, post–World War II, post-Holocaust, has come to live in for a time, to create in the midst of that history a work of art, a work of art that minds the past (exit visas, family photos) even as it predicts not only the creative future (engraving), but the procreative one (child).

Tacked or taped to the walls of the middle panel are reproduced reproductions: a Persian miniature; a photo of Georges Seurat's painting *Les Poseuses*, showing models nude before a reproduction of his *La Grande Jatte*; a letter written in black ballpoint ink; a paraphrase from Wittgenstein's *Philosophical Investigations*: "a language must be rooted in some collection of forms of life, and every particular form of life could be other than it is."

Reproduction is one form of life—child, art—that always makes another of what already is.

Painting is philosophical work—at least it is when the painting thinks, when the painting too is some collection of forms of life.

Among the many faces cataloged in the *Triptych* there is another face, an Arcimboldian face, and this face fills the entire middle panel. It stares at us as directly as does Simon Dinnerstein, as does his wife, as does his not-yet-existing daughter.

For eyes this face has windows. Through the windows we see what this face sees—the German village with the shingled roofs—which means this face is two-faced: it stares *at* us, but we stare *through* it.

Now we are inside the face we face. Now the painting is that face we wear over our face; I do not mean a mask. Sometimes (and this is where Dinnerstein stuns me) we must put on a face, not to hide our own, but to more fully reveal it. This painting is one such face: our eyes see through its eyes, and what we see is a world. The world—see Wittgenstein—is what we have from which to make art, and in making art, also make ourselves. We have this world; we have no other. Sometimes we cannot see this fact through our own eyes, in our own face, and so art lends us its eyes, lends us its face, not to protect or mask our own, but to remove the mask our own face has unknowingly become, to remove from our eyes the embroidered veil we have mistaken for our vision. This countenance is allegory's face (I can hear, in the steam pipes as they heat up with thought, Arcimboldo begin to laugh).

The allegory is thick because it is real: when the heat kicks on, the windows must steam, must become opaque. And then, tacked to the walls are those reproductions of works that are themselves a thinking, a thinking that inspires even as it respires, and as thought is itself a certain kind of reproduction of the world as it is perceived, so now these careful reproductions of reproductions take on their thoughtful life. Inside the face is the face's thinking.

And sitting on the table, this mouth of a table, the tools of expression wait, encircling that which they express.

The left panel and the right panel, they stare out at us, they face our face. The middle panel is the face we put on, almost as if the artist on one side, and the artist's family on the other, must become somehow our ears. Life, then, listens. That is, life is a form of listening—of perceiving—to the thoughts listening engenders, and in engendering,

creates the art that is of the world and pours back into the world. Whose face isn't, in each season, constructed of the fruits of that season? What a strange and visionary wisdom exists inside the *Triptych*, that in the middle of our face there is a face, and on it the evidence of many other faces, each in their odd way our own. This isn't the face we speak with, but the face that speaks through us. When we speak through it we do so to hear what it is that's being said (we do this as ourselves when we are more than merely our own, when we are, so to speak, double-faced); when we see we look so as to see what it is being shown. Art makes us this audience to ourselves—at least great art does. This is not selfish, but includes the self. We return to such art not simply to be in the face of it, but to reclaim by it, through it, by means of it, our own face. Great art gives us that face, our face. We return to see it so we can see. We return to it because, in doing so, in the miracle of creative attention, that true reciprocity, it returns us to ourselves.

The Life of Things

Simone Dinnerstein

My father's *Triptych* has loomed large in my life. It tells the story of my parents right before I was conceived, through my infancy. It's a story that I find endlessly fascinating. Who were they then?

As a child, I understood the tale of the *Triptych* as a real-life fairy tale. My parents had no money. They lived in an attic in Germany in a room with half a roof, sleeping on the floor, surrounded by furniture borrowed from the neighbor's garden. With characteristic disregard for rules, my dad began a hugely ambitious painting—his first painting out of art school—despite the fact that his Fulbright grant was expressly for printmaking.

My parents returned to Brooklyn, my dad sold his first drawing, and they thought that somehow gave them enough money to have a baby. Me. A New York art dealer, George Staempfli, then visited my dad's studio and bought the *Triptych* unfinished. The monthly payment installments (Staempfli was so wise not to give it in a lump sum!) supported the Dinnersteins' new addition for the next two years.

So the *Triptych* was born at the same time as I was, and it contains my parents' DNA just as much as I do. When I look at the *Triptych* I see where I come from. And if I wanted to tell someone who I really am deep inside, I would just need to show them those three panels.

My father's primary interest in art is in its humanity. He is not drawn to the surface of his subjects, to the rendering. He is interested in the life of things. He will travel across continents to see paintings that move and inspire him. In fact, that is pretty much the only reason he travels. He isn't concerned with the historical context of a painting, or the color theory behind it, or the iconography within it.

It is difficult to explain what draws him to respond to a painting, and what causes him to paint the way he does. I suspect that this is because he thinks in visual language.

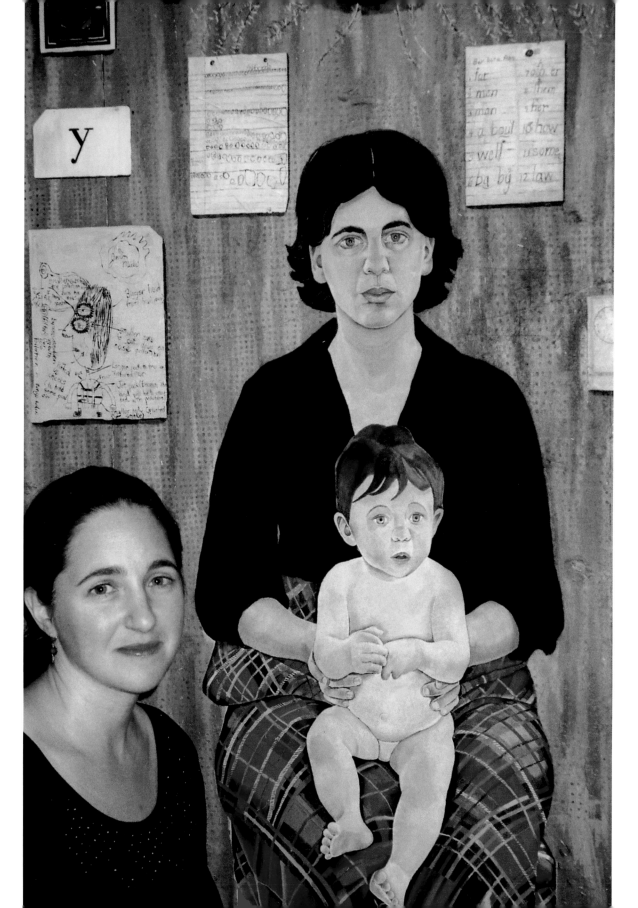

All of his paintings and drawings tell stories. They aren't allegorical or illustrative or didactic. They simply tell the story of the person who is modeling, of the apples on the plate. And that is not something that can be translated into words.

Simone Dinnerstein at the Palmer Museum of Art, Penn State University, June 2009

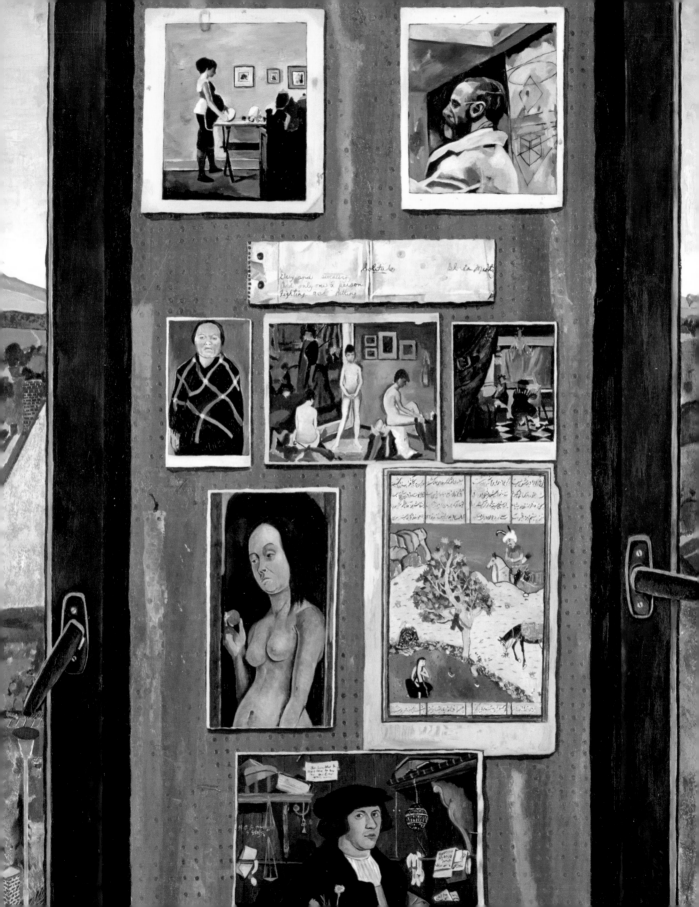

In Dinnerstein's Painting, an Echo Chamber

John Russell

Simon Dinnerstein was born in Brooklyn in 1943, at a time when Germany was a foe to be overthrown at all costs. In 1970 that same Simon Dinnerstein went to Germany on a Fulbright scholarship. Fulbrights for Germany were easier to get than Fulbrights for France, Britain, or Italy, and Mr. Dinnerstein responded in any case to the ancient German tradition of exact plain statement in art.

He went to Kassel, a city not much visited by foreigners except in every fourth summer, when the "Documenta" exhibitions have attracted the international art world to Kassel for months on end. He lodged in the outskirts of the city, where the steeply pitched roofs of the postwar housing estate peter out one by one, and the seraphic landscape beyond is much as it was in Dürer's day.

It looked a dullish sort of place, by the standards of Manhattan. But dullness can concentrate the mind, and Mr. Dinnerstein began to paint and draw not only what was immediately in front of him but also himself, and his wife, and all the things he had most loved in the way of past art.

It took him forever. Whether it would be ready for his show at the Staempfli Gallery, 47 East Seventy-Seventh Street, was long in doubt. The view from the paired windows would alone have been a year's work for many artists. Then there was the interior, with its floor-to-ceiling pinboard, its tableful of instruments shown in deep perspective, its seated portraits of the artist and of his wife with their small baby, and its encyclopedia of visual enthusiasms. Those enthusiasms included masterpieces of French and Italian painting in small-scale reproduction, air letters, children's drawings, newspaper clippings, and a big black letter y, islanded on white paper. The completed picture measures 6 feet 7 inches by 13 feet.

Neither scale nor perseverance has anything to do with success in art, and Mr. Dinnerstein's triptych could be just one more painstaking failure. But it succeeds as

an echo chamber, as a scrupulous representation of a suburb in the sticks, as a portrait of young people who are trying to make an honorable go of life, and as an inventory of the kinds of things that in 1975 give such people a sense of their own identity. Today is the last day of the show, but the triptych will be available to interested persons until further notice. It deserves to go to a museum.

Pictures of the Lasting World

Rudolf Arnheim

How do we recover the fugitive flight of time? Memory does its best. It recalls the cool spring, twenty years ago at the American Academy in Rome, where a group of fellows and residents had the chance to spend some time in the spirit of the Eternal City.

Among the artists in 1978 was Simon Dinnerstein. In his spacious studio I remember a large wall occupied by a faithful depiction of the flower market on the Campo dei Fiori. The painting reminded me compellingly also of the similar display at the foot of the Piazza di Spagna, where its symmetry, marked by the saleslady sitting in the center of the floral display, is in keeping with the overall symmetry of the Spanish Steps leading to the facade of the church of the Trinità dei Monti. This timelessness caught in the midst of a bustling city is in the character of Dinnerstein's work. It maintains the tradition of representing the lasting world as it lives in the work of the van Eycks, Dürer, Vermeer, and others.

Great paintings have always been more than a mere reflection of reality. But there is a particular quality I find in some of Dinnerstein's recent work. It is a kind of detachment from the immediacy of presence, an early example of what I find in Piero della Francesca's paintings. This quality has sometimes been called "magical realism." The figures are sharply outlined, which moves them from the realm of reality to that of depiction. There is a preference of frontality and profile, two firm positions resisting the natural turn of bodily movement in space.

Some of Dinnerstein's recent figures adopt these qualities of detachment because the naturalistic tradition has been affected by modern art. It has resisted the outerworldliness of cubism as well as the plaster-cast puppets of make-believe. The influence of these stylistic developments remains noticeable, but Dinnerstein's independence preserves his endearing nearness to our world, even when he watches it with the detachment of the observer.

And to the question which of
our worlds will then be *the world*,
there is no answer. For the an-
swer would have to be given in a
language, and a language must
be rooted in some collection of
forms of life, and every particu-
lar form of life could be other
than it is.

"Time Suspension" and *The Fulbright Triptych*

George Crumb

Simon Dinnerstein's art evokes, for me, something reminiscent of Marcel Proust in which memories of the past, the actual present, and dreams of the future are curiously interchangeable. I love his sense of "time suspension," suggesting that all earlier times may coexist with the present time. I guess I'm trying to do something similar in my composition!

Dinnerstein's work is very spiritual and haunting. At the same time it reflects the beauty of our physical existence. I do get a strong sense of the fragility of life in his work, very much like François Villon's "Where are the snows of yesteryear?"

Ballade (of the Ladies of Ancient Times)

Tell me where, or in what land,
 is Flora the fair Roman girl,
Archipiada, or Thaïs,
 who was her match in beauty's hall,
Echo who answered when one called
 over rivers or still pools,
 whose loveliness was more than human?
Where are the snows of yesteryear?

Where is Héloïse, so wise, for whom
Pierre Abelard was first unmanned
then cloistered up at Saint Denis?
For her love he bore these trials.
And where now can one find that queen
by whose command was Buridan
thrown in a sack into the Seine?
Where are the snows of yesteryear?

Queen Blanche, light as a lily,
who sang with a mermaid's voice,
Bertha Bigfoot, Beatrice, Alice,
Arembourg, heiress to Maine,
and Joan the good maid of Lorraine
whom the English griddled at Rouen;
where are they, where, O Sovereign Virgin?
Where are the snows of yesteryear?

Prince, don't ask me in a week
or in a year what place they are;
I can only give you this refrain:
Where are the snows of yesteryear?

Translated by Robin Shirley

No One Could Accuse

Thomas M. Messer

No one could accuse Simon Dinnerstein of being a fashionable artist. Not at the time he began, not now, and not at any time in between. Leafing through the catalog of his mature work that now spans four decades, one is struck immediately by his total disregard for prevailing taste, his apparent disinterest in the visual arguments of advanced art circles, and conversely, by his single-minded concentration upon the development of a highly personal, creative pursuit. Well before his thirtieth birthday, the young artist was already in possession of the technical means and the spiritual motivation that allowed him, in the late sixties, to set out on a very lonely road toward assertion of his role. It was clear to him that it had to be played outside of the enchanted circle within which current art and art criticism were enclosed.

It is difficult therefore to find an appropriate stylistic designation for Dinnerstein's contribution. He is a "realist" in the sense that intense observation, particularly in his earliest work, produced meticulous accounts of things, people, and nature. He was obviously fascinated by objects strewn around the glum habitations of proletarian surroundings. As with his portraits of the same period, narrative qualities predominate, but not to the exclusion of other aspects that could be called expressionist if one wished to designate thereby a visible concern with an inner reality that so visibly protrudes onto the smooth surfaces of his walls and facades. This concern is also mirrored in the mercilessly detailed features of his models. Likewise, in the rendition of flowers, trees, and botanical elements in general, Dinnerstein's preoccupation with inwardness at times assumes an almost magic intensity that approaches the category of fantasy. And finally, the painter's surfaces are so deliberately arranged, often with obsessive symmetry, and so carefully calculated with respect to structural ratios, that the term constructivist also would come to mind were it not wholly preempted in art historical parlance by abstract imagery. It is evident, therefore, that Dinnerstein's dominant realism is significantly enriched by every principal departure in twentieth-century painting.

In Dinnerstein's monumental *Fulbright Triptych*, such qualities are carried to a rich and potent synthesis. The work's central image, featuring an interior view with land-

scape, is placed between a frontal portrait of a seated man to its right and that of a mother and child to its left. This large-scale painting, in addition to dealing with issues of process and perception, has references to visual memory and identity, the workshop of a printmaker, childhood, and ultimately, the curiosity and awe of being a young family living in a foreign land.

The Fulbright Triptych brings to their triumphant conclusion the formal and expressive qualities characterizing Dinnerstein's art.

An Exchange of Letters

Guy Davenport & Simon Dinnerstein

Simon Dinnerstein
415 First Street
Brooklyn, New York 11215

November 1, 1990

Professor Guy Davenport
Alumni Distinguished Professor of English
Room 1365, Patterson Office Tower
University of Kentucky
Louisville, Kentucky 40506-0027

Dear Professor Davenport:

I am taking the liberty of asking the University of Arkansas Press to send on to you an advance copy of a forthcoming book on my work.

I have been very interested in your writing, which I first came across in an introduction to the art of Paul Cadmus. However, I must say I was very deeply struck by your book, *A Balthus Notebook*. I think you have caught so much of this very poetic artist with your really poetic book. Your sections which deal with what it is, if anything, that makes an artist "modern" are very pertinent in general, but I actually feel could have been written about my own work (you talk about Stanley Spencer and Balthus and Brâncuşi). Also, I heard an excerpt of a book of essays of yours read on the radio here in New York, and in it I think you described going out to the country for expeditions with your father and learning to really look at nature and to describe what it is you see. Having myself a strongly developed visual memory, I found these descriptions of great interest.

Somehow, on a kind of educated hunch, I am hoping that you might relate to the work in my book. Since 1973, I have been affiliated with Staempfli Gallery in New York. I have tried, in some way, to combine my interest in the figure, the dignity, humanity, beauty of people, with some "modernist" (whatever that word means)/abstract point of view. In this regard, I would like to believe that there is some theme or point of view in my work which stands it apart from certain trends in American realism, from "pop" to "hyper" to traditional figurative art.

I feel very lucky to have had the participation, through their writing, of Thomas Messer, George Tooker, and Albert Boime for this book. I know that you have been through the process of putting a book together, and I must say it is a deeply emotional undertaking. In this case, more than twenty years of painting and drawing are put together in this volume.

I look forward to your thoughts and comments and I would, in addition, find it a great pleasure to meet you, if you happen to be in New York.

Sincerely,

Simon Dinnerstein

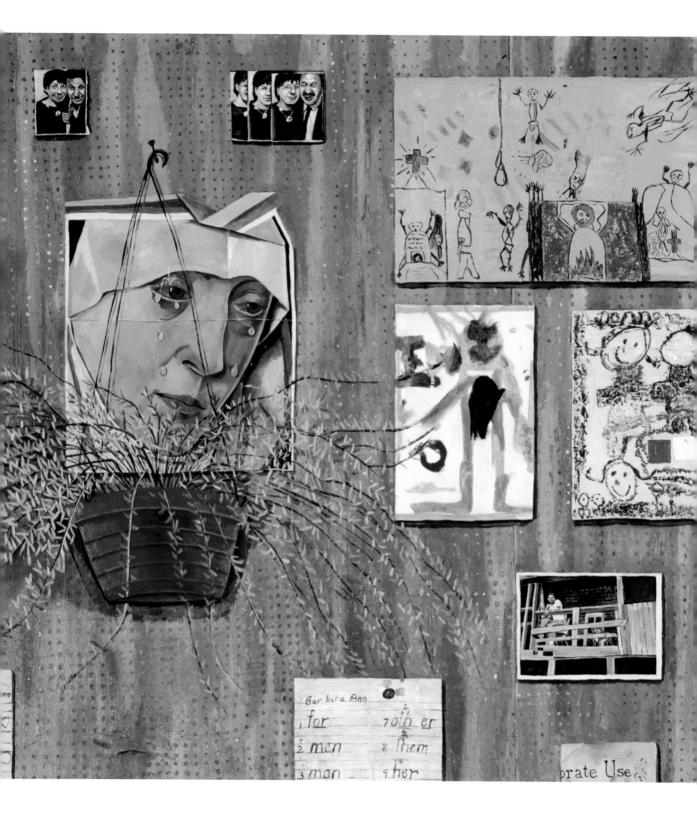

621 Sayre Avenue • Lexington Kentucky • 40508

21 January 1991

Dear Mr. Dinnerstein:

Just this morning I received *The Art of SD* and your letter dated 1 Nov. 90. I can't decide which to praise first, the splendid revelation of your painting, or your generosity in having a copy of the book sent to me. Both at once.

How in the world have I missed your work? The book is a vindication of my complaint over the years that cultural information is hard to come by. You will find me in the current issue of *Drawing* defending the draftsmanship of Grant Wood, which in a sane world ought to have been wholly unnecessary.

Seeing your work all at once is something of an overload. To the question "What do you think of modern art?" Gertrude Stein replied, "I like to look at it." I can begin with that simplicity. Your pictures are first of all good to look at.

Then one becomes aware of your powerful symmetries: the bilateral one that is a signature, and the inside/outside one of foreground and background. You are right to begin the book with *The Kelton Press*, which has these symmetries, plus a radial one. This amazing drawing also announces your digestion of surrealism (Max Ernst would have liked this drawing, and called it *The Insect God*), and like Ernst you see the wonderful harmonies of the natural, the architectural, the technical. Those trees reproduce; man participates in creation beyond the biological: the etching press reproduces images. The medium, charcoal, comes from the trees.

I must think and think again about the *Triptych*. Obviously you have put everything into it. My immediate feeling about it—and practically all your work—is that it is a perfect register (narrative, if you will, art-as-equivalent-at-the-highest-articulateness) of the Jewish soul. Fred Siegel once gave me a poster from a school. It is a lesson in the letter aleph, showing that the upper yod symbolizes Torah and God, the lower one is human life, and the diagonal is the boundary between the two. The illustration is of a family studying Torah at the kitchen (or dining room) table—father,

mother, daughter, and son. The *Triptych* says something of the same thing—and lots more.

It is an iconographer's heaven! That's Germany—Germany!—out the windows. "Here we are, a family. We have been civilized for five thousand years. We have experienced everything; we have survived. We flourish." Images of Assyria and Babylon to the right; children's drawings— renewal—to the right.

Zukofsky's "*A*" in paint!

There are a thousand things I want to say, by way of response. I needn't get them all into one letter. Obviously you sent the letter of 1 Nov. 1990 to the publishers, to be included with the book, which has just arrived.

I am writing a book about still life (which I derive from the basket of summer fruit in Amos, the most archaic book in the Bible). I have a bee in my bonnet about apples and pears, and your pears enrich my argument. More about that, later.

The little boy looking out of the eyeholes of his paper bag (188/189) is purest magic! All the flowers are marvelous. *Roman Afternoon* is a great painting, and *The Birthday Dress* a deeply meaningful one in its symbolism and psychology.

But let me race through this letter, so that I can get it in today's mail. I am basically a writer of inept fiction and of literary criticism. My writing about the visual arts is a dare on my part. Cadmus asked me to write the introduction to his drawings, as did Balthus (in a Byzantinely indirect way: he had seen an essay I'd done in *Antaeus* and sent word through his dealer that I was to "be encouraged" to write more).

You say in your letter that you hope I see that your work stands apart. It stands apart, believe me—it stands apart.

I could spend the rest of the day responding. That 1 Nov. date keeps plucking at my elbow as a seeming and hideous delinquency; I want you to have as immediate a reply as I can manage. The book warms my house just by being there.

So, before the postman comes to pick up the mail,

<div align="right">In great measure of gratitude,</div>

<div align="right">Guy Davenport</div>

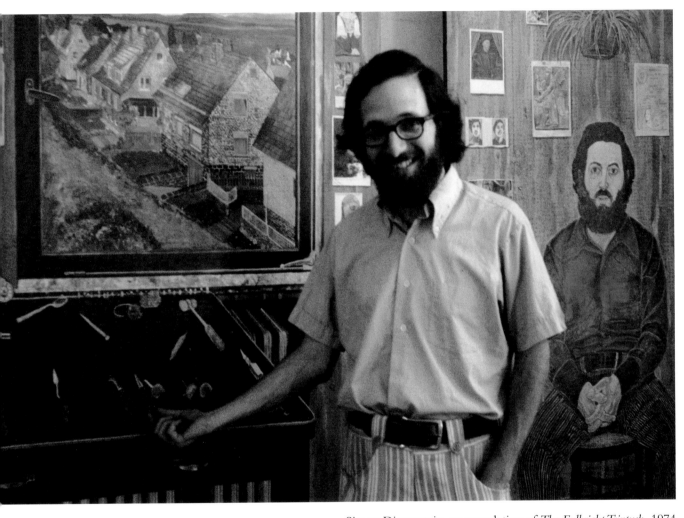

Simon Dinnerstein, on completion of *The Fulbright Triptych*, 1974

The Art of Simon Dinnerstein

Guy Davenport

Simon Dinnerstein's *Fulbright Triptych* is so symmetrically a harmony and so richly a composite of genres (family portrait, still life, landscape, and a collage that amounts to a complex poem) that its anomalies aren't immediately apparent. He himself has pointed out that it's a painting by a graphic artist (and his Fulbright project is there on the table, dead center, a copperplate engraving called *Angela's Garden*), the baby on his wife's lap had not yet been born (his daughter, Simone, now a concert pianist), and what we're looking at is a serene Jewish family in a country that slaughtered six million Jews from 1933 to 1945. And among the fifty-seven images thumbtacked to the wall is an exit visa from Russia, dated 1918. The Dinnersteins, like the Chagalls and Kandinskys, the Einsteins and Panofskys, move about in the turbulences of history.

When I first saw *The Fulbright Triptych,* I was immediately reminded of Louis Zukofsky's great poem *"A,"* which is also about a family in Brooklyn with a child who became a concert violinist. Zukofsky, like Simon Dinnerstein, took the family to be the irreducible unit of civilization. Ezra Pound took that unit to be whole cultures and attempted to show in his *Cantos* that we are a continuation of the European Renaissance and Enlightenment. William Carlos Williams saw the unit of civilization as the city and shaped that idea in his *Paterson.*

Another Brooklyn poet, Walt Whitman, had already synthesized migrating and diffusing cultures, the city, and the family as components of civilization in his *Leaves of Grass.* American culture habitually forgets its past and moves in cycles of rediscovery, forgetting and remembering, stunned into amnesia by the new, repeating forgotten pasts.

Art is always an invention inside a tradition. Beginning from scratch happened some 40,000 years ago—and with every child who takes up its crayon and draws a dinosaur driving a construction crane. There are many children's drawings in *The Fulbright Triptych* collage, alerting us to the subject of the painting: education of many sorts, most obviously that of a young artist learning his skills, of a young father starting

a family, of survival in a hostile society, of creative renewal. The Germany we can see through the windows is landscape that bred Hitler's inhuman barbarians; but it had once bred Dürer, Memling, Bach, and Thomas Mann.

Simon Dinnerstein's habitual left-right symmetry, his truthful rendering of materials, his eloquent distribution of light announce his distinction. They also include his painting in the art of our time, for beneath (or inside) most Dinnersteins there is a splendidly abstract design. Our guide to seeing this can be found in the most primitive art to survive into our time, that of the Dogon of sub-Saharan West Africa. The Dogon use four ways of making an image: a pattern of dots (as stars in a constellation, or the location of posts in the plan of a house), the connecting of the dots with lines (giving a legible abstraction), a filling in of detail to achieve what we would call a drawing, and the filling out into three dimensions to make a sculpture, a mask, a granary, a pot, or a house.

The Kelton Press (1969), a charcoal drawing, has an almost absolute left-right symmetry; remove what a Dogon would understand as "the fill" and you have a strong abstract painting. (Isolate the verticals and horizontals in a Vermeer of houses and you have something like a Mondrian.) I see this love of symmetry in early Dinnersteins as an emotional geometry imposing order not only on the visual but on the moral as well. This severe symmetry gradually gave way to explorations of asymmetry as Dinnerstein's meditations became richly sensual and intimate.

There is a steady shift of Dinnerstein's eye from northern Europe to Mexico. *January Light* (1983) is a Mexican Whistler. The asymmetry is Whistler's; the color is Rivera and Frida Kahlo. And there is a radical change from the domesticity of the early paintings to a Balthusian vision of the female nude sleeping or daydreaming, or simply being there. For Simon Dinnerstein is, to date, an essentially existential artist. His paintings say *this is*. His transition has been from *this is how things are* to *this exists: look*. This transition involved subtle changes in rendering; cloth became stylized, for instance, not seen cloth but Dinnerstein's imaginary cloth, with its own way of lying in folds, its own diaphanous difference, its own poetry of the eye.

Scholars will eventually want to trace Dinnerstein's still lifes (never quite like anybody else's), his social commentary (the stark *Arnold*, the views through Brooklyn

windows, his Italian flower markets, his paintings of people in rooms and playing children, his self-portraits and portraits of his wife and daughter), but it is his female nudes that command study. If symmetry was the beguiling order in his early work, a strangely chaste sensuality has replaced it. Our interest in any artist is deepened by the way a style treats a subject. We will never know how Picasso would have painted a woman talking on the telephone or a garage mechanic changing a tire. What's going on in the affinity of an artist for a subject? Monet and his water lilies? Gauguin and his biblical themes hiding inside Polynesian and Breton peasants?

In these current nudes we see an age-old problem being solved, the conjunction of the real and the imaginary, the factual and the ideal. Gold leaf cooperates with graphite in one canvas, color with grisaille, a literally drawn body with an ideal of beauty. It's as if Dinnerstein, having so often made a plant in a jar look like a miracle, or Brooklyn sunlight on an ordinary floor seem supernatural, has reversed the process, working outward from a mystical presence to a realistic surface of flesh. His technique and media have become more painstaking, his working hours longer, the canvases staying on the easel for years rather than months.

Practically all of Dinnerstein's faces wear the question "Why are you drawing me?"—the children in *Night*, the nude in *Dream Palace*, even his *Self-Portrait: Summer*. To the answer "Because you exist" we need to add that art exists, too, an intelligible world inside a largely unintelligible one.

The Theology of Art

Edward J. Sullivan

The Fulbright Triptych employs the ancient, tripartite format generally reserved for religious purposes in the Middle Ages, Renaissance and, in rarer instances, in later phases of the history of Western art. Often found on a high altar of a church or chapel, the triptych represents and celebrates the most sacred of persons. A typical main subject of this type of painting (which originated in the north of Europe but became a general feature of ecclesiastical art throughout the continent) would include New Testament scenes such as the Annunciation, the Ascension of Christ into Heaven, or the Assumption of the Virgin. Saints and angels would likely inhabit the right and left panels of the work (typically done in oil on wood) and donor figures (those patrons who commissioned, paid for, and were honored by the painting) would also appear on the side panels or "wings."

Triptychs in modern and contemporary art are rare, indeed almost nonexistent. While there have been many revival styles since the nineteenth century, few artists have attempted to employ this format, so essentially connected with such great names of the past such as Jan van Eyck, Rogier van der Weyden, or, in the baroque period, Peter Paul Rubens.

Simon Dinnerstein's use of the triptych form is not surprising, however. A dedicated student of old master techniques, he has created numerous updatings (and, indeed, radicalizations) of past traditions (styles, formats, and media) in his quest to meld the ancient with the modern. This painting, one of his most monumental achievements, constitutes both a dramatic break as well as a modernization of a hallowed tradition of Western art history.

There are many shocks awaiting the viewer of this work. The first is, perhaps, the dramatic liberties the artist has taken with the subject matter. I mentioned above that among the most common themes in a medieval or Renaissance triptych would have been a biblical subject, often (but not always) associated with the life of Christ. Among the most popular was the image of the Holy Family: the Christ Child, the Virgin Mary, and the (usually bearded) Saint Joseph. In this painting the artist is fully con-

scious of appropriating this theme and transforming it into a group portrait of his own family. He is equally mindful of his marginalization of what in earlier times would have been the main subject. Mother, father, and child have been displaced to the side panels. While still recognizable as an updated simulacrum of the Holy Family, they have now become subordinate actors in a drama whose main subject is art itself. The three figures (in roles that in the past would have been played by the angels and saints in the triptych's wings) here serve as witnesses to the principal scene while, at the same time, functioning as donors, or, rather, facilitators of the acts of creativity that are implied with such dramatic force in the foreground of the main body of the painting.

Carrying this thought further, however, we could also observe that the two adult figures in this scene serve, in fact, as paradigms of creativity, having brought forth a child (the Dinnersteins' daughter Simone was, in her own right, destined for a life as an artist—in her case a concert pianist). This manifestation of the act of creation parallels and stimulates the making of other forms of life—the "life" of art. Art, as represented throughout the work (on the walls, and especially on the altar/table in the center panel), is sacramentalized and literally raised onto a platform as the focal point of the painting.

Furthermore, this work, more than any other modern American painting, represents a dramatic homage to individual *things*. It presents to the viewer a veritable "language of objects." The three figures lead our eyes into the center, and from there our gaze radiates outward, taking in the vast quantity of elements that comprise the essence of this scene. There is an almost musical quality to this painting; each object becoming the equivalent of a note in a vast symphonic score.

This painting is also an homage to looking, an encyclopedic concretization of scopic intensity. There is a plethora of individual square and rectangular shapes throughout the composition which we initially perceive as a vast series of punctuations of its space. Yet we soon become aware that most of them are postcards or photographic reproductions of works of art (many of them well-known). They are famous paintings and sculptures in museums from Munich to the Metropolitan, each of them holding a special place in the aesthetic hierarchy of the artist. We are reminded of a wall of a museum, or, as André Malraux would have described it, a museum without walls.

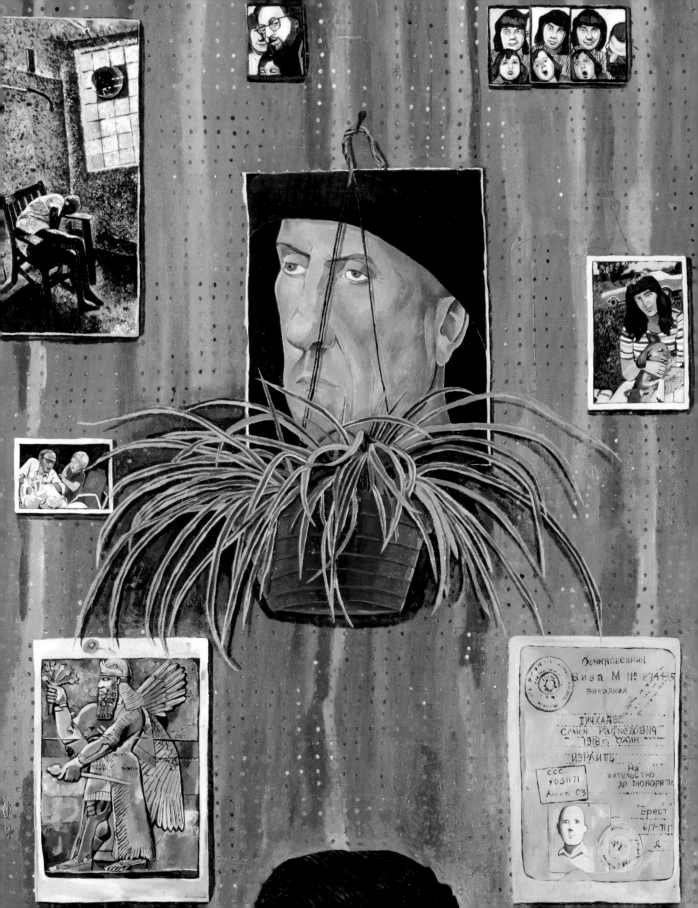

The *thingness* of these art reproductions is reinforced because they are interspersed with handwritten notes, family photographs, newspaper clippings, and children's drawings. In a very privileged position just above the central table we find an aerogram. This letter from afar is one of the most intriguing of all of the many bits of paper that populate the walls. It is obviously from someone important to be given such a place of honor. Yet we don't know who sent it. To whom was it destined and from where did it come?

Even the landscape outside the windows becomes a series of *things*. This is a village scene, two streets of a solidly middle-class Germanic neighborhood, yet the houses inevitably look as if they were made of blocks from a child's log set. The similarity of the structures enhances the sense of patterning and object-hood created by the images on the walls. Nature inevitably intervenes, however, in both the landscape scene as well as the interior. The streetscapes stop and a gentle, hilly, unpopulated landscape begins. In an analogous way, spider plants hanging in pots on the walls of the artist's studio relieve the planarity of the surfaces.

As indicated by the title of this essay, the real subject of this painting is the making of art. The table functions as the locus of creativity, the altar of the theology of art itself. It is a large, impressively detailed table, placed strategically before two sets of vertical white lines (the grills of two radiators) that serve to punctuate the space behind it, making it stand out dramatically from the brown walls. The table has two drawers that evidently guard a series of secrets, perhaps additional tools of art-making such as those on the table itself.

The artist himself has eloquently described the contents of this surface, which is tipped upward at a slightly unreal angle to allow the viewer maximum comprehension of all the meticulously illustrated implements there. Dinnerstein states that this is a "very large painting about the studio of a printmaker . . . The instruments on the table are burins, scrappers, burnishers . . . all to be used in [the] engraving process . . . The object [in the center of the table] is a depiction of a copperplate I was engraving at the time (*Angela's Garden*). I used gold leaf and oil to get at the particular luminosity of the surface of this form."[1]

Grateful as we are for Dinnerstein's own description of the objects represented on

the surface of his worktable, we sense that the real significance of this image goes far beyond appearances and typological characterization of the things before our eyes. The plate itself is a gold object, a shimmering thing that stands out dramatically from the deep black of the table's surface. Although it is, in its mundane form, a matrix for a print, it may be read metaphorically as a virtual sacred host. Were this a traditional religious painting of an earlier era, this gold disk would take the form of a miraculous wafer, such as the host in traditional portrayals of Saint Gregory, a doubting cleric to whom God revealed the mystery of transubstantiation through a miracle of elevation. (This was a well-known hagiographic incident, often depicted in medieval art.) Yet this is not a medieval painting. It was done in the 1970s, not the 1370s. Nonetheless, *The Fulbright Triptych* evinces an equally powerful message of the sacrosanct nature of art and human creativity.

There is also a distinct feeling of confrontation in this piece. It is enhanced by the artist's deliberate compression of space. Everything is pushed up almost impossibly close to us. The artist's space becomes ours and we are immersed in his reality; we are confronted and absorbed by it. In effect the *Triptych* is a deeply autobiographical, confessional work. It is a parable not only of creation but of the artist's life creed. The making of art is his métier; the belief in its transformative and indeed transcendental power is at the core of his earthly existence and it represents his deeply humane message made palpable for us in this painting.

Simon Dinnerstein

Phillip A. Bruno

I still now recall, thirty-six years later, the initial impact photographs of Simon Dinnerstein's *Fulbright Triptych* made on me. What struck me was the ambition, the self-confidence and almost arrogance of attempting to create such a compelling and stunning work demonstrated by an unknown, at that time, contemporary painter.

The huge central panel depicts a black, horizontal artist's working table with various brushes, knives, scissors, engraving tools, and a copperplate. Above it are two windows open to the village of Hessisch Lichtenau, Germany, where the artist and his wife Renée resided during his Fulbright grant in 1971. The view is of the main street of the village with blue sky beyond. Colors, tones, and precision convey a serious intensity.

This image is an homage to all artists' studio space. Pasted and pinned around these windows are many postcards and photographs of masterpieces of the past which have appealed to and inspired Simon. To its right a vertical panel represents the painter seated with his hands clasped between his legs looking directly at the viewer.

Balancing this vertical panel which is almost seven feet high, is its partner, depicting Renée and Simone. Renée, seated, holding their child, commands an equal amount of space as her husband. Their heads are level on either side of the composition. There is, too, an overall geometry disrupted by the random scattering of sixty reproductions and postcards on the studio walls which give hints of Western art history. It reminded me of Flemish masters of centuries past.

The scale of this *Fulbright Triptych* is a declaration of Simon's self-confidence, a statement of "I have arrived." No doubt I sense a great ego. Simon had come to the gallery by walking off the street, yet so impressed was I with photographs of the *Triptych* in its entirety that I thought his work was appropriate for a one-man exhibition at the Staempfli Gallery, of which I was co-director. When I showed the photos to George Staempfli he agreed, and we subsequently arranged to visit Simon's studio in Brooklyn to see the original. Simon explained that it was not yet finished, yet George and I were in agreement that we would give him a show, focused around the

Triptych. Our gallery's commitment to the work, Simon later told me, "had something of a magic, fablelike quality for him."

As finances were of concern to Simon, it was agreed that the Staempfli Gallery would purchase the *Triptych* and pay Simon a monthly sum over a two-year period until the painting was completed. It was to be the highlight and focal point of the Dinnerstein exhibition in January and February 1975. Subsequent to the exhibition and publication of the catalog, the *Triptych* received the Rome Prize.

The blackness of the central worktable anchors the painting's very symmetrical composition. The three figures—intense and sculptural—stare out at the viewer. Wife and baby emit a medieval calm; the tranquility of a Madonna and child.

William Hull, then director of the Penn State University art gallery, saw the *Triptych* and asked permission to have it sent to his museum for possible purchase. I am happy to say that today it forms part of the museum's collection of contemporary American paintings. Congratulations, Simon!

An Unfinished Painting: An Offer

George Staempfli

Staempfli Gallery
47 East 77 Street, New York 21, New York
Telephone: Lehigh 5-1919 Cable: Stagallery, New York

April 12, 1973

Mr. Simon Dinnerstein
20 Fiske Place
Brooklyn, New York 11215

Dear Mr. Dinnerstein:

Both Phillip Bruno and I were quite impressed with your work. I particularly liked the large unfinished painting. Here is an outline of my thinking:

1. I believe it would be a good idea to organize an exhibition of your work in this gallery when the big oil is finished. To show the drawings alone would not have the same impact.

2. We would be willing to offer you $— for the big oil (*if* we can get it in the gallery which we would have to test with a dummy!) and I would suggest that we would pay you $— a month toward that purchase for a year, and the remaining $— when the painting is finished. It is probably foolish to buy an unfinished painting, but I have confidence that you will live up to your own standards of excellence.

3. In return, Staempfli Gallery would expect the exclusive rights to represent you and to sell your work at least until after your exhibition here. At that time

we could arrive at some more permanent contractual agreement if we still both feel so inclined. In between time, our commission would be one-third of the sales price.

4. I frankly wonder if your plans for the *Triptych* won't prevent you from painting more accessible pictures. The two outside panels without the center would not make too much sense, and *with* the center they would restrict (for size and subject reasons) the sales possibilities almost exclusively to a museum. And museums, unfortunately, are spending very little money on purchases these days, mainly because they have no funds. I would urge you to think carefully before you start on the *Triptych* wings. Perhaps you could combine the two figures into another single painting, in which they would be independent of the existing center, both visually and emotionally. But that, needless to say, is your own problem. Let's put it this way: the center does not need the wings in any way.

If any of the above makes sense to you, give me a call and perhaps we can talk about it sometime next week.

Sincerely yours,

George W. Staempfli

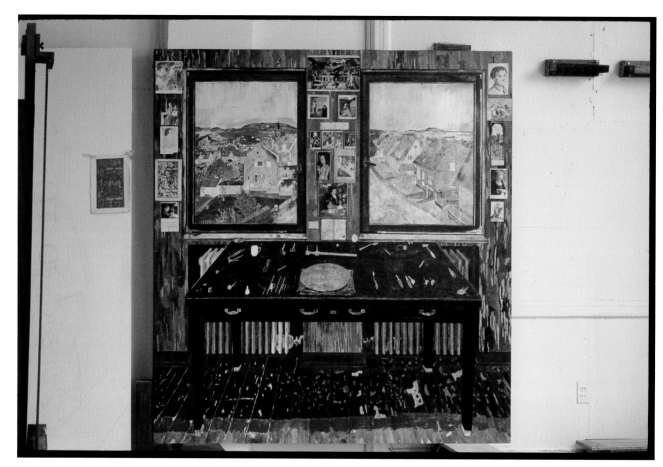

April 1973

An Uncompromising Quality . . .

George Staempfli

There is an uncompromising, almost merciless quality about the way Simon Dinnerstein looks at something he wants to draw or paint. It can be a person, or a landscape, or a still life—a corner of a flower garden or an ugly building across the street. Whatever the subject, he will recreate it with intense realism, exactly the way he sees it, without softening or embellishment, without "artistic liberty." He uses charcoal like a chisel, and his pictures have a gothic exactness and plasticity which defines their subjects in crisp angularity.

In only one work, his monumental *Fulbright Triptych* of 1971–1974, is there a noticeable mellowness and emotional indulgence. It is a largely autobiographical work, composed around the trinity of his wife, himself and their baby. The detailed objects appearing in the *Triptych*, grouped around the centered working table, give us a glimpse into the privacy of his family life. Bits of old letters, postcards, news clippings and children's drawings are pasted on the walls around the windows like pages out of a confidential diary. They relieve the stern and rather forbidding presence of the parents' portraits in the wings of the *Triptych*. We realize suddenly that Dinnerstein's detached and controlled use of hard-edge reality is merely a cover for underlying currents of sensuous warmth, and for his positive participation in the stream of life.

Catalog Introduction, First solo exhibit, 1975

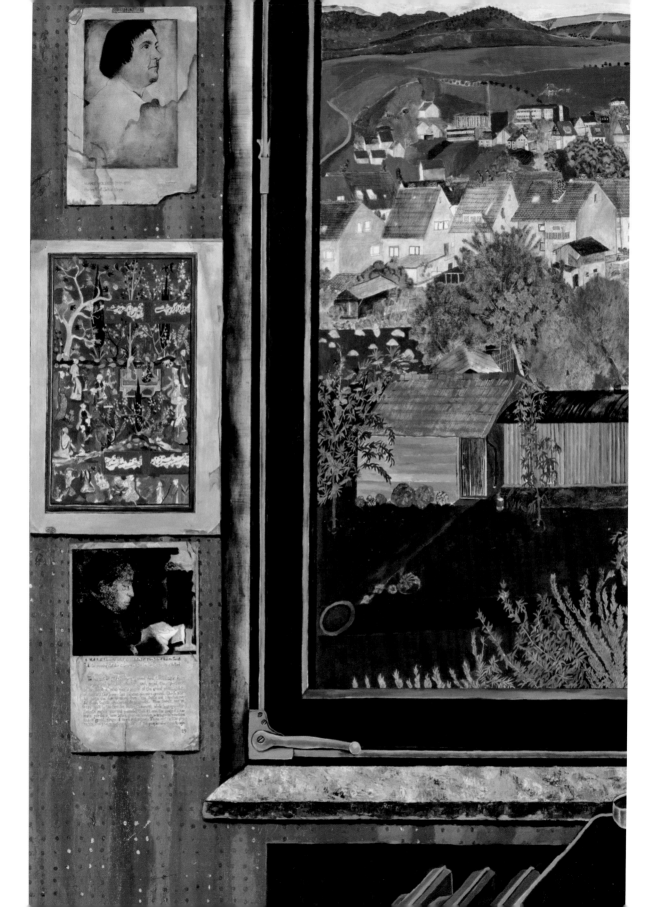

A Letter to William Hull

Simon Dinnerstein

Simon Dinnerstein
415 First Street
Brooklyn, New York 11215

November 16, 1982

Mr. William Hull
Director
Art Museum
Penn State University
University Park, Pennsylvania 06802

Dear Bill:

Phillip Bruno called me this past Friday to mention the news of the loan of the *Triptych* to Penn State University's art museum. I am very pleased about this wonderful news. I have a very special feeling for this painting, and showing it in a public space is so exciting to me.

Phillip mentioned your desire to have more information, details, and particulars about the painting. I feel somewhat at conflict about writing at great length in that there are so many words written about works of art. Moreover, the painting I have produced here is full of great layers of information dealing, as it were, with complex and subtle feelings, mysteries, and "wonderment." What I would like therefore to do is spend a bit of time "free associating" about the picture. Art historians/iconographers would say that the artist "knew" great hulks of knowledge and painted out of this knowledge. I can say positively that a great deal of my thoughts regarding this work came to me

after I started and also while I was finishing and during the years after! This fact is hard to understand, and I guess it is representative of the incredible complexity of psychology and thought and human motivation.

I started the painting in Germany (1971) while on a Fulbright (1970-71) and living in Hessisch Lichtenau (Quenteler Weg 31) and attending an art school in Kassel, Germany, completing the picture, after three years of work, in a studio on Fourth Avenue and Twenty-Fourth Street in Brooklyn. (My daughter was not born when the picture was started and was almost two years old when the work was finished.)

The imagery for the picture came to me "at one shot" in its totality! I mention this because it is a rare example of such insight; many artists work differently, myself included. Following are a number of my thoughts: the overall visual organization of the painting is an attempt to be abstract and formal as well as detailed and expressive; "perception" is a major theme, or the "grasping" of "what is out there" (the artist's attempt to "slow down" reality and "stop" or capture it); the presentation of tools and instruments and graphic utensils involving the measuring and the use of objectifying equipment as aids in this quest (i.e., as in Dürer's *Melancholia*); the sheer visual treat and joy in painting; the understanding of "forms of life," as in Wittgenstein's treatise on the difficulty or impossibility of language and visual identity; the various pictorial "excitements," such as other "forms of life"; the "humor" of a painting about a graphic artist (Fulbright-Graphics) and printmaker-engraver (gold leaf as copperplate), burins, engravers, etc.; the *Triptych* was my "first" painting since being a student at the Brooklyn Museum (1964-67) and was the first time I had felt the need to express myself in paint—the time in between spent mainly on drawing and graphics (there is a "humor" in attempting a fourteen-foot "first" painting); the possibilities, mystery, and enigma and wonderful potential of "paint" with its own suppleness and beauty "as an end in and of itself"; there are the various contrasting themes of sophistication/children's drawings with paint becoming "crayon," "ink," "pen"; the duality of sophistication/naïveté as expressed in colors, but also indicative generally of an approach to the world, i.e., seeing it for the first time like a bubble that somehow can be grasped (as the "beads of knowledge" or *Glasperlenspiel* of *Magister*

Ludi); the organization of left and right; there are the "time" themes, as well as the sheer risk of "time," the "gamble" of time well spent to fulfill a work of art; the concepts of "seeing" vs. "perceiving" as a major theme (note the importance of the picture of two men in the right panel: "seeing" closely—"seeing" significantly vs. "seeing" closely and not seeing at all); the belief that art (in the *Triptych*) is the visual counterpoint of the novel, i.e., the full measure of a man (art as a layered experience, complicated, design-oriented, enigmatic, but expressive internally as "thought" or "concept" or "idea"; "the novel as a tremulation can make the whole man alive tremble . . ." D. H. Lawrence; the inspiration of such writers as Hardy, Mann, Dostoyevsky, Kafka to summarize, engulf, and "compel" a large experience of "weighted, rounded form," "fecundity," "full-bloodedness"; the use of paint as an illusion and paint, literally, as an internal vehicle toward an idea (abstraction) (thoughts of trompe l'oeil, a beautiful but limited realism); the belief in art as a "force" or "compulsion" (Starbuck/Whale—white heat and purity of form and thought); the ideas of "seriousness" and "humor" and in contrast causality and absurdity; an attempt to get at design concepts of deep space vs. close forms ; the ideal of an ultimate viewing distance; up close vs. great distance, and optimally about 10'-12' away so one can just take in the two exterior panels; an interest in peripheral "close space" vs. exterior distance, the intimate depiction of a family, as "idea," and as pinpointed and "held" in time, living together and striving to understand and "get at" what is "out there"; the use of triangulation as a design motif, or in other words, the triad, or the trinity of protection, harmony, and love and sensuality within; an interest in both internal and external movement; the rather personal and perhaps idiosyncratic theory of the "flying eyeball "; the obsession with empiricism; the belief that paint can yield "spirit"; and organization and/or placement of the elements in the painting in terms of three, within which there is a division of "warm" exteriors and "cool" interiors ; the very strong conviction that every individual has a need for identity and the search for one's axis; the very real conviction that a "seeking" life is the most meaningful in that it provides understanding (possibly indicative of the idea of "art as diary"); and ultimately the fact that we carry on alone, singly or single-minded, with this search—

Grey and sweating / And only one *I* person /
Fighting and fretting.
—Gloria Mintz, 1965, age 13

Ultimately it is really the visual impact of the experience of the art on the viewer that counts. I have been struck by the amount of time people spend looking at this particular painting. I do not know that this is truly an important criterion; i.e., whether this aspect really matters; I simply put it out as something I have observed, and it is rather odd and wonderful to see one's painting looked at (or "read") for fifteen to forty-five minutes.

For your practical information, the spacing should be about 3¾" (–4") (use your judgment) between the panels. The area allows for the floorboard lines and general overall perspective to line up.

Please feel free to use any or all of this information or to edit. I leave it to your good taste and judgment. Furthermore, I would be curious to know how the painting is received—perhaps we could get together when you next visit New York. (I've two large drawings on exhibit now at the City Gallery, Columbus Circle/New York's Department of Cultural Affairs—announcement enclosed. I hope you would have time to see this work and that we could have a chat.)

So, again; I'm most excited!

Very sincerely,

Simon Dinnerstein

Where Are We? When Are We?

Alvin Epstein

On first viewing Simon's *Fulbright Triptych*, even in small reproduction, this painting is immense. Life-size. It looks as large as the room it portrays.

But what's going on?! What's happening here?
Where am I supposed to look?
No dynamic diagonals to lead my eye from here to there!
My eye doesn't know where to go!
I'm lost—I have to make a choice—this way or that?
No compulsion to start here—or end there!
Stop!!

I tell myself to look elsewhere—
 and now . . .
 look back again.
Don't try to "grasp" the painting all at once.

Read it—not as a book with one continuous story to tell—rather as many stories—a history.

Be content to wander through the history and not be compelled to start here and finish there.

Simultaneity—that's it! Simon's Simultaneity. Experience the pleasure of lingering here or there, where many things are happening all at once, independent of each other but all related by Simon's having chosen to include them—each story, or bit of a story, chosen and carefully placed in relation to all the others. Nothing arbitrary or left to

chance. Balance, order, clarity, all of it very personal to the chooser—Simon—and all of it available to us, to wander in at our pleasure.

There are the people, clearly a family even though separated by their shared world, facing us full face, frank, open, looking at us looking at them—(maybe *we* are the painting?)—but as frank and open as they are, they are also strangely silent and remote, letting their surroundings speak for them.

And the surroundings are a very rich, albeit mysterious, world in which these very specific portraits exist—an interior replete with personal references which tell us—and *don't* tell us—much about the lives lived in this interior, warmed by two aggressively industrial-age radiators, while through two picture windows (how apt the term—are they pictures or windows?) we see a village street where the details of houses, gardens, and walkways are decidedly suburban and of our own day, but the presentation is undoubtedly medieval—so time itself becomes ambiguous.

Where are we? When are we?

The answers are in those fleeting moments when the imagination clusters around any one of the myriad separate areas, and composes a story that evaporates immediately as my eye travels onward.

We Are All Haunted Houses

Kate Holden

"And to the question which of our worlds will then be *the* world, there is no answer." This tiny painted quotation on the wall of *The Fulbright Triptych* sits literally at the center of a massive composition. The painting represents a world into which Simon Dinnerstein has fitted—spaciously enough, but with the forensic anxiety of the analyzed—himself, his wife and (as yet unborn) daughter, his work tools, an altarlike table, a wall of assorted postcards, photographs, children's drawings and artworks, and, through the windows, the outside universe unto a green horizon. This is the artist's world, a tableau of memories, fragments, and images. It refracts a personal, lived cosmos; it is not *the* world, but it is *one*. Monumental in its scale, formal as its religious antecedents, the *Triptych* is yet a grave, intimate essay on the artist placed within—indeed, modestly seated magus of—the habitat of his artistic and personal heritage.

Every element of the painting is discrete and meticulously separated. Each object in this memento mori lies displayed as ceremoniously as a corpse: the engraving tools on the table in no danger of rolling off; the pictures on the painted wall perfectly straight and well spaced; the human figures, quiescent (even the infant) to the point of muteness. And yet the painting is a kaleidoscope, and its very variety speaks of beauty, richness, imagination, and curiosity. We are drawn closer, to appreciate each detail; our gaze moves from the mounted images ("I have that postcard"; "I love that Holbein"; "Look at the child's drawing") to the humans, dark-browed and reposeful as icons; from the empty foreground to the mythical horizon, as the ochre tones of "here" open to the light of a living blue and green "elsewhere." The painting is very still. But it is the stillness of a reflection, as much poised with potential as it is static.

With careful husbandry, Dinnerstein assembles a *lieu de mémoire*: a site of recollection—and collection. (Are the artifacts of the room actual personal mementos, or are they arbitrarily collected for effect? It doesn't matter: this is the art world of signs and signifiers.) The compulsion to re-create, duplicate in depiction, revisit, and memorialize is a deep mechanism of the psyche: a continuous haunting by our constituent his-

tories: "We are all haunted houses," said the poet H.D. Haunting comes from the refusal to grieve—or, to perpetually re-inter the dead—but the artist makes this conscientious practice into a formal offering, laid on another altar, the gallery wall. The *Triptych* archives detritus of the artist's portmanteau; a *Wunderkammer*, it preserves the dead, conserves the present, and freezes the fleeting (the baby, hesitating in its mutability). Unlike the detailed miniature images, his wife, child, and tools, and his own figure stand out from the flat plane of the painted wall, but are no less iconically flattened than the painted faces above, spectrally spectating as they gaze upon *us*. They bring to mind Eleanor Clark, writing of icons: "All Byzantine eyes have that directness . . . as if a cat should be walled up in the building of a house and centuries later come out snarling." The painting is now thiry-five years old: now it is truly a memento mori of the artist's life as was, yet it survives in the present moment, a revenant of its own memorializing.

What of Wittgenstein's question? Any true artist will agree on the impossibility—and dreariness—of deciding on *one* world. The only possible response is imagination, the assent that "every particular form of life could be other than it is," as the quote concludes; that the artist holds the delicate truth of his own world and worlds in his working hand. Dinnerstein's self-portrait in *The Fulbright Triptych* clasps one hand in the other: silently, he is answering the question.

Here's Looking At You:
Notes On the *Triptych* of Simon Dinnerstein

Herb Schapiro

What have we here? There . . . ?

Curious—a kind of personal museum?

A still life
 with a difference?

Something to look into . . .
 Why not?

 Come in
Come in from the old familiar streets,
 the hills beyond

You may enter
Through those windows in the back
 Just like that

Don't fret
You can do it—you have wings
you haven't used yet

(Marc Chagall used his all the time
 Your seven-year-old does the same
 and there's that other kid
the one who discovered Wonderland)

Just relax
Let your curiosity take you by the hand
 or push you around the scene

And you find spread out before you
 A grand show—or show-and-tell
So much there to see—
 Pictures, tools, the scribbles of kids
Fragments of a world, their world—
 the people at the sides

So much seems to tell you different things
 and at the same time
play with the little mysteries between

A place of plethora
 As the scholars might say
Of other places, other styles
 And the sketches of today

Emblems of the past
 Mingling with the visions of kids . . .
The past on the wall, collected, remembered,
 Catch as catch can
And, arrayed center stage,
 the utensils and implements
 of actions and concerns
Today

The house furnished with dreams and memories
while the future sits still
 there on the mother's lap

Nothing that unusual
 if you only stop
for a moment to reflect

Time caught in that moment

Something like your mind
which on a good day
 can show you and tell you
All kinds of things
 about all kinds of yesterdays
All kinds of tomorrows too
 And hold it all there
Bring it all home in a minute

Hold still for a moment, you out there—
 See the fullness of life
in the backyard
 of your own imagination, being

See what I show you here
 Something of our world, held still . . .

Meanwhile
This trinity remains there looking at you
 perhaps wondering, apprehensive
 about the next moment
as you walk about their eminent domain

They have done, they are doing
 and await the next move
 of their manifest destiny

And you?

"A view? Oh, a view!
How delightful a view is!"

Virginia Bonito

Or, in our case, a room with many views . . .

E. M. Forster's *A Room with a View* is the story of a young woman's journey to break free from Victorian social mores and in so doing to discover the transforming power of life and love. Simon Dinnerstein's *Fulbright Triptych* shares many of the same qualities—in this case an artist at a crossroad in his life and with his work.

Our first glance at this truly monumental painting reveals an insistent rectilinear geometry that serves as the armature for a stunning variety of elements—elements which one ultimately discovers belong to a realm of reverie celebrating themes about life, traditions, and art. The underlying physical structure of the painting broadly follows the Renaissance system of linear perspective with diagonals converging in a single vanishing point just above—not accidentally—the precocious, poignant, penned lines of the poem "Solitude" by a thirteen-year-old girl, Gloria Mintz. (From the Renaissance period forward, the artistic temperament has often been characterized as solitary, saturnine, and melancholic, a state of mind that prompts flights of fancy, genius, and self-knowledge.) Linear perspective was codified by the fifteenth-century architect Leon Battista Alberti, who proposed that in order for a painting to appear realistic, it should seem as if the viewer is looking through a window; and, in fact, the central of the *Triptych's* three panels opens to the outside world through two large "windows" that offer a view of a tranquil village where the warmth of a late spring day rises to meet a clear blue sky.

However, we sense immediately that it is the inner space, the artist's studio on the viewer's side of the "windows," where the energy is alive and kinetic, where art and

Angela's Garden, burin engraving, 11 ¾ in. diameter, 1970

79

life, the formal and the personal, coexist seamlessly. To the right and left of the main panel, we meet full-scale seated images of the artist and of his wife with their infant daughter. The back wall connecting all three panels is covered with postcards, photographs, newspaper cuttings, and scraps of paper—collective leafs in the diary of the artist that, like an extraordinary constellation, reside over and illuminate his own personal cosmology. We are confronted, we discover, not just by one structural perspectival convergence-point, but by a myriad of images, each with its own perspective system, in the richest sense the meaning of the term *perspective* allows. And we soon realize that each and every item tacked onto the wall, no matter how seemingly diminutive in the grand scheme of the *Triptych,* is its own window . . . portal . . . threshold, if you will, onto countless lives and a wealth of thought—time capsules in a way, acting as connectors from the distant past, pausing momentarily in the present, and holding the promise of a hopeful future.

The central panel is dominated by a very large worktable on which are laid a range of printmaker's instruments made personal by the coffee cup, a dried potato skin, and some seed pods from local trees. A circular copperplate, front and center on the table, and the only element that glistens, reads not accidentally like a great umbilicus, beckoning us to approach in order to discover the secrets held within. There, engraved on the golden disc likely by the very burins that surround it, is the most stunningly intricate, lush image of an enclosed garden—archetypal symbol of a sacred space where growth takes place out of harm's way. On a personal level, it is emblematic of a decisive moment for the artist during his Fulbright year. His corpus of work to date focused on large-scale, monochromatic charcoal drawings, and, to a lesser degree, printmaking, both distinguished by a masterful draftsmanship rooted in realist traditions. His proposal to the Fulbright commission, which awarded him the grant to do so, was to study northern Renaissance printmaking techniques, and especially the work of Albrecht Dürer. Settling in Germany, his first months were spent in face-to-face encounters with the masterpieces he had studied at a distance, and like E. M. Forster's protagonist Lucy, the Europe that is the repository of great artistic traditions began to work its magic on the artist. Though we know from Simon that the original plan for what became *The Fulbright Triptych* was only the single central panel, his ideas

for the painting continued to evolve over a three-year period during which time he chose the grander tri-panel scheme, a format that provided him greater thematic versatility and scope.

If the reader will allow an art historical aside here, it is worth mentioning that the format which Simon ultimately adopted for *The Fulbright Triptych* (literally, three panels), was popularized by fifteenth-century Netherlandish artists. The subject matter of these triptychs was primarily religious, most often representing themes related to dogma or mystical revelations. The side panels of these triptychs—commonly referred to as wings—were usually hinged to the main or central panel and were typically painted on both sides. In the closed position, these wings functioned like doors, concealing the main panel and its sacred image from view. Whether in the open or closed position, the imagery depicted on the wings related directly to the theme of the central panel and was usually the domain for placement of the donors, who often appeared as participants in the mystery; the human component, the connectors between earthly devotion, faith, and the divine revealed. Jan van Eyck's *Adoration of the Mystic Lamb* (commonly referred to as the Ghent Altarpiece), and Hieronymus Bosch's *Garden of Earthly Delights* (c. 1510-15) are universally admired as among the greatest of the northern Renaissance triptychs. Each is distinguished not only by craft, monumental scale, and cinematic vistas, but by their primary subject matter which is dedicated to the archetypal theme of garden—in the case of van Eyck, the Garden of Paradise, and of Bosch, as the title reveals, the Garden of Earthly Delights. As Simon often notes, on a personal level, van Eyck's Ghent Altarpiece is one of the most moving and mesmerizing works of art ever created, a tour de force in all aspects, pictorial and theological, given by one of the greatest master painters to have graced this earth.

While Simon's placement of himself, his wife, and daughter in the wings, or side panels of *The Fulbright Triptych*, is clearly a device borrowed from the traditional placement of donors in the wings of Netherlandish triptychs, it is, in his hands, ingeniously reconfigured. One major difference is that *The Fulbright Triptych* "wings" were not given the option to close; not hinged, they were intended to remain open. From their vantage point at either side of the main panel, Renée with Simone and Simon function like ancient guardians of portals, like great hieratic bookends making "sacred" the many

volumes of their own special story. Through the addition of the wings with their living, human component, the impact of the central panel is amplified. Undisturbed by human activity—which is left to be intuited—the central panel assumes the aspect of an iconic distillation retort, its function signaled by its own special garden, imaged in the engraving plate and radiating the smoldering golden tone of alchemical transformation.

The key to the implications held within Simon's *Triptych* is to be found at the back of the worktable. Along the back edge on the right, the worn stubs of colored pencils direct the eye to the sills below the windows, asplash with color. If anyone has ever seen the horizontal support bar of a well-used painter's easel, the analogy is all too evident.

In 1936, the surrealist master René Magritte offered a virtuoso parody of the Albertian pictorial "window" as a means of drawing attention to the relationships between visualization, tantalizingly real imagery, the blank canvas, and pictorial language. In his painting *The Key to the Fields*, Magritte presents the view of a meadow through a broken "window" pane, whose shattered pieces of glass, fallen below the sill, hold images of the broken segments of the "actual" meadow.

In the central panel of *The Fulbright Triptych,* between the "windows" and just above the back of the table, a letter from Renée revealing a peculiar dream about the prospect of childbirth is tacked to the wall:

> Simon—Just woke up from the craziest dream. I was having a baby in our apartment in Germany—Dr. Neff had all this crazy apparatus hooked up—Both our mothers were there arguing with the doctor about how the baby should be delivered—I was scared because I thought there was a dead baby in me, but when the baby was delivered I faked everyone out because it was just a big air bubble!!! Wow, what does this all mean!!!!??★?

The letter, and its noteworthy placement within the dense complex of imagery, signals a fundamental turning point in the lives of Simon and ultimately Renée. Renée had tacked a German coin to the back at the center of the main panel in just about the same location as the image of her letter on the front, reinforcing the magic held by that particular moment. Under the coin she wrote:

Begun in Good Faith and High Hopes on May 3rd, 1971 Hess Lichtenau
Quenteler Weg 31 Germany with the love of Renée.

And on that day in May, Simon flipped the monochromatic-charcoal-drawing-and-printmaking side of his own "art coin" to the color side, launching his career as a distinguished contemporary realist painter. And like the animated runner in the stopwatch, so poignantly placed between Renée's letter and the color-filled windowsill to its right, Simon was off and running, ready to take on the challenge posed by the conundrum on the scrap of paper tacked so purposefully to the left of Renée's letter (and so meaningfully articulated decades earlier in *The Key to the Fields* by Magritte):

> And to the question which of our worlds will then be *the* world, there is no answer. For the answer would have to be given in a language, and a language must be rooted in some collection of forms of life, and every particular form of life could be other than it is.
> (This quote by Ludwig Wittgenstein, perhaps from his text *Philosophical Investigations*, appeared in the *Village Voice*; Simon clipped it and had it among other items with him in Germany.)

A group of diverse images clustered between the windows (above the letter, stopwatch, and Wittgenstein quote) chant Simon's personal litany of inspired creativity and daunting challenge. At the very top is Giovanni Bellini's *Sacred Allegory*, a painting that intrigued not only Simon but captured the attention of none other than Degas to copy it—no doubt drawn to it by the structural perfection of its visionary presentation of pious devotion that imbues the terrestrial realm with an atmosphere of calm silence, as well as for its place in the history of art as a hallmark of the sort of flawless artistic production that flourished in the learned circles of Renaissance humanism, philosophy, and theology.

Below it, to the left, is a painting of a pregnant woman, preparing a meal perhaps, that directs attention to the mysteries of life and birth that are silently at work as we occupy ourselves with daily routines. (Titled *In the Kitchen*, it is a tip of the hat by

Simon to his older brother, the noted artist Harvey Dinnerstein. It is, at the same time, an acknowledgment by Simon of the hard-won realization that although there was already one fine artist in the family, each of us, no matter, must follow our own heart and calling.) To the right is *Self-Portrait,* in which Edwin Dickinson (1891-1978), distinguished member of the National Academy of Design, of which Simon is currently a member, has pictured himself picturing, with another of his images at his back (featuring intersected circles, lozenges, and cubes) the elemental geometries that underpin all created matter.

Below these, the poem "Solitude":

Grey and sweating
And only one I person
Fighting and fretting.

The poem hovers above visualizations of its handwritten, pointed observation: an older, calloused, pregnant woman, seemingly unmoved by the miracle of life in which she is participating, drawn by Käthe Kollwitz; *Models* by Seurat (1887-1888), and *The Art of Painting* by Vermeer (1662-1675). Thus, we are reminded of the private journey that is the creative process. Read from left to right this set of "paintings within paintings within paintings" illuminates the very shift from monochromatic imaging to pointillist dots of color that combine in the eye to the opulent tonalities of Vermeer that is at the heart of Simon's own painting. The center of this particular set is punctuated by the standing nude model at the midpoint of Seurat's painting, within which she and her companions tell the story of transformations that belong to the composing of pictures, a message reinforced by Seurat with his inclusion of a portion of his renowned painting *La Grande Jatte* into the picture to the model's left. The standing model—noteworthy for her neutrality—plays a similar role as a protagonist in Simon's painting, calmly signaling the call to participate in some new depiction to be envisioned in paint.

Further down and strategically positioned, van Eyck's *Eve* and the Persian miniature to its right reverberate the central theme of protected garden and of the dilemma posed by the hubris that is enmeshed in human nature.

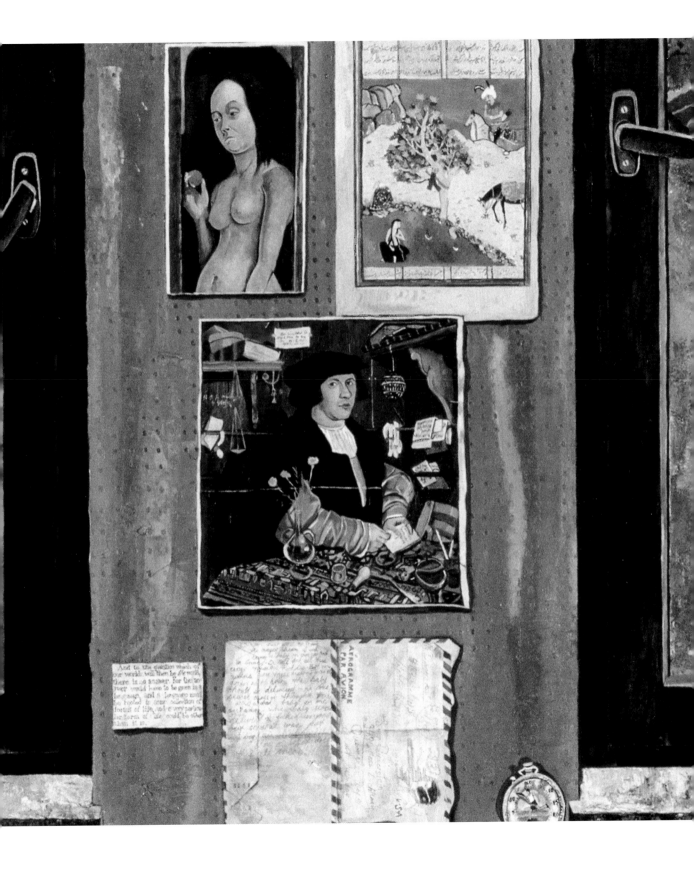

Below these, our musings are halted in the purposeful glance at the viewer by Hans Holbein's merchant, *Georg Gisze*. Front and center at the viewer's eye level in the run of items between the "windows," and proudly surrounded by the many various items and inscriptions that tell the story of his enterprising nature and his intellectual bent, the Gisze portrait is the microcosm—the raison d'être of sorts, of the macrocosm that is Simon's *Triptych*.

Each unique image in the array of items on the walls of the side panels, like those we have taken note of as they appear between the "windows" of the central panel, is similarly charged with multiple layers of meaning: from the details of famed Netherlandish paintings by Bouts and van Eyck, taped above the heads of Renée and Simon—springing as if from living plants—of a tearful Virgin, who has witnessed the sacrifice of her son for salvation (and as such is the archetype of every mother, religion aside, who grieves the loss of a child); and of *Baudouin de Lannoy*, ideal male role model, whose stolid expression belies his ambassadorial and courtly successes; to the spontaneous, imaginative color drawings by children; photos of family pastimes and lovers' outings; passports that tell of travel and immigration; to the continuum of postcards and snippets of text that hold private admiration for great art.

Lending a mood of stoic calm as an armature for its flights of fancy and musings about creativity, Simon's stylistic choice of direct, hard-edged structural formality is the perfect foil for the flood of myriad thoughts, imagery, intellect, and emotion that are the driving force of the *Triptych*.

Each item that cumulatively was called on by the artist in the creation of the grand scheme of this kaleidoscopic vision of the phenomenon we know as our humanity has been *re-pictured*—thoughtfully and soul-searchingly processed through mind and hand by Simon—in the replication of the wall of his studio in Germany. The wall is a testimony to the artist as intellectual, in continual study of the curious wonder that is existence. Unquestionably, part of the creative process that culminated in *The Fulbright Triptych* were daily confrontations that are also the subject of this painting—the gauntlet of uncertainty facing every artist as they address the nagging, overarching questions: Who am I?; Where will *my* art fit in the great expanse of what has gone before?; Will I nonetheless have the courage to confront the blank surface before me with the hope that enlightened vision and bright imagination will be my constant guides?

Simon returned to the United States at the end of 1971, with the main panel in tow and well underway. In the three years that belonged to the evolution of *The Fulbright Triptych* (1971 to 1974), Simon and Renée's lives truly filled with color. Chroma brought a new vitality to Simon's pictures, and a baby girl, Simone, colored their world in ways to that point unimaginable—life and art were, like the secret alchemical garden, in full flower.

In this writer's view, *The Fulbright Triptych* is the map of the struggle to become not only a consummate painter but, in its richest sense, a whole human being. Its message sounds the call that art is everywhere; and, that it is to be found in each and every one of us. It holds the proposition that each of us can and should be the artists of our lives—expressing through language, sound, or visual form the pageantry that is our existence in all of its sorrows, adventures, and joys. It speaks to the essence of courage found both in love and in the intimate acquiescence of heart, mind, and will to the profound, higher vibrations of the life force that are the truest threads of the fabric of our existence. As such, the *Triptych* stands as a wondrous symbol of the core elements of true alchemy, of the power to transform base matter into *precious mettle*.

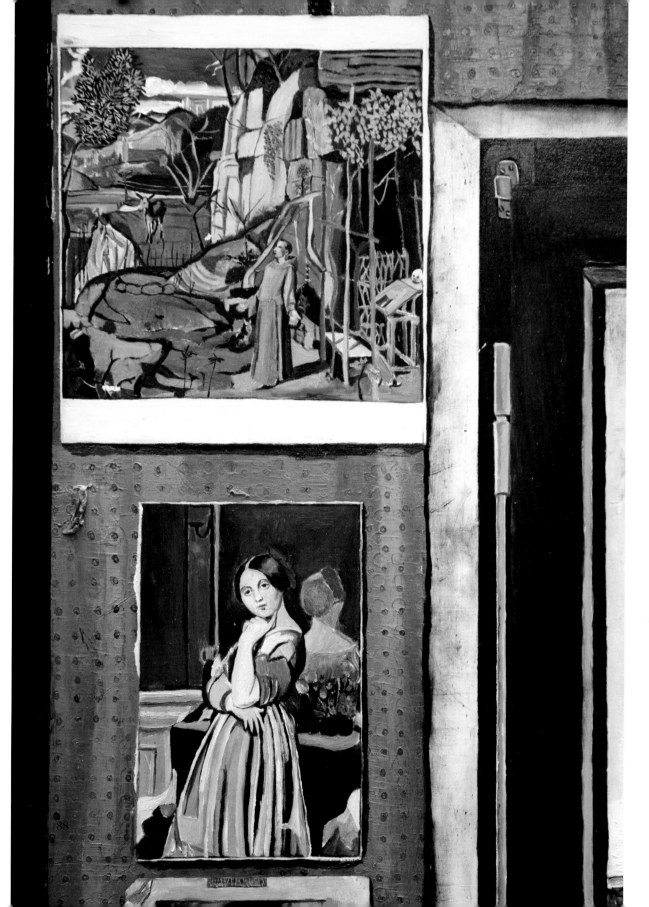

Simon Dinnerstein's Conceptual Painting:
The Fulbright Triptych
Thalia Vrachopoulos

Inasmuch as Simon Dinnerstein's work is grounded in the human figure and line, it looks to the classical genre. But in its attention to detail, his work relates more to the northern Netherlandish aesthetic as seen in his *Fulbright Triptych*. The figure, combined with abundant detail, poses an antithetical contrast that differs greatly in its stylistic orientation, aligning Dinnerstein's art to the so-called *tableaux vivants* of the international Gothic style. Dinnerstein's use of gold leaf, the triptych idiom, and his mannerist style are also part of this late-medieval style.

Although this tripartite work is autobiographical, it is entitled *The Fulbright Triptych* after the grant that made its creation possible. At its center, a large square painting portrays a wall in the artist's house decorated with various-size pictures, and containing a horizontal worktable upon which rest a series of printing-trade tools. On the table surface, exactly in the middle, is an image of an oval-shaped copperplate engraving entitled *Angela's Garden,* depicting bushes, plants, fences, and walking paths. The left vertical panel shows the artist's wife Renée holding in her lap the couple's yet-to-be-born daughter Simone as a young toddler. The right panel contains the artist sitting in a chair with linked hands on his lap, spider plant hanging above him, surrounded by images from various periods of art history. It would not be stretching the point to read the spider plant's appendages as arteries linking the artist to the history of art and its best-known protagonists. For to be sure, Dinnerstein has engaged with the working methods and styles of these all-time greats.

The images embellishing the wood-paneled wall of the artwork can be identified as the traditional art-reference system popular among artists. Yet in this work, because of their specificity, they signify the artist's own history, both morphological and philosophical. A good example is the spider plant hanging above Dinnerstein's self-portrait, which would go on to become a leitmotif in the artist's work. As used here, the device prophesies the future use of this natural motif combined with self-portrait, in which the complex network of branches represents the artist's mental and complex state of

reflection. Dinnerstein uses this motif repeatedly in future works such as *Counterpoint* (1993), *Rear Window* (1994), and *Reflection* (1999).

Images such as the Eve from the Ghent Altarpiece by Jan van Eyck, shown with children's drawings or African art nearby, combine to offer us a multilayered dialogue between historic and modern art. History has served artistic vocabulary for eons, but Dinnerstein offers us an incomparable feast that, like Jules Verne's *Time Machine,* allows us as viewers to simultaneously visit places and partake of images from the present and distant past.

As for his chosen format, the triptych, it has a long and rich history. Before paper reached Europe, the Romans used styli on wax tablets to write. In Byzantium, diptychs and triptychs existed as carved ivories and iconostases. Dinnerstein's work has already been read in terms of religious symbolism, specifically Christian. It was Robert L. McGrath who associated Renée and Simone as the Madonna enthroned with Child and the artist as Christ, the Man of Sorrows in late-medieval paintings. McGrath also drew an association between the tools of the artist's trade portrayed in the middle part of the triptych and the instruments of Christ's passion.

In fact, artists very often have seen themselves as martyrs. In the nineteenth-century Gauguin's *Yellow Christ* is seen as a self-portrait. In the early twentieth century, modern artists, especially the German Expressionists, felt misunderstood by their viewers. It was Picasso who portrayed the artist figure as a Harlequin. However, because of Dinnerstein's ongoing interest in the thought process and pensiveness, as well as the conceptual nature of this work, we may compare his alter ego to the famous Dürer print *Melancholia* (1514). This work best expresses the tortured nature of the artist, who, alone with his thoughts, tries to reconcile the pragmatism of existence with the creative impulse. Surprisingly, this engraving does not make a physical appearance in Dinnerstein's triptych, yet it is ever-present as inference. Dürer created his print after returning from a second trip to Italy, where he absorbed the popular idea of the artist as divine creator, in other words, as more than just craftsman. Thus *Melancholia* represents the artist's frustrated attempts at rivaling divine beauty. James Snyder, the northern Renaissance specialist, sees *Melancholia* as the summing-up of Dürer's "anxieties and vanities . . . in an unusual and provocative self-portrait."[1] *Melancholia* can be analo-

gized to Dinnerstein's *Triptych* in that, as representatives of the artists' psyche, these works are artistic meditations on technique, observation, creativity, planning, proportion, and so on. In fact, Dürer was known to warn his students about the dangers of over-thinking their work because it could cause melancholy, one of the bad humors or bodily fluids that was believed to cause illness. The creative genius's greatest nightmare is the lack of accomplishment. So as the day comes to a close, the artist becomes ever more anxious about what he has made and if it doesn't measure up to his expectations he becomes melancholy. This is obvious in *Melancholia*, where the figure sits like Rodin's *Thinker*, with her head resting on her hand, thinking. Indeed Dinnerstein has stated that "in a way *The Fulbright Triptych* is a meditation on process and perception, the artist's wonder and quest toward understanding."

The legacy of the northern Renaissance masters Lucas Cranach the Elder, Albrecht Dürer, Jan van Eyck, and Pieter Bruegel the Elder are prominent everywhere in the *Triptych*. Furthermore, Dinnerstein is conversant with southern Renaissance artists too that appear in his triptych to a lesser extent, as well as later neoclassical figures like Ingres, whom he admires for his use of chiaroscuro and line. When asked who his favorite master of all time was, Dinnerstein answered without a moment's hesitation: Ingres.[2] One need only glance at the *Odalisque* in grisaille to see that this artist's aesthetic sums up much of Dinnerstein's methodology. Like Ingres's, Dinnerstein's art is grounded in line rather than color, and his means of choice is graphic, involving engraving or drawing. Indeed, line was used in Paleolithic wall paintings, in Mesopotamian tablets, and on Greek vases. Pointed tools like burins used in making copperplate engravings can be associated with the spearheads used for sgraffito drawings on damp clay on Mycenaean pottery. In Dinnerstein's art, because of his extremely detailed style, line is a methodology of work intensity and concentration, as well as virtuosity and historical knowledge. The importance of line is evident throughout Dinnerstein's work as well as his admiration for Ingres. Ingres's portrait of *Louise de Broglie, Contesse d'Haussonville* (1845), appears in the left portion of the *Triptych*'s central panel. Although he claimed to be a conservator of the academic enterprise, Ingres worked outside of it; he is known for his expressive anticlassical distortions of form that endeared him to modern artists. As one of these, Dinnerstein

creates with expert line, while imbuing his forms with a gently executed subtleness in shading, at times even using distortion to accentuate certain areas like Simone's stomach in *Anticipation* (2002-03), and in the elongated face of the sitter in *Portrait of Thomas Parker* (2004).

Dinnerstein's work cannot be called academic in the strict sense of the word because it contains enough expressiveness to relate it to the symbolist or the northern Renaissance traditions. His style is eccentric, originating in his concepts, and executed in a personal manner that includes using subjective deformation resulting in a linear rendition of objects and people the way they are in his imagination. For even when people are real as are Renée and Simone, Dinnerstein places them in imaginary psychological situations. Dinnerstein is not merely copying the real world around him. His art engages with the subcutaneous layers of meaning that lie within its exterior facade. Dinnerstein's art is deep, significant, and conceptual, not only in its symbolism but also in its conceptual rendering of form.

Dinnerstein's *Fulbright Triptych* is a symphony of meaning whose layers resonate with the artist's life experience, but is so much more. Like Holbein, whose stunning portraits captured a wealth of detail (as seen in *The Ambassadors*), Dinnerstein offers us a true showpiece in his triptych. The appearance of Holbein's portrait of Georg Gisze, a German businessman working in London, demonstrates Dinnerstein's admiration of this master. Holbein depicted a great deal of detail in this Hanseatic portrait. A table is covered with a rich oriental carpet, on top of which appear scissors, pens, a seal, a glass vase with three carnations, a box of coins, numerous documents, keys, bells, scales, and inscriptions of various kinds. For both Holbein and Dinnerstein, the written script as sign is significant. It is seen as prominent signatures or dates or lettering within Holbein's painting; in Dinnerstein's triptych, text is found on letters, children's drawings, copies of passport pages, and so on. Like Holbein, Dinnerstein uses oil on wood panel to produce his work. Painting on panels results in a more linear and exactly rendered style that is quite difficult, if not impossible, to correct in the case of a mistake.

Dinnerstein's relationship to the sixteenth-century northern master Pieter Bruegel is evinced by the miniaturish quality of the landscapes in the central panel, landscapes that are akin to Bruegel's *Return of the Hunters*, one of his *Four Seasons* series. Both in

the personal stylization of their figures and in the amount of detail they produce, these two painters are unrivaled (except perhaps by Hieronymus Bosch).

Dinnerstein's *Fulbright Triptych* is full of imagery signaling his engagement with art history, seen in his inclusion not only of this portrait by Holbein, but also in his inclusion of the tools of a printmaker. In this respect Dinnerstein's goal is not to reproduce these objects as trompe l'oeils the way Holbein did, which endeared him to American realists such as Harnett, Peto, or even their immediate predecessors the brothers Peale, but rather to depict these elements in a way that challenges our vision. One may compare Harnett's *Still Life Writing Table* (1877) to Dinnerstein's central panel to see the similarities and differences. Harnett's favorite subjects were still lifes of books combined with other objects on a table, or his "smoker" groupings of mugs with a cigar box or pipe. He depicts them realistically to the point of fooling the eye into seeing them three-dimensionally. Dinnerstein, although capable of such effects, as seen in the landscapes on the wall, does more than play with our perception. Dinnerstein is more like Cézanne, whose work is about sensation and visual perception and who was interested in new concepts of spatial construction. The psychological realism with which Cézanne has been characterized in his pure manner of observing nature can also be found in Dinnerstein, who while maintaining a complex dialogue with historic models of technique and subject, is nevertheless direct in his observation. In contrast to this directness, in certain other areas of this work Dinnerstein uses a type of perspective that is emotive rather than true to the motif, as seen in the table's angle within the central panel. The volumetric proportions of his objects, like Cézanne's, are at times Euclidian and at times insubstantial, as seen when comparing the reproductions of the miniatures in his central panel and the figures of himself and Renée with Simone. It is certain that this master is familiar with Eastern examples of art which are flat and iconic in their style, which is probably another reason he uses them. But the way that the central motif, the table, is slanted toward the viewer instead of receding in scientific perspective, is a dead giveaway of Dinnerstein's engagement with Asian art and the use of multiple perspectives. Manet, who collected Japanese ukiyo-e woodblock prints, did this in his *Bar at the Folies-Bergère*, while also taking inspiration from Velázquez's *Las Meninas* and the older master's use of the paradox to create interest.

Manet used two different perspectives in this masterpiece, as we see the barmaid from a typical western view and simultaneously her reflection in the mirror behind her from an oblique perspectival view. Because the barmaid's reflection is so far away from her person and because there is no evidence in the foreground of the man engaging her in conversation, the only way to make sense of this work is to read it from the bottom left corner looking up.

Dinnerstein's style can also be related to that of the American Magic Realist George Tooker in that it does not strictly adhere to reproducing reality. In both of their works there is an element of fantasy, seen in Tooker's *Voice* (1977), wherein two people appear to be listening to each other from either side of a partition. A similar type of existentialist drama seems to be taking place in Dinnerstein's *A Dream Play* (1986) and *Night* (1985), in which the characters appear to be taking part in a fantastic play. Most of them are separate, alone, individual, a fact that relates them to Tooker's tendency to visually depict modern-day isolation and alienation. Both Dinnerstein's and Tooker's works result in essays of a mysterious nature in atmospheres wrought with imaginary possibilities. In most of Tooker's paintings, the idea of isolation and withdrawal are prominent, whereas in the *Triptych,* there is a warmth that reaches over even the expanse of the main panel from Dinnerstein to embrace his loved ones on the other side. Although the artist appears alone and in a pensive state, the objects in his painting, as if his wishes and dreams, the Madonna and child near Renée, speak volumes of love.

The Fulbright Triptych may be read as an exercise in the ordering of his universe like that of the later fifteenth-century philosopher Sebastian Franck, who, when treating the subject of mankind in general, wrote, "All men one man. Who sees one natural man, sees them all." Natural man to Franck meant one who is unsophisticated therefore uncontaminated. To Dinnerstein also, it means someone unspoiled by the desires of so-called consumerist technological society; rather someone in synchrony with the order of natural life.

Three O'Clock at the Burghers of Calais

Juliette Aristides

At fourteen feet in width, *The Fulbright Triptych* was Simon Dinnerstein's first painting. Dinnerstein had returned from Europe, where he started the painting, with a new family. He held the opinion that artists should not be rushed into showing or selling work until they have a serious point of view to convey. In keeping with that philosophy, he was running out of money fast.

In an act of faith, he took some photographs of the center panel of *The Fulbright Triptych* to a gallery he respected in New York. Dinnerstein invited the owner to come and see the actual painting in his Brooklyn studio. As Dinnerstein described it, in those days it felt a further journey to go from Manhattan to Brooklyn than to Paris. The dealer came and looked at the work for a half hour without comment and left saying Don't call us, we will call you. Four days later he wrote and offered to buy the work in its unfinished state. Dinnerstein was paid monthly over the next two years until its completion.

The Fulbright Triptych started as an independent painting and ended as a grand commission. It brings to my mind another impressive commission. I find it noteworthy that I met Simon Dinnerstein for the first time in the Metropolitan Museum of Art in front of Rodin's famous sculpture *The Burghers of Calais*.

Rodin's commission depicted a heroic event in the fourteenth century when a few prominent citizens of Calais offered up their lives in order to save their city from a crushing siege. Rodin's sculpture captures a moment of shame, defeat, and surrender. The burghers were rich men, who took off their elegant clothes and walked barefoot to what seemed a certain death. Along with them were the keys to the walled city which provided unrestricted access. This event was meant to be the moment of their disappearance. Instead, it became a defining moment which exalted them into collective memory as symbols of heroic self-sacrifice.

Traditionally, sculptures of this kind had a strong compositional hierarchy. Rodin depicted the burghers uniformly, without a clear visual focal point. His champions are shown isolated and equal in their grief. In traditional sculptures, the hero, more divine

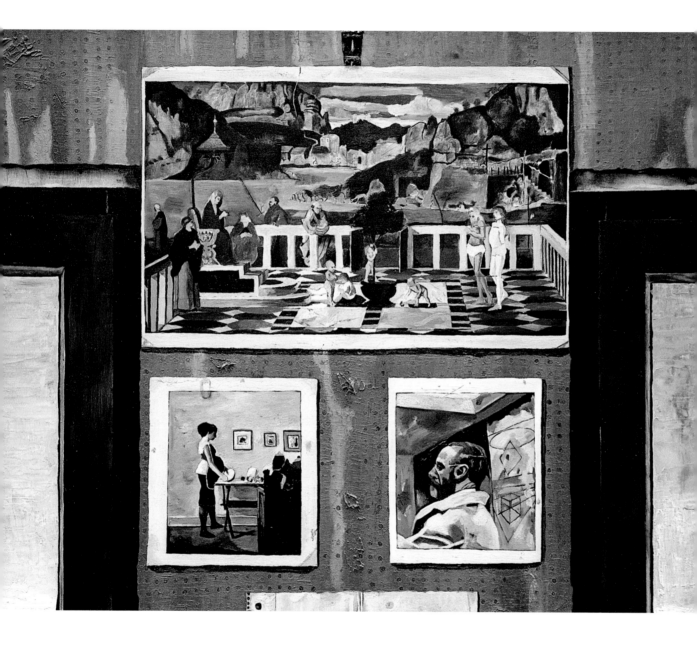

than mortal, would be depicted gloriously raised on a pedestal, inspiring our worship and admiration. Instead, Rodin intended his sculpture to be displayed on ground level, eye to eye with its viewers. His heroes are walking among us, allowing us to enter into their suffering.

Very few of us will ever experience any crossroad remotely as dramatic as that of the burghers. Most of our lives are defined by small acts and everyday decisions. Life often feels messy and conflicted—the weight of work, responsibilities, and relationships stream by in an endless parade of activity. Our acts of faith often end inconclusively—our sacrifices, small and less noticed. Without the distance and clarity of history, life is not tidily wrapped up, distilled as is so often depicted by art.

Dinnerstein's *Triptych* sets the stage with a formally balanced composition, yet its subjects lack an obvious hierarchy. His figures seem solitary and look to us rather than to each other. Each element in the work is painted with equal clarity. Events and memories represented by postcards pinned on the wall form cluttered notations of thoughts and emotions.

There is no heroic formula used in the painting, just an artist making an honest attempt to translate his life into art. The life-size work draws us in, alluring us with its large scale and the disarming frankness of its execution.

Prior to becoming a painter, Dinnerstein was a graphic artist (drawings and engravings). In *The Fulbright Triptych*, he integrated the emotions of a painter with the precision of an engraver. He bridged the two mediums by drawing the whole first pass of the painting with a Rapidograph, a thinly pointed technical pen. He wanted to capture the diminution of space in the landscape so he made the draftsman's choice of linear rather then aerial perspective.

Dinnerstein chose the historically significant format of the triptych in which to create a secular contemporary painting. We can recognize some of the uniqueness of his painting by seeing how it departs from convention.

The painted triptych originated in medieval art and was strictly religious in nature. The three-in-one format provides a subtle reference to the Trinity. The three panels could be hinged so the painting could be folded and moved. Proportionally, the two side panels of Dinnerstein's painting could fold in to form the size of the center square. The historical triptych was an altarpiece facilitating worship and serving as a con-

templative centerpiece in religious ceremony. The center panel formed the focal point of the work with the side panels augmenting the narrative. The subject matter was usually key events in the life of Christ or other religious themes.

In *The Fulbright Triptych*, where one would historically expect to see Jesus, we find a simple table carefully laid with the tools of an engraver. The secular work of the artist has taken center stage. The side panels do not portray saints worshiping or attendant patrons kneeling in reverence; instead we have the formal portraits of the artist, his wife, Renée, and daughter, Simone, gazing directly at us.

In his book *A Beginner's Guide to Constructing the Universe,* Michael S. Schneider discusses the significance of the number three. The number one represents unity, a self-contained completeness and as such a perfect symbol of divinity. The number two describes opposites or polarities which results in tension—Dinnerstein and his wife sitting on either side of the center panel. The number three creates a binding element forging a resolution of the opposing forces. Their daughter, born out of their union, sits contentedly on her mother's lap.

The triptych format silently speaks of the reconciliation of diverse parts into a whole: three individual elements brought together to form a new creation. In *The Fulbright Triptych*, these elements are the artist, work, and family. This painting records and celebrates the conflicts inherent in the life of an artist. Dinnerstein unified in art what is often disordered and complicated in life.

A few months ago, I received a group e-mail from a friend jubilantly announcing the birth of his daughter. The next day there was a response from an artist saying, "Congratulations and when do we hold the memorial for your painting career?" I know the feeling. The urgent weight of life feels far more pressing than the call of art, which demands an idealistic investment of real time and money into an unknown future. However, the moment of the artist's disappearance can become his very making.

Dinnerstein and I spent some time talking after our initial meeting in front of Rodin's sculpture. I had been chasing a thought during our conversation but it felt inappropriate to speak aloud. Maybe I was guilty of projecting my own feelings and experience upon his art. Finally I asked: "Are you expressing some tension between work and family in your painting?" He laughed openly for the first time and said, "Clearly."

The artist offers the keys to his city and walks out.

Renée Dinnerstein, with three-day-old Simone, September 21, 1972

An Unanswered Question

Robert Beaser

Those of us who work exclusively in coaxing meaning from sounds—extracting coherence from building blocks of self-referential materials that have no significance beyond themselves and their contextual definitions—can find ourselves in a state of stupefied representational overload in the presence of the iconography of a painting. When I first met and became friends with Simon Dinnerstein at the American Academy in Rome in September of 1977, it was clear to me that as composer and artist, we were both somehow wrestling with similar historical imperatives: in a moment of rigid modernism, institutional abstraction, the cult of the avant-garde, how could we recover the past without losing our location in the present? Simon's response to this unanswered question had already begun in his monumental *Fulbright Triptych*, which he was shipping from Kassel, Germany, to New York in preparation for an exhibition at the Staempfli Gallery. I recall viewing it there for the first time in 1979. It troubled and confused me. I felt as though I had been lured into some inscrutable alternate universe where time was bursting at random vectors, where the age-old Catholic Trinity of Giotto had been body-snatched and replaced with sphinxlike Brooklyn figures staring blankly at me, surrounded by a casual hodgepodge of pinned-up artifacts floating in virtual space, challenging me to accept their anachronistic rights. In short, I knew I was in the presence of a fearless artist. I was immediately infatuated.

Music unfolds in real time, a series of articulated sounds moving across a linear plane, in chronological progressions which—in order to establish meaning—need to relate at all moments that have occurred prior and project what could happen in the future. Often music of excessive complication masquerades as art by preying, like the "emperor's new clothes," on a listener's insecurities and latent pretentions. Complication in music obfuscates meaning by stuffing a work full of information overload. The density and rapidity of the flow is too much for a listener to aurally assimilate—this has been scientifically studied—and therefore we cannot build an understanding of how one parameter speaks to another. Many people are cowed into submission by the sheer amount of detail thrown at them, and either give up because they feel that

they are too uneducated, or praise it grandly because they can't understand it. When I hear works like this, I tend to be pulled and bent like a branch, and then snap. But I like to make a crucial distinction between complication and complexity. Complexity can be defined as a deep saturation of the many parameters of musical syntax, creating multiple layers of interlaced meaning, which interact over time and provide a rich and textured aural experience that is both visceral and intellectual. In other words, musical arguments need to first create expectations in the listener. Once these expectations are created, over time they can either be delayed (read: deceptive cadences), thwarted, transformed, or ultimately met. Since absolute music cannot refer to anything but itself, these expectations need to be built by contextualizing all of the musical material—and parameters—within a piece, so that the material can assume significance beyond itself and become part of a compelling discourse.

A composer needs to adjust his ears when looking at a painting. While representational painting may have the disadvantage of not unfolding in real time, it has the distinct advantage of working with symbols which refer to things outside of themselves—and expectations do not have to be created by organizing images solely through contextualizing them, because they have meanings already built-in. It is pretty hard for me not to see a fixed canvas as something which is alive in time and space. In some of Dinnerstein's later works, this motion is brought front and center, such as his spectral and redemptive *Night*, where juxtapositions and reiterations provide the fulcrum for a sense of haunting movement. But *The Fulbright Triptych* is a work that is deceptively static at first. This is probably why I was nonplussed. I knew, however, that all was not what it seemed. As I studied it, I began to see movement in the details, tension in the underlying architecture, and I began to uncover the poetry in the dreamlike suspension of interior and exterior worlds, the dance between the characters and their antecedents, and the multifarious artifacts and fragments which orbit around them, pulling them forward and backward in history. That there was complexity in the layering of these elements was clear and undeniable from my very first encounter, even if their precise meaning was elusive.

I am drawn to hybrids in music: Palestrina (and others of his time) interpolated the popular secular tune "L'homme armé" into the most sacred of their church Mass

settings; Stravinsky's *Pulcinella*—where fragments of eighteenth-century Pergolesi (which we now know to actually be spurious) are dressed up in twentieth-century neoclassical attire—or conversely placing reworked Lithuanian folk tunes at the opening of his sacred *Symphony of Psalms*; Charles Ives creating sonic tapestries which intermix popular café music and military marching band fragments with eerie chromatic cluster chords to create his boldly hallucinogenic *Central Park in the Dark*. Many others, from Liszt to Ravel to Orff to Bartók, use folk sources to form the bones and sinew of classical orchestral essays, all of which ultimately influence my own works, in pieces such as *Mountain Songs* (1985), which recast Appalachian folk tunes in unexpected architecture, rhythms, and context such that listeners aren't exactly sure just what they are hearing. This very uncertainty, "neither fish nor fowl," the gap between what is familiar and what is new, that ambiguous distance which creates something wholly "other," is what drew me to *The Fulbright Triptych*. I felt as though I had seen this mise-en-scène a thousand times before, and yet its disposition was wholly new and strange to me. Who *are* these people? Why are they grafted onto a landscape from a wholly other place when they don't seem to belong there? What is the meaning of these various letters, pictures, quotes, and artifacts that surround them? Why do I feel connected and yet curiously displaced? Why are they staring at me?

Much of the strength of a work of art can be attributed to contradictions. This is what provides tension and conflict, what arouses subjective emotional response, keeps you coming back. In the case of musical hybrids, I find it's usually best to let the music wash over you at first and not to dissect it too soon. Later, as you revisit—and you will revisit—you start to try to get below the surface and understand what makes them tick. At the American Academy back in the seventies it seems like every conversation I had with an architect there involved the comparison of architecture with music. It's clear that classical architecture occupies space using hierarchical ranking of compositional elements. Once the larger form is established, the rest is defined by dividing smaller details into metrical units, the rhythms and stresses of which create the surface energy that relates proportionally to the larger whole. We went to visit Palladio's Palazzo Chiericati up in Vicenza to witness this firsthand. But we certainly didn't have to go very far outside the front steps of the Academy building to see it in action. As I

studied the *Triptych* further, I was first stuck by what appeared to be its bilateral symmetry: it is divided down the center. At the same moment it is of course overtly tripartite: after all, it's a triptych. So it is formed perhaps in a kind of musical hemiola—three in the time of two. Brahms uses hemiolas to devastating expressive effect. Whenever there is balance, of course, every little thing that deviates from that order creates tension. I started to see it as a kind of musical sonata allegro form, or ABA. First on the left, mother and daughter staunchly holding forth uprightly in the exposition, then, in the great middle panel, we have the battleground development section, and finally, the recapitulation with its self-portrait of the artist, hands clasped and legs slightly apart. There may even be a narrative transformation from exposition to recapitulation. See the difference with the way the mother and daughter sit in contrast to the way the artist sits. The two windows to the outside world, in the middle panel's development section, contrast the sacred and secular, and stand in precarious balance—as a link connecting these images. The hanging potted plant on the left has wispy leaves under the Madonna's tears, while its balanced counterpart on the right is full-throated under the stern gaze of the patriarch Baudouin de Lannoy. The final cadence is punctuated by the photo of the Madonna and Child echoing the mother and daughter sitting in the exposition; a tiny ancient statue with clasped hands which seems to wink over the shoulder of the artist's own hand-clasped pose.

I ask myself: why did I first read this triptych from left to right? We are culturally conditioned to, certainly; then I recall something that Beethoven does in his massive *Eroica*—something as revolutionary to sonata-allegro form as what Napoleon (to whom the work is ostensibly dedicated) achieved on the battlefields. Smack in the middle of his development section of the first movement, he does what no one had ever done before: he introduces an entirely new theme. It blows our preconditioned expectations to smithereens. While the exposition and development sections of the movement are in E-flat, this theme appears, weirdly and otherworldly in E-minor—a key seriously removed by a number of flats from the tonic center of the work. Dinnerstein places his copper engraving plate in such a position. The effect is galvanizing and striking. The plate is surrounded by engraving tools and laid on the center of the table, so it is prepared. But its central position forces us to prioritize it as a kind

of cupola to a greater building with flanked wings on either side. And it is an anomaly, because it is unique in the painting, like Beethoven's new theme. It is "other" yet part of the historical continuity and flow. It anchors us, brings us to the illusion of certainty, and reminds us of the artist's past as an engraver, just as the painting itself intimates his future.

The left-to-right impulse to view vanishes as we soon try to take the *Triptych* in from all angles because, of course, we can do that with a painting. The disciples of Schoenberg and the Second Viennese School tried to invent musical systems which could retrograde or invert sequences of pitches and events, thus subtly manipulating forward motion in time. The early minimalists took cues from African and Balinese polyrhythmic systems, and slowed perceptible time down. Presently, in our digital age, we have the capacity to sample and quantify material in ways that can take this deconstruction to new and mind-bending extremes. Yet no matter how you slice it, music still needs time to exist. Not even John Cage could get around that. But in painting and the plastic arts, time is supplied by you and me. We decide how much time to give it. What a relief not to be stuck in the center aisle of a long row in a huge concert hall during a four-hour Morton Feldman marathon (I do love his music) with no way out. A painting you can just walk away from!

So why didn't I? Because what I could not reconcile pulled me back and back again. What I could not reconcile haunted me; these oddly yet meticulously rendered figures and images, this über-realism which maybe wasn't real at all. The seemingly static surface energized my imagination, and I suddenly found myself diving into the dynamism of the details: all the children's pen drawings, the scribbling, the Renaissance figures, the paintings repainted, the handwritten Wittgenstein quote on a paper fragment which offered more than a clue. The images pinned on a drab wall, sacred and profane, all ages and generations: generations of family, stages of personal life, parents' passports; generations of art and artists, objects as symbols and signs which reflect inward on themselves and cast a hazy light on all which come before and after. A modern religious triptych that glows in the ancient gold of Cimabue, where the glow turns out to be painted wood walls, where the halo over the Madonna turns out to be a potted plant, and religion turns out to be assimilated Brooklyn Jews in post-

Holocaust Germany. The hybridity becomes alive and the painting begins to float on these axes. Time is no longer teleological, but moves in many multiple directions. The line perspective from the receding hills out the windows is three-dimensional space, and suddenly the generations float from my eyes straight to the far horizon and back again in an endless loop. I hear lyrical lines softly singing through. The objects pinned to the wall are in motion, moving through vectors in time and intersecting at random junctions. A mixed polyphonic ghost-chorus, the voices are hocketed, and there are waves of imitative counterpoint—although some of the fifth-species rules may be just a bit bent. The complexity of Dinnerstein's dream vision begins to come into focus for me as the picture itself goes out of focus. The symbols are speaking to each other, hierarchies established; formal tension intertwines with threaded details, my expectations piqued.

The Unanswered Question, as Wittgenstein asks in the pinned background—which of these worlds is *our* world? And the nonanswer is: all of them and none of them. All of these images could be what they are, or they could be something else. There is no one world, no choice to make, because the proof would require rooting in a static certainty. And we can glean from this painting that no such certainty exists.

The Dinnerstein Enigma

Philippe Grimbert

Every collector has had the experience: over the years he becomes one of the objects of his own collection. No longer the possessor, but the possessed, he succumbs to his countless finds lined up in rows, crowded together on shelves. Later on, well after he is gone, when we contemplate his life's work, his own face will be added to the long list of treasures that he himself will have accumulated.

A life—when one takes the time to pause in the ceaseless flow of days and look upon one's own destiny—is it not indeed other than a collection? A collection of memories, of emotions, of special moments, carefully stored in the way we return precious objects to the attic of memory where we regularly return to caress them with a loving glance. And if a glance is, in effect, so fundamental, it is because the pro-found events which mark our path inscribe themselves deep within ourselves in the form of images.

A triptych always evokes the feeling of an overture, and Simon Dinnerstein's is no exception; its panels reveal a life unfolded in three dimensions, like the three divisions of time to which each one of us must necessarily submit: past, present, future. The entire space onto which this vast window opens leaves no room for void, giving the vertiginous impression, in depth, of many paintings within a painting. It is indeed an entire exhibition which displays here its many canvases but within a single frame, offering to our eyes photography, memory, and symbolic imagery delineating the existence of the painter himself. The past spreads itself before our very eyes, and the childhood of both art and artist, present all at once in the marvelous innocence of chil-dren's drawings and also in the evocation of canvases by the great masters, always present at the origin of the painter's vocation. The present: Is the author of the *Triptych* himself an element within his own collection, in the company of his family? It is also the place of its own creation, with its windows framing a landscape unknowable as real or interpreted. It is the letters, the notes, the writings, all these inscriptions through which reality becomes symbolic, transmissible, capable of being assimilated. The future, so far as it is concerned, is surely contained not just in the promise of the child on her

mother's lap, but also in the enigmatic object, a work in progress on the worktable, surrounded by an additional collection of tools that will conspire together to further its own development. The solar disc, mysterious shape engraved with inscriptions, is the opacity of the work itself; it's the saint of saints in the intimate temple of the artist; being so true that the creative act eternally remains a mystery not just for the onlooker, but also for the creator himself.

And since the word *mystery* is upon us, let us think of one of the masters of literature, Edgar Allan Poe, particularly in one of his celebrated short stories: "The Purloined Letter." A document avidly sought after by seekers, which despite the scouring of a residence from top to bottom, remains undetected despite their efforts and for a simple reason—because it is not in fact hidden but rather, on the contrary, because it is in plain sight, which paradoxically renders it invisible.

Would not Simon Dinnerstein's *Triptych* be such an exhibition of "purloined letters" with the presence of its images saturating the field, revealing as much as it conceals the profound nature of a work of art and a life?

Translated by Philip Lasser & Michele Thomas

Simon Dinnerstein and His Wings

Michael Heller

In the spring of 1973, Simon Dinnerstein—unknown and unannounced—marched off the street and into the Staempfli Gallery in New York City in an act of youthful bravado, with some reproductions of his work. Clearly, this work had something to it, and the sheer chutzpah of Dinnerstein's gesture perhaps did not go unnoticed either. Within a few days, George Staempfli and his associate, Phillip Bruno, in an almost unheard-of excursion for a major New York gallery owner to make, went out to a then-not-at-all "hip" Brooklyn to visit Dinnerstein's studio and see the originals of his pictures.

Among the works that engaged Staempfli's interest was Dinnerstein's uncompleted *Fulbright Triptych*. The center panel of the work was only half-finished and the side panels were not far beyond the imagined stage. When Dinnerstein showed his maquette of the project to Staempfli, all that existed of the wings were photographs of the figures that would be painted onto the panels, Dinnerstein and his wife Renée. The baby sitting on Renée's lap in the current finished work had only been born a few months earlier in late September of 1972.

On the basis of that Brooklyn visit, and in only a few days' time, Staempfli sent a letter offering to buy the picture in its unfinished state and to represent Dinnerstein. In the letter, Staempfli also suggested that the end panels of Dinnerstein's triptych-to-be were probably a bad idea. "I would urge you to think carefully before you start on the triptych wings," he wrote. Not only did Staempfli feel they were unnecessary, but that if they were part of the piece, the size of the work would make it unsuitable for anything but a museum or institutional purchase. Indeed, in the letter laying out a contract with Dinnerstein, Staempfli worried that he might not be able to get the work into the gallery for an exhibition and proposed that he would make a dummy first to see if the painting would fit.

One has some sympathy with Staempfli's point. Framed and with proper spacing between the panels, Dinnerstein's *Fulbright Triptych* has an overall dimension of 79 ½ inches in height by 168 inches in width. Each of the "wings" is 79 ½ inches high by

38 inches wide. Without the wings, the center panel alone approximates a square with 80-inch sides.

Here I want to discuss what I sense to be the transformative impact of those wings on Dinnerstein's triptych. But first, let me say that the story of the young artist's resistance to the wishes of the older, far more powerful gallery owner testifies not only to Dinnerstein's daring but to his integrity and artistic vision. It is hard to imagine such a singular act today, especially when most young artists kowtow without resistance to the demands of the gallery, the market, and its clients.

At a current exhibition of his work at the Loupe Digital Studio, Dinnerstein talked about his philosophical argument with Staempfli and his insistence on completing the two wings. He described in some detail how they added a certain quality of "warmth" to the overall work, how they were a kind of invitation into the entire conception that lay behind the triptych.

If the side panels of Dinnerstein's triptych are "warm," then the uninhabited space with the etching table in the center panel is, by contrast, "cold." For what it demonstrated primarily is the cool, impersonal violence of the art gesture. The gaze from the viewer's eye transmutes itself into the brushstroke, the carving, the burin's line on the copper surface, all similar acts insisting that you will see *this* and not *that*. A space and volume are created in which a projection of that gesture, one amounting to a culmination of effects, takes place. As well, there is a kind of coldness or objective edge of nonambiguity to the engraver's art. It is one of incision, of cuts inflicted on a surface as opposed to paint laid upon a material, canvas or paper, almost as if the surface were being engarbed. With the two wings bracketing the center panel, this coldness is even more emphatic. One thinks of the oppositions at work: while the human form dominates the wings, the center panel is all about art and its supersessions. Everything about it is dominated in some way by art and the artist's vision. Even the landscape beyond the windows of the workspace has fallen under the control of or been mediated by the artist and by the architect who built the structure in which the engraver's work space is situated. The center panel embodies in every conceivable way the active vocabulary of the artist, making a visual entity, something like the poet tuning words, trying to heighten some of them and dampening others, in the hope that you hear what the poet has meant you to hear.

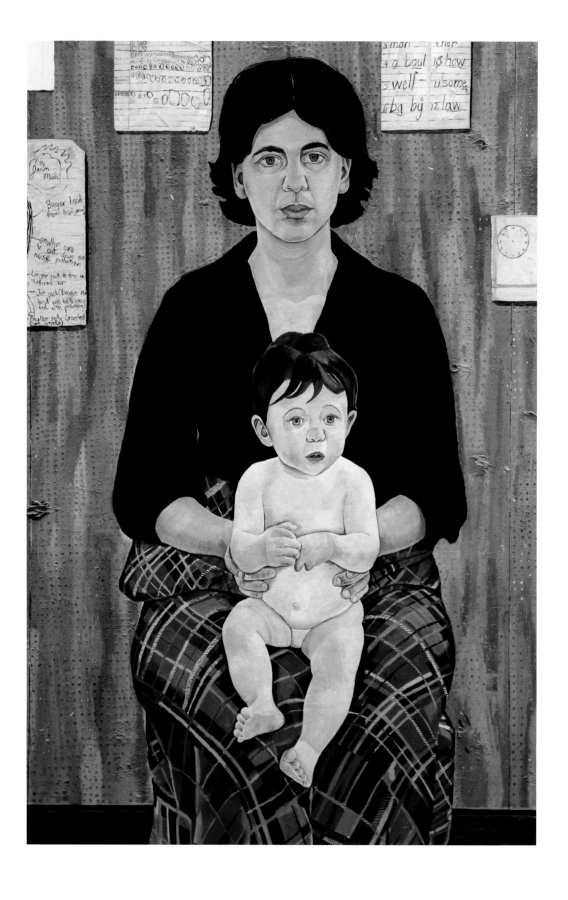

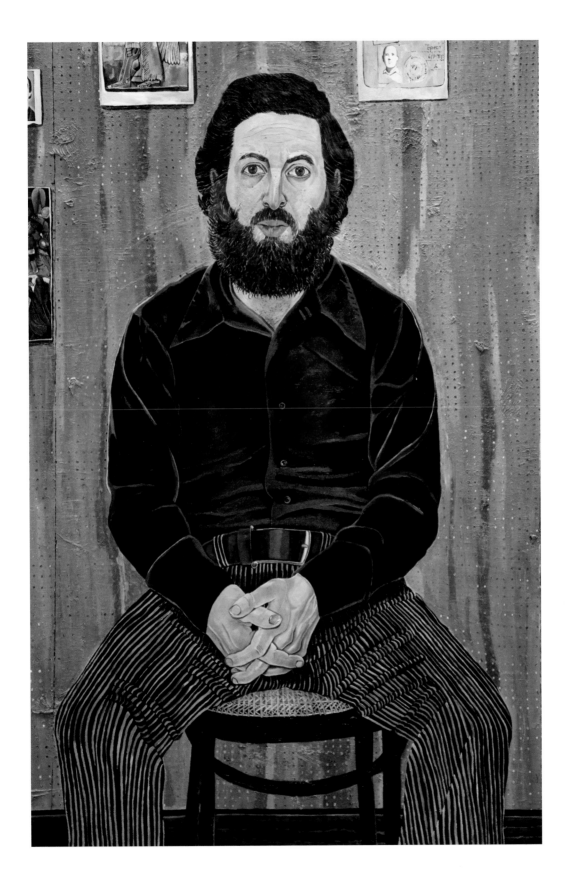

But to return to Dinnerstein's comment about warmth and the more elevated temperatures of those peopled wings. The left panel containing the image of his wife Renée, hands clasped around their child, hints at medieval altarpieces and pietàs, even as the matter-of-factness about the rendering of the figures suppresses any indulgence of overt religiosity. The right panel shows Simon, his hands held together, his boot shoes almost impossibly large in the foreground. He looks less the artist than the workman at a construction site. Yet both figures are surrounded by the objects they love and care about, Renée by the work of her students, and Simon by reproductions of art and its memorabilia. The two figures express a kind of thereness, of being comfortable and at-ease in their place. But for the eyes (of which more in a moment), there is something unassertive and nonaggressive about the poses, which alone marks the panels off from much American family portraiture. The two figures exhibit little of the pride and self-righteousness found in those of say Grant Wood's *American Gothic*. One could write an essay on how Dinnerstein's two panels in fact reverse and even invert the psycho-social values of that older painting.

Yet another, even more profound dimension of *The Fulbright Triptych* is made manifest not only by Dinnerstein's insistence on having his wings as part of the picture, but also by the way he wishes the entire work to be exhibited. When the Palmer Museum of Art at Penn State University borrowed Dinnerstein's triptych for exhibition, he specified that it was to be hung with a separation of three and three-quarters to four inches between panels. In this instruction, something interesting and mysterious is going on. For even the most casual glance at the *Triptych* shows that the two sides are to be seen, in an illusionistic sense, as just more of the room depicted in the central panel. The sameness of the wall paper, the height of the floor molding forming a continuous horizontal line across all three panels, the orientation of the floorboards in terms of a vanishing perspective in the center panel, all these are meant to suggest one continuous space in which the work desk, wife with baby, and artist are cohabiting. And yet Dinnerstein's instructions were that there should be gaps between these panels.

The older Christian religious triptychs, depicting scenes of the Trinity or biblical episodes, were in the service of unity, of bringing the aspects of God or of his worldview into a single vision that contained and embraced all sorts of phenomena. On altarpieces or on walls, the side frames of the pictures usually abut each other. Even

the frames for such works were often determined by material and weight, by the necessities of the site where they were to be placed, and by the wealth of the patron, perhaps more so than by artistic considerations. The close grouping expressed a religious or cultural unity. One could imagine that for some artists the need for frames and the dictates of location were interferences with expressing that unity.

In our time, one senses some reversal to this order of things. In a world filled with the loss of many forms of authority, with chaos and suffering the lot of much of the world's inhabitants, the modern artist is uncomfortable with the idea of unity itself. What once belonged together no longer seems properly connected, and the old projected universes of religious and cultural meanings have been blown apart, shattered into fragments, and isolated. Such disjunctions have become the essential elements of much art, especially that of artists such as Bacon or Beckmann or Paula Rego who make use of the triptych form. Dinnerstein, here in his *Triptych*, seems to join this company. If I read these artists correctly, their use of the triptych painfully reminds us that the form today signifies a broken totality that can only be unified, at best, by an act of artistic creation. Dinnerstein's wish to have the panels separated by a few inches, despite the illusion of unity they depict, seems to be an ambivalent expression of that cultural and social brokenness.

Wallace Stevens, in his essay "The Relations between Poetry and Painting," calls the making of art or poetry a "constructive faculty." For Stevens, revealment and repair of that brokenness is the essential task. And in Dinnerstein's *Triptych* we see such a constructive, unifying faculty firmly at work, even as it depicts the isolation of the artist from his work and from his family and from any other number of combinatory "decreations"—another word Stevens uses to describe the modern artist's gestures.

One unifying force is Dinnerstein's powerful and often astonishing technique, which in his painting offers a partial answer and repair to that question of dissolution and brokenness. Throughout the *Triptych*, there are bravura moments of artistic magic, such as the painted airmail letter over the workspace in the center panel or the school children's exercise sheets. The precise representations of engraving tools and the highly detailed engraver's plate of a soon-to-be Dinnerstein, *Angela's Garden* (the actual engraving turns up reproduced as No. 22 in the Hudson Hills Press catalog *Simon Dinnerstein: Paintings and Drawings*) are other instances. Moreover, the care that

Dinnerstein takes with all these elements is almost spiritual in nature. In its loving, skillful, and democratic embrace of person, object, postcard-sized old master renderings of portrait and landscape, remnants of memory and souvenirs, Dinnerstein's encompassing technique *is* itself a basic unity.

And there is also something more which lends a mysterious and complex unifying power to the work contained in those two "warm" wings with their psychologically acute life-size portraits of the artist and of the wife with her infant daughter on her lap. The eyes of both adult figures are wide-open, staring straight at the viewer. These are not inviting looks, but, like their own representations on the wings, they are strong gestures of discrimination and question. They project much more than a mild curiosity about who is looking at the painting, looking at the "me" of these pictures. Rather, it is as though the visual act mirrored itself back to send a message to the spectator: this intense unsettling look is what this picture is about, is what being human is about. Suddenly the spectator has become the subject of the artwork rather than the other way round. In fact, one could intuit a fourth panel to this picture, one facing the other three in which the spectator, subject to the same intense scrutiny as the couple in the panels, is almost transformed into an artwork or, as in contemporary theater, forced to become a participant in the play.

Here the act of creation is at its most naked and clear, one in which the artist says: this is what my life, my history, my training have led me to do. And we, as spectators, can't leave it at that because this work of art, with all its variations and tonalities, draws us in. It plays us like a work by Shakespeare or Beethoven. The final decisive act, like the existence of that after-the-fact *Angela's Garden* or the instructions to keep the wing panels a little distant from the center one—is given meaning by the viewer as he takes it all in: the incredible richness of detail, the little pictures and memorabilia so beautifully painted on the painted walls, and by the pictures of man and wife, and of a child who did not exist when the picture was first conceived. Through all those elements we get to a deeper understanding for ourselves, which, once grasped, leaves us captured by those figures in the wings. They look at us more powerfully than we can look at them. We've been brought to something as strong as the last scene of a *Lear* or a *Tempest* or the final note of a symphony. The details both move and release us, as though Dinnerstein's wings had unfolded themselves once again to embrace us.

Time Comes Back

Maurizio Gregorini

In reflecting on how Dinnerstein might have developed the idea for this triptych, I told myself that an absolute prerogative must have been a sense of welcome. *The Fulbright Triptych* is precisely about hospitality and welcoming.

This painting reflects an impelling desire to show every single thing in its own secret world, all that every artist intends to disclose about his own mystery. It is as if, at the peak of a life that has already gone by, one had to listen urgently to one's own voice. It is the tale of hope and anguish the youth carries with him as he prepares to cross the threshold into adulthood.

The resultant intensity, so evident in this work, is transmitted to the viewers, impelling them to mirror themselves ardently in this journey through their own pasts. We look directly, without intermediaries, in an all-consuming search for the absolute; we look in a process of boundless, uncompromising participation at the *Triptych* and with provocative passion back at our lives.

I feel the exact same pleasure every time I look at *The Fulbright Triptych*, because Dinnerstein, rather than flaunting culture, prefers a straightforward presentation of situations, colors, nuances, and linguistic simplicity. Those who are about to enjoy this work should not feel diminished by the magnificence of the painting. This is, perhaps, the only one in the artist's career which brings into play the gift of a love that is not predicated on anything—not language, not religion, nor ethnicity—true love does not give orders, does not ask for submission, but brings to life and restores the mutual experience of being together.

Since the artist's interpretation of that gift always presupposes the viewer's, I like to think of *The Fulbright Triptych* as a painting about desire. Where does man end and artist begin? I cannot say, because in this painting man and artist are one and the same, thanks to the painter's hypnotic style. His grasp of the spiritual and existential dimension, distilled to its precious essence somewhere between irony and pain, poses the eternal question of the meaning of beauty.

The charm of inanimate wisdom, imprinted on Dinnerstein's canvas, is enhanced by his nuanced autumnal palette and expressionistic use of colors to exalt the intimate and everyday: the wife wearing a black blouse and geometrically woven skirt; the recently born daughter portrayed nude; the table with its tools so meticulously ordered (as if to say inspiration came to him gracefully rather than roughly); the landscape outside the window, so naively powerful and tremendously evocative that it inadvertently moves one's interest away from the inside of the house. Ultimately there is Dinnerstein, quietly engrossed in himself, and as his facial expression evinces, already mature in knowledge. It is as if he is saying I am, I am here, and this is my world: share in it.

In this way, the painting brings to mind a preference for a lifestyle that's neither insular nor revolutionary, but rather embracing of the liberation that transforms pain into a forward-looking pictorial language. Simon Dinnerstein himself is bewitched by this quest, as if he were obeying the design of a "Stranger" who knows how to manufacture knowledge and fascination, arousing the pleasure of uninterrupted wonder not only in himself but also in the observer.

In *The Fulbright Triptych* everything has meaning: oddities, propriety, natural softness and harshness, human harmonies and disequilibrium. The image reveals a cosmic complexity that can unify anything, holding together the equilibrium of the enigma for each emotional phenomenon that lives within. The visual lyricism of *The Fulbright Triptych* seems to be the foundation of a world in which the viewer, upon entering, is conditioned to establish a truth or to reveal its essence; namely is forced to question or determine the meaning of our maximum perception of life on earth.

A lyricism of nuances and forms expresses eloquently the ongoing investigation concerning the secrecy of identity, time, and, naturally, of the truth of painting. Perhaps this is why looking at this work of art creates the impression of revealing measurements and reflections that are, yes, human (why not?), decisively celestial, precise details about the soul's journey on earth.

In an original *sacra famiglia* in the Christian tradition (note his wife's pose, the *religiosity* of her naked feet, her firm grasp as she displays her offering for our viewing, all elements that contribute to seal a predetermined destiny), this nativity-like scene

is set in a modern context (observe closely the pictured reproductions—Persian miniatures, family portraits, sketches, children's drawings, letters, and various writings—that fill the walls, copies that serve as reference for new ideas), *The Fulbright Triptych* intends to extinguish each and every old light of the soul.

We may, at last, cross into a new dawn, a spirituality till now unknown. From the darkness and the hidden wounds of the instinct may at last sprout, not the stray adventure of a life that makes us feel the unreliability of the human condition, but the amazement of surrender before a spectacle of knowledge that, in other places, we would dare call the *ultimate fulfillment of poetry*.

Translated by Silvia Gilliotti & Stacy Mazzone

The World to Come

Daniel Mark Epstein

The floor of the artist's studio, brown bare boards, has been carefully swept. There is no sign of the painter's drippings and spills, the chaotic palette of a year's mixing and daubing. It might be a doctor's office or jewelsmith's shop.

There is a single object on the floor: a bronze-colored sycamore seed or prickly burr has rolled under the engraver's worktable. The burr lies directly beneath the right rim of the copperplate centered on the black surface, the disk that will create a burin engraving to be called *Angela's Garden*.

Burr, burin. A verbal pun to match the visual, for the copper color of the prickly burr brightens in the copper of the burin engraving. The wild, fantastic multiverse of Angela's pointillistic garden of leaves and petals—that includes one tiny, clearly defined burr in the thicket of cherry trees and branches—has flowered from the little world of the seed beneath the table.

If the artist were seated at his work, his sharp burin poised above the copperplate, the objects that would meet his vision first upon looking up would be the pale blue aerogram from his wife, Renée, in Brooklyn, and a clipped quotation from Wittgenstein. These are posted low between the windows, near the desk where the stopwatch with the runner on its face leans from the black surface toward the aerogram, casting a crescent shadow (trompe l'oeil) upon the wall. The sweep-hand of the dial is phallic, comical, starting from the runner's groin, pointing to the letter with its curious dream.

Renée dreamed she was giving birth in this very place, this apartment in the German village. She was frightened because she thought the child was dead within her. But then in the dream she "faked everyone out because it was not a real child but a big air bubble! Wow, what does this all mean!!!!?" she asks her husband, thousands of miles away.

As if in response to the question or as comment on the dream, there is the quote from Wittgenstein on a square of paper next to the letter, explaining (as only the Austrian philosopher could explain years before the Holocaust) that our grasp of the

world to come is impossible. The language we use to describe it is rooted in life and life is uncertain, ever-changing.

So the child of the dream that is only an air bubble becomes the naked girl-child on Renée's lap in the triptych that was painted by Simon the engraver seated calmly opposite, but not in this world, which is the world conceived by the burr and burin. In this world of the burr and the burin, man and wife, and the double view of the German village, there is, as yet, no painting and no child. It is all prophesy and magic. The year is 1971. The child on her mother's lap has yet to be born.

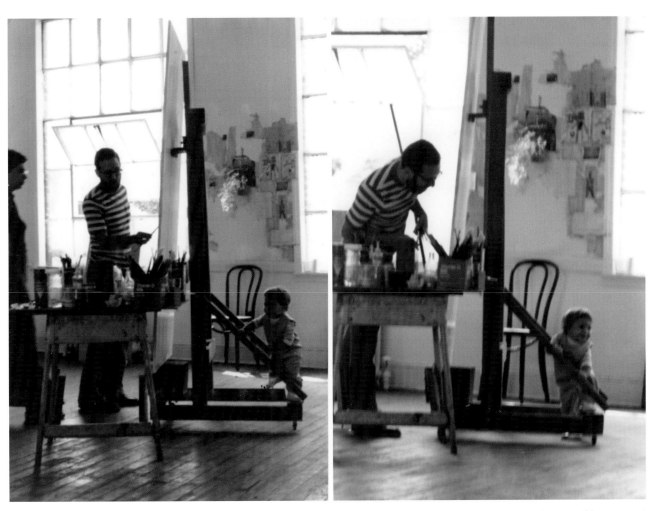

Fourth Avenue studio, Brooklyn, c.1973

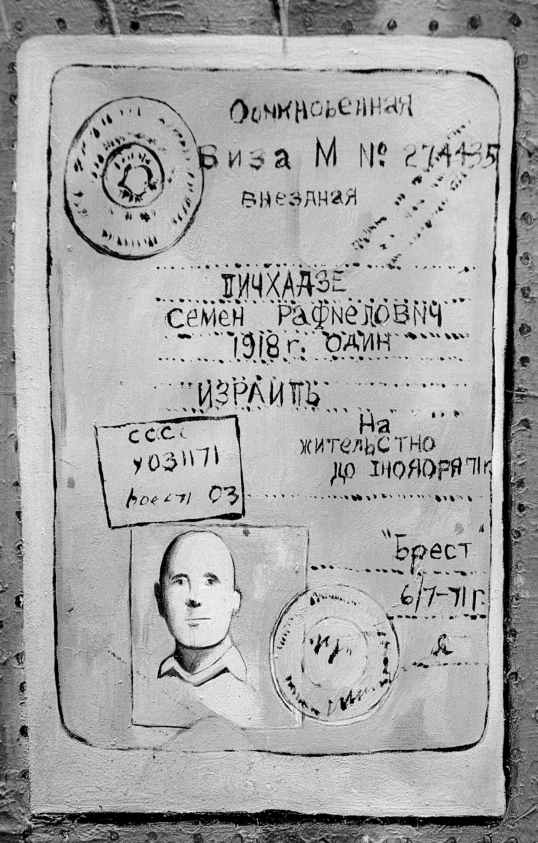

The Exit Visa

Louis Menashe

Doesn't anyone stay in one place anymore?
—"So Far Away," Carol King

How many Jews want to leave the U.S.S.R?
Answer: 250,000,000
—Old Soviet joke

I. *Dynamics in Russian History*

V. O. Klyuchevsky, the eminent Russian historian, wrote of people in motion, citing that feature as a key to understanding the course of Russian history and its background. The melancholy question asked by Carol King is suggestive of a particular phase in U.S. social history—the sixties and seventies, when young people, especially, left familiar moorings to seek love and bliss in San Francisco or communal peace and harmony close to the earth in the New England countryside. Klyuchevsky wrote of the vast population movements in the quest for farming land and pastures through the centuries across the Eurasian plains. Among the colonizers were settlements of Eastern Slavs, whose most powerful and numerous members were the Great Russians.

The Russian princes, later Tsars, established their commercial and political center in Moscow, and what was once a city-state became the platform for an expanding polity that eventually stretched to the Pacific, and then some, to the peripheries of what is now the northwest U.S. and Alaska (as Sarah Palin might point out). The Tsars did it by force and diplomacy, and when it came to their own people, they tried to insure socio-economic stability by enserfing the peasant population. Keeping the Russian peasants in one place to work the land for their masters and the state was the goal. It was largely successful, but the system continuously leaked. When peasant serfs faced cruel masters, tax collectors, or military recruiters—they often *didn't stay in one place anymore*, adding another wrinkle to Klyuchevsky's tableau of people in motion. (And, Carol King permitting, to her *Tapestry*.) They fled. They went to borderlands

over the horizons in every direction. Their communities formed the cores of Cossack settlements with special identities within the Russian empire. Other groups fleeing far away from Moscow included dissenters from the established Orthodox Church.

Stalin's empire embraced special identities as well—"enemies of the people," he called them, and motion was also involved, of the involuntary kind. When he wasn't physically "liquidating" them, Stalin transported them wholesale to camps in Central Asia and Siberia, comprising the *Gulag Archipelago* so painfully documented by Aleksandr Solzhenitsyn, himself one of those victims. (And who was later forced into exile abroad.) During World War II, Stalin targeted whole national groups for expulsion from their homelands—the Chechens, the Volga Germans, for example—on grounds of national security. Just before his death in 1953, there were rumors of an impending massive transfer of the many millions of Soviet Jews out of European Russia into exile, to the eastern territories of the U.S.S.R. The rumors have never been documented as either true or unfounded, but such a projected horror was well within the scope of Stalin's relentless paranoia.

Jews in great numbers had become special subjects of the Tsars after being absorbed into the empire following a grab of Polish territory in the eighteenth century. The opposite of motion was their intended fate: the Russian government established a special "Pale of Settlement" confining the Jewish population to the western zones of the empire. Only special services or high achievements allowed Jews to live outside the Pale, a zone where murderous pogroms erupted against them with regularity. But they fled too, before and after the Bolshevik Revolution, and were among those populating the great waves of immigration to American shores in the late nineteenth and early twentieth centuries. Perhaps Simon Dinnerstein's ancestors came here then?

These Jewish waves—this motion—from Russian lands continued well into the twentieth century, cresting and falling with shifting conditions in the political climates, particularly those affecting relations between Moscow and Washington. Lenin had called the Tsarist empire "the prison-house of nations," but the description surely applied to the successor regime of the Soviets he helped establish. It wasn't easy for Soviet citizens to exercise the basic human rights of simple travel, of short visits or

extended residence abroad, or of—gasp!—permanent emigration altogether. Soviet intellectuals alienated from the regime practiced their own version of emigration, a nonphysical, virtual emigration; they called themselves "internal émigrés." Mindful of world public opinion during the Cold War, the Soviets conducted tokenist measures in emigration policy that allowed for family reunion. Jews, Armenians, and ethnic Germans were the chief beneficiaries; they could apply for exit visas, provided they offered proof of relatives abroad. Soviet Jews applied in great numbers in the 1970s, but the proper documents were of course meted out by Moscow bureaucrats, and they were permission-stingy. "Let my people go!" was the cry hurled at Moscow by Jewish groups in the West in support of the thousands of Soviet Jews seeking, but denied, emigration—"refuseniks," they were called. Sometimes Moscow relented, as it did in 1973 and 1979, and the results were sizable waves of Jewish emigrants leaving the U.S.S.R. I once asked a Muscovite Jewish friend of mine, a former writer and journalist, why he left the country of his birth. "Because," he said, "Soviet life meant eating a pound of poison every day!"

We should therefore add to Klyuchevsky's picture of people in motion these distinctly Soviet patterns: forced exile abroad, sending millions to the gulag at home, multiple waves of those seeking escape by emigration to promised lands. Israel? The U.S.?

II. *Dynamics of Art Appreciation: Don't Just Stand There*
Let's look at Simon Dinnerstein's majestic, festive *Fulbright Triptych*. Seeing it in the flesh, all six-feet-seven-inches by fourteen-feet of it would be ideal. Absent the real thing, imagine seeing it with the help of a reproduction. Take an establishing shot of it, view the whole, take in the three panels, focus on the central worktable and the windows above, and let your peripheral vision absorb the pinboard backdrop with its pageant of Dinnerstein's "visual enthusiasms," as John Russell called them. Okay, don't just stand there now, start your virtual walk from left to right, past the seated Renée Dinnerstein and the infant Simone on her lap, past the worktable and the two windows, past the seated Dinnerstein . . . No; stop. What's that above his left shoulder? Look closely. Oh, it's a Soviet exit visa, or at least Dinnerstein's drawing of it, with his

diligently hand-copied printed information in Cyrillic. Was the original reproduced in some newspaper or periodical here, or in Germany while Simon was there, and did it attract his "visual enthusiasm"? Was it part of a general story about the exodus of Soviet Jewry? Or was it something about that figure pictured in a head shot, passport-style, in the lower left-hand corner? If only he could leap out of the document, as the matinée idol in Woody Allen's *Purple Rose of Cairo* did from the screen. He could tell us why he's leaving, where he's from, where he's going. No matter; with some under-standing of Soviet practices, we can deconstruct the document and make a stab at piecing together a small part of his story. What is not evident, we can imagine, or make some educated guesses.

His name is Semyon Rafielovich Pichkhadze, that is, Semyon, son of Rafiel, family name Pichkhadze—in the customary Russian manner, the given name, the patronymic middle name derived from the father's first name, and lastly the family name. In all likelihood he's Jewish, but not Russian-Jewish; his last name with its "adze" suffix tells us he's Georgian-Jewish. (Another prevalent Georgian suffix: "vili," as in Iosif Vissar-ionovich Dzhugashvili, i.e., Stalin.) The name Pichkhadze is common enough in Georgia; there's a prominent political activist by that name there now. Any relation to Dinnerstein's Pichkhadze?, I wonder. His Semyon Rafielovich was born in 1918, which makes him fifty-three at the time of leave-taking, and he is departing alone from the exit point at Brest in the Byelorussian S.S.R., probably leaving from there by rail for, according to established procedures, Vienna. The official destination marked on the visa is Israel, but that was purely formulaic. He might indeed be joining relatives there, or, more likely at that time, heading for, according to another common procedure, Rome, the departure point for that other promised land, the United States.

The visa is marked "Ordinary," but getting that document in those days was far from an ordinary matter. *Dokumenty* were the paper foundations of the Soviet, and Soviet-style systems. I.D. documents, work documents, residence documents, travel documents—these were among the ubiquitous and obligatory parts of the Soviet landscape that divided the powerful from the powerless. The distinguished poet and translator Charles Simic, who left his native Yugoslavia with his family as a "displaced person" or "refugee" at the end of World War II, comments on that grim circumstance

that hemmed people in: "It's hard for people who have never experienced it to truly grasp what it means to lack proper documents." He adds that the culture of "proper documents" also offers the bureaucrat "The pleasure of humiliating the powerless."

Denial of the visa request by Soviet authorities was the ultimate humiliation, but the wait for the visa, often measured in years, stung as well. There were other humiliations and hardships once the visa request was made. Neighbors might brand you a traitor to the motherland. It might cost you your job, and it might be difficult to find another while you waited for the visa to come through. At one point, Soviet authorities demanded an exorbitant "diploma fee" as compensation to the State for the educational services rendered to the departing individual. A career in what were considered certain sensitive areas of science, industry, or technology would make a visa request hopeless. Such was the Soviet "pleasure of humiliating the powerless."

We don't know how many bureaucratic hoops Semyon Rafielovich jumped through, or how long he waited for it, but he got his exit visa. Of course, he had to surrender his passport, an important *dokument* all Soviet citizens were compelled to have. The visa alone was now his primary I.D. and his enabling travel *dokument*. (An accompanying visa was probably issued by the embassy in Moscow in charge of Israel interests in the U.S.S.R. since no diplomatic relations existed between the two countries. Soviet "anti-Zionist" policies naturally made Soviet Jewry uncomfortable.) Another date appears on Semyon Rafielovich's visa. Dinnerstein's transcription is incomplete here; we have to connect the dots to complete one of those stern phrases from the Soviet chancellories: Permanent Place of Residence, known familiarly in official and unofficial circles by its resonant acronym, POMZHE (Postoyanoye Mesto Zhitel'stva). Semyon Rafielovich's POMZHE established his Soviet residence until November 1, 1971, and he had to depart before then. If not, he had to go through the whole visa application process again, alas. Fortunately, he left in time, on July 6, 1971, from Brest, as noted above.

Where have you gone, Semyon Rafielovich? Our wandering eyes turn to you. Was it indeed Israel, or did you settle in one of those Soviet-immigrant enclaves in Brooklyn or Queens, New York? If you are yet among the living, you would be ninety-one, not so old by reputed Georgian standards of longevity, at that age still "up on a horse,

up on a woman." How was the transition from the rigors of Soviet life to freedom abroad, with its other brands of rigor? Was your Soviet education or job experience good enough to land you satisfying work abroad? Did you ever experience nostalgia for the homeland, its faults and all? Did you ever expect the mighty Soviet Union to end its days with such a whimper, and so soon? Did you live to know that hundreds of thousands of fellow Jews from Georgia, Byelorussia, Ukraine, Russia, and other regions of the Soviet Union followed you before and after its collapse? They populate cities everywhere now in this modern variant of the Diaspora.

Whatever. Know this, though, Semyon Rafielovich: you have achieved a certain kind of immortality, thanks to your place, just over his left shoulder, in Simon Dinnerstein's *Fulbright Triptych*.

Where Beauty Lies Next to Violence and Despair

Mary Pope Osborne

The Fulbright Triptych is a rich view into the inner life of an artist. Simon Dinnerstein sets the scene with precision and order. The center panel consists of a table neatly laid out with engraving tools. Above the table, two windows open onto the outer world of a German village. A man and woman sit on opposite ends of the table, and it is their inner world that the *Triptych* reveals through the drawings, prints, and scraps of paper tacked on the wall above their heads. Some of the prints are by great artists like van Eyck, Ingres, and Donatello. There are pieces of paper filled with quotes and a passport or identification card from Russia in 1918. Because the children's drawings spring from the primal imagination that is the genesis of all great art, their work is particularly powerful.

The composition of the *Triptych* is anchored by squares and rectangles. This orderliness gives the work a geometric tidiness that belies the worlds within the room, worlds that must have been fundamental to the development of the artist. The juxtaposition of the children's pictures against the other art gives the *Triptych* its tension. What is one to make of the childish drawing of a beaver attacking a piece of wood with its terrible teeth? Why does one feel despair in a page of zeros signed by Alfredo? Monsters shooting death rays appear in Roberto Ortiz's drawing, while a picture signed by Jean Miele shows a figure distorted by the deadly effects of pollution. The young artist has given the body "smaller ears to cut down on noise pollution," a little torso "stunted from smoke," and puffed up cheeks "to hold some good air."

Children learn to link context and meaning through their imagination. C. S. Lewis once noted that imagination is "the organ for meaning." Perhaps it is the constant need to blend the atavistic chaos of a child's imagination into a larger context of beauty and culture that makes *The Fulbright Triptych* powerful.

Perhaps the artist is saying that while the primal imagination is the engine that drives the artistic process, the gifts of art and culture balance the fierce teeth of the beaver, Alfredo's zeros, and Jean's bleak view of the future. The serene world inside the

studio where beauty lies next to violence and despair just might be ample fortification against the banal menace of the German village and the world outside. In *The Fulbright Triptych*, Simon Dinnerstein gives us an artistic view fueled by the primitive psyche, enriched by culture, and balanced by order. And seated solidly in their chairs, the man, the woman, and the child stare out at us with hope and endurance.

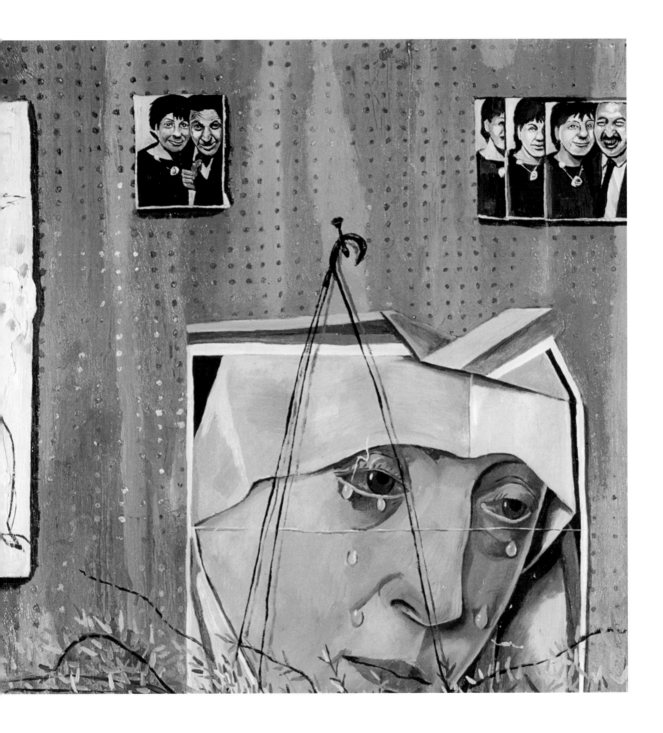

Through Children's Eyes: Entering Simon Dinnerstein's World

Richard Waller

> The artist appeals to that part of our being . . . which is a gift and not
> an acquisition—and, therefore, more permanently enduring.
>
> —Joseph Conrad

When we presented Simon Dinnerstein's painting *The Fulbright Triptych* at our university art museum, we chose a special location in the gallery space for its display. Not only did I want to emphasize its importance in the artist's oeuvre, but more important, I wanted to facilitate the visitor's encounter with this complex and intriguing work.

On walking through the museum with guests, I often mention that this particular gallery has ideal proportions. As you enter the space, the far wall is the perfect placement for a work of art, truly a "liminal space," the touted ultimate environment for experiencing a work of art described in discussions about the museum setting. Years ago, we presented an exhibition of the works of Robert Motherwell, and we installed his incredible 1965 *Lyric Suite* series of twenty-four paintings on this very wall. The bench placed in front served as a station of contemplation for this overwhelmingly beautiful series. On one occasion, I was compelled to stay open past our regular closing to accommodate a viewer lost in the power of the experience. Thus, when installing our exhibition of Simon's work, I knew without hesitation where to place his triptych, and the proof of the correctness of this decision was witnessed in our visitors' responses to this sensory feast as they came through the exhibition.

What I did not recall until recently were several of Simon's works in the exhibition that involve the world of the child, especially his drawing *Night*, which was placed on a wall leading to the room with the triptych painting. In this image children are wearing masks made from paper bags, and overhead looms an imaginary world full of witches, bats, and demons. Although this drawing and others dealing with childhood remain enigmatic images, they demonstrate the artist's fascination with the fantasy

world of children and his desire to include a psychological level in his work beyond a factual representation. Considering these drawings with children guides us to aspects of the *The Fulbright Triptych* I will focus on here.

In the left panel of the painting, Simon's wife, Renée, is holding their daughter, Simone. The child is still very young, but she looks expectantly at us and we know she will soon be determining her own place in this world, she will soon develop her own being separate from her parents. Simon sits in the right section, the pendant panel completing the artist's family; together they enclose the world of the studio with the landscape view through the window that comprises the middle panel.

The background wall of the room is covered with utilitarian pegboard, a practical, inelegant solution in the studio for hanging and attaching various things. However, it is transformed in the painting to a rich surface with nuances of color. Attached to this wall are the flotsam and jetsam of an artist's studio environment—postcards, reproductions, notes, sketches, plants, and other ephemera. These are arranged with the grid of the pegboard clearly showing through. In formal terms, his painted squares and rectangles resonate as if they are the push-and-pull planes of a Max Beckmann abstraction, while undeniably representing bits and scraps of an artist's active mind and studio practice. With almost no overlapping, these odds and ends take on a power that foregrounds their content, and we readily question the artist's intent of their inclusion in the story of this painting.

Looking closely, you find there is order to this seemingly random accumulation of things. Easily recognized are the images replicating icons from the world of art. Looking more closely, Simon has placed several works by children into this hierarchy of images from high art. Further, we notice he has placed them only in the left and right panels, the spaces that he and his family occupy, the panels that bring children's artworks to mingle and be equal to masterpieces of high art.

Surveying some of the children's images, I was first struck by the ballpoint-pen drawing *Bigger head (More Brainpower)*. It is funny yet poignant. Above it, Simon has placed a card with the letter *y*. Used by his wife as a flash card in teaching, here it also seems to ask us a question. Elsewhere, we find a masterful dragon, a full-blown battle scene, and even evidence of the struggle with learning to write the letters of the alphabet.

In speaking with Simon about the children's art included in the painting, he emphasized his desire "to inhabit those drawings, to inhabit the childish energy." Not only must he get the "feel" correct, he must also translate the drawing marks of the child artist into the oil brushstrokes of the accomplished adult artist. We accept artists copying the works of master artists, learning from iconic images from many cultures and times. This is a time-honored approach to attaining an understanding of how another master artist has constructed a work, its structure, its color, and its formal elements. It is also a way to increase one's skills as an artist, as many artists attest to the lessons they have learned from studying the works of their progenitors. Turning the tables a bit, Simon also wanted to reach into the art-making techniques of the child, and for a moment to occupy that worldview. As adults, we have forgotten the mindset of the child that allowed us to create with such blithe spirit and joyous abandon.

Other artists have incorporated children's works into their own art, and they have attempted to embrace the child's free-spirited approach to image-making. Many artists long for that lost innocence. However, in this painting Simon seems to be placing the drawings on exhibit with a precision of placement and juxtaposition to give them a certain presence and to tweak our response by giving them such serious consideration. He has inhabited those drawings as he desired, and he has given us a deeper understanding of their unfathomable reaches into the world of the child. The artist explained to me that he felt that "combining the childlike world with another world is a very modern idea." In this painting, he has brought the mystery of the child's point of view to have an unparalleled impact on our experience of his triptych. If not modern, the combination is nevertheless compelling. His fastidious placement and representation of each and every element in the scene is countermanded by the insistence of the child's vision.

The quote by Joseph Conrad at the beginning of this essay also begins the introduction by Lewis Hyde to his book *The Gift: Imagination and the Erotic Life of Property*. The author successfully argues that the work of art is a gift and not a commodity, and in his conclusion he states, simply and to the point, "We know that art is a gift for having had the experience of art."

As we contemplate Simon's gift to us of this painting, we find this enduring experience. As we stop in front of *The Fulbright Triptych*, we should all match Simone's open, expectant gaze as we immerse ourselves in the elements of this painting, from Simon's careful arrangements of objects and space to childhood's unexpected entrée to aesthetic experience.

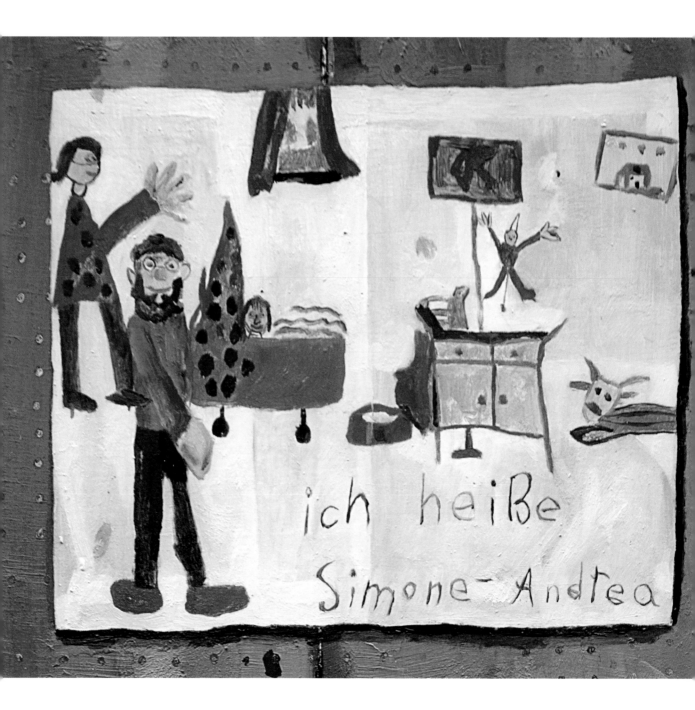

ich heiße
Simone-Andrea

Time Travel: Revisiting *The Fulbright Triptych*

Brian W. Goesl

I was introduced to Simon Dinnerstein's work almost immediately upon arriving at the Texarkana Regional Arts and Humanities Council (TRAHC) as the director of community programs in May of 1999. Our Regional Arts Center is the only secure gallery for fine art between Dallas, Texas, and Little Rock, Arkansas. We cover a one-hundred-mile service radius that includes Louisiana and Oklahoma, as well as Texas and Arkansas. We are the largest cultural organization in our region and our mission is "To Grow People and Community Through the Arts." With that in mind, TRAHC seeks to expose our populations to cultural experiences and opportunities that normally do not exist in our region, while actively supporting and nurturing our local and regional performing and visual artists. As with most nonprofits, we are under-funded and understaffed, with an extremely limited endowment, which means every staff member wears multiple hats, sometimes simultaneously.

The principal exhibition for 2000 had been arranged by TRAHC's previous executive director, an anonymous local donor whose college roommate was one of Simon Dinnerstein's neighbors in New York City, and my predecessor. All our new executive director and I really knew was that this exhibition was arriving in less than a year; it consisted of multiple paintings by the artist Simon Dinnerstein, who had received critical acclaim nationally and internationally numerous times, and virtually no preparation had taken place for this exhibition at our facility. The works were almost all from private collections in the United States, and the most significant piece was *The Fulbright Triptych*, worth tens of thousands of dollars. This pivotal piece was to be on loan from the Palmer Museum of Art at Penn State University, and it became obvious very quickly that our standard insurance policy would not cover an exhibition of this prominence. We would need to immediately find funding for the additional insurance. Our installation was to be one of only three in the United States before the works were returned to their owners. Oh yes, and there was also a beautiful four-color catalog that was being printed in support of this most noted artist's work. I was given a phone number where Mr. Dinnerstein could be reached.

I don't remember who made the first call, but just as if I were standing and looking at one of Simon's paintings for the first time, once that conversation began, I suddenly became part of an entity that was far larger than the normal scope of our own lives in Texas. As an institution, we became totally enveloped in a very significant body of work and with an artist who is able to capture his environment in great visual and emotional detail. Our new executive director and I viewed this exhibition as an opportunity to make a positive statement about a change we were initiating at TRAHC and in our area: "The recognition of the importance of art and its utilization within our region's culture."

Twelve months later, following numerous conversations with Simon, we received the works and the catalog several weeks prior to Simon's arrival for the opening reception. Being the curator I had been taught to be, thirty years and several careers earlier, I notified him that the quality of the shipping cartons was of great concern to me. Though none of the works had arrived damaged at our facility, knowing how often art shipments are mishandled in shipping, I had serious doubts about several of the cartons making it intact to the next venue, let alone back to their owners. My concerns were met with similar thoughts as I sent Simon elaborate descriptions of the shipping cartons, ranging from just single-layered cardboard sleeves and boxes to plywood cases with nails quite literally falling out of them. I had, for a short period of time in my undergraduate years, dreamed of being an artist, and the sensitivity of the handling of my work at that time created a common voice through which Simon and I began to communicate. And thus a friendship with Simon began, not by discussing the significance of art in the twenty-first century, but rather the structural integrity of cardboard, single and multilayered.

In discussions about placement and the selection of works, Simon was always very generous because of the Regional Arts Center's limited space. His preference was that *The Fulbright Triptych* should be the central focus and the anchor for the exhibition; the balance of the works would radiate around and support the *Triptych*. He said that he trusted me implicitly and knew that he would be very happy with whatever layout I created for the exhibition.

And so it evolved; as each lid was lifted from its case and every carton meticulously opened, the beauty and depth of each work was revealed. Each new unveiling presented a work that was more powerful than its predecessor. The ability that Simon has to capture a moment in time is remarkable, whether it is a still life, a portrait, or a fantasy world combining multiple elements. It is more than photo-realism that emerges on paper, canvas, or board. The images have a presence, an energy and soul, in which paint, charcoal, Prismacolor, and graphite are simply the media, the messenger.

It took four of us to lower *The Fulbright Triptych*'s shipping crate to the floor for opening; we could only imagine what treasures lay inside. We had seen the image of the work that is shown most often, but what was revealed as we opened the lid was so much more. The sheer size of the center panel, the depth and richness of color, the creation of the wall paneling, the "slices of life" images were nonstop, they began flying at us as we discovered more and more intimate snapshots of Simon's world in the early seventies. We broke for dinner and I stayed to rearrange the other works, now that I'd begun to really experience the magnitude of these three panels.

Drew Ellison was my one remaining helper after dinner. He and I lifted the two side panels out of the crate and leaned them up against the wall, leaving space for the center panel. As we raised the largest of the three into place, something almost miraculous began to happen—we were suddenly being transported into Simon's studio where the *Triptych* was created. We were quite literally standing in the room where Simon had lived and painted for over three years. Drew remarked that he had seen photo-realism before in galleries across Europe and the United States, but never a painting such as what he was experiencing here with "Simon's triptych."

We took copious measurements, because I only wanted to hang these panels once. The three panels were reinforced wood and they were quite heavy. Each one makes a very powerful visual statement in its own right, but the three together need to "become one" once they are hung. Level and plumb is the mantra, and they are not all the same height. There was virtually no margin of error without them looking uneven and unrelated to each other. As we were repairing one of the brackets on the center panel that had pulled away from its brace, my wife Patti arrived with our two-

and-a-half-year-old daughter and our nine-month-old son. She had been hearing about Simon's work and this specific painting for the last twelve months and had to see what progress we were making. At the time, it was not uncommon for me to be hanging works alone until two or three a.m., because I was the sole person responsible for the installations. This was indeed a rare treat for me to have help in hanging an exhibition. Drew and I took our final measurements, marked the wall, drove in the extra large anchors and hung Renée with Simone sitting in her lap on her plaid skirt. Simon's panel came next, with his postcards, miniature paintings, photos, self-portrait, children's artwork, photos of artwork, and the spider plant. As soon as we hung the center panel, we were immediately looking out of his studio windows, then down at the table he used for printing. The table stood in front of two radiators underneath the two matching windows and rested on multicolored floorboards, his etching tools and printing materials, the copper disk, the window latches, the rooftops and blue sky outside his studio windows all surrounded us. This intense realism was all painted by just one man, not collaged, printed, or silk-screened. We walked away and then came back for even closer examinations multiple times. Drew left shortly thereafter; he was ready to call it a night. This wasn't photo-realism; this was seeing an intimate room through the eyes of its creator. My young family was suddenly sharing time with Simon's young family in his studio, and almost thirty years of time were bridged instantly. The significance of this experience remains with Patti and me to this day.

I remember quite vividly Simon entering our gallery the following week and standing and staring at his studio, after not having seen it for some twenty-plus years. Neither of us said a word for probably half an hour as he "experienced" seeing his young wife Renée with their baby daughter Simone sitting on her plaid skirt, he with a full beard and head of hair, the smells and memories of that studio washing over him as memories were reawakened. He would walk away and look at other paintings, describing to me the technique he had used or the background story of the work. Then he would be drawn back again and again, sometimes just to gaze at what he had created and lived almost thirty years earlier. I felt extremely privileged to be able just to be a "fly on my galleries' walls" that afternoon.

Some might imagine themselves as actors in a scene, staring at *The Fulbright Triptych*, focusing on an individual element of the work itself and studying the incredible technique exhibited in its images. On the other hand, others might stand back to admire the grand scope and true spirit of this work. In either case, the *Triptych* captures a moment in time and draws us in to be part of it. For me this is what truly great art is. You are physically pulled in and become part of the actual work itself and you are changed forever by this experience. Whether it is a moving piece of music, a poignant movie, a dance transforming time and emotions on a theater stage, or a piece of poetry, art in its greatest and purest form dramatically includes us in the experience. This exposure to art shifts our lives in an ethereal way. It affects the way we feel about ourselves, our fellow human beings, and the world in which we all live.

Begun in Good Faith and High Hopes

Dinitia Smith

What is the story here? On the right-hand side of the *Triptych* sits a man. He is virile, the artist, his body tensed, energized, ready to go, as if he has been restrained only briefly so that his image can be captured in paint. On the left side is a woman with a pure unadorned kind of beauty, sensual hips; fecund. She holds a child whose cylinder of a body conveys solidity, fleshliness. The child's alert face makes you wonder if it is only seconds before she too demands to be freed from her mother's grasp, before her mother must get up from the chair and chase after her. Here you have it—on the one side, maleness, the artist, and on the other, countervailing side, domesticity, the demands of a wife and child. Yet there is tenderness in this portrait, of course, in the purity of the woman's face. She is a loved person, is she not?

The triptych form partly originates in religious iconography. It is significant that in the painting neither the man nor the woman is in the center panel. What is privileged here is the process of making art, the tools of Dinnerstein's then-field of drawing and graphic art. Set out in meticulous, scapular order are his engraving tools, a hammer, a knife, burins, scrapers, burnishers. And at the very center of the painting, shining like the sun itself, is an oval copperplate, depicted in gold leaf. It is art that has primacy for this young man. There is irony here, because Dinnerstein won his Fulbright as a graphic artist, and yet from the Fulbright came this, his first painting since he was an art student at the Brooklyn Museum. *The Fulbright Triptych* is a statement about the explosion of ambition and self-realization, a declaration that the artist is now going to extend the horizons of his work.

The eye goes next to inspect the two windows behind the worktable. For a fleeting second, it seems as if the two landscapes seen within them will be like the terracing in Renaissance and Flemish painting. But a closer look—and it is not so. Here you have in the two windows a depiction of the small German town of Hessisch Lichtenau where the Dinnerstein family lived from 1970 to 1971. Rows and rows of modest twentieth-century houses, neat gardens, picket fences carefully delineating the property

of the owner, a plain, flat landscape beyond, the faint shadows of mountains on the horizon. Here is German bourgeois respectability. It is, in certain parts, a commonplace little town. In the right window, one of the houses has a strange metal fence which is attached incongruously to a picket fence. Next to that is a red brick house which looks as if it is trimmed in black asphalt brick, with windows that are out of scale with the rest of its size. Through the left window, we see a corrugated metal shed, perhaps used for storing gardening tools. The close viewer or reader of the painting can't help but make the associations—whether they were conscious or not on the part of the painter—to the potential beneath the surface for disorder in German history, for violence, for distorted national pride, a longing for order, and a willingness to conform, to subjugate the self to power.

But let us look more closely at the balance in the triptych. This "reader" does not come to the painting innocently. She benefits from a contiguous knowledge of the exact references in it and she cannot help but bring to the painting that knowledge. What fascinates—and daunts—here is the richness and intricacy of these references. There is almost no way that they can be contained in a written narrative, which is why the painting must exist. Because like music, painting is an art form that lives in the realm of association, that can encompass a kind of three-dimensionality that simple prose, certainly an essay, cannot.

In the two outer panels of the triptych are written out the details of the conflicts of the artist's life. Always, they are balanced out and yet in collision. On the right, the lean and intense artist. Above him a cold and unyielding face from van Eyck's *Baudouin de Lannoy*. On the left panel, in direct apposition to that face, is one from a Flemish pietà, her eyes bloodshot with weeping, the tears rolling down her cheeks, hanging over Dinnerstein's wife, Renée, who sits holding her baby in her own version of a pietà. It is as if the wife mourns and weeps, while the husband looks out cruelly, unalterable in his intent and ambition. But there is also a picture of van Eyck's *Annunciation*, from a panel of the Ghent Altarpiece, suggesting the artist's adoration of her. Above the wife, Renée, hang the icons of her own profession as teacher, her students' drawings, a perfect graphic rendering of the letter y used to teach children phonics, the laboriously drawn letters of a child in class. There is also in the left panel, Renée's

panel, a rendering of a primitive fertility figure, another reference to pregnancy and motherhood.

Again, on the right, artist's side, a child's drawing of a dinosaur breathing fire—the artist's burning ambition? But he is beholden also to his sexuality. There is a reproduction of a Larry Clark photo of a young couple making love, an acknowledgment of the sex and love that got the artist into this bind anyway. There are joyful pictures of the Dinnersteins, Renée, their daughter, Simone, taken in a subway photo booth. And another rendering of Renée, with long, sensual hair, holding a puppy, a young woman before she is gravid with child.

Crucially, on the artist's side is a painting of a printed page, a passage from *Moby-Dick*. They are the words which lie at the heart of this effort, describing the obsession of the artist, for whom work is a matter of life and death, the quest that dominates him just as the pull of domesticity has grown stronger. The words are from Ahab's rant about his search for the great whale: "He tasks me," Ahab cries. "He heaps me; I see in him outrageous strength."

In the middle panel, close to Dinnerstein's side, is a rendering of Holbein's *Portrait of a Leper*, the artist, perhaps, afflicted in his domesticity. Under it is Dinnerstein's painting of a reproduction of the *Avignon Piéta*, in which the male Christ, significantly, the adult Christ, his sides pierced, lies dead in the arms of his chaste mother. The suffering artist.

At the very center of the triptych in the vertical space between the two windows is a painting of a letter that Renée wrote to Simon in 1971, recounting a dream. He was away in Europe, she was in Brooklyn. "Just woke up from the craziest dream. I was having a baby in our apartment in Germany." In the dream their two mothers are present, arguing with the doctor about how the baby should be delivered. She is terrified. "I thought there was a dead baby in me but when the baby was delivered I faked everyone out cause it was just a big air bubble!!!" Renée's own Annunciation.

But there is a secret to the *Triptych*. Behind the painting, hammered onto the wooden crossbars, a coin has been nailed. It is another reference to *Moby-Dick*, to the doubloon Ahab nailed to the mainmast of the ship and promised to the first man to raise the great white whale, yet another reference to the artist's obsession. The coin, first mentioned in chapter 36, "The Quarter Deck," and later at length in Chapter 99,

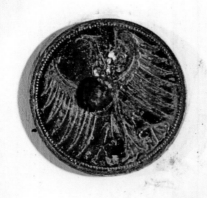

Begun in Good Faith
& High Hopes
on May 3rd, 1971
Hess. Lichteray
Quenteler Weg 31
Germany
with the love
of Reneé

"The Doubloon," was a gift to Dinnerstein from Renée. Beneath the coin, hidden at the back of the triptych, is a message from her: "Begun in Good Faith and High Hopes on May 3rd, 1971 Hess. Lichtenau, Quenteler Weg 31, Germany, with the love of Renée."

The woman as inspiration, as the purveyor of domesticity which saps the artist's will and his energy, but who is also his strength. It is their secret.

Wide Open

Valerie Sayers

Those Days

Simon Dinnerstein brings his whole life to-date to *The Fulbright Triptych*, but a viewer might bring some dates, too. 1971 to 1974, the years when the painting was produced, were years of collective and massive discontent: idealism looking bedraggled, the war slogging on, the last days of peace and love dwindling (Simon's striped pants! Renée's luxuriant skirt!). *Those* days.

I've studied the painting in reproduction with great pleasure: its maximalism appeals to me enormously. The three panels' multiple manifestations of the human face and form—especially the Holy Family Dinnerstein creates of his own family— are as enticing to me as the centrality of the copperplate on the engraver's worktable (we artists are all in favor of placing our tools dead center). Safely ensconced in a book, the *Triptych* has already conveyed to me an air of gentle authority: the artist says he will bring not just the craft but the vision of the past to painting the present. He will reconcile them.

But when I travel to the Palmer Museum of Art to see *The Fulbright Triptych* in person, I'm not at all prepared for time to wash over me the way it does. Up close, the painting puts me under a completely new spell. For starters, the size of the panels produces a much more insistent, if good-humored, authority. This painting *demands* equal time for concept and affect, for form and substance, for grand narrative and scraps of the quotidian, for a man's work and a man's family. If this artist celebrates Great Men of Art History he also celebrates Great Classroom Teachers; if he makes an icon of his wife and daughter he also remembers his forebears in shards and fragments, as if in a dream (and, in one of my favorite mysteries, in the narration of a literal dream). This painter says that in these times—those times—he won't be pinned down: not by school, not by concept, not by rejecting history and not by getting mired in it, either.

Balance

I look at *The Fulbright Triptych* for hours, moving from image to image, puzzled, drawn in, eager to skip away to the next fragment, and the next. Who needs hyperlinks? The scope is exhilarating: this is what the engraver chooses to do for his *first* painting? Far out. The graceful form of the triptych is also funny, with its strangely reverent jokes that art is what is worshipped here, and that the artist's best patrons may be his own family. The subverted form summons centuries of sonnet pranksters (Anne Sexton, Tony Harrison, Shakespeare himself), but the thread of time pulled through centuries calls up novelists who trade in time: E. L. Doctorow, Toni Morrison, and—I can't help it—Proust and Tolstoy. I am humming Mozart and Dylan. The artist offers narrative puzzles and clues but look at him there, transcending time, an off-center Zen master overseeing a study in balance.

To see the painting in person is to lose a sense of time as well as to gain one, but when I finally allow my gaze to settle, I'm not meditating on time but on paint. The brown walls and floors were there in reproduction, all right, but now I'm taken aback by the abundance of brown, even as the walls dance with unexpected hues and texture, by the thick heavy brown of the floor, its layers of shellac scruffy and scuffed and glorious. Even the prickleballs beneath the engraver's table celebrate the grub and grit of daily life. And maybe it is the meticulousness of these browns that makes that central copperplate summon a golden egg in my mind, that makes every homage-laden, precise reproduction that covers those walls all the more delightful. One thing to pay Holbein the honor of exactitude, quite another to honor the *floor*. But the floor is where I start: at Renée's feet.

A wife-and-mother's presence in this context moves me deeply, but I am just as moved by the images that cover her end of this altarpiece to art: the weeping Virgin above her is red-rimmed, her tears glassine, but Renée is alert, contemplative, in control of whatever it is she's feeling as she holds her little girl. She's surrounded by happy family photos, but the child artists Dinnerstein has tacked around her reveal their fears, even their terror (dangling nooses, attacking war planes, bodies stunted "from smoke," the artist, Jean Miele, notes). We think we specialize in eco-consciousness these days, but in those days, too, even children saw that the future we were creating might well

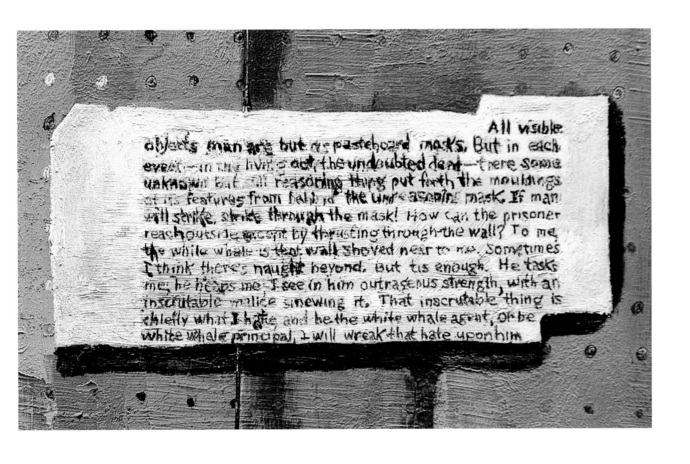

go up in smoke. How steadily Renée sits next to the clocks with the disappearing faces and the exquisite letter y (why?). This woman isn't about to sit around weeping, not in these changing times. The work of women and children is honored here in a way that strikes me as not just prescient but joyfully subversive.

I skip over the central panel to get to the artist himself, and am struck by how decisively I've moved from female territory to male—maybe it's the severe stare from the van Eyck portrait above the painter's head, or maybe it's the ritualized violence of that sword-wielding angel who hovers so close to him. The breadth of Dinnerstein's visual devotions is a challenge, the familiarity of many of these images a solace. This artist won't forget where he comes from, but we who don't know him well will have to guess. (Whose emigration papers are these, and what does the Cyrillic signify?) I slide back to the upheavals of 1918 and forward to the sexual revolution: an erotic charge emanates from above. What an embrace, what a smooch, what long fingers on that hand between her legs. But the children's work has migrated into this world too, the Dinnerstein family, past and present, high above the artist—and off to the right is another Madonna to link Simon to Renée.

The center panel is as limitless as that gauzy blue horizon, as fecund as those green fields. To a dweller of the twenty-first century, the tidy town suggests, all at once, the richness of community and tradition, a life conjoined with nature, and the worst excesses of conformity (as Guy Davenport points out in some amazement, Dinnerstein started painting this German landscape barely a quarter century after the Shoah). To settle into the center panel is to settle into the contradictions and reconciliations of the whole: the conjoining of engraving and painting, male and female, the past and the future of figurative art, the artist's studio and the bourgeois world of houses, fences, and gates. Dinnerstein hops over the fences, and it is his movement back and forth between worlds that has kept me moving across, around, through the triptych.

But the museum is closing now, and like the stopwatch above the artist's tools, I really am running out of time—when the artist has taken all the time in the world (all right, three years of his life) to honor the work he esteems. In my last moments with the triptych, I move back and forth between Saint Francis and this gruesome elegant pietà I am ashamed not to know. My childhood was filled with magnificent images

of Raphael, Botticelli, and contemporary Catholic kitsch, and Dinnerstein sends me back to those often surreal juxtapositions, his impulse to capture the worldly accumulations of time in this painting akin indeed to the grand ambitions of altarpieces and cathedrals. For me, the wonder of this arrangement of work that spans so many centuries and sensibilities is that it is so precisely ordered, and that it might take a lifetime to crack all his codes.

Our Moment

And I can't help wanting to crack them. I am not the Zen master the painter is, and as I take my leave I find myself clutching after meaning in these loaded images— maybe I am a little like Renée, whose aerogramed baby dream, directly above her husband's tools, cries out: "What does all this mean!!!!??★?" Wittgenstein, to her left, answers: "To the question which of our worlds will then be *the* world, there is no answer."

There is no answer: certainly there is allegory in this imposing and inviting work, but this is also a painting that seeks to deepen its own mystery, to summon the artist's dependence on the sacred and the profane but also the mundane and the workaday, the demands and the comforts of family. Dinnerstein has tacked up Melville to remind us that "All visible objects, man, are but as pasteboard masks," but if he surrounds himself with masks he just as surely surrounds himself with (well, there's no other word for it) love.

I could stay for hours more—the triptych is already an old friend, its world my world—but time's up. I step back to see the whole one last time, and I'm struck all over again by how precisely Dinnerstein captures not just his moment as an artist, but those days, 1971 to 1974, when modernism is getting that played-out look and the crudest ironies of conceptualism are, already, just too easy; that moment when we're feeling betrayed by the past but longing for wisdom and order; that moment when the whole world is either stoned or gazing through smoke but an artist, however laid back, decides to keep his eyes, and his work, wide open.

Painting Pointing Past Itself: Heterogeneity and Contingency in *The Fulbright Triptych*

Roy Grundmann

Looking at *The Fulbright Triptych*, one does not get the sense that one looks at a single, unified object. The overall size as well as the detail and density of its contents compels one to treat it like an installation or a mural, whose perusal prompts the viewer to assume an ambulatory relation to the work. Moving alongside its three panels, one steps up close to make out its details, and back again in an attempt to behold the entirety of the work's structure and composition, only to shift position again in order to be able to consider its elements in various combinations and from different angles. The numerous objects depicted in the *Triptych* not only include different kinds of paintings, but reference a broad array of image types and documents, such as photographs, Polaroids, drawings, postcards, small posters, magazine clippings, handwritten notes, envelopes, and an exit visa. This list merely refers to the objects and images hung on the walls. To it we must add the depiction of two windows in the middle panel with a view of a small town and the countryside behind it, the table with the printmaker's tools on it, positioned directly underneath the windows, the radiators half-covered by the table, and the family of three (father, mother, and daughter) who are placed in the two outer panels, with the father on the right and the mother and child on the left.

While *The Fulbright Triptych* is neither a collage nor an installation—it does not feature any items that were pasted onto or affixed to it, but consists solely of a painted-on panel—its different elements evoke the impression of great heterogeneity. This impression is caused not only by the diversity of the objects themselves, but by the uneven conceptual configuration of space and by the hybrid invocation of different representational conventions and periods: the triptych format and the flat, frontal presentation of the characters is reminiscent of medieval ecclasiastical art; the near-taxonomic array of utensils on the table and the unconventional placement of the figures in relation to it obliquely invokes primitive art's effort to document its own civiliza-

tion. This aspect is, in my opinion, confirmed by the inconsistencies in the construction of outdoor space, which suggests that mythology and symbolism attenuate the initial impression of an organically extending space. Due to these factors, the notion of the painting pointing past itself is not to be understood merely as a metaphor for the illusion of space that it creates. Referencing both symbol and reality, presentation and representation,[1] *The Fulbright Triptych* pictorially and conceptually wants to be more than a painting, more than either an object or a medium. It is not a work of multimedia art, but it bears the mark of intermediality. It evokes other mediums discursively, through its own discourse of painting.

While the objects on the wall are clearly identifiable as painted representations of drawings, photographs, clippings, or handwritten notes, their painterly qualities increase their generic attributes. In the encounter with the work, any appreciation of the material specificity of, say, a faded Polaroid or a wilted, dog-eared magazine clipping is replaced by a different semantic decoding process. This is the same process that also puts various pictorial segments in relation to one another, subjecting them to multiple readings and placing them into speculative narratives about the depicted family members and their relations to the objects on the wall and the space in which they are seated—which, in turn, gives rise to further speculation about their fates, histories, attributes, and so on. Of course, it may be argued that what is at issue is really the traditional hermeneutic process of reading figurative paintings. But this process is complicated by two aspects—the first is the plethora of pictorial elements that confront the viewer in their dialogic array and that define the act of reading the painting as an elaborate task. This self-reflexive acknowledgment of viewership is supported by the second complication of traditional hermeneutics—the strong inscription of specularity whose effect is compounded by the considerable gradations of realism, the uneven designation of artifice, and the combination of flatness and depth. While the inscription and refraction of viewing positions has been an inherent condition of painting since the fourteenth century, the establishment of perspectival coherence has also had the effect of suturing specular identity into illusory coherence. By contrast, *The Fulbright Triptych* fulfills these conventions only superficially and, in fact, subverts them through intimations of spatial incoherence. It has been argued that *The Fulbright*

Triptych does not yield an epistemologically coherent view. Instead, the viewer's gaze is thrown back onto itself,[2] an indication that the work is a product of the modern era, obliquely effusing, as it does, modern art's tendencies of distortion and abstraction, as well as postmodern art's synthesization and polemical hybridization of diverse logics, periods, and styles of representation.

Figurative paintings, due to a denotative dimension that is largely absent from abstract art, are often perceived as having a larger degree of "self-evident contents" that would seem to overdetermine their interpretation. But, as Roland Barthes concluded many years ago, denotation ultimately is subsumed by connotation.[3] In this sense, the horizon of interpretive possibilities of any figurative work is as wide as that of abstract or minimalist art. In addition, *The Fulbright Triptych*, through its palpable inscription of spectatorship and through what has been termed its "combination of epigrammatic precision and epic prolixity,"[4] suggests that the viewer's interpretive work may easily incur an additional layer of reflection. The fact that critics speak of their impression that the painting projects "contradictory attitudes"[5] can be read as an indication that we evaluate not only the work, but our own engagement with it, our labor that we invest in the reading process, and our feelings that get sparked and that may themselves become the subject of reflection, along with the memories that the viewing process may generate. None of this is to take away from *The Fulbright Triptych*'s denotative wealth. In contrast to nonfigurative art—particularly high modernist art and the minimalism of the neo-avant-garde, whose avoidance of denotation and legibility is emblematic of modern art's resistance to objectification and its striving for autonomy—*The Fulbright Triptych*'s surface detail identifies its objecthood as something inviting. It *wants* to be "used" by the viewer; it invites reading, decoding, and interpretation.

The painting offers an inexhaustible spectrum of possibilities of interpretation and narrativization. The array of various objects and segments that fill the painting does not produce a seamless complementarity, but a partial overlap that perpetually defers finite interpretation. There is the implication that many of the elements have a certain relevance to one another. Or, to put it differently, they are in dialogue with one another. They want to speak to one another and to the viewer. Any danger that meaning may become closed is undercut by the frisson that is generated by the diverse and

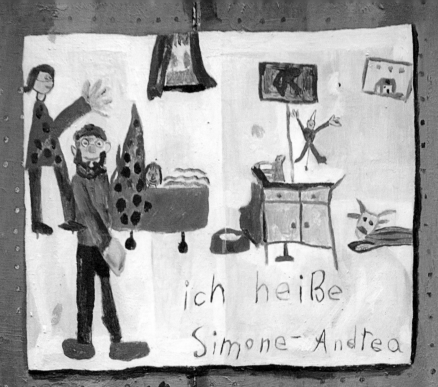

ich heiße

Simone-Andrea

All visible objects man are but as pasteboard masks. But in each event — in the living act, the undoubted deed — there some unknown but still reasoning thing put forth the mouldings of its features from behind the unreasoning mask. If man will strike, strike through the mask! How can the prisoner reach outside except by thrusting through the wall? To me, the white whale is that wall shoved near to me. Sometimes I think there's naught beyond. But tis enough. He tasks me; he heaps me. I see in him outrageous strength, with an inscrutable malice sinewing it. That inscrutable thing is chiefly what I hate; and be the white whale agent, or be the white whale principal, I will wreak that hate upon him.

contradictory implications which emerge in the comparison of its various segments. Dialogue thus always incurs a certain measure of misunderstanding, uncertainty, and ambiguity. All this makes the triptych fraught with meaning and possibilities. The reading process is additionally complicated through subtle irony and self-reflexive theatricality. For example, the painter's family is not depicted as a unit but is separated by the painting's structure. Allusions to holiness (the mother-and-child motif, the vaguely biblical look of the father) are undercut by the interjection of art-making into the scenario. Displacing the family to the outer panels, the large table in the central panel functions as an altar of sorts, but displays only the artist's utensils. Art is thus identified as a decidedly secularized form of religion.[6] At the same time, art's centrality to German idealism's quest for eternal truth is juxtaposed to the dullness of an average German village, which is expressed through the bland postwar architecture and the nondescript countryside behind it. Noteworthy as well is the association of the artist's tools and the art-making process with the painting of Hanseatic merchant Georg Gisze located just above the letter that hangs directly above the table in the center of the middle panel. *The Fulbright Triptych* here cites a classic example of Renaissance art that registers the historical rise of the middle class and locates art-making in proximity to mercantile interest.[7] Implicitly, Dinnerstein thus situates himself in relation to the marketplace, even if the production context for *The Fulbright Triptych* is, as the title of the painting points out, that of a state-sponsored fellowship.

This aspect, the Fulbright scholarship's mission of creating understanding and friendship between different cultures and people, is of importance if one considers the broader historical context of postwar German politics, arts sponsorship, and German-American relations. While postwar German history up until the mid-1960s was overdetermined by the geopolitical, economic, and ideological polarization into east and west, with West Germany, under a Christian conservative government, recruited into NATO and built up as a bullwark against communism, the period from the mid-to-late 1960s through the 1970s was determined by a succession of liberal socialist governments that effected political changes in several areas: West Germany initiated a politics of cooperation with Eastern Bloc countries, particularly with East Germany. From within, it sought to demonstrate its spirit of democracy by establishing a public

sphere of open political and cultural debate, and by cultivating the ideology of consensus building. As part of this democratic ethos, but more specifically within a socialist spirit, government legislation substantially improved access to higher education, while also insisting on the independence of the educational sphere from the control of centralized government. The late sixties and early seventies also saw aggressively stepped-up state sponsorship of the arts. While the West German state had heavily funded the arts since its inception in 1949, during the sixties funding became extended to less well-established arts and to film and media. Significantly, monies were not restricted to artists from Germany—which is one of the reasons why West Germany became a global center for experimental art and for several international avant-gardes. As a response to the Nazi period's suppression of artistic freedom, artists in West Germany were highly encouraged to exercise unconditional critique of the system. Allowing artists to bite the hand that fed them was regarded as proof of the liberal democratic climate of the new republic. Art was also assigned a crucial role in helping West Germany demonstrate that it was willing to own up to its historical responsibility of coming to terms with the legacy of the Nazi period. The fine arts and performing arts came to complement a broad-based cultural initiative, which included historical education about the Third Reich for all citizens via school curricula, museum programs, and memorial events, a politics of reparation and reconciliation with the victims of the Holocaust, and a sponsoring of German-Jewish relations (which were regarded as overlapping if not synonymous with German-Israeli relations).

The Fulbright Triptych can be related to certain aspects of this period, particularly with regard to the representation of the Jewish resident artist in a land that had killed six million Jews. Dinnerstein depicts himself and his family through a series of ambiguities and dualities that point to the historical paradoxes of the relationship of Jews to Germany. On the one hand, the family in the painting alludes to Christ's family and thus stresses the origin of Judeo-Christian ties. This allusion is undercut by the female gender of the child, which secularizes the family. A similar internal contradiction is achieved through the tension between the secular, contemporary look of the mother and the slightly anachronistic look of the father, whose unconventional pants and full beard invoke vaguely biblical connotations that implicitly point to the role of Judaism

as spiritual and cultural sponsor. The altarlike table with utensils and the reshaped and repurposed mini triptych on it identifies the significance of Jewishness in the secularizing role of art (religious signifiers are converted into artistic ones). The painting particularly alludes to the crucial role of Jews as patrons, collectors, and connoisseurs who, in one way or another, have significantly furthered Western art since the Renaissance. The image's polysemy thus serves as a commentary on the complex history of Jewish identity and also on the complicated relation between being Jewish and being German. Situating the family of three within a German-identified environment, the triptych testifies to the fact that it was once again possible for Jews to live in Germany, whether as foreign visitors or as Germans. But it is also possible to regard the family that is depicted as not being Jewish at all. Their looks combine impressions of suburban plainness with elements of folklore in a manner that was not uncommon for educated Germans who were influenced by the semiotic codes and the lifestyle of the counterculture of the late sixties and early seventies.

These signifiers of ambiguity, heterogeneity, and eclecticism stand in what initially appears to be a contrasting relation to another element of the painting: the clear-cut division between inside and outside space. This separation references a division between Jewish private sphere and German public sphere, alluding to the punitive consequences of Jews' resistance to fully assimilate to German culture and the protective measures these consequences necessitated. But this binary, too, is undercut, particularly if one applies a historical perspective to German culture that considers the centrality of the private sphere to the construction of the public sphere in the early modern era. The official, idealist version of this model regards the private sphere as the space in which German burghers could educate themselves without being disturbed by the vitiating influences of advancing capitalism and bureaucracy.[8] Once their exposure to arts and letters had made them into fully human(ist) beings, they could, in turn, wield this education and moral maturity to make the outside world—signified as the public sphere of political and philosophical debate, but also as the sphere of commerce—a better place. However, not only does this model not consider Jewishness as a factor in the construction of enlightenment culture—it also conceives of the construction of this culture exclusively in dialectical terms. *The Fulbright Triptych* qualifies

this model by identifying the private sphere as a decidedly nonpure space that already contains signifiers of commerce, of politics, and of a broad array of artworks, not all of which would have been considered respectable pieces of education for burghers.[9] In this sense, the painting's commentary on the private/public split complicates rather than reinforces the cultural dynamic that subtends this divide. The relation between private and public, which is so central to German history and philosophy, is here implicitly identified as always already hybridized.

The painted view through the windows onto the outside reflects the painter's choice to consider Germany in relation to a broad historical framework. While the rendition of village architecture does not ignore the consequences of World War II (bland 1950s building style is stressed over medieval village architecture that might have been destroyed by air raids), this reference is implicit at best. Its mutedness suggests a certain resistance to reducing the depiction of Germany to signifiers of the Nazi period and its aftermath. Instead, the painting rhetorically conjures an image of the village as a place outside of history by evoking the impression of the ordinariness and calmness of village life and the gentle beauty of the surrounding nature. This depiction is not incompatible with the rendition of the inside of the house, if one chooses to reread what I have characterized as Jewish eclectisism in a decidedly more apolitical manner as a love of "the arts" as conveying a transcendental, seemingly objective kind of beauty. It is important to understand this rhetorically broadened view about Germany as a reflection of the painting's production context, which saw a dual strategy of legitimizing Germany vis-à-vis the world: on the one hand, efforts were made to explicitly thematize the legacy of the Nazi period and to enlist the arts into this process; on the other hand, Germany and, perhaps more accurately, "Germanness" became once again promoted in terms of a Kantian understanding of ahistorical and apolitical values: the cherishing of beauty, truth, and virtue, and a promotion of art for art's sake. The goal of this dual rhetoric of legitimation was to seize on aspects of German heritage that were deemed uncontroversial and regarded as German culture's contribution to Western epistemology and philosophy. The ultimate goal was to recuperate Germany within a climate of reconciliation and understanding between cultures—a politics that was practiced by the United States, West Germany, and Israel alike.

While *The Fulbright Triptych* references this political agenda, it also safeguards against some of its stultifying implications. The painting's numerous instabilities produce a sense of constructedness about its aesthetics. Its address to the viewer is self-conscious and the painter's self-portrait is performative. He is aware of his own role as articulator of these ideologies of cultural understanding and reconciliation, because these are closely connected to the purpose of the Fulbright fellowship. And while the fellowship is a way of enlisting the artist in the service of cultural ambassador, the category of the visiting fellow or artist-in-residence also implicitly undercuts ideologies about the national specificity of art production and a nation's "cultural goods" with discourses of transnationalism. In this regard, it is particularly notable how the triptych seizes on the tension between Germanness and Jewishness by thematizing migration and diaspora. While Jewishness is nearly synonymous with diaspora, the painted detail of a 1918 exit visa from Russia is fraught with associations and implications. The visa codifies diaspora as westward and not exclusively based on refugee status, and it draws attention away from the forced exile of many German Jews, which might have been a more obvious choice for Dinnerstein to comment on. The artist's own sojourn in Germany for the Fulbright fellowship constitutes another aspect of this transnationalism. Unfolding in a very different historical period, Dinnerstein's trip to Germany is nonetheless indirectly a result of the history that has passed. As a Jew visiting a country whose own Jewish community has been radically reduced, his visit must be seen as a continuation of the diaspora, whose reverse direction lends it demonstrative force and political charge. The implications of his visit—which took place at a time when many non-German Jews still refused to visit West Germany—also make him an eyewitness whose stay in the country enables him to "inspect" it firsthand and use his art as a form of testimonial.

Needless to say, Dinnerstein's Jewishness makes his role as eyewitness/evaluator more charged. Bearing witness has, of course, been a central element in the uncovering and bringing to trial of the crimes of the Holocaust. Yet, to understand the particular implications of the witness model that pertains to Dinnerstein's mission, it may be useful to point out that the deployment of witness testimonials did not remain uncontested during the postwar period that saw efforts to confront the Holocaust. What

compounded the confrontation of the ineffable personal and historical trauma was the emergence, during some of the trials, of an infamous, defeatist logic of Holocaust denial, that, as French philosopher Jean-François Lyotard has explained, has necessitated the rethinking of nothing less than the very foundations of language, on which arguments and counterarguments, debate and discourse, and, indeed, the social as such are built.[10] At issue was a "bad faith" question that attempts to play out the status of the eyewitness against the existence of gas chambers. As Lyotard paraphrases it:

> In order for a place to be identified as a gas chamber, the only eyewitness I will accept would be a victim of this gas chamber; now, according to my opponent, there is no victim that is not dead; otherwise, this gas chamber would not be what he or she claims it to be. There is, therefore, no gas chamber.[11]

In addition to the general crisis that befell epistemology and representation in the aftermath of the Holocaust, this logic of cynicism triggered a particular philosophical response, which, like numerous other responses to the Shoah, was influenced by Jewish skepticism. It argued for a new understanding of language itself, and implicitly, a new understanding of the social. It claimed that speech acts are deeply incommensurate, as though two speakers barely inhabit one and the same reality. Consensus becomes impossible not because of the quality of the argument but because the foundation for consensus-building is no longer given, as one participant in an argument is unable to assume the perspective of his/her opponent. Lyotard's theoretical investigation, which was triggered by the Holocaust trials but applied its insights to general linguistic structures, concluded that the social is so radically fragmented that reality can no longer be consensually verified. Quite influential from the 1970s to the end of the millennium, Lyotard's thinking uncovered the irreducible residue of relativism that inheres in linguistic structures, whereby notions such as objective reality and the categorical imperative lost much credence in the age of postmodernism. This epistemological shift also partially caused the redesignation of the function of the witness, who is no longer regarded as the purveyor of objective proof, but whose testimonial is contingent on the ability to clearly define an argument's discursive parameters (implying that speech is always political). The witness's main task is no longer to rectify injustice but

to keep testifying to its existence and to exercise "damage control" by keeping injustice from getting bigger. To retheorize language and the social this way has also had profound consequences for our understanding of aesthetics. Heterogeneity is redefined as the incommensurability of signs and speech acts, no matter whether the term is applied to the formal structure of a particular artwork or to its medium and specific contents.

The primary purpose of this admittedly long excursion is to contrast it with Dinnerstein's exemplification of eyewitness. Notwithstanding its formal and textual instabilities and its pronounced relation to witnessing, *The Fulbright Triptych* is not anchored in issues of incommensurability, but in the mode of dialogue and communication—just as Dinnerstein's visit to Germany took place under the aegis of fostering understanding and reconciliation, not radical dissent. The painting's discourse of intermediality, as well as its tropes of hybridity and "impurity," do not operate on the "black hole" principle of interminable ellipsis that determines abstract art's resistance to legibility and appropriation. While the triptych's textual ambiguities and frissons are apt to trigger debate, their dialogic relationship suggests a constructivist concept of consensus-building.

As such, the painting's mode of address seems close to the basic views and values that informed the communicative ethics discourse that was being advanced by Jürgen Habermas and other continental philosophers in the seventies and eighties.[12] This line of thinking rejected skepticist notions of incommensurability and, instead, set out to theorize the concept of conflict from a pragmatist and constructivist perspective that assumed that it should be possible to draw on language to define ethical principles.[13] The result was the claim that the irreducible ethics criterion for any debate is the ensurance of a standard of equality. The criteria for equality are established not with regard to identities or traditions of its participants, but primarily with reference to the debate scenario itself. According to Habermas, one of the main proponents of discourse ethics, ethical standards are supposed to be guaranteed by the two major criteria that shape the public sphere as the sphere of debate: the quality of the discourse, which is supposed to constitute a rational critical argument judged on its own merits and not by the identities of the arguers, and the quantity of participants, which ideally includes

everyone who is a participant in the public sphere.[14] Most importantly, discourse ethics stipulates that all participants share a minimum of common ground that enables them to entertain all other participants' perspective for the purpose of constructive debate, which implies the consensual establishment of basic rules of engagement.[15] Any other differences between the speakers (such as race, class, ethnicity, gender, or specific and irreversible details of their respective histories) are regarded as secondary at best, because they can ideally be compensated for by the educational and emancipatory effect of the public argument itself and of participating in it.

As the principles of communicative ethics had emerged from within the context of postwar liberal democracy, it's assumed that Western liberal democratic tradition is capable of being an impartial sponsor of scenarios of public argument and debate. While the notion of the radical fragmentation of the social has drawn its share of criticism, the theory of equality advanced by discourse ethics is not unproblematic either. It reduces the concept of equality to the parameters of the communication scenario, whereby it seeks to legitimize its explicit dismissal of structurally and historically deeper and more complex inequalities between the speakers. In other words, the sponsoring agent perceives itself as neutral and even perceives the universalization of definitions of ethics and equality as a necessity.[16] While Lyotard's radical skepticism has been criticized for giving free reign to relativism, discourse ethics (and Habermas's version of it in particular) has been criticized for its idealist notions of a public sphere and a communication community that dismiss the actual gravity of participants' differences, which, rather than being attenuated by public debates, get reproduced in them. Habermas's explicit universalism proposes a model for a language community that pays no heed to the concept of otherness and disregards the fact that the other possibly has no stake or a very different stake in this community and its norms.

It is here that the question of a potential parallel between the centrism of communicative ethics discourse and the putatively retrograde status of figurative painting in relation to modern art needs to be addressed—a parallel that would, as it were, pivot on the issue of universalism. One might argue that this problematic is encountered in *The Fulbright Triptych*'s designation of painting as a foundation that produces the pictorial elements as ontologically equal. Representing not only specific works, but

other art forms such as photography and drawing, painting becomes the master sponsor of styles and motifs and the initiator of the dialogues and debates that become part of the viewing process.[17] This ontologization posits a clear limit to the concept of heterogeneity in that the very mode of thinking heterogeneity is made contingent on the foundational parameters and regulatory logic of a master discourse. This master discourse becomes the objective correlative to the implicit universalism of 1970s notions of discourse ethics.

The analogy between *The Fulbright Triptych* and the notion of discourse ethics prevalent in 1970s Germany is apposite and problematic at the same time. It is apposite to the extent that the painting, like any work of art, can be read as an allegory of its mode of production. It reflects the various contexts that intersected at the time of its making—international cultural exchange, German-Jewish reconciliation, the considerable influence of Habermasian thought in 1970s West Germany (which included concepts of the public sphere as well as the germinal concepts of what would evolve into discourse ethics),[18] and the (self-)legitimation efforts of West Germany as a liberal nation-state whose sponsorship of the arts is a direct extension of its notion of democratic pluralism and its emphasis on dialogue and consensus-building.[19] But the analogy is also problematic, and this is for two reasons: first, because it pivots on outdated notions of what defines a work of art, its medium, and its historical materialist context; and, second, because the question remains to what extent a work of art can be compared to a country's political and discursive structure in anything but the elastic terms of allegory.

I began my discussion of *The Fulbright Triptych* by pointing out its dialogic nature. The dialogue between its various textual elements—the details it offers, the individual artworks it cites, the mediums it references or invokes—translates into a dialogue between the painting and the viewer. I also pointed out that, while this dialogue is occasioned by a master discourse, it may evolve or, as one might call it, "spiral out" to a point where it is no longer determined by the structure of the work itself. Recent art theory has argued that this spiraling process should lead us to redefine the concept of medium. It should no longer be determined by the work; its hermeneutic engagement by the viewer no longer exhausts itself in the retracing of the work's formal and

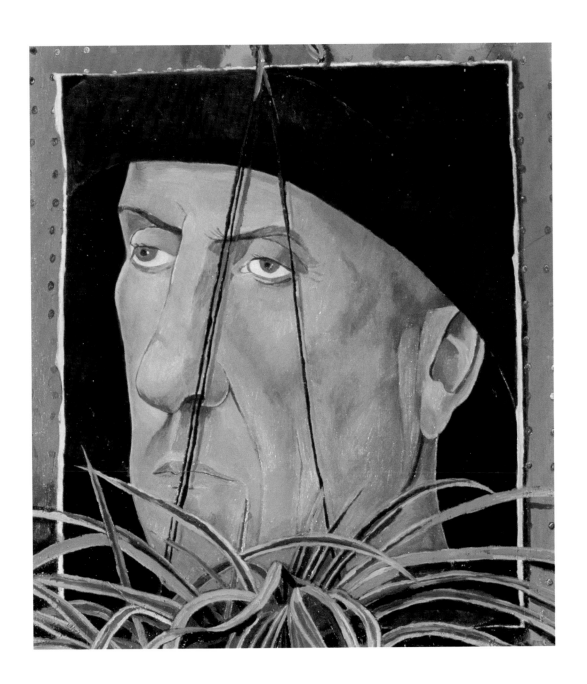

thematic elements. As this hermeneutic engagement is influenced by a number of factors—which include the work itself, the historical context of its production, the specific historical moment of its reception, and the various contexts that can be brought to the reading—it is the combination of all these factors that make up the medium of a work. Medium is now defined as what Juliane Rebentisch has characterized as the potentially infinite horizon of context constructions.[20]

While *The Fulbright Triptych* arguably constitutes a privileged instance of this phenomenon due to its self-reflexive tableau style and its stress on presentation, theatricality, and the act of viewing, the principle of potentially infinite context construction basically applies to all works of art. In this respect, any claim about the putatively retrograde status of figurative painting in the modern world and in relation to modern art is ultimately untenable. But what about the status of the specific analogy between the triptych and the notion of communicative ethics that formed part of the painting's historical context of production? I have already indicated that the structural comparison between painting sponsoring the dialogue of pictorial signifiers in *The Fulbright Triptych* and liberal democracy sponsoring a communicative ethics in West Germany, while compelling, may have certain limits. I have argued that the horizon of context constructions occasioned in art reception is potentially infinite, but can the same be said of the order of dialogue generated by the particular mode of discourse ethics that assumed a sponsoring role in West Germany's political structure and public sphere? As discourse ethics is founded on consensus building, it adheres to a fundamentally different universe than art and aesthetics, and while it wishes to sponsor infinite debate, the mode in which this debate is cast has been shaped by the pragmatics and exigencies of fostering communication, not by the radical freedom of aesthetics. On the other hand, when one takes a look at the high degree of liberalism that was, in fact, achieved in West Germany's public exchange of ideas, one has to acknowledge that the concept of consensus-building, regardless of its intentionalist undercurrents that make it an ill-fitting comparison to aesthetics, significantly underwrote the ethical mandate that public debate must remain unconditionally free and unstifled. The discourses and debates that emerged during this period—be it with regard to the legacy of the Third Reich and the war, with regard to the urban guerrilla movement, or with

regard to the emergence of the Extra-Parliamentary Opposition (APO)—were often less predictable, more open and fearless, and, in this sense, perhaps also more radical, than in other European countries. Not unlike the discourses that spiral out from a viewing of *The Fulbright Triptych*, these debates often retained but a tenuous relation to their point of origin. To offer a tentative conclusion on this question, one might say that while aesthetic discourse and political discourse may not adhere to the same order of operation, they should not be considered to be completely separate either, as their respective contexts and the manner in which they are constructed do intersect. If anything, this obliges us to be more precise in our own determination of the relevant contexts when we discuss either subject. Viewing *The Fulbright Triptych* encourages us to do just this, for what makes this work compelling is its explicit refutation of the notion that art exists apart from politics and only for art's sake.

Bild als Bildungsroman

Colin Eisler

Possibly pretentious, this descriptive title for Simon Dinnerstein's autobiographical screen commemorating a keenly developmental year overseas is equally apt for artist and author. Born in the Buddenbrooksian Hanseatic culture of Hamburg, this writer, having studied *Kunstgeschichte* and taught for many years, finds Dinnerstein's tripartite self-portrait, his *Bildungsroman*, one in which creative growth is achieved by assimilating the art of others, rendered in a seductively familial *horror vacui* reminiscent of the domestic cheer of Karl Larsen's domestically detailed *House in the Sun*. In that paean to the Swedish painter's family life and work, he celebrates the multiplicity of elements contributing to the creative joys of both ways to genesis.

His encyclopedic Fulbright Year *Jugendwerk*, mirrored within Dinnerstein's voluptuously detailed recollection, recapitulates the ontogeny of thousands of years of earlier visual achievements to present the proverbial Young Man in a Hurry to become an Old Master, so seen in a Darwinian self-study of developmental skill and ambition from the primordial cave of child art to the recent present.

Appropriating the sacred formula of the triptych, one often taken over by German artists of the nineteenth and twentieth centuries so as to intensify their images of faith, friendship, and allegory, Dinnerstein too has personalized and profaned this trinitarian presentation. Now it commemorates a formative phase as Portrait of the Artist as both a Young Old Master and *brave père de famille*.

Pinning up works by van Eyck, Fouquet, van der Weyden, two Bellini, Holbein, and Vermeer, these are seen along with other signs of realism together with Assyrian, tribal, and Renaissance sculpture, and prints after Seurat and Degas. The young artist shows these not only as sources of inspiration but also as paragone for his own skills. Dinnerstein's selections represent returns to various Golden Ages, rejecting the fashionable schools then the sole legitimate area for the arts, presenting a brave declaration of independence from the influence of current costly art periodicals and from that of the vast, and vastly dispiriting, Venetian Biennali in his vivid exercise of *reculer pour*

mieux sauter. It could also be that there is a spirit of competition, of *reculer pour mieux dompter.* Added to the past are those images of child art, so central to early modernism, explored in Germany circa 1900 and exhibited by Paul Poiret, Roger Fry, and Alfred Stieglitz. Long the concern of artists and parents alike, images by children challenge and affirm our own sense of achievement. Those noble little savages' daunting feats were retraced in seventeenth-century art and collected and explored by French kings and nineteenth-century psychologists alike. Only very young children prove immune to, using the Yale Kabbalist's phrase, the Anxiety of Influence.

The scene abounds in *cartellini,* those little pieces of paper, sheets of notations, re-creations of documents, possibly as crucial as passports. What these all signify is anyone's guess. They were first very popular in the north Italian Renaissance, though also naturally found in classical antiquity, where they bore the artist's signatures or other important messages, often to ownership. Hans Holbein the Younger, much admired by Dinnerstein, was fond of such devices, as, earlier, were Mantegna and members of the Squarcione circle. Some of these *cartellini* may have related to the distant past or to the popular conceit that a picture is worth a thousand words. They stress levels of reality and the powers of illusionism. Dinnerstein, a "literary artist," clearly responds to the allusive, not the elusive powers of the lettered paper fragment, employing it with infectious pleasure.

An ugly, impersonally rustic German village is seen through the window, one typical of those built or rebuilt after the successive horrors of the First or Second World Wars, each of these exacting a heavy toll on its fields and villages.

When young, few factors loom larger than Memory, the less to remember, the more significant whatever there may be becomes. Often the self is recorded following closely upon the very time that the Now happens, in diaristic fashion. With age, recollection becomes an often involuntary adventure in the arbitrary, teeming with sudden, unexpected and uncalled-for reminders. These jolts from the past often enjoy greater vitality than can the present to which their receiver may somewhat reluctantly return. The Now is seen in the collaborative labor of the artist and his wife: their daughter Simone. Seated on her mother's lap, at the left, she has grown up to be a most gifted pianist. A key factor in this tableau is Narcissistic reflection, that dimension

selected by the fifteenth-century Florentine theorist Leone Battista Alberti as the basis for Art's invention. The Greek shepherd's fatal passion and acceptance of his reflected image for reality initiated the powers of painted illusion.

In the *Fulbright* screen's presentation of Me, Myself, and Eye, the basic conceit is handily fulfilled—"By my triptych shall ye know me." In some ways, Dinnerstein's pictorial recollection is a painstakingly intricate *Bild* of an exhilarating European year's *Bildungsroman*, a visual "This I learned," "This I saw," and "This I did," "Here I am"— all brought back and forward by mirrored, reflective experience, where self-discovery is made possible through retracing others' achievements.

By appropriating the beatified context of the triptych, *The Fulbright Triptych* sacralizes formative experience, now placed within the context of secular worship. But precisely who or what are we praying to? Is it to the enduring miracle of responsiveness elicited by great art? Or are we bowing before the force of youth, to the prideful experience of self-education, one inspired yet undaunted by past feats? This is essentially an exclusive and excluding image, abounding in precocity's hermeticism, teeming with the isolating, compelling self-interest almost invariably critical for survival in the arts.

Two artists, one anonymous, the second a young New York painter, bring to mind the same drives shared by Dinnerstein in his eloquent recreation of Study Abroad. The first is a little-known early sixteenth-century artist from Hans Holbein the Younger's circle, who produced a cosmically painted tabletop for the standard bearer Hans Baer of Basel. Here, in a neo-Eyckian and sometimes Boschian fashion, he presents a massive assemblage of almost everything pertaining to life and art alike. The tabletop was ordered early in 1515, the year of Baer's death at the Battle of Marignano. At the center are the patron's arms conjoined with those of his wife, Barbara Brunner. One wants to look and look and look again at this mixture of rebuslike elements. What the hell (or in heaven) does this magical miscellany *mean*? What did the Swiss painter have in mind, hand, and heart? Nothing may really matter but for the mystery of selection and recollection, in the seeming absence of choice in this illusionistic infinity of thingness. Was this artist young, with a sort of "I can do anything better than you can" perspective? Or did he approach "maturity" with its desperate need to assert "I can

still do anything better than you"? We may never know. What matters is the power of memory and the manifold ways in which recollection may be recreated by appearance.

So much more than mere trompe l'oeil, rising above and diving below sheer visual sleight of hand, the cluttered tabletop questions the very fact of fact, along with the existence of existence. Encyclopedic, the table includes the image of *Elck*, simultaneously Everyman and Nobody, a concept so popular just before the Reformation.

Memory as imagination, or as imagined memory is the sustained feat of another artist, Elena Climent, who was given the complex commission to recreate no less than six scenes from the politically correct rainbow of New York writers by painting their respective authorial voices, these realized through depicting their Greenwich Village literary workplaces. These six panels were painted within the unimaginatively short period of six months. This cycle, *At Home with their Books*, consists of vertical panels measuring ten by thirty feet in its entirety. It was installed in New York University's Languages and Literature Library. Jane Jacobs, who saved the Village from Robert Moses's would-be depredation, is among the six chosen to be shown by way of using books for their own writing.

Just as the tripartite work communicated a message of genesis, so does the very large Library cycle, in which "my working site *is* my literary insight, representing my creative self." Predictably, publications play the key role in every study, their covers or bindings bespeaking the words within.

Shrinking violets have no place in an ever-more cruelly competitive art world. Dinnerstein's street is all too singularly appropriately named/numbered "First." No one can, or should, ever hope to quite comprehend any painter's necessarily self-justifying ego, especially after photography's invention, when the basic need for the mirroring visual arts became obsolete, calling for radical redefinition of mission.

My daughter, also an artist—a poet—was prematurely prescient of this demanding situation. For her very first sentence, she simply but eloquently placed two key, highly conceptual words in succession, making for a stance so critical to creative survival: "First I."

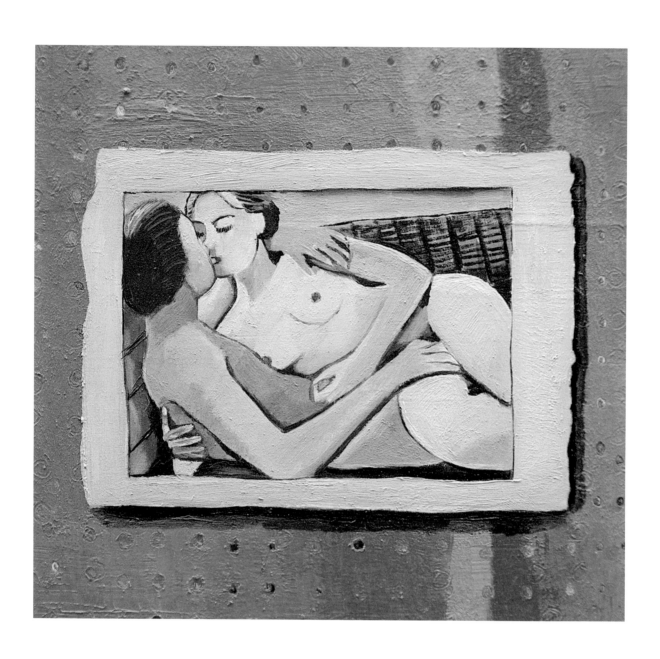

Classicism vs the Unbridled Individual Voice/ New York Madness of the Early 70s/ And Other Meditations on *The Fulbright Triptych*

David Krakauer

It totally made sense to me when I found out that Simon Dinnerstein's epic master-piece *The Fulbright Triptych* was created in New York between the beginning of 1971 and May of 1974. No wonder this amazing painting resonates so strongly with me personally. The time period of its creation corresponds almost exactly to my three years at NYC's legendary High School of Music and Art . . . the time in my life when I truly came of age. Every time I see the painting so many feelings and sensations are conjured up that relate to this truly remarkable era living in New York City. Yes, the painting is set in Germany. But what I see depicted here are Jewish-American New Yorkers looking transplanted and lonely. It feels somehow like this painting could only have been realized back in New York, with the tremendous energy of that time and place feeding Simon to create something of such epic proportions. It seems to me as if the viewer is witnessing the Dinnersteins in Germany suspended in a kind of faraway dream, with both Simon and Renée in their separate worlds: literally on each side of the triptych, each with their own specific iconography behind them. I get the feeling that life is on hold for these two individuals and their child. It seems like they are waiting to get to the next place. I had a similar sensation when I lived in France in the midseventies. I remember dreamily walking through the streets of Paris wondering what kind of effect the whole experience would have on me once I returned to NY to "do my own thing" on home soil.

So what was this crazy energy of home/New York City at that time? The place was a gritty mess . . . brimming with energy and excitement . . . and the potential for danger all the time. The romantic days of "New York is a Summer Festival" (c. 1965) were over. The subway hardly functioned. The city was broke. I remember that strong vestiges/ruins of 1940s NY still remained: rotting Burlesque signs ("twirly, whirly girls") . . . right next to the old Howard Johnson's sign, faded placards everywhere,

Fascination: with its pinball arcades, creepy fortune teller lady machines, and the store mannequin cowboy who would "challenge" all comers to "draw!!!" . . . and the giant Camel billboard of the man who blew smoke rings . . . So New York could have been thought of as a mess . . . but it was also magical and wonderful . . . caught between an older period and a newer time yet to come. I was constantly running around town until the wee hours of the morning with my composer/jazz pianist buddy Anthony Coleman. We caught Monk at the Vanguard, Mingus at the 5 Spot, Ornette Coleman at his loft on Prince Street (which was a ghost town at the time), the up-and-coming Steve Reich at BAM, the legendary "Papa" Jo Jones and other former 30s Basie sidemen in small spaces in Midtown, etc., etc. Plus we had the amazing experience of seeing Duke Ellington several times at the Rainbow Grill where all we had to do was put on a jacket to be served a drink. I remember one night the lights went low, and Duke started striding on "Honeysuckle Rose" behind the tap dancing of "Honey" Coles. It was 1925 all over again. New York in the early 70s was truly like being in a perpetual time machine. Amid this, Anthony and I were creating our own music, using New York as our great "university of the streets." We were performing jazz repertoire way before Jazz at Lincoln Center . . . playing everything from Jelly Roll Morton to Monk. But we also did many Coleman originals and were fiercely obsessed with the desire to find our own individual voice. The city was our playground. I remember rehearsing everywhere from East New York to the South Bronx, participating in the loft scene with concerts and jam sessions, and going to play all night at the café Pepper and Salt somewhere in the Bronx. It was a wild time for me . . . this sheltered Jewish Manhattan boy.

I can just see Simon and Renée returning to this mad, mad post-60s world of New York in 1971. Perhaps I'm projecting, but I can see Simon in a totally possessed state, driven to break free of the sense of isolation and waiting he must have felt in Germany . . . compelled to put this smoldering tension into a huge-scale work. I can palpably feel through the painting a tremendous sense of liberation and the crazy energy of New York driving him forward. And then what blows me away and seems to pull the painting all together is the pegboard! In this day and age of sampling and exact photo reproduction, perhaps we might take a copy of a master painting for granted.

But when one takes the time to REALLY LOOK at these amazing depictions of paintings, children's drawings, newspaper clippings, and photographs, it's clear that this collection of images on the pegboard tells the story of the life and craft of a master painter. (What it must have taken to execute just one of these miniature images in and of itself is mind-boggling.) What I also find interesting is that Simon, whose lyrical/fantastical depictions of the nude are astounding, chose to copy a poetically sexual photograph as his one "personal" earthy/nonclassical nude on the pegboard. This seems to create a small epicenter of energy where extreme passion wants to burst out of the bigger painting. Thinking about my own pegboard that I created over the years, with pictures of my teacher Leon Russianoff, drawings my kids made, paintings that rocked my world, the Elect Hillary's Husband button my daughter gave me, fortune cookie missives, Times Square photo booth snapshots, postcards from friends and lovers, it's clear to me how a pegboard can be such an extremely intimate look into a person's life. The pegboard in the *Triptych*, with its wild mix of imagery, seems to create an amazing tension between the control of classicism and the desire to burst free. I can really relate to this thinking, how my study of classical music in conjunction with struggling to find my own voice as an improviser created an incredible inner tension for me that I was only able to start to resolve in my early thirties. This resolution came through an embracing of my own "roots" music (klezmer) with the goal of creating my own personal voice from that place. Perhaps again I'm projecting, but I see this kind of tension between classicism (held in passion) and the search for an individual voice (bursting out) in *The Fulbright Triptych*. For me it's that specific tension in the painting that creates its incredible emotional power.

Lastly, there's one other level of connection for me. I remember the first time I personally felt the power of paintings to inspire tremendous emotion and change lives. This happened shortly before the coming of age period I've been talking about. Still a boy, around 1967 or '68, I went over to my first teacher, Joel Press's, apartment on Thirty-Third and Third for a rare lesson at his house. Joel is a wonderful jazz musician whose home reflected his close relationship to painters, dancers, and the avant-garde movement of the late 60s. It was an enchanted place for me. Joel had been married to the Chicago School painter June Leaf. June's paintings and dioramas were all over

the house. Their stark emotions, insane sense of humor, and delicious sexuality were an incredible awakening for an eleven-year-old boy. Once I had seen these paintings, I knew I had passed the point of no return. I couldn't be "normal" ever again and was irrevocably put on the path to find my own creative voice. Being asked by Simon to write about *The Fulbright Triptych* encouraged me to look really deeply into a specific painting and at painting in general. The more I ruminated on the subject, the closer I came to remembering what inspired me in the first place to do what I do today. Thank you, Simon, for encouraging me to undertake this voyage of memory; giving me the opportunity, through a deeper exploration of *The Fulbright Triptych*, to ask myself the eternal question once again: What does it all mean?

Two Roads Converge …

Richard T. Arndt

Mysteries abound in *The Fulbright Triptych*, none more puzzling than its title. As in all its maker's work, his choices—in this case, over three years of growth— demand to be taken seriously. The fourteen-foot painting was born in a tiny improvised studio in the German crossroad town of Hessisch Lichtenau, where the artist and his wife in 1970, searching for Dürer, sought refuge from the steep rents of Kassel, far beyond their Fulbright means. At the outset, the artist imagined no title more dramatic than the address of the rude living-working space they had reclaimed from an unused attic. By the time of their return to Brooklyn in 1971, the painting had only begun its growth.

A clue to its origin comes from a later oil (1976), showing a table between two closed doors, crammed with the painter's untidy tools. It contrasts with the engraver's worn gear carefully arranged like a Tiffany showcase in the *Triptych*. The later work proclaims a painter deep in his craft; the *Triptych* is a salute to engraving. The *Triptych*, sprouting wings, surely flew out from this cliff-dwelling.

Another hint as to its birth comes from an earlier charcoal drawing (1970) of a wary Renée seated between different German windows showing the same townscape outside, but sharply different in detail and mood. The walls, albeit from another dwelling, are flowered wallpaper; the underlining ledge below the windows displays a second floral pattern; the window frames are wider, clumsier, and tightly latched. Behind the woman and her artbook, a small depopulated town weighs in on the viewer; it huddles under menacing skies and conceals the lands beyond. The *Triptych*'s windows instead are picture frames, lined with what seems to be gilt inserts; they show the same town but opened out, with airy spaces and well-kept gardens; in the distance, soft fields and hills swell towards skies of a pale Mediterranean blue.

Fulbright executive Ulrich Littmann's memories of the momentous Vietnam-obsessed Fulbright year of 1970-71 set a context. The couple moved first to a Rhenish suburb to meet the Fulbright Commission's wise insistence on German language-training—an irritant for two people who knew words were not their only means of communication. Managers of Fulbright Americans abroad know, after the exhilaration

of travel and arrival wears off, that a wintry slump may follow, as young people far from home settle down to work in a strange new culture with attendant discomforts, new rules, and other signals. And beneath all, in Germany, lay the gnawing ambivalence, reflected in the woman's face in 1970, of living in a country which only decades earlier had systematically killed six million men, women and children most of their faith.

The *Triptych* has left foreboding behind. Its long *Wanderjahre* gave its maker time to tell the beads of change in his life—the happy ending of his German stay, the role of George Staempfli as *deux ex machina,* the birth and growth of a talented daughter, the shift from the microscopic cutting-in of engraving to the colorful and gestural macroscopic building-out of sculptured oils, the absorption of an indispensable European past, and surely the coming-to-terms implied by a young couple's pact with a new place. The open, inquisitive faces of the flanking couple suggest resolution, reconciliation, perhaps even hesitant steps toward forgiveness.

Four years after the *Triptych's* odyssey ended, in the spring of 1978, I was at work in my office as Cultural Attaché and chair of the Fulbright Commission in Rome when I received a call from Rudolph Arnheim, then resident art critic at the American Academy headed by the late John D'Arms, his colleague at the University of Michigan. In polite yet firm words, he said I *must* come to the Academy, that afternoon if possible. The command was intriguing and two hours later I drove up the snaking streets of the high Janiculum to the Academy gate where Arnheim waited. He led me up two staircases and knocked at a door. It opened and there was *Flower Market, Rome,* ten feet wide, drawing me into its profusion of colors, textures, and surfaces, all yearning to lift off the canvas. At its center was as beautiful a face as I had ever seen, haloed by the central window frame in the siena-washed wall behind her; with an unreadable smile she reigned over six long rows of white buckets jammed with every flower in Italy. I barely heard Arnheim's introduction to Simon Dinnerstein.

In his second year in Rome, with Renée and the young Simone, he had already come to terms with its opulence of site and memory and was deep in the new work which had caught me so unprepared. Its setting in the Campo dei Fiori, presided over—behind the painter—by Ferrari's brooding statue of the burnt heretic Giordano Bruno, might have lent ambivalence to those who knew it was there, but I saw only an affirming swirl of colors and patterns.

Renée, charcoal drawing, 25 x 39 in., 1970

Six decades of residence in the Fulbright world have brought me into contact with many overseas-resident American artists, some with and others without Fulbright support. In 1963-64, John Ferren underwent a life-changing experience in Beirut and for his remaining years ached to push deeper into the Middle East. Arthur Danto, after trudging up the Italian boot as a GI, was still a "painter doing philosophy" when he spent a Fulbright year in 1949-50 Paris, mixing with greats like Santayana and Alberto Giacometti, and making a film with Albert Elsen on Rodin's *Gates of Hell*; around him worked dozens of artists—Sam Francis, Joan Mitchell, Jack Youngerman, Shirley Jaffe, Ellsworth Kelley, some on the GI Bill. Not surprisingly, Italy's Fulbright alumni likewise offered God's plenty—Frank Stella, Lee Bontecou, Dmitri Hadzi, Nona Hershey, Bunny Harvey, among many others.

Simon in 1976 was sheltered by the Academy in Rome, a precursor to the Fulbright Program, but born six decades earlier as an architecture school, then merged with the School of Classical Studies in 1912. Since its birth in 1948, Fulbright history has intertwined with the Academy, thanks to the great Princeton humanist-art historian Charles Rufus Morey—Cultural Attaché from 1945 to 1950—who created the Italian Fulbright Commission that year and launched the practice of having Academy directors all but ex officio on its oversight board.

The French had launched the idea of an Academy abroad in the seventeenth century: after Poussin uncovered Rome for France, Louis XIV filled the gap his death left, lodging the Académie de France in the splendid Villa Medici. There, artists like Corot fed on the city's riches and explored the light and landscapes of the Roman Campania—the Académie in Simon's years was directed by no less than Balthus.

The idea of an *American* Academy, responding to Italy's lure for American artists, came in its time. Early in the nineteenth century, American émigrés relished the materials, the light, the classical and Renaissance architecture, the plentiful models, the skilled craftsmen like bronze-casters and stonecutters, and the overwhelming ambiance of history, art, people, and cultural landscape. The powerful Greek-American sculptor Dmitri Hadzi, an exemplar in the 1970s, came after his Fulbright year in Greece to continue his discovery of self, shaping time-drenched memories of Mediterranean cliffs, rockforms and shadows, all bearing mythical names of Greek legend.

Dinnerstein, like Hadzi, probed behind the mask of the picturesque for a deeper sense of what he saw and who he was, in space and time. While Hadzi produced a dozen works a year, Dinnerstein, as he had in Germany, focused his principal energies on a single work, the *Flower Market, Rome*, nine months in the making. Scouring the markets of Rome for buckets of new flowers each season, he planted an imaginary forest of colors and forms that overrode nature's cycles and brought together, outside time, a mass of floral textures. Only decades later did I encounter the *Triptych* and conclude that, whatever else Simon might do, these two works had already set daunting standards.

Why a *Fulbright Triptych*? First, begin by de-consecrating the word "triptych." While three-panel works are common to its churches, Christianity has no monopoly on the triple form; in its rich non-Church history, the triptych is common to many cultures, ranging from filigreed Arab windows to Chinese and Japanese screens and exquisite Persian mirror-backs—Persian miniatures hang to the left of each of the *Triptych*'s windows.

Perhaps the name Fulbright, changed from German Vollbrecht, was an obvious subject, even if for most Americans he is remembered as little more than a troublesome gadfly senator from the northwestern corner of a then-insignificant southern state. But around the world his deeds made him something else: a monumental American, the creator, as Arnold Toynbee put it, of the greatest program of human interchange ever conceived, a global movement of which Simon felt himself part and whose spirit the *Triptych* seeks to catch.

How does a visual artist embody or pay tribute to an idea, let alone a spirit? With Fulbright, many have tried: Milton Glaser did a poster punning on the name; a U.S. postage stamp played with cybernetic symbols; portrait busts and plaques are everywhere; but even the life-size figure standing on the front lawn of the University of Arkansas lacks what Rodin gave Balzac. The *Triptych*, instead, avoids literalism and manages to ennoble the idea, the program, its progenitor, and of course its creator—in Shelley's words, it honors,

stamped on these lifeless things, / The hand that mocked them and the heart that fed.

Doubtless each of its 400,000 alumni worldwide, of whom perhaps 90,000 are American, found in the Fulbright experience a unique and highly personal meaning.[1] How then does Dinnerstein depict his personal Fulbright experience so as to swirl these multitudes into a single visual statement?

Fulbright's program and the *Triptych* build on the idea of place, both in space and time. Eudora Welty said of place that it "absorbs our earliest notice and attention; it bestows on us our organized awareness; and our critical powers spring from the study of it and the growth of experience inside it." To this, she added the ultimate Fulbright insight: "One place comprehended can make us understand other places better."[2] Fulbright's own four years as a Rhodes Scholar at Oxford's Pembroke College taught the young innocent abroad this simple truth and dictated his lifetime commitment to democratizing the Rhodes experience, for America and for the world. In his vintage cracker-barrel style, he argued that "mutual understanding is a helluva lot better than mutual *mis*-understanding."

Place has dimensions. The two-dimensional geography of the *Triptych* shows a studio in the banal Hessisch Lichtenau, in a Germany which three decades earlier had been the world's most despised enemy. Policies change rapidly, but ordinary human beings change little even over three decades: in 1970, the Dinnersteins' host-town doubtless harbored the same localist provincialism that Fulbright feared in his own beloved country. Yet there, in that time, a young couple found friends who helped them build a sanctuary, *their* space, a rough studio-residence; in it an artist and his wife found refuge, and in time reconciliation.

On the walls of his studio, Simon taped the painter's usual medley of visual and verbal memories, then set about depicting the whole. These painted collages make no attempt to fool the eye; they are miniatures which suggest past, present, and future, coexisting and prefiguring the Janus-mask symbol of the Rome Academy. The past is represented by minutely crafted portrayals from his "imaginary museum"—history new and old, seen through postcards, reproductions, quotations, letters, photographs, children's art and writing, and an unknown Soviet's exit visa. A centimeter to the right of the precise center of the core-panel, we find Holbein in his studio, cluttered with tools and objects. The future, time-yet-to-come, is suggested by the couple's pri-

vate work of art, a daughter born later (fall 1972); here she is little less than a year old, hence added to the *Triptych* in 1973 (her name pays tribute to Hessisch Lichtenau— "Simone" derives not from her father but from one of two daughters of friendly neighbors of Simon and Renée's generation).

The *Triptych*, too, shows time as growth and place as learning: marking a point in the unrolling of an artist's life, it denotes change, motion, and discovery; it records a moment at which an artist overcame fears, lay down the burin, and picked up brushes.

Beneath Holbein, slightly to the left of dead center in the table display, shines a rendering in oil on gold-leaf of Simon's last copperplate, inscribed on a disc of old gold— his superb *Angela's Garden*, the backyard of a neighbor in a faraway place called Brooklyn. Brooklyn runs throughout his "museum without walls," adding distance and corresponding emotions. Opening new doors closes old ones; travel leaves sadness at home and brings moments of homesickness, represented by Renée's letter from Staten Island, nostalgic snapshots, a painting by Simon's brother, a haunting poem by an immigrant child in a Brooklyn yeshiva, and seed pods picked up later on Brooklyn streets. The golden center shines like a priestly monstrance ("*Ton souvenir en moi luit comme un ostensoir*," wrote Baudelaire*)*, but it is first of all an engraver's copperplate whose prime reference might better be Holbein's pair of ambassadors, standing amidst their kingly gifts clustered around the luminous centerpiece of a distorting mirror— still a puzzle to iconographers. Simon and Renée, ambassadors too, are surrounded by their treasures and engage the viewer.

The studio in the *Triptych* is not the prison that the 1970 charcoal suggests. The artist has loosened the window-latches, given the houses below breathing room, disclosed their gardens and tidied the streets—winter has passed. Where the charcoal showed a single street visible only through the right window, an ugly rutted track repelling travel, the *Triptych*'s street shows through both windows; it has been widened and made enticing: now two upward-flowing streets seem to merge just below the windows, then stretch toward the hills and the bright horizon. What was closed, dark, and foreboding in the charcoal drawing has become pleasant, inviting, beckoning, engaging. The street has become the artist's open road, the path to life as discovery, of others and self.

Painters tend to bring roads, railroads, rivers, and coastlines down from the upper right edge to the lower left. Dinnerstein's road instead begins at the center marked inside the studio by Holbein and the golden disc; it leads to a point on the horizon concealed by the windows' frames; two streets funnel toward a mysterious somewhere, with a tiny time-clock on the table set to measure the journey. Unlike arteries, roads run in two directions, and when they cross or join, they both converge and diverge; yet this path flowing from a depopulated source shows little sign of arriving or bringing in. Rather it urges us out and away. It is the perfect Fulbright road.

Unlike much painting of our times, the *Triptych* flows from a tradition which demands to be "read." Every viewer will read a different text—deeply etched memories of my own Fulbright year in France in 1949-50, for example, cry out to be *heard*—sounds, words, voices, odors, inflections, and music. Reading the *Triptych* with the aging eyes of a fallen-away literary scholar and former cultural diplomat, I see a work growing from a seed to the point where its creator realized he had journeyed miles beyond a meaningless address in the German countryside. Perhaps only then did he begin to nurture the idea of depicting the Fulbright spirit, not the senator's vision so much as the hundreds of thousands of young people his Act enabled to leave their places and find other worlds. Words by the million have flowed about the senator, his program, and its impact, but only one painting tells the story so deeply. No visual work of art I know might more fittingly serve as the Fulbright icon.

I would like to believe that the senator, as I knew him, would be pleased.

Against the Tyranny of Mad Momentum, There Is a Monument

Miller Williams

On the day Senator William Fulbright died, his wife called to ask if his life might inspire a poem that I could read at his funeral. I felt honored to be asked, as I feel deeply honored to take part in the recognition of Simon Dinnerstein through marvelously broad attention to *The Fulbright Triptych*.

The title and circumstance of this painting took me—quite understandably—back to this poem. I saw, as I read it, the many ways in which Simon's life, mine, and the lives of thousands of others have been richly changed by passage through the doors the senator opened to us onto our futures.

I'm drawn to the painting in part because it speaks so well to me of the kinship between the arts. Good poetry carries a touch of irony, showing us that what we might at first call opposites can be very close to identical. The figures on each side of the central frame—one female and one male, she holding a child in her lap, he without a lap but with a beard—would seem at first to be from two sides of the world. Slowly, their colors, shoulders, facial expressions, and presence say that they are one. The importance of irony is that closeness means nothing unless it follows distance. Good poetry is made of the stuff of this world, and draws the reader in to become a part of the poem, as *I* will always find myself in this painting, however invisible to others.

Anyone looking at this painting after reading what I've just written is going to be nodding. I celebrate Simon's powerful work as I celebrate the life of a man who helped make that work possible.

For J. William Fulbright
On the Day of His Death

Walking the square in a tree-thick mountain town
in Arkansas, a visitor is shown
a face and a few words, a monument
in bronze and stone,

a good and visible and local sign
of all the good he left us, something to touch,
but other monuments will last as long and say as much.

Think of students with minds made darkly rich
by cultures not their own, and who can say—
given the sweet contagion of a thought—
how far away

the tremors of opening minds may resonate?
Beyond our great-grandchildren? Farther than that?
Socrates taught young Plato at whose student's feet
we all have sat

through forty increasingly nervous centuries
while those rare minds turned other minds around.
Then think of the hundreds of nations, talking and talking,
the endless sound

of words, words, in every language words,
old terrible words but better than bombs by far.
This brave cacophony, he brought about.
All that we are—

fumbling and noble, enduring, uncertain, and weak—
this body of nations embodies: the foulest and best,
imperfect memory, fear, the one long hope,
and the half-expressed

deep rage of half the world, brought barely together:
one simple resolution, his gift to earth;
some words, when we had little faith in what
words could be worth.

Then think that every time, alone in darkness,
someone finds the courage to take a stand
against the arrogance of power or lifts
one hesitant hand

against the tyranny of mad momentum,
there is a monument. And there. And there.
And there, in a thought that seems at times too simple
for us to bear,

that peace is a progress moving first in the mind,
something left a little more clear
in the heads of the heads of state and common people
because he was here.

What shall we say, now that he's not among us?
We might speak for a moment as if he were.
We might take once his imaged hand and say,
We'll miss you, sir.

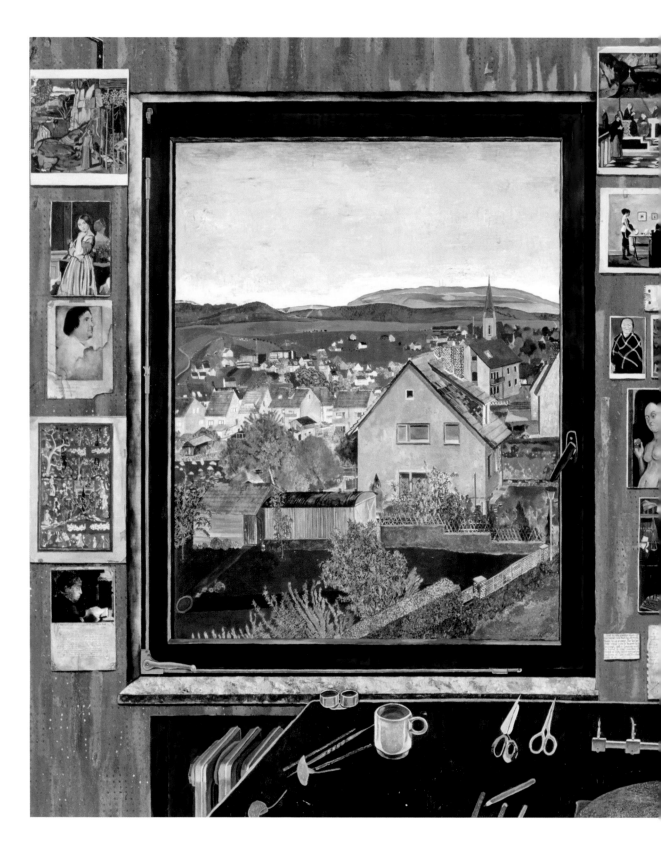

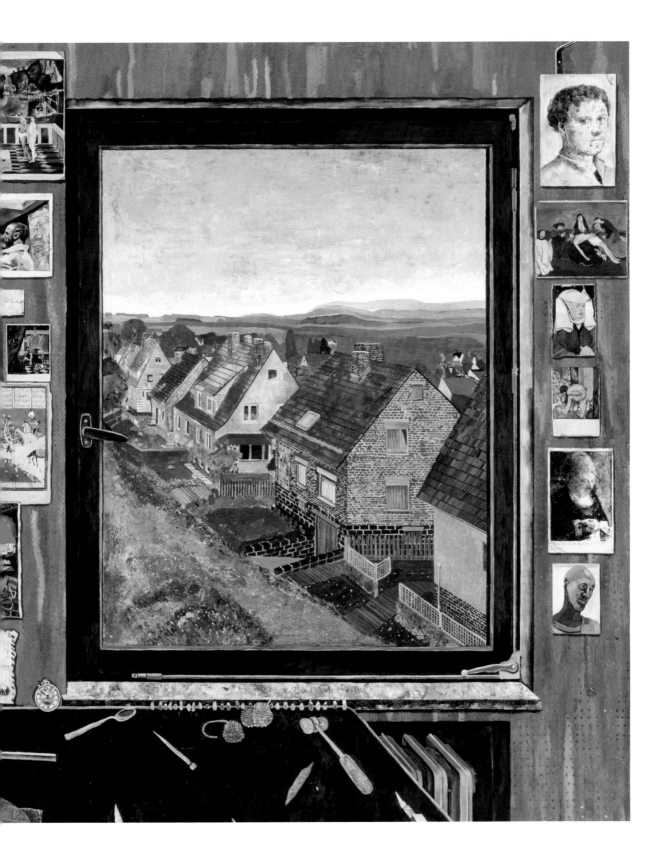

A European Perspective

Ulrich Littmann

Almost four decades have passed since I met Simon Dinnerstein for the first time upon his arrival as a Fulbright grantee in Germany in summer 1970. There were some occasions during his stay to discuss projects and to hear what grantees wanted to tell the sponsors of the fellowship program called Fulbright Exchanges. Since that time we have been in informal contact. The *Triptych* in its present form was begun during Simon's grant period and finished three years later.

When we look at the *Triptych* we are dealing with a rather complex issue: prima facie, there is a fairly large-size painting, providing reality, well constructed with three somewhat somber persons in a room, but apparently quite separate; in between them we see window perspectives, a table with fine-arts utensils, the walls clustered with all sorts of correspondence, sketches, pictures, memorabilia—a scrapbook atmosphere.

However, a second look invites questions, reflections, and comments, and out comes a totally different set of observations and references.

The title keeps us wondering: while the format of a triptych is obvious, its association with "Fulbright" appears to be a mystery. No image of the late Senator J. William Fulbright, no documents regarding the so-called Fulbright Exchange Program or Fulbright scholarship appear in the painting—so the painter might as well have chosen any name for his work. Yet, the name immediately places the painting into several frames of reference.

At least three years elapsed before the *Triptych* was finished, years of significance for the artist, but also for Senator Fulbright as well as for the German-American exchange program. A few sentences on the history will create a new perspective for the painting. Some historians may recall that the representative from Arkansas had introduced, in 1943, the so-called Fulbright Resolution committing the United States to the idea of the United Nations as a peace-saving institution; they may remember how the then-junior senator from the Ozarks expressed concern over the atom bomb

dropped on Hiroshima and in September 1945 introduced an amendment to the War Surplus Property Act. By this funds were made available for an educational exchange program that was designed to be operated on strict partnership principles between the U.S. and signatory states, and to pursue a dual objective: the promotion of (academic) knowledge and the furtherance of mutual understanding between nations. With the Fulbright-Hays Act of 1961, the scope of the Fulbright Program was expanded even further to invite host-country cofunding. The German Federal Government (remembering that the binational Fulbright Commission of 1952 had been the first institution after World War II in which American and German distinguished personalities met and planned as equal partners) immediately signed a cost-sharing agreement which kept exchanges afloat during America's heavy budget cuts in the late 1960s and early 1970s. Thus, we can understand Dinnerstein's reason to apply to Germany because there were more Fulbright grants there than anywhere else. And the name "Fulbright" at that time was associated with the senator's attitude towards the engagement of the U.S. in Vietnam. German—like many European—students, politicians, and citizens cherished Fulbright as a desirable model American, although his "Arrogance of Power" was cited more than read. And while the U.S. was criticized in many quarters, Fulbright and the exchange program under his name were spared all local inconveniences. This exchange program still exists among many new efforts in many national and international organizations.

Against this more historical-philosophical background, Dinnerstein's *Triptych* reveals a lot more insights and aspects. We have to "read" the *Triptych* as one piece of art, and through its parts. The side panel with the artist tells us something of himself, of his interest in medieval art, of his interaction with philosophy—perhaps a brief reference to his application for a grant. The artist is a family man. Even though the child on the lap of his wife Renée did not yet exist during the grant period—Simon Dinnerstein obviously includes in his account the period of work on the *Triptych* beyond the stay in Germany—the family has been a major element in his Fulbright experience. Also, as we know that the spouse allowances of a Fulbright fellowship were rather meager and required considerable sacrifices from the young families, we

can understand that Renée—the person in the other side panel—worked part-time as a teacher in a local school of the U.S. Army. The images hanging on the wall behind her bear witness to her relations to the kids in her class, but some of them also depict the Vietnam War. Her side panel with the child indicates, too, that both Dinnersteins were part of the local society. It is still remembered among friends how that elderly landlady of the Dinnerstein apartment was deeply disappointed when the couple left at the end of the fellowship: "I thought you came to us for good because you are one of us." In the little town of Hessisch Lichtenau, such a statement was a big compliment.

But both figures on the side panels appear to be somewhat lonely. The expression on their faces transports the idea of a typical passport photo and does not do justice to the Dinnersteins as I came to know them. The portraits look like a reflection and ingredient of the post-fellowship period at home. In this sense we find the work as a description of background, adventure, and report or result of Dinnerstein's stay abroad. However, Simon's sense of humor tends to lead viewers astray—you should see his smile when he takes notice of people wondering about this immovable photo!

Toward the end of his scholarship Simon Dinnerstein discussed with us the possibility of doing a major painting of the situation and work of an artist abroad. Most regrettably, funds for extensions or renewals of grants were further cut, but the discussions and plans are still rather vivid in my memory. It is true that artists—and fine-arts students in particular—go abroad to find the vistas and impressions that strike them as interesting or as alien or as fascinating. Simon Dinnerstein's work in Italy, such as *Flower Market, Rome*, is vivid proof that he can stand in that tradition even by applying his very own style of order and color. *The Fulbright Triptych* is different in approach and philosophy: it is the self of personality, environment, and activity. The choice of format, i.e. the triptych, reflects the travels that Simon undertook during the Fulbright year to various places in Europe—and it was Europe with France and the Netherlands as primary regions of interest.

The center panel represents Simon Dinnerstein's activities as a Fulbright grantee in an exemplary manner. The basic principles of Fulbright exchanges are here formalized. The advancement of knowledge—in the case of artists, creativity—is clearly

indicated by the burins, scrapers, and so on, and, of course, by the copperplate in which we recognize *Angela's Garden*. But otherwise there are no samples of Dinnerstein's rather extensive graphic oeuvre, and reproductions of paintings or photos match the wall decorations on the right panel. Yet his Fulbright application included Dinnerstein's plans and hopes to study graphic arts, and to investigate the graphic techniques of Dürer and his contemporaries. The other objective of Fulbright exchanges, to further mutual understanding between nations, is manifest in the windows overlooking Dinnerstein's temporary hometown. A very quiet and friendly atmosphere with orderly houses suggests a peaceful environment; the peaceful world that Senator Fulbright had in mind as an ideal goal. Germans would know that the place was close to the Iron Curtain, characterized by barbed wire and militarily equipped border guards on the East German side. But in the perspective no people can be seen in the streets and gardens. And, for that matter, there is no indication that, during the early 1970s, German university towns of all sizes experienced student demonstrations against the U.S. activities in Vietnam or against local political intentions in Germany. Would Simon be left without any feeling for his German neighbors and his American fellow grantees? From my own observations and meetings with Simon, I suspect that he is fooling his audience once more. He did care for his social environment of all different kinds, made lively comments and suggestions at grantee meetings—but there were no students demonstrating in Hessisch Lichtenau, and the various forms of protest in the bigger cities did not really interfere with his work as an artist.

Dinnerstein does not like to discuss his own paintings or prints. He rather lets his works speak for themselves. Yet, like in the *Triptych,* he hides or veils his personal attitudes and philosophy that go far beyond the creative art. The Wittgenstein translation on the wall behind Simon gives an inkling of the dimensions. On such tracks the Dinnerstein that I came to know becomes a thinker who presents his views as honest scholar, and in a vivacious manner. I felt, still feel, that Simon Dinnerstein would have fitted well into the legendary Black Mountain College in North Carolina. I can visualize him debating his own formal approach to form and content with Josef

Albers and adding to the atmosphere that breathed the spirit of the Bauhaus.

In 1974, when Dinnerstein completed his *Triptych*, Bill Fulbright had just lost his seat in the senatorial elections, although the signum of "his" exchange program was spreading through Europe, i.e. beating swords into ploughshares. It stands to reason that the *Triptych* is an homage to Senator Fulbright as well as to the exchange program that he initiated, and (above all) to Dinnerstein's personal experience as a Fulbright grantee.

To See and Be Seen: *The Fulbright Triptych* of Simon Dinnerstein

Robert L. McGrath

> The deeper one dives into his private world, he finds the most public, the most universally true. The people delight in it.
>
> —Ralph Waldo Emerson

I no longer recall precisely the first time I saw a reproduction of Simon Dinnerstein's *Fulbright Triptych* but it was probably around 1975 after his first one-man show at the Staempfli Gallery. At the time I was deeply absorbed in the study of early Netherlandish painting and, having recently emerged from graduate school, still firmly clung to art history's dirty little secret: the further removed an image was from its actual source the better.[1] I do remember, however, my startled reaction to the colorful simulacrum of this seemingly magisterial work. Here at a moment of intense aesthetic pluralism in American art (ranging, inter alia, from minimalism to color field and photorealistic painting) was the product of an artist who sought deliberately and studiously to ally himself with those traditions and practices of representation to which I most fervidly responded. Here was a pictorial intelligence so engaging, a sensibility so firmly aligned with my own, that I was drawn to ponder the meaning of his work on several levels at once. Splendid in technique (as far as I could discern from a color reproduction), challengingly complex with its plethora of arcane signifiers, and intriguingly elusive in meaning, *The Fulbright Triptych* seemed to resonate ardently with my own interest in the fifteenth-century pictorial dialogue between symbol and reality. Informed by an appealing ceremonial gravity, the painting further possessed the disquieting allure of posing more questions than it answered. Here at last was an art historian's artist, and a live one at that!

Now twenty-plus years later, I realize that my early disdain for the contemporary (in my view the only good artist was a dead one) was at least partially misguided.

Nonetheless, my enthusiasm for Dinnerstein (which admittedly was grounded as much in an aversion to the present as in an attraction to his work) has increased as I have come to realize the complex originality and profound modernity of his vision. While initially I was attracted to the disciplined astringency of his style (no inchoate gesturalism) and the apparent homage to tradition (no tedious fields of monochrome nullity), I have come, with the benefit of hindsight and experience, to appreciate the subtly subversive, even transgressive, nature of his art. Simultaneously conservative and progressive, ordinary yet surreal, humble and arrogant, Dinnerstein's great painting is as old technically and aesthetically as it is structurally and conceptually new.

For starters there is the traditional format of a monumental triptych, a charged configuration that only very few moderns have essayed. Implicitly religious in purport, the triptych (pace Rothko) has not fared well in our remorselessly secularized world. Moreover, the hieratic connotations of a wider central panel—that is, its rhetorical claim to authority—militates against the broader democratic ethos of our times. With characteristic modernist inversions, however, Dinnerstein locates the trinity of his holy family in the wings while privileging the instruments of the artist's passion in the central panel. Much as *Christ as the Man of Sorrows* is enframed in late medieval paintings by the nails, thorns, scourges, and flails of His torment, the portraits of the artist as secular *Schmerzensmann* and his Madonna-wife (in the eccentric albeit traditional locations of donors) are deployed as figurative parentheses to the burins, burnishers, scrapers, and halolike copperplate of the engraver's craft. Consecrated artifacts, enshrined upon a table-tabernacle, they inscribe (literally) the agon between *teoria* and *praxis* that seems to be one of the principle subtexts of the panels. In addition, this encyclopedic display of tools located on a workbench evoked for me the famous Joseph panel of the *Mérode Altarpiece* in the Cloisters in which the gentle craftsman plies his artisanal trade. Above all, the familiar modernist trope of the sacralization of art as religion provides the ideational imperative for this secularized altarpiece, a deliberate displacement of orthodox religious iconographies (only the *Annunciation* panel on the exterior of van Eyck's Ghent Altarpiece affords a strikingly similar void separating two lateral figures). Despite the artist's remarkably well-assimilated understanding of early Netherlandish art, only a twentieth-century painter, fully cognizant of

the New York school, would so aggressively decenter the traditional focus of pictorial interest. This deliberate figural purgation of the main panel (despite, or because of, the marginalization of the authorial self to the wings) seemed to me to denote a radical subjectivity as ego-driven as the most angst-ridden canvases of Pollock or Rothko. Things are declared then concealed while, as a consequence of the process, the seemingly private becomes apparently public.

What historic persona is this bearded, frontally posed figure, fixing us with his stark iconic gaze, supposed to recall? A reincarnation of the Assyrian king Assurnasirpal (black-and-white reproduction of an anointing genie to the left of his head) or van Eyck's God the Father from the Ghent Altarpiece (detail of Metropolitan Museum's *Last Judgment*, below left of right-hand panel)? Perhaps the hairy Christomimete Albrecht Dürer (despite the absence of a single visual referent to the greatest of all engravers)? Arguably, we are solicited by the relentless frontality of the image to adduce all of these associations (as well as some I haven't thought of). Those singularly inactive hands of the artist (no benediction, no assertion of manual dexterity—the gesture is loosely derived from Dürer's 1498 *Self-Portrait* in the Prado) surely play a role here. At least there can be no ambiguity concerning his uncanonized sponsor, van Eyck's *Baudouin de Lannoy* (Berlin), whose head sprouts from a planter like an exploded Romanesque capital. In the left wing the artist's wife and child also appear miraculously suspended in a canonic pose derived from Donatello's sphinxlike *Madonna and Child* in Padua (reproduced at the upper right of the artist's head); her sponsor Dirk Bouts's *Virgin of the Lamentation* (Paris).

Bizarre indeed are these two figures who starkly confront the viewer in trancelike poses of contemplative absorption. At one level they seem to reciprocate our scrutiny. At another, little is revealed as our gaze is turned back upon itself. Meanings are intimated but are not confirmed. In a further move, a brilliantly disguised reprise of Rogier van der Weyden's famous invention, Dinnerstein enframes himself and his wife with replications of images that, like the voussoirs of a Gothic arch, allow (in the formulation of Erwin Panofsky) the combination of "epigrammatic concision with epic prolixity." In emulation of the great Flemish master, Dinnerstein is able to "concentrate upon a few crucial themes yet supplement them with circumstantial narrative." Among

these surrounding "enthusiasms" are reproductions of the works of favored artists (Fouquet, Bellini, Ingres, Seurat, Holbein, all influenced by the great Netherlandish "primitives") and children's drawings of monsters (gargoyles) and warfare (apocalyptics) as well as self-referential photographs, letters, and an anti-logocentric quotation from Wittgenstein, the latter presumably instantiated to privilege the image over the word and the world.[2]

Returning to the central panel we are afforded a divided landscape vista through open windows as famously occurs in van Eyck's *Madonna with the Chancellor Rolin* (Paris) or Rogier's *Saint Luke Painting the Virgin* (Boston). These sources are internalized with such subtlety that it is only after closer analysis that we come to appreciate the placement of the village's church steeple on the side of the modern Madonna (together with a *hortus conclusus*) while the view through the window on the artist's side (*sinister* or *dexter*, depending upon a religious or secular orientation) is more suggestively profane. A holy family, inhabiting a "tower of chastity" that is simultaneously the artist's studio: the paradoxes are as multiple as they are intriguing. While Jan and Rogier's tower rooms are sumptuous interiors with marble floors, porphyry columns, and richly carved furnishings, the Dinnerstein studio is adorned with cheap wallpaper and displays wooden floorboards sorely in need of refinishing. Cast-iron radiators rather than cozy fireplaces provide heating for this austere and somewhat alienating space.

Surely it is also no accident that a reproduction of Holbein's money-grubbing Hanseatic merchant *Georg Gisze* (Berlin) is located directly above the workbench, an altar whose only god is art. This image serves not only as an *exemplum* of occupations and behaviors to be avoided but affords an obvious visual precedent for the notes, letters, and images appended to the wall of the studio. The presence of van Eyck's *Eve* (with the apple of the Tree of Knowledge) from the Ghent Altarpiece, located in proximity to Gisze, further thematizes the idea of earthly temptation. Casting a shadow over all is Holbein's *French Ambassadors* (London), a celebrated image in which the singularity of portraiture is also transmuted into a quasi-heraldic art form.

What, finally, are we to make of the most striking paradox of the painting: Why is paint used to pay homage to printmaking? Why are there no reproductions of engrav-

ings on the *Bilderwand*? What are we to make of those nuanced intervals between the printmaking tools and the profound silence that pervades the purported activity of art-making? Presumably, the burin has been set aside for the brush, but the artist's inactive hands pose still further questions for the viewer. Again, a Netherlandish source offers suggestive analogies with Dinnerstein's *Triptych*. *The Portrait of a Young Man* in London by Petrus Christus, van Eyck's best-known pupil, is also a discourse on painting and printmaking, high art and popular culture, novelty and tradition. A popular broadside of a poem printed beneath an image of the head of Christ in the Christus portrait clearly resonates with the haiku poem, dream letter, and assorted replications in *The Fulbright Triptych*.

Dinnerstein's selective naturalism, like that of his esteemed mentors, aspires to a synthesis of representation (*Vorstellung*) with presentation (*Darstellung*). Representation occurs in the circumstantial narrative afforded by the multiple replications of paintings, photographs, drawings, and texts, while the formal treatment of the portraits differentiates them markedly from the surrounding flux of signifiers. Icons of complex modern selfhood, these portrait-figures seem intimately close, yet infinitely remote. Significantly, Dinnerstein's refusal to instantiate the transcendental connotations of a hieratic center, to both solicit and reject the symbolic claims of an altarpiece triptych, complicates the reading of the image. Our attention is deflected from the figuratively voided but ideationally charged central panel to the iconic periphery, where a recusancy of psychological engagement throws the viewer back upon his own resources and responses. In Dinnerstein's hieroglyphic world of memory and longing we can apprehend, but never fully penetrate, the nuanced subtlety of his artistic intention. Is the world within and beyond the frame fallen or, conversely, has it been redeemed by art and love? Is this a painting about creation and procreation, about giving birth to art and babies and the ensuing division of loyalties?

At some deeper level, *The Fulbright Triptych* seems to me to be a painting that is very much about separation and exile. There is the separation of husband from wife, art from life, and theory from practice. In addition, this great painting is informed by a palpable aura of exile: exile from home, from nature, and, perhaps above all, from the grand traditions of European painting.[3] Dinnerstein, like many displaced American

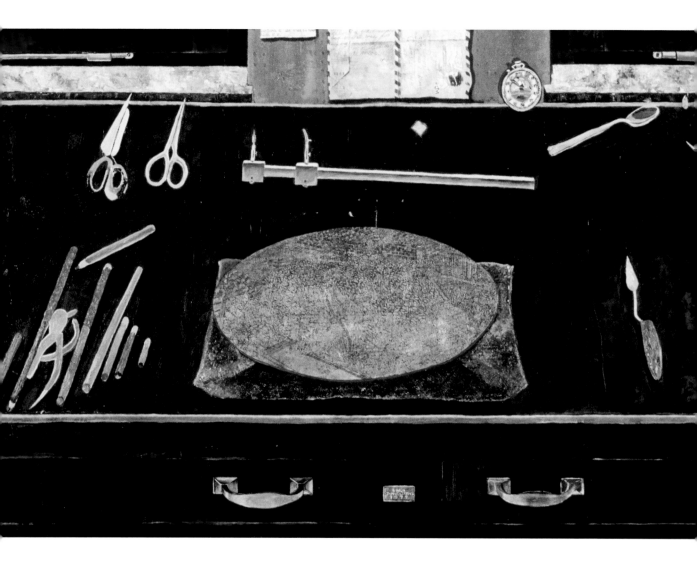

artists, invites us to reflect upon these fundamental questions of art, identity, and the burden of expatriatism. Out of a similar responsibility to art and history, I hope someday to view the actual (as over and against the virtual) painting. But then again, this art historian, in sympathetic accord with Simon Dinnerstein, often does much of his best thinking in front of reproductions of great works of art.

Happily Vanquished

Gabriela Lena Frank

Quality friends open the door to other quality friends . . . So it was in 2004 when the members of the gifted Chiara String Quartet introduced me to their colleague Simone Dinnerstein, a uniquely talented pianist who was dancing to her own career tune, quietly and inexorably. Like many others, I found her rendition of Bach's *Goldberg Variations* riveting, a performance that unfolded note by glorious note, sometimes as peals of laughter, sometimes as a muted intonation. Without having yet exchanged much more than pleasantries with Simone, her command over such a wide emotional breadth suggested to me pivotal figures in her life likewise of mercurial and deep feeling.

I was not wrong, as I would soon find out. Simone's parents, Renée and Simon, are lovely warm people, and of that Jewish New York sensibility familiar to me from my own father. The fact that they had already heard my music as performed by the Chiara String Quartet fast-tracked our connection, albeit in absentia, and what remained was for me to know Simon's work as a painter. "It's intense." Greg Beaver, the cellist of Chiara, told me, flipping his Little Prince hair. His eyes widened: "You'll like it."

Bueno, I was definitely über-curious. I can still feel the torrent of rain and snow I braved to visit the Dinnerstein family home in Brooklyn, stumbling in from a black shiny night to the startling luminosity of various oils stacked against the walls of the living room. I don't remember much of the house, so immediately arrested was I by unsettling eyes gazing from the canvases of surreally impossible situations made possible under Simon's skilled brushstroke. I do remember my cheeks flushing uncomfortably from an intimate feeling of déjà vu as if I was staring down the last vestiges of a receding dream in the early morning hours of my own bed. This man has a vivid dream life, I thought. These paintings are not even remotely unprecedented.

What followed was, simply put, a conversation. Hot tea. Watching and admiring Simone's toddler son play. And I think there was a towel offered so that I could dry my hair off. Over that evening and in subsequent conversations and get-togethers,

Simon and I perhaps made an unlikely pair: a Brooklyn Jew and a Berkeley-bred gal thirty years younger descended from Lithuanians, Peruvians, and a solitary merchant from mainland China. And yet our mutual fascination with revealing that which is hidden made us artistic cousins. Simon revealed himself as a man who may carry his intensity close to the vest, but given a bit of time, the veil of cordial shyness readily lifts. He is eager to converse on any number of subjects, and is deeply invested in his art, stirring a profound reaction in others that is heartfelt and honest, not charlatan. These are the kinds of people I fall in love with, time and time again, and very quickly, it was a natural and inevitable decision to compose a piano quintet for Simone and the Chiara String Quartet inspired by Simon's vivid body of work.

In April 2005, *Ghosts in the Dream Machine* premiered in Philadelphia under the sponsorship of Astral Artistic Services. From my program note:

> I've long held a deep and deeply private enjoyment of my dream life. As a young girl, I used to share my wild forays into adventure and fantasy with my older brother, himself an avid dreamer. I went on to become a composer, often tapping a similar well of invention and creativity for my music; and my brother became a neuroscientist specializing in sleep research. Is it too great a leap to say that our early fascination with the odd sleep-journeys our minds took dictated the paths of our adult lives?
>
> *Ghosts in the Dream Machine* for piano quintet derives its inspiration from the creative mind of Simon Dinnerstein, with whom I feel real artistic kinship. I find his artwork to be fantastically evocative, casting ordinary subjects in a decidedly unordinary light. Simon accesses that imaginative spirit tucked away in the recesses of our dream world, and the recurring themes of mystery, night, and wonder are what drive this quintet. Originally, I held Modest Mussorgsky's *Pictures at an Exhibition* as a blueprint. As a musical work, it likewise finds inspiration in artwork and as a result, encompasses many short and rather direct movements. I worked a good while with this model . . . to little avail. The music I was coming up with was nice, but Simon's work is not "nice." In subsequently studying the drawings that inspired Mussorgsky, I quickly identified my conundrum:

Mussorgsky's pictures of Russian daily life are straightforward and pictorial. Two old men. An oxcart. Chicks playing. On the other hand, Simon's work is psychologically rich without being promiscuously diffuse, and in reworking my initial ideas, I found that a two-movement composition encompassing large dimensions and focusing intensely on mood and color was more fitting than a collection of miniatures dancing lightly over multiple themes. In addition, I wished to highlight the special relationship between the premiering pianist, Simone Dinnerstein, and her father, and have consequently scored the first movement for solo piano. Simone is ably joined by her colleagues the Chiara String Quartet in the second movement. In this way, I hope to have succeeded in musically rendering the potency of Simon's art.

The first movement, "Nocturne-Sonatina," draws inspiration from *Nocturne* (1982) and *Sonatina* (1981). The second movement, "Night Scenes," draws inspiration from *Night Scene I* (1982) and *Night Scene II* (1983)."

Several years have passed since *Ghosts* was unveiled, and it's gratifying to note the performances that have occurred in the hands of the originating musicians and others. In digging into the compositional coffers of my old sketches that managed to escape the recycling bin, I laugh to read the notes, both in music and words, scribbled to myself, especially from the early (i.e., wildly flailing) stages identifying which of Simon's paintings I would work with:

Passage of the Moon: This sheen, and the strrrretch! A Copland-esque widely-spaced chord in piano with messy-pedaled reverb picked up and then delicately (tip of bow, choked high on string) glissed down by Chiaras, voiced likewise wide? Wide how? Parallel always or changing? I'm hearing twelfths around tenths. Game this.

Rear Window: Totally unflinching in this gaze. I hear a diminished triad, not train-like, tundralike (but not silly, think directly), in pinched strings . . . All grace-noted by piano. And a wellspring, very dark, *muy oscuro*. Lovely C# minor sitting like a cloud over the piano strings. Again, messy pedal. Game this.

Purple Haze: Simon lingered on this in the gallery. I need to try, run it through my mill to each person in quintet, see what they would do with her, this Floating Lady. Julie on 2nds: Cats yowling, in a great way. Becca on 3rds: Definite motor hum. No 4ths, veers you too close to the cliffs of Peru. Jonah on tritones: Reminding you of ragtime licks. Ack, must thwart. All on 5ths: Chiaras would kill me, ha ha, as they should. I'll spring this on them later, psych! Greg on 6ths: Stretching. All on 7ths: Like this, but too comfortable for me. Could convert to 9ths for Simone, though. Hmm . . . Do I need to rewire these associations I have? Am I fossilized?

Joel's Shoes: I hear drop-outs. Full on, everyone, and then whoops, pull rug, and you're left with just one tone that's quiet but a little rough. Hearing a tritone *con sordino*? Scrubbing a bit? And where, oh where, does this little doggie go? Into the shoes? Becca and Julie do a toss-and-turn between them? Jacob's Ladder-like? Game this.

Flower Market, Rome: Impressionist, shimmer, F# major against C major for something of Ravel, Scriabin, but rhapsodic within squares, a dizzy grid? And me who does not like Scriabin, and me without my spoon, lol. Too obvious to do tremolos in strings—Simply sing arco, *senza vib*, no forced lyricism? Ack, three melodies crowding me at once. If I were ambidextrous, I could get at least two down now. Hurry, fool-ette!

Garfield Place: Undulating lines, but not sexy, sinuous. A bit clockworky but rich, not able to tell the difference between the strings and piano. Middle register best with the piano then, a lovely B minor buttressed against A♭ major. Violins must stay on G string, even up high. Gaming.

Studio Still Life: Busy. But this is supposed to be Studio. Still. Life. But it's busy to me. Busy stillness? . . . Annnnd . . . Whoop, there it is: Interlocking tight figures, can totally get that. I could chain-link pizzicatos with truncated and intermittent arpeggios for Simone, some up, some down. Game this.

And finally, one lone confession, unadorned by accompanying music scribblings, regarding the following:

The Fulbright Triptych: There is no room for me to add to this one. This is a veritable memoir. Simon still sits like that! A-slump in his middle. It's so much him, I'm not a good enough composer to be able to enhance or reflect this. My brain's gone too literal. Maybe in ten years I'll have the skill . . .? . . .? . . .? Nope, not even then. Nada comin' to me except the most trite and unworthy of ideas. Dinnersteins deserve better. Ungame. Game a-over. Don't even ASK for overtime. Deadline and all. Go along now, woman-cita, nothing more to see here.

From all of the paintings that I surveyed in the preparation for *Ghosts*, my sketches reveal that *The Fulbright Triptych* defeated me from the onset. But, to be perfectly truthful, I was *happily* vanquished by this painting, a dizzying yet well-spaced kaleidoscope of everyday painter's objects, wooden floor panels, children's drawings, a beckoning town vista, and Simon's own suspiciously corduroy pants as he sits with Renée and an infant Simone in what appears to be a sunroom. My music to this? I think I would have crowded Simon, not walked hand-in-hand with him. Beyond the pictorial content, the execution itself of *The Fulbright Triptych* still holds me in a vise, but an oddly secure one. Simon chose to only use oils, but magically managed to suggest decidedly different media—the evocation of pencil and crayon in the pictures intimately tacked on the wall behind the Dinnersteins still takes my breath away. Such skill! Music already streams through this, and I'm glad I had the wisdom to step aside. There are other cracks into which I can pour my restless ego, bubbling and attention-demanding. *The Fulbright Triptych* stands as an effervescent whole.

In retrospect, I realize that it is amazing, exciting even, to retrace and relive how Simon has touched me, from the startling first reveal in Brooklyn that miserable wet night, to the act of thumbing through my humble sketches for *Ghosts*. In the cuttings and unfinished ideas that wound up on the editing-room floor of my composing studio, there is lingering life, little embers that still glow. Some I have indeed pivoted toward other works, and one could say there is a little bit of Simon in this symphony, or that woodwind quintet, or these arias composed since *Ghosts*. Others still await

corporeal form. Whichever the case, I can't deny the compelling testament chorusing volumes about the longevity of Simon's work. In other words, just as Simon's paintings are not even remotely unprecedented, neither are they even remotely finite. To me, there is a kind of immortality, an immortality of moving tenderness, to be able to stir such a strong response of emotion and creativity in others. It has been a privilege to stumble across Simon's path, and I know that countless others will delight in his vision as I have.

Simon and Renée Dinnerstein, Jeremy Greensmith and Simone Dinnerstein and their son, Adrian Greensmith, at the Palmer Museum of Art, Penn State University, June 2009

Simon Dinnerstein's Family Romance

Albert Boime

I interviewed Simon Dinnerstein extensively in the week of August 9-13, 1989, and when we decided to call it quits I felt we had touched only the tip of the iceberg. For me, honed as I was on the construction of an art historical past that had no opportunity for rebuttal, having to confront a live specimen as a primary source—as if the subject of a recent book of mine, Van Gogh, could be reached by telephone—was fraught with complications. Nevertheless, Dinnerstein's openness and analytical mind finally put me at ease and yielded so much intelligence and information that I could convince myself that I had the makings of a case study of the relations—dare I even repeat the old formula?—between an artist's life and work. Hopefully, out of the welter of our exchanges and personal constructions there emerges a mosaic of some shared reality.

In many ways, Simon made it easy for me. His most audacious speculations always emanate from, and return to, a basic core idea that he recapitulates in his life and his art. Both in his everyday experience as spouse, father, and friend and in his cultural practice (what he might call his "visual diary"), he attests to a profound attachment to the people in his life and the immediate material environment in which his human relations unfold. He studies them intimately: the way they look, the way they feel, the way they interrelate. He draws them in tightly defined interiors, close-up and conscientiously, revealing all the lineaments of their existence. Some critics have called his pictures cruel in their ruthless exposure; I think this is an exaggerated general description of his work. What Dinnerstein does is to relentlessly particularize his subjects in their spaces until the macro and the micro become visually one. More often than not, he chooses models with strong personalities who do not flinch under intense scrutiny.

Dinnerstein's work is full of ambiguity and never lends itself to easy labels. But his close scrutiny and claustrophobic environments consistently draw the beholder in close to share in his lifestyle. The centering of the family affection and the links to the rest of the world through this centering becomes an ecumenical mission, as if Dinnerstein wants to draw the whole world into this family center. Thus the family mediates the world for Dinnerstein, but the family on its own terms. This public expo-

sure of his intimate life is meant to "show people that they might get in touch with something in themselves that is deeply and even painfully private." What each of us experiences and suffers in isolation is often the result of conditions—physical and environmental—that are generic to the species. Dinnerstein's awareness of this paradox and need to share it is central to his visual thematics.

This attitude is surely related to the impact of his father on Dinnerstein's intellectual and psychological development. Louis Dinnerstein was an ardent union organizer and committed leftist preoccupied with the social injustices in the United States. Dinnerstein remembers him as somewhat dogmatic, having a single solution for the world's ills and pushing it home at every opportunity. This brand of engaged politics left Simon cold and dissuaded him from following in his father's footsteps: on the contrary, he determined to avoid universal, generalized solutions and instead to satisfy himself with things that were near at hand and manageable, things that he could really change or influence.

Simon observed the despair and the anger and frustration of his father. While Louis Dinnerstein was absorbed in ideas and political solutions, his domestic life fell into disarray. Louis subjected his wife, Sarah, "a very dreamy kind of person," to verbal abuse and intimidation. In reaction, Simon rejected his father's public posture to privilege the world within his jurisdiction, to construct a world he could govern. Instead of trying to remake the conditions of civil society, he shapes a harmonious domestic center around which the family, friends, and neighbors orbit. As against the father, Simon elevates the family space to highest priority and relegates the world problems to the periphery.

In this sense, Simon is a red-diaper baby—a child of a radical parent—who switched to Pampers. Like many of his generation, he was more critical of the failings of the Old Left and New Left than of the recalcitrant and conservative sectors of U.S. society that opposed them. He renounced the Left's global mission as a solution to society's ills, but guarded their social concern for the wider population and their milieu. His work is not only meant to be accessible to a broad audience, but his subjects are drawn from domestic surroundings and local neighborhoods. His range of subjects embraces his pregnant wife, their extended families, an alienated Polish

refugee, a childlike and awkward uncle, a meditative black female student from the West Indies, a reclusive German tenant, and ordinary objects in his home and studio. But if he keeps within a range of experience that was the focus of his father's social concerns, he does not portray it in overtly political terms. His subjects are not the oppressed proletariat, but psychological creations defined by their relationship to his interior, domestic realm. In other words, he does not go out into the world to preach, but rather he strains the world through the sieve of his family circle. Put another way, he curbs his anxieties about the Other by bringing the Other into his life where it may be subject to dominion. Under these circumstances, his subjects may enjoy a degree of freedom, humanization, and love denied them in the politicized exterior world. The harshness of his scrutiny then becomes a litmus test of his realism—a realism that feeds back his measure of control.

He is equally harsh on himself. His *Self-Portrait*, nude from the waist up, betrays a curious expression. Like most self-portraits, it was done by looking at a mirror, but in its finished state it looks out at the beholder. The quizzical look seems to address the beholder as a kind of superego, a surrogate father that says, "Who do you think you are?" A child, aware of parents watching, acts momentarily on his or her best behavior to gain approval. The parent, knowing full well that this is a momentary state related to the surveillance, addresses the child with the answer, "I know who you are and what you are about"—an attitude that persists and becomes part of the challenge to the child's sense of self. Thus the realism of this work presupposes a firm grip on the artist's response to the question, "Who do you think you are?" The artist can allow himself this degree of realistic self-questioning, since he is confident that he possesses the means to respond affirmatively. Dinnerstein's world is subject to his control that begins tentatively and gradually tightens; everything is inevitably marshaled to insure an accurate response. And it is accurate, and can be accurate, within the limited boundaries he sets for himself.

His major works, starting with *The Fulbright Triptych*, confirm this hypothesis. His by now legendary bulletin board (really, a storyboard) is filled with items rendered with the meticulous and trompe l'oeil perfection of a Harnett or a Peto. Every autobiographical incident or detail is treated with an unwavering gaze. Here he takes his

studio as the center of affection and attraction, with himself, his wife, and child grouped around the worktable. It is an unusual painting, and at first sight I kept wondering how it could be so effective with all of its quirkiness and eccentricities. For all of its complexities, however, he conceived of the image as a whole from the start and carried it out without preliminary studies—an image that burned itself into his eidetic memory. Even the wry title contributes to the strange aura of the picture by being both an echo of the past and a statement about modern artistic patronage: in the Renaissance such a picture would have been named for an individual patron or donor, while contemporary patronage takes the form of institutional grants and prizes that provide a major source of support for the artist. It was while he was studying in Germany with the aid of a Fulbright grant that Dinnerstein began the painting.

Thus the work maps out the autobiography of the artist while under obligation to the Fulbright grant, the enabler of his ambitious enterprise. He received the grant to study printmaking at the Hochschule für Bildende Künste in Kassel, and in a sense the work pays homage to both the grant and the craft of the printmaker. The entire central panel is built around the table with its clinical organization of the tools of the graphic designer and an engraved copperplate in the center. Thus for his first major painting, Dinnerstein opted to represent a taxonomic chart of the printmaker's profession, an understandably cautious theme for an ambitious first picture. I would call this ironic and sometimes whimsical work "The Taxonomy Lesson of Dr. Dinnerstein." Yet despite its obvious didacticism and cautious thematics, it is spellbindingly intense: a paradox that is a hallmark of the artist's total production.

The painting's energy derives in part from the intrinsic rebelliousness of the project. Dinnerstein was awarded the Fulbright on the basis of a proposal having to do with a printmaking project, and in the end the most important work he did with it ran counter to the proposal. Dinnerstein refused to be stifled by either the stipulation of the grant or his own initial proposal.

As a result, the work was steeped in paradox and ambiguity from the start. It is the story of the graphic designer in paint, as if printmaking itself was incapable of telling this story. Simon, however, refused to capitulate to the academic "hierarchy of modes" before wresting certain concessions from it: the pigment must humble itself to the

meticulous replication of the scrawls of preschoolers as well as other crude marks and gestures traditionally alien to it, and it must faithfully delineate kitschy reproductive images. Hence alongside the figural and landscape signifiers of high art we find the child's Crayola sketches, printed texts, magazine, tabloid, and postcard reproductions, and the cheap subway mug shot obtained in those fast-disappearing booths that once yielded for a modest price candid photos for passport and wallet. These were not only painstakingly but also painfully duplicated in a recalcitrant medium. It is this struggle between his awareness of the traditional importance of the paint medium and his intrinsic love of the graphic media that is played out in this visual scenario and keeps it from lapsing into genre. He paradoxically elevated the status of his own printmaking experiments to the level of high art that succeeds only on the condition that it too can be transformed into a reproducible object and tacked onto someone's bulletin board. In this sense, it overcomes the loss of high art aura from reproduction by recreating a "lower" level aura through its own fascinating reproductive properties. It resembles a monumentalized projection of those old newspaper comics with built-in incongruities that asked, "What's Wrong With This Picture?"

Thus, on a deeper level, this collagelike depiction of self-identity is a personal view of the history and nature of perception. The clue to this aspect of the work is the paraphrased quote from the writings of Ludwig Wittgenstein, pasted between the two windows just above the table in the central panel: "And to the question which of our worlds will then be *the* world, there is no answer. For the answer would have to be given in a language, and a language must be rooted in some collection of forms of life, and every particular form of life could be other than it is." The key to Wittgenstein's thought is the emphasized article "the" before the word "world" that suggests the futility of establishing *the* reality. Reality then becomes at any given time the relativized conception of the extent to which our particular "forms of life" —language and therefore ideology as well—delimit our soundings of what's out there in the void.

Hence the reflective Dinnerstein-Wittgenstein persona could hardly take itself seriously within the bounds of its quest for *the* reality. Just as the artist forces high art to come to terms with children's art, he also juxtaposes the text of the philosophical sage with the haiku-like poem of a thirteen-year-old pupil named Gloria Mintz,

whom Dinnerstein taught at an Orthodox girls' yeshiva in Brooklyn: "Grey and sweating / And only one *I* person / Fighting and fretting." Here is precocious recognition that the quest to make existence rational and meaningful in modern society through fixing *the* reality is in itself a subjective solution taking place in isolation. Dinnerstein accepts this as a given, and thus takes as his starting point the personal lens of family (the extension of himself) and its environment.

The Wittgenstein quote forms part of a series of three objects including an aerogram letter from Dinnerstein's wife Renée (then visiting her parents in the States) and an old broken stopwatch, upended on the worktable, whose face depicted a male sprinter. The aerogram's front has the return address of Staten Island and the Dinnerstein address in Hessisch Lichtenau, and, together with the stopwatch, comments on the heightened awareness of the vagaries of space and time in the modern world. Additionally, Renée's letter to Simon describes a bizarre dream about childbirth that involved both their mothers. The reference here to another state of consciousness that seemed "real" at the time amplifies the epistemological issues raised in the painting.

The broken stopwatch suggests that the painting is an attempt to "freeze" or "catch" a moment in space and time, a metaphor that Dinnerstein employs often in describing his particular realist approach. He imagines himself as a kind of butterfly collector trying to nail the subject in flight. Yet Dinnerstein's trail rarely leads beyond his home or studio interior so that the specimens he gathers in his net are neither exotic nor rare, but those in his own backyard. Within these confines he sees every detail with an obsessive evenness so that, initially at least, the viewer seems to confront a rigorously controlled space seen close-up. In the case of *The Fulbright Triptych*, where the view extends beyond the studio to embrace part of the town of Hessisch Lichtenau (here framed by the windows like two more pictures on the wall and mediated by the perspective of the working table), Dinnerstein deals with the contradictory all-over emphasis by having recourse to his delightful metaphor of the "floating eyeball." He paints as if his eyeball could detach itself from his head and float over the areas beyond his immediate sight and return with the immediately concealed visual information. This is a conceit rooted in childhood fantasy, but it does reveal a good deal of Dinnerstein's desire for a kind of omniscient presence in his own backyard that is the yardstick of his reality.

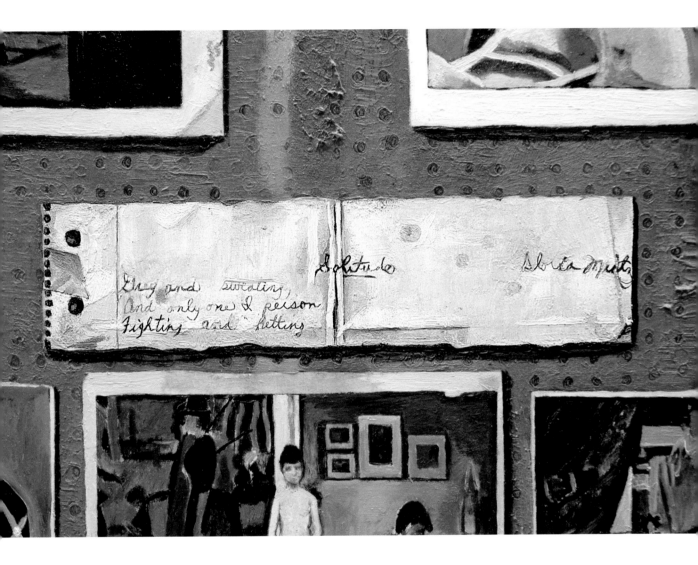

The voyeuristic impulse is central to both the making and viewing of art. The beholder in the first instance is the painter, in the second it is the public onlooker. Thus the painter makes public that which was private and the audience becomes complicit in this act of exposure. Dinnerstein's awareness of this dynamic in his own work comes through in an astonishing childhood recollection that he revealed to me in the course of our interview in August 1989. It occurred to him recently while he was drawing a nude female model (*Dream Palace*), and they discussed their earliest fantasies of their possible futures. Dinnerstein then recalled that the first time he had a "vision" of himself was when he was about four years old. He was alone in the apartment and seated on his parents' bed, when he had the sensation of floating outside of his body and looking down on himself from the ceiling. He remembers thinking something like this: "Boy, this is amazing! This is what it feels like to lie on my parents' bed." Then he floated all around the room, taking account of how the dresser, the drawers, and the window shades looked as if seeing them objectively for the first time. By the time he floated back into his head, Dinnerstein knew that he "wanted to do something with my life that was the equivalent of that."

Henceforth Dinnerstein committed himself to being an observer, someone who is able to see oneself and others "in situations." While explaining the curious detachment of his visual practice, his childhood fantasy is also a wonderful modern parable of the origin of art, updating the fabulous accounts recorded by Pliny. According to Freud, about the time our nascent sexuality reaches its first peak, between the ages of three and five, we begin to indicate signs of the activity that "may be ascribed to the instinct for knowledge or research." This activity corresponds on the one hand to the sublimated need to obtain mastery over the environment, while on the other it is impelled by the energy of scopophilia. Its relations to sexual life are of fundamental importance since curiosity in children and the quest for knowledge are inevitably linked to sexual drive. What Freud calls "the riddle of the sphinx"—the nagging question of birth—is a vivid memory of many people during the prepubescent period. Although children cannot make the direct connection between the sexual act and having children, they develop an interest in sexual relations in order to unravel the mystery of marriage itself and discover their role in the process. This early childhood

research is always carried out in solitude. At this point, the child takes a crucial first step of independence and displays a high degree of detachment from both parents and surroundings.

Thus it is probably not a coincidence that Dinnerstein's experience occurred in the parental bedroom when mother and father were absent. The "floating eyeball" emancipates sight from walled-off ignorance, enabling the child to uncover the mysteries and hidden objects on the forbidden side of closed doors, concealed in dresser drawers and behind drawn window shades. (Simon spent many of his lonely childhood hours gazing out of windows, and the window became a fundamental metaphor for his work. Not surprisingly, a favorite movie is Alfred Hitchcock's *Rear Window*.) The discovery of the private realm of the parents, the wish to be able to gaze unflinchingly into all of its labyrinthine manifestations, must be an integral psychic component of Dinnerstein's quest for self-discovery.

Dinnerstein noted in our interview that at the time he recounted his childhood memory to the model, her expression had something "dreamy" and "vulnerable" about it. These are precisely the terms that he used throughout our interview to characterize his mother, whom he credits for his own creative disposition. Indeed, he often seeks in his female models precisely this sort of expression that resonates with his memories of his mother. (These very often are sexually charged expressions that produce a type of oedipal displacement that may also be signaled in the reproduction of Larry Clark's erotic photograph of *Teenage Lust* that appears on Simon's side of *The Fulbright Triptych*.) Although this look coincides with a traditional patriarchal attitude, Dinnerstein also gives his male figures a similar mood of reverie and pensiveness. Thus this particular expression, and the mystery of it associated with his mother, may have triggered the childhood associations that led him directly to the parental bedroom.

The most cursory examination of *The Fulbright Triptych* reveals that the maternal and domestic theme is central to a number of the images affixed to the walls of the studio: the Virgin Mary, Madonna and Child, pietà, primitive fertility figure, a paternal surrogate for a mother (described as "warm, melancholy, and tender") with his daughter, a reproduction of Seurat's mother sewing (according to Dinnerstein, Seurat rendered it with "lots of mystery and expression for his mother"), a domestic scene by

the artist's brother, Harvey Dinnerstein, entitled *In the Kitchen*, a Käthe Kollwitz portrait that resembles Dinnerstein's mother, and the critical left panel depicting his wife holding their infant daughter. Hence this first attempt is inextricably linked with the Mother image and the domesticated environment, a visual manifesto that sets the direction for Dinnerstein's subsequent production.

There is a starkness and alienation in this studio space so clinically arranged and artfully prepared. Renée and Simon occupy the left and right panels, gazing at us out of their extreme isolation. This quarantine look of the space speaks in part to the curious status of the Dinnersteins: American Jews, residing on their Fulbright in the Protestant German town Hessisch Lichtenau, just outside Kassel. One photo on the wall of the panel representing the artist shows a despairing figure confined to a cell-like interior. It reminded Dinnerstein of the scene in Camus's *The Stranger* in which the protagonist is incarcerated and feels his world rapidly shrinking and consoles himself by investigating his ever-diminishing and restricted space. The Dinnersteins' provisional standing and sense of confinement is demonstrated in part by the need to fix their self-identity so insistently through the bulletin-board motif, and to invent their own environment within the unfamiliar geographical and topographical entity. On the wall just behind and to the right of Simon's head is a Soviet émigré's passport (Dinnerstein's mother was a Russian immigrant, as were his paternal grandparents), metonymically pointing to the conditional and relative nature of national identity. Again, this sense of identity is filtered through his maternal side; the artist claimed that the document reminded him somewhat of "a passport photo of my mother." In a sense, Dinnerstein has sought to create a sympathetic Motherland within the alien Fatherland.

It is through the mediation of this reinvented space that we are allowed a glimpse of the outlying town. The sides of the neatly organized table are extended outside by the edges of the main street, leading us along a residential row of compact houses and gardens as tidy as the arrangement in the studio interior. The one-point perspectival scheme that orders the composition leads ultimately to the hills on the distant horizon, finally asserting in metaphorical terms the Dinnersteins' place in this domain. But the view out remains rigorously controlled by the two windows that subordinate it to

the exigencies of the bulletin-board motif, in effect transforming it into another collage component.

The stringent organization of the composition is part of the artist's acknowledged contradictory attempt to grasp the data of everyday phenomena through a personalized construction. The broken stopwatch in effect is the mocking metaphor for the desire to "slow down" and "stop" reality in order to pin it down on the pictorial surface. The conscientious arrangement of the engraver's burins, burnishers, scrapers, and measuring instruments pointing toward the outside world signifies the imagined potential of human artifice to objectify the surrounding reality. The centerpiece of the table is the oval copperplate, which has a landscape design inscribed in reverse of the actual print. Seen up close, the brickwork and foliage engraved on the plate with the burin are clearly visible, thus creating an equivalency with the phenomenal world as depicted in the picture (though lacking color) and submitting it to the dominion of the printmaker. Thus, reality in this crazy-quilt tapestry becomes a multilayered texture of images woven within images.

The appearance of Flemish and northern Renaissance clippings on the wall clues us in to the kind of obsessional quality Dinnerstein admires in the work of other artists, from van Eyck to George Tooker. (He satirizes his own obsessive impulses in a passage from *Moby-Dick* tacked on his side of the wall, quoting an exchange between Ahab and Starbuck.) His methodical replication of reproductions of works by Rogier van der Weyden, Hans Holbein, Jean Fouquet, as well as more modern painters such as Jean-Auguste-Dominique Ingres, Georges Seurat, and Edwin Dickinson pays homage to his idols but also serves to measure his own performance and ability to "see" against their own. Thus his self-identity asserts itself in this embrace of the history of art that forms as significant a part of the environmental texture as the town outside. Indeed, his own meticulous rendering of his studio space attests to his wished-for position in this history at an insecure moment of his career.

Part of *The Fulbright Triptych*'s power attains through the hermetic representation of commonplace subject matter. I found it challenging to reconcile what comes off to me as a medieval or Renaissance allegory with the excessive familiarity of the motifs. The accessibility of the persons and things is contrasted with the remoteness

of the space and its clinical rendering. This ambiguity rescues the work from anecdotal genre.

Yet if it is the evocative character of the commonplace that empowers the painting, it achieves this at the expense of topicality. The arrangement of the familiar in the guise of tradition suggests the deliberate effacement of the topical. Except for the image of a photograph of two men clipped from the *New York Times* that addressed the issue of mistaken identity in a controversial rape case (thus relating to the work's basic theme of perception), little in the picture points to an awareness of the burning political topics of the day. This is all the more surprising when we recall that the picture dates from the period 1971-1974, a critical stage in the war in Vietnam. Dinnerstein's sympathies were clearly on the side of social justice, and he continues to oppose the jingoist and nationalist expressions of the Right. He had participated in protest demonstrations (including the Civil Rights March on Washington in 1963) and did everything possible to get himself exempted from the draft. Furthermore, his own rejecting of nonrepresentation and involvement in figuration shares the cultural ideals of those turbulent years when the need to communicate with the broadest possible audience became an imperative for the generation of the sixties.

But at the peak of the Vietnam and Civil Rights period he grew disenchanted with the public process. At this moment, the anxieties he inherited from his paternal side predisposed him to be suspicious of what could be accomplished by protest. (His own investigations reveal that consolidation of the national wealth increased dramatically during the decade, as if to hint that the wealthy elite encouraged protest as a diversion from their own power play.) He articulates his fear of the rhetoric and sloganeering of groups and movements that espouse drastic change achieved through collective action by an expressed horror of a certain kind of extreme "idealism," the idealism that leads to the creation of exclusionary fraternities such as the Ku Klux Klan and the Nazis. Here he rationalizes his position by assuming the pose of the skeptic and realist; indeed, distrust of idealism he interprets as the only sensible form of modern realism. The misplaced idealism and what he felt to be its shallow rhetoric he associated with the political posture of his father, whose dogmatic public role prevented him from maintaining a rational private world. Hence Simon's commitment to the private as against the public: the desire, whether conscious or unconscious, to succeed in that

realm where his father had failed. His self-identity had to be mediated through the narrower world of the family rather than through public demonstration. At the same time Simon brought all the instruments at his disposal to depict this intimate private life with the scientist's objectivity, as if to lay bare its dynamics for systematic analysis. As in the case of Camus's protagonist, Dinnerstein focused on the walls around him in proportion to the receding of the public world.

If Simon's work shuts out his world from this kind of topicality, it is nonetheless modern in its presentation of the tension between the private and the public realisms and in its deadpan representation of the familiar. (In this he shares the qualities of the painters he most admires, George Tooker, Lucian Freud, and Antonio López García, who unite the grand figurative tradition with the contemporary commonplace.) Above all, he is modern in his openness to other visual media—film, photography, and television—that have decisively affected his mode of seeing. Throughout our interview, Dinnerstein returned again and again to the influence of Ingmar Bergman on his work. Dinnerstein has viewed the Swedish director's films many times over since he first encountered them in the mid-1960s, and he is especially fascinated by the filmmaker's investigation of various levels of self-identification, the intermingling of complementary viewpoints within one identity, the fusion of dream and reality as a part of identity.

The double portrait of himself and his daughter, in which the two are shown in a half-length view close-up to one another but moving in opposite directions, exemplifies the Bergmanesque influence of such films as *Persona* (1966). Dinnerstein and his daughter occupy the same shallow space, with their heads drawn up tightly together, akin to the colossal double close-ups of Bergman's optical field, while preoccupied with their own personal thoughts. Within the domestic foyer Dinnerstein visually unites father and daughter, but also emphasizes their divergent orientations. This convergence and divergence of the two generations may be seen as analogous to the theme of splitting and fusion in Bergman's film.

Dinnerstein's fascination with the tension between and the intermingling of identities, as well as his fascination with the ambiguous space between the dream and waking states, is explored further in the monumental drawing *A Dream Play*. As in *The Fulbright Triptych*, the artist has located himself and his wife and daughter at either

end of the picture to frame the central action that in turns links them like two ends of a Japanese scroll unfurling across time and space. The panoramic ensemble depicts members of the Dinnersteins' extended family entering and exiting in dream, rather than in real, time. Thus deceased ancestors mingle with the living, and the living are seen in multiple stages of youth and adulthood. Renée Dinnerstein is glimpsed not only as a mother watching over her daughter, Simone, but appears also as a child of nine years when she bore a remarkable resemblance to the daughter. Dinnerstein depicts himself at the far left at his drawing table, recalling the self-references of Velázquez and Goya in their royal group portraits. In this case, however, the subject is his own family and leaves no doubt that he is the choreographer of this Dance of Life and Death. He alone is conscious and aware—the "dreamer" who sets the dream play in motion as he "narrates" the text of his extended self-portrait.

The motif of the artist taking over the main narrative function was inspired by a newspaper photograph of Iranian pilgrims. An unveiled matriarch wearing black in the immediate foreground plane addresses the viewer/photographer, while the other figures are self-absorbed in the background. Her full, intelligent face is brightly lit, while the background tourists move almost trancelike in the murky shadows. As a kind of mediator between the beholder and the picture crowd, she functions as interlocutor and chronicler of events. Perhaps it is significant that a maternal image sparked the germinal idea of the familial *A Dream Play*.

The title was suggested by August Strindberg's drama of the same name, which a friend recommended to Dinnerstein after hearing his explanation of the subject. Strindberg's "Note" at the beginning of the play states: "the Author has sought to reproduce the disconnected but apparently logical form of a dream. Anything can happen; everything is possible and probable. Time and space do not exist . . . The characters are split, double, and multiply; they evaporate, crystallize, scatter and converge. But a single consciousness holds sway over them all—that of the dreamer. For him there are no secrets, no incongruities, no scruples and no law."

The bizarre coincidence of Dinnerstein's design and Strindberg's conception took an even eerier turn when, in the course of executing the elaborate drawing, Dinnerstein watched a televised showing of Bergman's last film, *Fanny and Alexander*

(1982), which itself merges dream and reality in a frankly autobiographical work. As the last scene fades, the screen blacks out, and what appears is the quotation cited above from Strindberg's play read by Helena, the family matriarch (in voice-over). Since the source of the quote was not cited, Dinnerstein experienced an uncanny sensation of déjà vu. Bergman's picture (one that Dinnerstein has viewed several times), in fact, was deeply influenced by Strindberg's play, and the filmmaker staged the play for the theater several times in his career. He uses the play in the last scene as a pretext for reconciling the generations through the participation of the grandmother and daughter-in-law ("There are parts for both of us") on a plane that blurs the boundaries of theater, dream, and actuality.

Both the play and the film stress the dreamlike state of earthly existence and the burrden of the past that weighs on the minds of the living. Dinnerstein was especially struck by the scene near the climax of the film when the ghost of the recently deceased stepfather rudely reminds Alexander that he will not be rid of him so easily. The anxieties of his own childhood continue to haunt Dinnerstein as he depicts the memory traces of the associative sights and sounds of the past hovering behind the claustrophobic familial procession. A prolonged row of squalid brownstones marches across the distant horizon like an elevated subway, reminiscent of a long horizontal tracking shot in film that suggests time unfolding.

Dinnerstein's realism grows out of his sense of a kind of foreordained trajectory that each individual existence must follow, and *A Dream Play* creates his own world of necessity through kinship, class background, and environment. The psychological vectors of mother and father that shape the personality for further encounters are rhythmically choreographed across the surface. Acceptance of, and facing up to, this "fatalistic" view of existence implies a strategic form of modern realism. Dinnerstein relentlessly depicts his motifs with the documentary quality of old passport photos and amateur snapshots, achieving a montage of the family photograph album. As a result, he establishes a persuasive matrix that predisposes us to accept improbable juxtapositions and anachronisms.

Dinnerstein's sense of predestination does not mean that one must yield wholly to blind destiny: in dreams positive images arise that alert the dreamers to those per-

sonalities who may play a beneficial role in their lives. As he stated in our interview: "If one truly believes in fate ... then you dream in your dreams of the person that you will be linked up with; you don't need to search for that person—you just dream of that person; when that person comes along they fulfill what they match in the dream you've had. There's something very beautiful in that." This implies to me that Dinnerstein feels that he can control his own fate through the re-creation in another medium of mental images.

A Dream Play's atmosphere suggests a loosening of the stringent gaze that marked *The Fulbright Triptych*. In addition to opening his art to the possibility of representing other states of being, this change also coincides with a shift in thematics beyond the nuclear family to extended kinship associations. Dinnerstein examines the historic strengths of the extended family: the respect for one's elders (here indicating a more tolerant attitude toward his father), the communal nurturing of children, and the labor of parents to guarantee their children the fulfillment of their creative potential. Allowing for the indirectness of Simon's visual construction that tends to prevent the work from lapsing into outright didacticism, we may perceive that the work's content stresses relations in its various forms: sexual, parental, filial, brotherly, and by extension social and political relations. By the 1980s even the militant Left had caught up to Dinnerstein's position and abandoned an exclusively economic-oriented program in favor of a pro-family analysis. In *A Dream Play*, Dinnerstein has added a vignette of two African-American children gazing out of a window into the Brownsville street, a motif inspired by a *Life* magazine photo. The vignette is placed just above the portraits of himself and his brother and father to the left. Albeit a personal allusion to Dinnerstein's own daydreaming propensities as a child, its incorporation here evokes another side of family life in America. (This would not be the first time that Dinnerstein situated desolate individuals near windows as symbolic of their isolation; another example is *Nocturne* (1982) which depicts a displaced Polish refugee suffering from his sense of being "alien" in a foreign land.)

The year before he began the picture Dinnerstein organized an exhibition of his work at the Gallery 1199 in the Martin Luther King Jr. Labor Center, New York City. The gallery is named for the adjacent Hospital and Health Care Employees Union, Local 1199. The artist's father, Louis Dinnerstein (who appears twice in *A Dream Play*)

had been an active member of this organization during its stormy period in the sixties and seventies when issues of civil rights and black participation dominated the agenda. Older members of the union recalled that Louis had energetically agitated on behalf of gaining a fairer proportion of African Americans (the majority of the union's membership was black) among the leadership. Dinnerstein, in a gesture that indicated a greater awareness of his father's role in his choice of career, proudly dedicated the exhibition to the elder's memory, "an ardent supporter of 1199 and a man who followed his deep convictions."

It is no coincidence that the subject of three of Dinnerstein's most important recent works in the Gallery 1199 exhibition was a young black woman named Cheryl Yorke. She modeled for *In Sleep*, the work reproduced on the exhibition's flyer that carried the dedication on the verso. Yorke had been a student of the artist at New York City Technical College and profoundly impressed him with her "inner peace and depth" and her "extraordinary outer, formal beauty." The third work in the series, the one that provoked the most comments, depicted her asleep and dreaming. At first glance, the work presents the viewer with the Western stereotype of the exotic languid woman, vulnerable and exposed to the patriarchal male gaze. Dinnerstein, however, plays with the stereotype in wanting to represent the model "in her fullness"—including the "baggage" of the past that she carries into the present. Above her reclining form Dinnerstein repeated the model in an interwoven chain of recumbent poses that almost cinematically trace her bodily shifts in sleep. These less conventional postures—such as one on the right in which she cups her chin in her hand while hunching her shoulders forward—reach beyond the Gauguin-like cliché of the native woman. In the zone directly above the garland of sleeping poses, Dinnerstein inserted representations of the model's childhood memories of her homeland, the island of Saint Vincent in the Caribbean Sea. On one end of the panorama is a portrait of her father as a youth, while at the other are snapshot vignettes of herself alone and one showing her together with her mother and sister. Just left of the father's image is a scene of the construction of the family dwelling with the help of the extended family and friends. Thus the intricate dream imagery evokes multiple associative memories of the communal experiences on the island of Saint Vincent, building on the motif of the *Nocturne* and anticipating *Night* and *A Dream Play*.

There was a good deal of comment regarding *In Sleep*, with contradictory interpretations offered depending on the point of view of the spectator, "from plantation scene to migrant workers, to William Blake and Gothic entombments, to Caribbean mysticism and Mexican realism," according to the artist. One black woman wrote emphatically in the visitors' book, "Unfortunate Reality of Our Past, Hopefully not Our Future," while a white woman commented that the woman is "asleep like her people are asleep." Dinnerstein was surprised by the variations of these interpretations from his own "vision" (no artist can predict the reception of work because, like the weather, the political climate changes constantly), but clearly he and the model are partly responsible for these reactions. One of the vignettes in the zone of reverie portrays a group of workers cutting and harvesting sugarcane, a scene the model remembered as common when she was growing up. Although blacks on the island (who constituted the majority of the population) would have been wage laborers at that time, the rising stalks in the background are metaphorically inseparable from the history of slavery in the West Indies. The reason that Africans were wrenched from their homeland and transplanted to the New World in the first place was because of the voracious demand for sugar in European markets. Thus the complex visualization allows for the multiple levels of association carried by the model in the deepest recesses of her memory, embracing not only the immediate recollections of parents and indigenous community, but the earlier trauma of disrupted family life and the building of a new life under radically altered environmental conditions.

Yorke's dreamy, introspective traits evoke Dinnerstein's reminiscences of his mother even while linked in his thoughts with his father's efforts to make Local 1199's leadership more responsive to black participation. It is not surprising that her contact impelled him to re-create her extended family as a fundamental component of the picture's content. The year following the 1199 exhibition he commenced *A Dream Play*, which amplifies the same theme in an autobiographical context while maintaining the link to *In Sleep* by the introduction of the two contemplative African American children gazing out the window.

Thus the question of the nature of the family unit was very much in his mind the year (1986) Bill Moyers presented his negative CBS Special Report, *The Vanishing Black*

Family—Crisis in Black America, that stacked the deck for a pathology in black families so overwhelming that they seemed beyond redemption. Moyers's viewpoint would have been adverse to that of Louis Dinnerstein, who had long ago perceived that behind the familiar "blaming-the-victim" syndrome laid race, class, and gender discrimination in America. Simon's own recent connection with Local 1199 and the critical presence of his father in *A Dream Play* would have predisposed him, if only inadvertently, to consider some of the wider implications of the "crisis" in the American family structure.

Despite the affirmative theme of the drawing, Dinnerstein unfurls an examination of the politics of the family that is about power and domination even at its most positive moments. The human family is almost predominantly defined in sociological terms by males, who generally posit as its foundation the fundamental presence of the father. Yet the "ideal" of traditional family structure and the values on which it is built is becoming singularly rare in this society, thus belying the narrow definition of family Moyers accepted in his documentary. While images are always multivalent and rarely reducible to single explanations, to my mind Dinnerstein's *A Dream Play* is especially significant in its metaphorical restoration of the power of the family model so recently degraded to a symbol for exploitation by opportunistic politicians. Through the complexly nuanced figuration of an extended family of mothers, fathers, grandparents, uncles, and aunts, Dinnerstein establishes the family as a unifying principle, the essential nurturing unit from which human beings draw their mental, emotional, and physical sustenance. It is perhaps the renewed sense of kinship and communal ties developed within the traditional extended family that can make room for single-parent units, especially mothers, and the homeless.

But it is women who give birth, and it is children who represent the one entity absolutely indispensable to any notion of human family. Dinnerstein's frank acknowledgment of the tensions of childbirth had been expressed in 1972—when still at work on *The Fulbright Triptych*—in his astonishing pair of drawings of his pregnant wife, entitled matter-of-factly *8ᵗʰ Month* and *9ᵗʰ Month*. Their shallow fields, almost wholly filled with the dilated body and accentuated by the riveting focus on accessory detail, convey a distinctly claustrophobic atmosphere. Although the swollen torso relates

his wife to the great Earth Mother, few artists have made their studies of the naked model such a vivid and disturbing experience for the beholder. These large, ungainly, looming portrayals of his wife near to term, and therefore representative of their intimate private life at that moment, surprised me in the public space. Ordinarily, it runs counter to expectation to see the nude model pregnant (an exception like Gustav Klimt's *Hope I* manages to keep within tradition by making pregnancy erotic), but in this instance Dinnerstein probed the female body with such relentless and uncompromising objectivity and from such unflattering angles that one becomes less aware of the academic tradition than of a tense vigilance bordering on the grotesque. Dinnerstein's commitment to microscopic realism in this period inclined him to view the depiction of his pregnant wife as a clinical and historical obligation. It is as if the artist deliberately set out to debunk the mythical notion of the blissful state of pregnancy near parturition and capture the *angst* of the experience. In this sense, the distended abdomen and enlarged breasts with their taut network of veins complement the overstretched nerves of Renée-Simon sharply registered on her face. In *9th Month* the carefully executed chain lock on the door follows the curve of the breast and abdomen, metonymically pointing to her "confinement." Yet the rawness of the study with all of its awkwardnesses and lack of conventional decorum infuses the older tradition with new power by repositioning the nude in a modern context.

Mother and child are the subjects of another innovative attempt at the nude, done five years later as a fellow at the American Academy in Rome. *Roman Afternoon* is a startling and unexpected composition of Dinnerstein's nude wife and child listlessly stretched out at opposite ends of their couch in a kind of mirror image. There is a distinct sculptural quality in the sharply defined mattress edge, akin to a marble slab, that runs parallel to the horizontal axis of the work. Draped with crisp white folds of the bed coverings silhouetted by the dazzling Indian red wall behind, the setting is reminiscent of eighteenth-century neoclassical interiors.

This time sensual warmth is restored to his wife's body, as well as an appreciation for the smooth contours of the body in relaxation. Mother and daughter gaze out of the picture, intent on fixing the artist-viewer's gaze, who happens to be both spouse and father of the models. Hence they must vie for his attention. The work is singular in its equal emphasis on the nudity of the mother and prepubescent child. Traditionally,

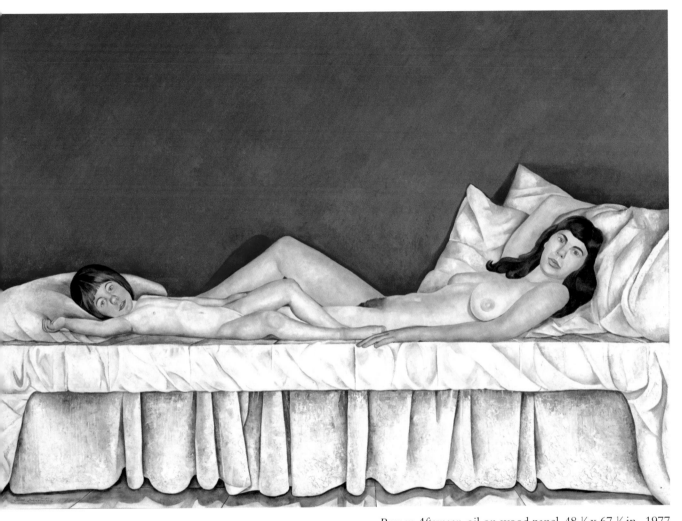

Roman Afternoon, oil on wood panel, 48 ¼ x 67 ¼ in., 1977

the mother is depicted clothed and holds and/or attends to the nude child without being conscious of the viewer. Thus did religious sanctity and bourgeois decorum dictate the figured modesty of the maternal role. But Dinnerstein overrides the convention by representing mother and child with their respective fully developed and nascent sexuality.

Rome clearly represented a more affirmative historical moment in the family's evolution. The Vietnam War had ended, Nixon had resigned, and the bicentennial celebrations seemed to hold out the possibility of national reconciliation. On the personal side, Dinnerstein had found a perceptive and sympathetic dealer, George W. Staempfli (who purchased *The Fulbright Triptych* when it was still unfinished and paid monthly installments until its completion), had his first one-person exhibit, was a member of the faculty at the New School for Social Research, and in 1976 ran off with a Rome Prize Fellowship. Formally, this chronicle is recorded in Dinnerstein's new delight in textured and painterly surfaces, and in his exhilarated response to the brilliant colors of his new environment.

In the ritualistic interview of the Rome Prize candidates, Dinnerstein explained to the committee that he believed it still possible to create a modern figurative art on par with the work of the past. His ambition was to go to Rome and produce a "total vision" of the contemporary world with the intensity of the old masters. His major project at the American Academy, *Flower Market, Rome*, attests to a sense of elation and well-being marked by a more public theme and the explosive colorations of fifty identifiable species of blooms. This is demonstrated by the artist's own impulse to jump into the floral ensembles as if they were a sea of cushions when he first discovered them in the Campo dei Fiori in Rome. He wanted to re-create this sensation or vision of himself "jumping into the painting and lying on the flowers." Dinnerstein's definitive work is ten feet wide and took nine months to accomplish. It depicts one of the characteristic flower stalls swarming in the Campo dei Fiori, where the retail florists set up their booths for locals and tourists alike.

Dinnerstein was struck by the iridescent play of flowers in these stands, which seemed to "float off the ground." Their endlessly varied hues and textures set off by the ochre-orange–tinted stucco of the walls "would just glow." Returning to the stu-

dio, he reconstructed one of the flower stalls on canvas by building up the surface with a dense mixture of pigment, marble dust, and stone to capture the variegated textures. As a result, the rich layering resembles a fresco with its heavy relief underneath. Although the pervasive relief is justified because so much of the canvas is given over to the luminous floral passages (standard academic practice calls for the highest relief in the brightest lights), the final effect gratified Dinnerstein by amusingly duplicating the avant-garde look of the dense, allover webs of Milton Resnick's nonobjective paintings without the loss of the subject.

Both the theme and the title suggest a more public content than we have heretofore seen in Dinnerstein's work, but in fact it enlarges upon the personalized vision we have identified with the theme of the family. The figure of the flower vendor was posed by Teresa Gregorini, a native of Trastevere and close friend of the Dinnersteins, who stood in for the actual owner of the stall. The cropping of the outdoor space at the very edges of the flower ensembles creates the familiar claustrophobic space of the painter's indoor scenes and in fact yields a "hothouse" effect. Gregorini, seated in the center, presides over the tiers of flora like a venerable matriarch of a family portrait. Traditionally, flowers are metaphors for childbirth, sexuality, and regeneration, and here they suggest surrogate children. Indeed, the work could easily be entitled "The Madonna of the Blossoms." The Madonna image is invoked by Gregorini's stately frontal presence, her dark sedate costume, the crossing gesture of her right hand, which preserves her modesty, and the ingeniously contrived halo formed by the arc of the window behind her.

Teresa Gregorini's subtle smile recalls the preclassical Greek kore, and brings us back again to the characteristic expression of Dinnerstein's mother. Gregorini, however, represents the more ambivalent attraction of woman/mother embedded in a matrix of efflorescences. We may recall the artist's vision of himself jumping into the painting and lying among the flowers—a wish to be "absorbed sexually or sensually in the painting." Dinnerstein also stated at one point in our interview, "I'm a real sucker for flowers," referring to a desire to compensate for the absence of flowers in his childhood. Surely, the association of mother/Madonna/woman and flower is central to the unfolding dynamic of Dinnerstein's work and relates back to the parental space. The

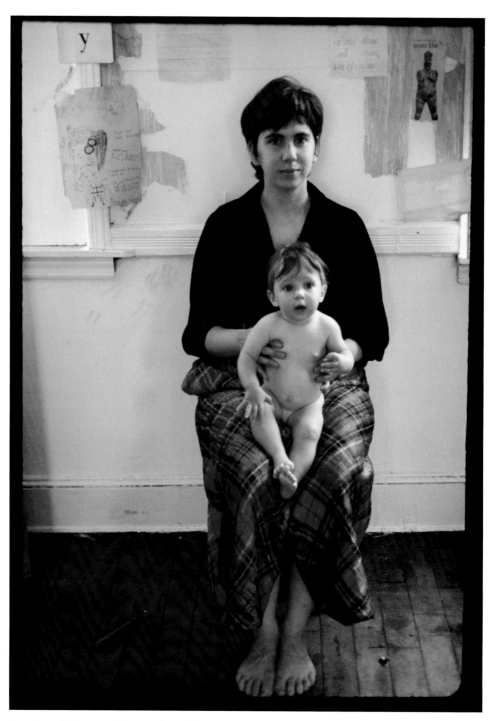

Renée and Simone Dinnerstein, c. 1973

regenerative ideal is further implied in the simultaneous display of nearly an entire year's growth of flowers—autumn chrysanthemums, spring dahlias, and otherwise ephemeral forget-me-nots thrive side by side—so that Dinnerstein's picture becomes a "real allegory" about blossoms that perpetually glow: a flower stand that could not exist in actuality. The work took exactly nine months to complete, and in a real sense, Dinnerstein gave birth to his ideal environment centered on the maternal memory trace.

The flip side of this affirmative and brilliantly illuminated picture is the large drawing known as *Night*, representing the eruption of nightmare or infantile anxiety caused by the absence of the parents. A procession of pre-kindergarten children marches out of the drawing trancelike in the direction of the spectator. They are enveloped by a vast terrifying landscape that recedes rapidly into space toward a pale crescent moon spreading its eerie network of lunar beams over a universe haunted by dreaded creatures of the night—demons, skeletons, witches, bats, and a frightening subway "El" screeching around a curve. This is a world of children without parental presence and the security of the family embrace, a world that is, according to a friend of the painter, "unsafe." Dinnerstein himself recalled that in making the drawing he "wanted to get at things that I felt as a child made me anxious."

Dinnerstein's unusual mixed-media drawing was based on an incident that occurred in Renée Dinnerstein's preschool class. She had organized a dramatic representation of Maurice Sendak's children's book *Where the Wild Things Are*, and each child went to work eagerly creating his or her own mask from supermarket bags. But a startling thing happened after they donned their makeshift costumes: they began to grow frightened by the sight of each other and by their own claustrophobic reactions to being enclosed within a mask. The wearing of the masks had transformed the world of the secure classroom into the world of their nightmares. The result was a sense of apprehension and alarm that led to a quick removal of the disguise. That this experience resonated with Dinnerstein's memory traces is registered in the terror-stricken expression of the child at the extreme left, the artist's "surrogate," who serves as interlocutor for the visual scenario.

As in *The Fulbright Triptych*, Dinnerstein wanted to express a childhood vision in

a style consistent with the subject. He executed the chimerical figures with the "scratch out" technique, which consists of laying down a multicolored surface with Crayola crayon, covering it with black tempera, and then scratching through the black layer with a pin to reveal the colors underneath. This interception of "high art" with children's imagery and drawing style is made possible through Dinnerstein's mastery of graphic techniques which contest the established boundaries of high art.

The painting known as *Gregory's Party* further attests to Dinnerstein's desire to conjoin the child's world with the realm of high art. In this case the pretext was the "party" organized by the artist's daughter for the Raggedy Andy toy she had named Gregory. Children create their own fantasy world within the "real" domain of their parents, in effect acting out the role of "parents" toward the miniature world they create. This is especially evident in the dollhouse (a conspicuous emblem of Simone's world in the later *Sonatina*), where the child stands in relationship to the dolls as the parents to the child. The fearful presence of towering adults is now worked through in the child's analogous relationship with miniaturized toys. This is most vividly observed in Simone's tabletop community of every conceivable type of figurine arranged in a hierarchical society (*The City, the Town, the Emperor of China*). The child, powerless in the adult realm, now exercises control over a Lilliputian realm set up on a tabletop or floor.

For Dinnerstein this type of children's play is yet another instance of the blurring of the boundaries between dream and reality. The organized play space that Gregory inhabits is subjected to the dominion of Simone, who in turn establishes the composition for Simon. In this sense, the artist's own cultural practice relates to the childhood fantasy of governing a reduced version of the adult environment. The sheer delight of the artist in the crisp colors and outlines of the toys takes us right back to the invented world of *The Fulbright Triptych*. Here again the depicted and actual are not sharply distinguished: the contrast between the casual—almost "natural"—pose of Gregory and the more formal pose of Simone suggests that the artist telescoped the distance between play and actuality. Reminiscent of the scene in *E.T.* where the extraterrestrial creature conceals himself among the toys, Dinnerstein subjects the unknown to the known.

Gregory's Party, oil on wood panel, 42 x 64 in., 1979

The whimsical but macabre self-portrait entitled *Emerging Artist* reconciles many of his anxieties and intellectual aims under the rubric of a powerful metaphor. Dinnerstein portrays himself as a hybrid creature, with his head issuing from the body of a turtle. He crawls hesitantly across the foreground space, fumbling for his pencils and crayons, while in the background the immense landscape falls away to infinity under the radiating lunar network of the crescent moon. The frightening atmosphere of *Night* is linked with a crisis of professional self-identity.

As in *Night*, it was Renée's preschool class that inspired the work. The turtle was the class pet and totem, and the children even read books to it. Renée suggested the turtle as the subject of a picture, and this sparked a vision of the hybridized self-portrait of the merging and emerging artist. (Renée also suggested that he add the pencils and show himself wearing glasses.) Dinnerstein thinks of the portrait as an example of a Quixote tilting at imaginary windmills. No matter how determined we are to make life meaningful, the "shell" we carry about always constrains us from "delivering the goods."

Hence Dinnerstein reveals in this autobiographical parody his innermost anxieties: the concern for the "baggage" of the past that haunts the present, the fear of losing control over the environment, and ultimately, fear of immobility at the moment of self-understanding. The metaphor of the turtle answers to more than one facet of the artist's self-portrait. He claims to work slowly, and he talks often of wanting to slow down the pace of reality to the point where he can capture it on the drawing surface. Finally, Dinnerstein talks of making works so intense that spectators are stopped in their tracks. What could be more natural than to choose as his totemic emblem the animal that sums up so many sides of his personality? In the race between the tortoise and the hare, who would not place their bets on the tortoise?

"Where the Heart Stands in Perfect Sincerity"

Nancy Ekholm Burkert

When I was introduced to Simon Dinnerstein's *Fulbright Triptych*, I felt most deeply drawn by the forthright gazes of the artist and his wife. In meeting for the first time, we entered a silent dialogue, while continuities of history were at play on the walls, through the windows, and over the rooftops to a far horizon. The wife looks not demurely down to (the advent of) their child, but directly at me, and I identify with her unadorned simplicity, the warm geometry of her plaid covering, her bare feet so squarely placed on the plane of the floor, her stoic countenance. This is not a solipsistic exercise by her husband, who sits in solemn ease on a Thonet chair, his artist's hands folded. His serious mien tells me that he is sharing everything that brings cohesion and meaning to his life.

There is both harmony and tension in the symmetry of the *Triptych*. Art both connects and divides. Hours required for creation are solitary, and the engraver's art is among the most concentrated. The worktable, given pride of place in the central panel, could be both bridge and barrier here. Is it just coincidence that the word *solitude* in the *Triptych*'s one-point perspective rides at the vanishing point?

As Saint Jerome in his study, surrounded by tomes, hourglass and scissors, or Joseph in Campin's *Mérode Altarpiece* with his augur, nails, and hammer, or as Merchant Gisze in Holbein's portrait, the painter Dinnerstein, in E. H. Gombrich's words, sets out to "characterize a sitter through his setting."

Are we not fascinated with the "tools of the trade?" Would not viewers of all ages want to know what those "things" are for, the calipers, the palette knife, the engraving tools, the loop? And what of the fruits of the plane tree, tactile baubles gathered on a recent walk, perhaps. "Who lives in all those houses?" children might ask, and note that drawings like their own preside equally with the great masters. Table legs and radiators are a small child's landscape, but mother and father are paramount in any vista, here, the tactile corduroy, the blue velour, that ample lap with its welcoming bright plaid. The mystery for them will not be a "fantasy," or an oversimplified rendition of the

complex forms they see every day. Theirs will be curiosity, recognition, and comfort. They know what is true.

Via the replicated items affixed to the wall, we are informed by the artist's most iconic images, transfixed by his inclusive homage to many mentors which include Käthe Kollwitz, Edwin Dickinson, Holbein, Ingres, Seurat, Degas, Vermeer.

It has been put forth that there is an affinity in Dinnerstein's *Triptych* with northern European painting, the Flemings Jan van Eyck, Memling, Rogier van der Weyden, and Hugo van der Goes, among others. Yes, the attention to and validation of interior objects and ambiance, the distant landscapes through a window, and other similarities can be found. But the Flemish subjects are most often engaged either with one another, or a biblical or social event. They are looking into some interior dimension and only rarely seem to seek our own.

I prefer to see a strong affinity with early American folk portraiture, and would place this *Triptych* squarely in that lineage, a lineage with titles like *Gentleman Holding Oboe,* or *The Family at Home.* The unaffected directness of husband and wife reminds me of the concentrated dignity of the early pioneers and of our Native Americans, as they held their poses long for the camera's flash, in a serious claim on posterity, if not immortality.

Our itinerant artists were not untutored, but with uncomplicated purpose they represented their subjects to the best of their ability, included their significant possessions, the view through windows or curtains to their exterior environments. These artists' use of strong local color, of patterned surfaces, an undefined light source with lack of cast shadows, clearly delineated spaces and symmetry, the whole perceived and translated without subjective equivocation or intentional abstraction, could also be attributions of *The Fulbright Triptych.*

Richard Wilbur has written a poem called "Praise in Summer," in which he chastises himself, the poet, for elaborating on a theme or object in an attempt to magnify it, which only "perverts our praise to uncreation . . ." and results in "wrenching things awry." He writes, "Does sense so stale that it must needs derange/ The world to know it?"

Abstract expressionism, among other forms, is often equated with intensity of passion and emotion, elevating it in this fashion above the likes of Ingres, van Eyck, Dürer, or Piero della Francesca. I might contend that in the attempt to delineate what we see, within the heights of our limitations, we pay homage to things *as they are*. Representational artists can be equally passionate in their mode of praiseful regard.

I feel Wilbur's "praiseful eye" in all of Dinnerstein's work.

The Quaker philosopher John Woolman wrote that there is a principle which is pure, "deep and inward, confined to no forms of religion nor excluded from any, where the heart stands in perfect sincerity."

Such was Simon Dinnerstein's heart, when he painted *The Fulbright Triptych*.

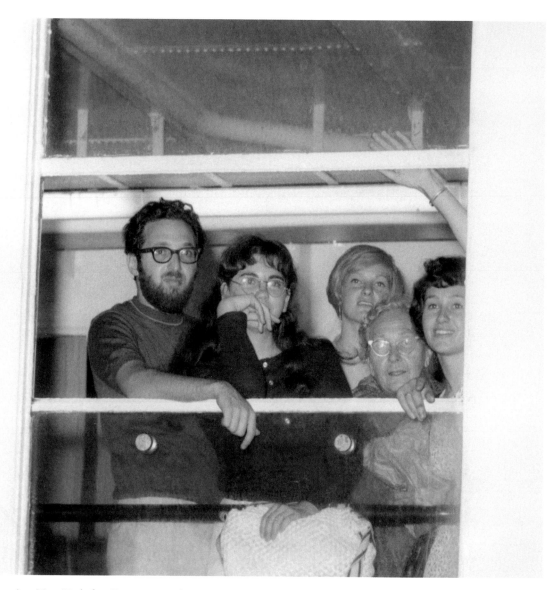

Leaving New York for Germany on the *T.S. Bremen*, August 1970

The Fulbright Triptych: A Love Story

Renée Dinnerstein

August, 1970 . . . Simon and I standing on the deck of the *Bremen*, oompah band booming maudlin German music in the background, our families anxiously waving from the shore . . . we were off, on Simon's Fulbright fellowship, to the land of Dürer, of Bach, and of a terrible holocaust that practically annihilated the Jewish population. Excitements, expectation, confusion, guilt . . . all of these emotions were playing havoc within us.

For Simon, a twenty-seven-year-old Jewish artist who grew up in the post-World War II years, spending a year in Germany was more than the sum of its parts. We both found it almost impossible to have a conversation with a mature German without thinking, "Where were you? What did you do? What would you have done to me and my family?" But living in a small town, making new friends (our not-yet born daughter Simone Andrea was named after the two children of our new friends Gerlinde and Herbert Wenderoth) forced us to confront many of the complexities of human existence. Our own country was dropping napalm on villages in Vietnam, as was often brought to our attention by young Germans who we met at the art school and in the village.

That year, I saw in person the art that I had only previously seen in books. Simon and I were overdosing on art and it was wonderful! Van Eyck in Frankfurt. Dürer in Nuremberg. Grünewald in Kolmar. Simon even got special permission, with the help of the Fulbright Commission, to enter into the then-East German city of Gotha to view one of the only original existing Dürer copperplates. I got to go along on that complicated but exhilarating trip.

Simon often spoke with me about his desire to put all of these experiences and thoughts together in a major statement in some way that was personal and not pedantic. Although he had a grant in graphics and had not, since art school, done any significant painting, as crazy and perhaps unrealistic as it seemed to me at the time, a monumental triptych was what he envisioned. In April, he ordered the wood and, without any preliminary studies, began work on the central panel.

The painting took three years to complete. In August, the unfinished panels were transported by ship to Brooklyn, New York, and, with the financial support of the Staempfli Gallery, Simon continued to work on this project until its completion in 1974. *The Fulbright Triptych* was the centerpiece of his first one-man exhibition at Staempfli Gallery in 1975.

This past August, my now grown-up daughter, her husband Jeremy, my seven-year-old grandson Adrian, Simon, and I made a seven-hour pilgrimage to Penn State University (our rental car stopped working along the way, slowing down our progress) to visit with this painting that has been so much a part of our family history. As I stood before it, I noticed something that I had not thought of before. At the top of the left panel, Simon included some photos that we took on one of our first dates, in 1964. We rode on the Staten Island Ferry and when we arrived at the terminal we found a machine where one could take inexpensive little pictures. Then my eyes skimmed all the way over to the right panel. At the very top, Simon included the same kind of photos, only this time they were of Simon, myself, and two-year-old Simone. There it was! A story of our life from when we met until the completion of the painting. I imagine that each person will see something very particular or personal in this painting. One could concentrate on the history of art, on the juxtaposition of the printer's studio with the painted image, with the scene of a young American family in a foreign land, but for me this painting is the ever-lasting, monumental story of our love and of our voyage together through life.

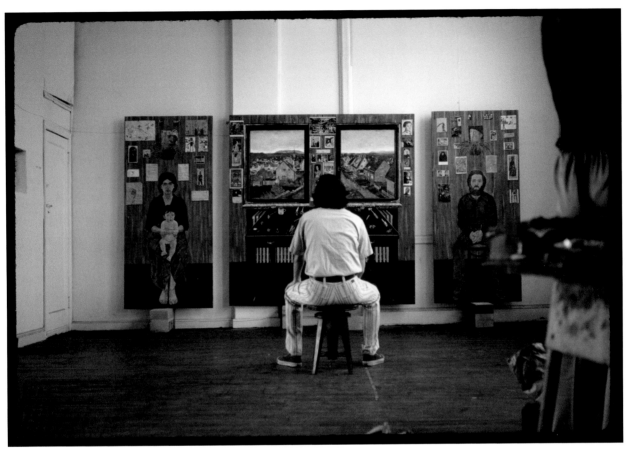

c. 1974

An Interview with Simon Dinnerstein
December 2008–January 2010

Marshall Price

Marshall Price: The first question I wanted to ask, Simon, is when was the last time you saw the painting in person?

Simon Dinnerstein: In 1999 and 2000 the *Triptych* came to New York, was exhibited at Saint Peter's Church, and then toured the United States. If you look at the catalog for that retrospective, you will see the different venues. So, basically I haven't seen it in about eight years.

MP: How did it make you feel to see it again after that period of time?

SD: My first response was that I couldn't believe I had created this. It just seemed well beyond anything that I was capable of. I'm not saying this to pat myself on the back. It just seemed like the best possible me, times a hundred.

MP: And that was something we talked about in the car on the trip to State College.

SD: It is both an act of bravado in a way, but it also has a certain amount of confidence—weirdly confident for someone so young. Even with financial support, it is a hard painting to believe that you could pull off, because you have to have a tremendous amount of belief to do this. I think that the painting has an odd combination of a certain intellectual side and a lot of innocence. I think the innocence is an interesting characteristic. It's not a painting about entitlement. There's something about it that— it's not about rendering or entitlement, it's about the *belief* in these images, not patting yourself on the back.

MP: One thing that struck me about the work is the use of a very strong iconographic program. Iconography played such an important role in northern Renaissance imagery as well. So there's an interesting parallel that I've always thought between this painting and iconography of the northern Renaissance.

SD: You mean people like Panofsky?

MP: Panofsky's explorations of iconography in Renaissance painting.

SD: I think what you're saying is true. The difference is that I think the best art to me does not have a program, and so, if I had carefully figured out these images, they wouldn't have looked like this. In other words, there's a disparateness and a diverseness to the imagery that goes from quotes to children's art to adages to northern Renaissance painting. But there isn't a *strategy* here. I believe this is connected to a sense of innocence or awe that I had at that time in my life.

MP: I think we were joking on the trip to the Palmer Museum about your youthful ignorance or bravado, or this combination of things as far as the genesis of the picture. It's interesting in the context of your overall body of work to think that not only was this the first real painting you did, but I remember when we were there standing in front of it, I asked you if you thought it was one of your most important works as well, and you said you thought that it was. Could you elaborate on that a little bit?

SD: Well, I think that sometimes knowing too much holds you back and sometimes not knowing enough, out of a sense of ignorance or a sense of incompleteness, allows you to attempt something that is far greater than you, in your most wise state, would think impossible. If you took an analogy which was literary and you thought of certain pictures as being novels, certain pictures as being novellas, certain pictures as short stories, certain pictures as poems, this painting, I might consider to be the equivalent of a large novel. There is a wonderful essay that I remember reading by D. H. Lawrence, "Why the Novel Matters," in which he compares a novel to a human being, to the

well-roundedness of the human being. Not all art demands to be painted ten feet wide. You have to have the right subject and if you don't have the right subject the image is going to appear puffed up. The subject is what calls for the scale. Fourteen feet is the right size for this painting, as strange as this may seem.

MP: When I first saw the *Triptych* it reminded me so much of Courbet's *The Artist's Studio*. In thinking more about the relationship between your painting and Courbet's it struck me that Courbet's painting is an allegory of the past, while *The Fulbright Triptych* seems to be in some ways almost an allegory of the future, with your wife and your newborn daughter and of course the medium itself—being a painting and the first painting and your future as a painter. I'm wondering how that strikes you—if you were thinking of Courbet's painting at all when you did it.

SD: I have to tell you that I'm very touched by what you're saying. That's quite a painting to compare mine to. I did not consciously think of that painting at all. In fact, I didn't see it until a few years later when I was living in Rome at the American Academy and I traveled to Paris. During my year in Germany, I think I was more interested in Flemish painting and the way that the Flemish painting and the Flemish sense of reality combined with a contemporary idea of life. Also, there's a very interesting thing that takes place in the dialogue between the artist and the art historian or an artist and a critic. Art historians like to wrap something up in a nice neat package and convey the fact that this is this, this is this, this is this. From an artist's point of view, I learned a great deal about the painting *after* I completed it. I learned themes that are present in this painting after the painting was done and I didn't have a clue as to what I was doing at the time that I worked on it. Really good writing on art, it seems to me, tries to deal with the *mystery*, the *doubt*, or the reach of the artist. By putting it all down concretized, it looses something. For instance, in my painting, the use of children's drawings standing right next to icons of Western art is, I thought at the time, very interesting, but I guess secretly you could argue that it's a rebellious activity and maybe a transgressive act on my part that I didn't think that much about.

MP: You painted the painting when you were fairly young and you had a daughter, and in the central panel are the tools of the printmaker, of the engraver, but it's a painting and it was really, in many ways, your initial painting. In thinking about it in more of an allegorical context than simply a portrait of you and your wife and daughter in your apartment, it struck me that in many ways it's a harbinger of your future as a painter.

SD: You know, if you examine all of those visual pieces of information, that's what I had circa 1970, 1971, 1972, and 1973, when I worked on this. If I did this painting now I would have completely different images in there.

MP: But there are also those artists who work in series, George Tooker being one of them. And I'm wondering if it occurred to you to revisit this theme in an updated version.

SD: Actually, that's a very interesting point because there are small paintings that I've recently done. I'm not sure if you saw these, but they are about eight by ten inches. Each painting juxtaposes a reproduction of a work of art with a still life. What I was trying to do was to see if I could do a really tiny painting, control the forms, and get a composition that was dynamic and striking. I could easily see those paintings shown with the *Triptych*. And they're painted even better than the *Triptych* was and they share that same theme. In other words, they both explore the theme of the importance of visual imagery and how they intersect in your life. They become the baggage that you bring with you. I wanted the complexity of this visual baggage. In the car ride that we took to the Palmer Museum, I mentioned to Jhumpa [Lahiri] that if I visited her office and looked at her bulletin board, I could probably surmise something about her. I could guess at who she was. So, in this painting there is a kind of detective story going on as to, "Who is this person that all of this information represents?" At the end of the visit to the [Palmer] museum, which was a very emotional experience for me, I said to Jhumpa that I thought the secret of the painting was the space between the images.

MP: That's interesting.

SD: In art—you must know this—but when doing a portrait or figure there is what's called *negative space*. The negative space is the shape that is not elucidated, that is the absence of what is portrayed.

MP: And sometimes, often I think, that is just as, if not more important, than the positive space.

SD: That's in a sense what I'm getting at here. You know, there's another part of this that I've always wondered about. There are no studies for this painting. This image came to me totally, and that's not the way I usually work. I think sometimes the best images come like this but they usually demand some studies, or something that comes before.

The other thing that I would say about this picture, the thing that I really like about it, is that it has no commercial value whatsoever. It represents to me a certain type of art that I am incredibly moved by. It goes under the category of "it *has* to be done." In other words, the walls will fall down, the building will fall down, I'm in my studio and one of us is leaving this room alive: me or the picture—the picture or myself. And, it has nothing to do with whether it can be sold or the financial part of it. It has a compulsiveness about it. I think my best pictures are like that and the art that I like the best really has that quality. In other words, the artist just *had* to do it. Van Gogh's pictures have that kind of character. There is actually one study that I did for the copperplate. I had to do that study because I had never used gold leaf before. I did the study to understand how gold leaf could be used and how I could make changes in the gold leaf—manipulate it. Basically the gold leaf form represents the copperplate. The print, from that plate, is of *Angela's Garden*. I had to paint over the gold leaf to give a sense of the ink that is stuck in the plate. At the museum, when we lit the painting correctly, I hope you can remember that the plate gave the appearance of levitating.

MP: I was delighted to see the actual plate in your home. One can look at the painting and miss so many things because it is so complex. But the plate is at the center of the painting and it is very difficult to miss it. I remember it made such an impression on me when I saw it in the book, especially reproduced in detail. When I went to your house last week and saw it, I thought "I've seen this before; I know exactly what it is." It was that present in my mind.

SD: You should know that this is an engraved plate. Engraving is different from etching. It is done with a burin. In the painting, these are the instruments on the table with the wooden handles, I cut into the plate by moving the burin in a straight line, directly ahead. The burin is always moved in a straight line and to get curved lines or circles the plate is turned—turned a little bit or turned 360 degrees. The plate sits on a pad (leather pillow), and the pad is sprinkled with powder so it makes the plate easy to turn. Dürer worked on a very similar type of plate. Dürer is one of my heroes and you could use the appellation for him, "the Prince of Art." I think he literally was the prince of art. He knew this and he carried it off. It would be impossible for someone to cut those plates other than him. My plate was cut in the same way. In the *Triptych*, the plate is depicted in perspective. It is basically a circle seen in perspective as an ellipse. There is a certain way that this effect is achieved. The front part of the circle—the part that faces you—is bigger than the back part of the circle and that gives you a sense of perspective. I first painted the image with a red ground and added the gold leaf over this surface. I scratched into the gold and worked it to make the gold look more like copper, giving it a sense of glow and vibration. I did not use gold leaf again after this until I did the painting of a woman reclining with a gold screen behind her [*Passage of the Moo*n, 1998.]

MP: And it's used over a much larger area of the surface in that painting.

SD: Yes, it is. The curious thing was that I used to do the engravings at night. And, what kept me going is that I would listen to basketball on the radio. These games were broadcast by Marty Glickman, who was a long-term New York City sports commen-

tator. This man could speak seven hundred words a minute. He would be talking as fast as possible and then he would say "basket." And then he would go through another seven hundred words and he would say "basket." There was something about listening to that rhythm while I was working that really kept me going, even though it sounds quite nutty.

MP: Of course, that's when the Knicks were winning, though, right?

SD: Yes, a lot different than today. [Laughing]

MP: You went to Germany on a Fulbright grant to study Dürer, correct?

SD: Yes. You have to understand that 1970, when I went to Germany, was only twenty-five years after the Second World War. There were definite ambivalences about going to Germany [on my part], considering the Holocaust and what went on there. There is another aspect to Germany which is very intellectual, very well-educated, classically educated, deeply studious, musical, artistic, and so forth. It's a country that has almost a split personality. It's quite amazing that—between ambivalence and antipathy for going—such a remarkable painting came out of my experience of living in this country. It gives one pause as to whether life is realistic or surrealistic, because very unusual things happen, unexpected things. For instance, you came to visit an open studio that I had two years ago and a few days ago you accompanied me to Penn State University. Now, that's very unusual—you just have to let things happen. Don't you agree?

MP: I do, I do.

SD: Well, you know, my wife's father was quite sick at the time that we left. There were some mixed feelings that we both had about going. I didn't know about his illness until well after I applied for the Fulbright grant. Something in me felt that if the picture was exceptional or remarkable or really pushed to its limit, it somehow would have overrode any second thoughts I had about the country, the time, Renée's father, all of

that. I guess many artists and many people have different senses of perfectionism or what perfectionism means to them and how it pushes them on. Does perfectionism come from your family, does it come from your father, or does it come from some commitment to the things that they felt were important? This painting is sort of a perfectionist's dream or a perfectionist's nightmare. It's very much *pushed* and not every painting that I do can have this quality. In Degas's oeuvre there's a painting he did of the Bellelli family and that painting is much bigger and much grander than most of his paintings. Many of his paintings are impressionistic but *The Bellelli Family* is a very formal painting. It has a different motivation than many of his other paintings. I think he may have done only one painting like that. An artist may have only a certain amount of grand paintings that he or she is motivated to do. Maybe a novelist only has a certain amount of novels to write, because we are fallible human beings.

MP: One of the things that I've noticed in looking at your paintings and in speaking with you is the importance that Renée has played in your life. I remember talking to you about this painting, the *Triptych*, last week, and you recounting the story of when Renée had to go back to the States to see her father. I'm wondering if you could talk about that again because I found it so interesting with regard to the genesis of the picture.

SD: Well, a few things hit me on this score. One is that, for some reason I thought of the painting in its totality as being cool and warm. So, the exterior wings with the human beings in it seem warm—not mushy warm or off-the-charts warm—but warm, and the interior seems cooler. Right away I felt that was important. And, there is a left-right element in it, and I'm not sure if I'm right about this, and I'm not even sure if you agree, but the right-hand side of the painting is stronger than the left-hand side of the painting—not just this painting. This may be a Western way of thinking, as opposed to Eastern. Somehow Renée and Simone seem to balance my side. So if you reverse the two it really wouldn't work as well, to me. Well, as far as Renée is concerned, I would say: the sun, moon, and stars, so she was a natural for this, i.e., to be depicted. Simone came later. She came after the painting was well on its way and she

adds more form, more strength to the left-hand side. The letter that Renée writes, which is in the middle of the middle panel just above the plate, is a letter that she wrote to me when her father was sick. When she returned to New York we wrote to each other back and forth. That letter dates the painting. It can be actually read and I've always thought that the letter was extremely funny—serious, but funny.

MP: What was Renée's initial response to your conception of this painting?

SD: I should preface this by saying I could not be the type of person I am or the type of painter I am if not for the fact that I met this person who—I guess the thing is I am the best possible person because of her and I really hope that the reverse is true. I thought of this painting when she was back in New York and really it was a difficult time. I think in the forty-three years we've been married we've lived apart maybe two or three times. That's a lot of time to spend together. In this case, she was back for a month and I thought this idea up and I wrote her on an aerogram card a diagram of the whole thing, I wrote out all kinds of information, rebuses, arrows, and all different things—I was very worked up about it. I knew where to get the panel and how the panel would be made and I was going to gesso it and I was really like *over the top*, fantasizing about it. I sent off the aerogram and our aerograms would cross, because it took six or seven days to go one way, six or seven days to go back. I finally received a response from Renée. The start of the letter dealt with some small issues and what she was doing, and then at the very end she said, "Oh, and regarding your wish to do this painting, this very large painting and your descriptions of it and so forth and so on, my advice is *don't do it*." And I have to say that her reasoning was that I had spent the last three of four years entirely doing drawings. Up to that point the Fulbright year had been spent on drawings. One of the drawings I did right around that period of time was a drawing that is in the National Academy's collection (Renée's uncle Arnold.) These drawings are incredibly worked out and incredibly extreme, but still they are not paintings. Since I was out of art school, I had not done any paintings and now, in my letter to her, I was proposing doing a *fourteen-foot* painting.

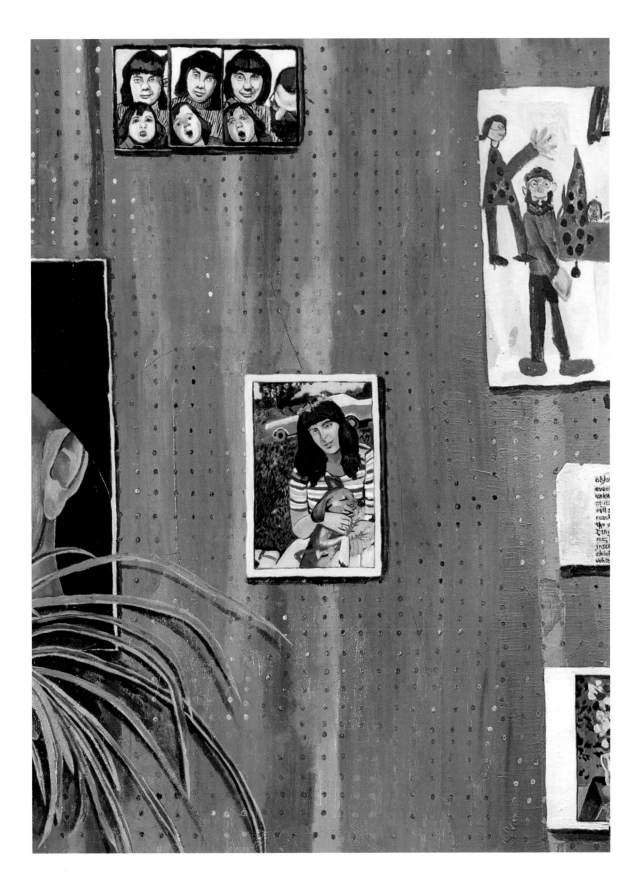

MP: If we could go back, just for a second, to the works that are depicted within the painting. In the painting you juxtaposed a variety of images from the northern and southern Renaissance, the nineteenth century, contemporary art, and even photographs—all things that just about any artist might have on his or her studio wall. You've also included children's drawings. I'm curious to hear you talk a little about their inclusion. I'm wondering, for example, if you were familiar with Paul Klee, or Kandinsky's ideas on children's drawings, or Robert Goldwater, the art historian, about how children's drawings are completely free of any sort of societal influence because they were created by people who were too young yet to have had any inhibitions. And I'm wondering if you were reading any of those texts or if those ideas interest you with regard to children's drawings.

SD: I never read one text about any of that. The impetus to do this had to do with Renée's teaching and the fact that I loved the way these drawings looked. I'm a big fan of Edwin Dickinson and there is a wonderful painting, *Artist's Hand Holding Children's Drawings*. It was in the Academy's exhibit of Edwin Dickinson's work and I think it was located at the ground floor. There is also something I remember reading about Dubuffet wanting to have a *museum* of children's drawings. For me the issue was the beauty and primal energy of the childrens' drawings. I wanted to get oil paint to look like the art of children. In other words, could I get oil paint to look like a watercolor, a pencil drawing, or ballpoint pen? So the idea was to manipulate paint to describe all these subjects, to *occupy* these visual enthusiasms. Somewhere, secretly, I must have had the desire to tweak fine arts and to include without any sequencing of "higher" and "lower," children's art and fine art. And so, high and low art are mixed together. Also, it seems to me that the use of children's art in my painting could have only been done in the twentieth century. There are some examples of children's art in previous centuries, but it is incredibly rare. I think I've seen one in a book on self-portraits, but I can't remember the artist's name. It puts the painting in a context which I like very much. It puts the painting in both the tradition of fine art and yet something that is very much in our contemporary time, very much *now*, without pandering to *now*—it just *is*.

Bar bara Ann

1 for 7 oth er

2 men 8 them

3 man 9 her

4 a bout 10 how

5 well 11 some

6 ba by 12 law

MP: As far as the study of children's drawings goes, I believe it was in the early part of the twentieth century when people actually started to look at the work of children as being important in any context whatsoever. Just at the same time when modernism and abstraction really took off. So it's interesting to think that modernism was almost *necessary* for someone like Kandinsky, Klee, Goldwater, whoever it was, to look at children's drawings, to recognize their importance.

SD: You know there's a great quote from Matisse which has to do with "To look all life long with the eyes of a child." He says it much better but that's the idea. It's a very unusual concept and I think that your point about it being connected with modernism is absolutely true. The thing about modernism that I am struck by is that it has two identities. One is the small-m modernism and one is the large-M Modernism. The small-m modernism is a much more intriguing notion, as it is full of contemporary ideas, contemporary thought and a certain open-ended element. The large-M Modernism is a club with a few members who aren't interested in things beyond their few members. A lot of people have trouble with the large-M Modernism, but the small-m modernism, the part that lets the children's art into this contemporary world of art, is wonderful. Do you think I'm right?

MP: Yes, I do. And I also think it's interesting to consider the area of crossover between the small-m modernism and the large-M Modernism and how there's an interdependency between them. But at the same time they are separate realms.

SD: As a figurative artist the thing about the difference between small-m and the large-M occurs when you consider a museum like the Museum of Modern Art. To me, the Museum of Modern Art is an example of Modernism with a capital M. It's like a club. It has membership, but you can't apply to be a member. That's my take on it. The issues in modernism are way bigger than the Museum of Modern Art, way more interesting and questioning, probing—a real example of modernism would not be a club because it would, by definition, be so open.

MP: Yeah, well, the Museum of Modern Art was constructed, unfortunately, by art historians. [Laughter] So, it's a construction, in many ways. That's probably a topic we could spend hours on, I'm sure. I have many problems with the Museum of Modern Art and its recounting of art history.

SD: Well you know, when I was in art school, the most prominent painting that they had on display was Tchelitchew's *Hide and Seek*. They haven't shown that painting in twenty years. I grew up looking at that painting. I always thought that painting was quite stunning. Why would it not be around? It's because it lost its membership to the club. How could it lose its membership? It is highly individualistic, quixotic, quirky, adventurous, pulsing. It has more of the aspects of modernism with a small-m but it lost its cachet and so it's been kicked out of the club.

MP: And likewise today, the most requested painting and the best-known painting in MOMA's collection is Andrew Wyeth's *Christina's World*. It's the best-known work in the entire collection—not the *Demoiselles*, not *Starry Night*—but Andrew Wyeth's *Christina's World*. And again I think it's a bit of a pariah within this world of modernism.

SD: Now, if you really wanted to mix things up you could show *Christina's World* next to the Jackson Pollock. For instance, there's an exhibit now at the Met of works bought under the regime of Phillippe de Montebello. It's a very interesting show. You come into a room and you see Balthus's painting *The Mountain* and next to it is, I think, a Renaissance painting by—I hope I'm right about this—Guercino, which is a Caravaggesque image. The eclecticism means you can admire an African sculpture with nails running through the chest of some human being and respond to a Balthus painting together in one space. I would like to see that type of eclecticism at the Museum of Modern Art. Why should the Wyeth be in the corner just as you're leaving that floor? And, you know, finally about that, the Balthus paintings haven't been displayed since the museum changed its format. So, they own a few Balthus paintings which are now being given the Tchelitchew treatment. It is a little bit like what happened to writers under the Soviet regime, when the commissars came in and decided that a

writer was déclassé. So this major painting by Balthus, *The Street,* which is a totally weird, wonderful painting, is all about modernism and yet isn't shown in the modern section of the Museum of Modern Art. I don't get it. You know that painting?

MP: Yes.

SD: It's a wonderful painting. The first time I saw that painting I was really put off by it. It got under my skin. It had a perverse sense of thumbing its nose at the viewer. But the more I saw it, it grew on me. I like the fact that so many things about the painting seem not to work, seem to be mistakes or incorrect. But the mood of it is almost out of *Alice in Wonderland*, one that envelops you as though you are lost in a fairy tale.

MP: I've always felt that *The Mountain* painting at the Met is an unsuccessful painting. But I also think on some level—and it's something intangible that I can't quite explain—but I've also felt that on some level Balthus was . . . did it almost on purpose to be deliberately irreverent or something, because the other painting of the young girl with her skirt showing is I think incredibly irreverent. I don't know if you feel that way about his work, but I think there's an inherent irreverence to it, or deliberate irreverence.

SD: He would say that you're reading into his work. That's his take on it. As far as *The Mountain* goes, all figures in that painting seem isolated and separate one from the other. And it seems as if it earmarks an event that has happened which is quite unclear about a possible fall—a moral fall or a sexual fall. And it's a curiously choreographed scene. Part of it looks like visions from *Wuthering Heights*, which is something he had illustrated. In his illustrations, he depicts himself as Heathcliff, and I think his former wife, a woman named Antoinette de Watteauville, plays Catherine. So, I think the painting might be related to that.

MP: That actually brings me back to your painting. I find it really fascinating how we continue to engage with works of art over the course of time and how we change over

time, but also how the work itself can change over time and how our interaction with it can change over time. Could you give us a sense of how your interaction with the painting has changed over the course of—it's been almost forty years since you painted it.

SD: Curiously, when I did this painting I thought I was very old. And I thought I hadn't really accomplished anything, or a lot, or really my potential. So, I was very critical of myself. I was all of twenty-seven. So, you know, that gives you a sense of how you see yourself and how you don't see yourself, because really I was incredibly young. When I hit thirty it was very depressing, because at that time in the sixties, the antiwar students and political activists had a statement which was their credo, "Don't trust anyone over thirty." Thirty marked the point where you were supposed to have accomplished something, and it was very depressing.

In my home, when I move a picture from one wall to the next, the image appears different. I remember traveling to Washington to see an exhibit of Lucian Freud. I went to Washington at three o'clock in the morning to see this exhibit, arrived at eight o'clock in the morning, went to the Hirshhorn Museum, got in line at nine o'clock in the morning, saw the exhibit at ten and revisited it four times during that day. I liked all of the paintings—I love his work. But there was one painting that I really didn't like. It really bothered me, *Naked Girl*, 1966. It is a painting of a woman who is reclining on a bed. And that painting struck me as too much. It was as though someone was really hitting on this woman and I felt it was kind of pathetic. Two or three years later I remember going to Hirschl & Adler and seeing an exhibit of British painting on the School of London. It was on two floors. When I got to the back of the second floor—oh, it included really good examples of the artists Frank Auerbach and Leon Kossoff, who works almost in a childish way, i.e., thick, thick, thick paint . . . and, Kitaj. When I got to second floor, to the very back of the second floor, I saw the painting I had seen two or three years earlier in Washington and it was the *best* painting in the show. The same painting, the exact same painting. Hands-down the best painting in the show.

MP: Was your recognition of it being the best painting in the show immediate?

SD: Immediate. Immediately, I thought it was clearly the best painting. It disturbed me because I had such a strong negative response earlier to it. I think it speaks to a number of issues, one is that you can't step in the same river twice. But sometimes a painting disturbs you or gets to you and it must be for some reason, some secret or hidden reason. The painting, in this different context, stood out to me to be so singular and so stunning and I thought of the absurdity of the two responses.

MP: It just shows you how works of art continue to have a dialogue with us—a very active and engaged dialogue—long after they are made and even after we've seen them numerous times.

SD: That is really something that we probably share in common, which is a belief in the palpability of visual images.

MP: I wonder if you could talk about the Staempfli Gallery and how the painting was purchased.

SD: I did not know Staempfli Gallery at all except for a show that I had seen five or six years before of Antonio López García, and that show, I thought, was the best show I'd ever seen by a contemporary artist. To me it had everything that art should have.

I had a particular idea about showing my work and this idea is different than many of the students I've had. Many of my students are in a hurry to show their work. I wanted to wait and develop a point of view before exhibiting.

I had come back from Germany with this painting drawn out in Rapidograph pen and I worked on it in a room that someone gave me in Park Slope. The floor in that painting is the floor from that room. A German apartment would not have a floor that looked like that. That's the subfloor in a brownstone. After having that place, I then shared a studio with a sculptor friend, Joel Rudnick. Some months went by, my daughter was born, and I found myself completely running out of money. I mean it's

not like I had trust funds or anything like that—we were completely broke, and we were really feeling it. So, my original idea about exhibiting had to be amended (and quickly!).

I then remembered the López exhibit at Staempfli Gallery. Because of the feeling that I was being pushed against the wall, I took a bunch of reproductions of my work and went up to the gallery. I walked in off the street with *no* introduction and first met Phillip Bruno, co-director of the gallery. I showed him a grouping of photographs. Phillip said that he would like to show the work to George. After that I got a phone call saying that they were interested in coming to my studio in Brooklyn. I didn't realize at the time that coming to Brooklyn [from Manhattan] was a further trip for them than going to Paris! They first came to my apartment in Park Slope. Then they came to the studio which was on Twenty-Fourth Street and Fourth Avenue, a very working-class neighborhood. The two of them were tall, well-dressed, distinguished, strong-looking men. I remember they stood looking at this painting for a long time. The middle panel was about three-quarters done, the left and right panels were gessoed white. I had previously given them a maquette showing the images for these panels. They looked at my painting for about ten or fifteen minutes but didn't say a word. Then, breaking this palpable silence, George said to me: "I think that's a great painting, and I'd like to own it." I'm a very worked-up kind of person. I can quickly get excitable and I, of course, was very struck by what he said. I easily heard all the words in the sentence and I was waiting for him to clarify his thoughts; however the two of them got their coats on, walked down the stairs, and I trailed along behind. They waved down a taxi and just before they got into the taxi, Phillip Bruno looked at me and said, "Don't call us; we'll get in touch with you." I immediately called Renée, told her what had happened, and said, "Do you think this guy is shitting me or what? You know, what does he mean?" We were both amazed.

Four days later I got an incredibly well-written letter from George Staempfli, which started off by saying: "Phillip Bruno and I were very excited by your work, especially the large unfinished *Triptych*. We propose to buy this painting in its unfinished state and to pay for you every month to work on it, and when the painting is finished to have a show here which would have at least two other paintings, plus all the rest of the

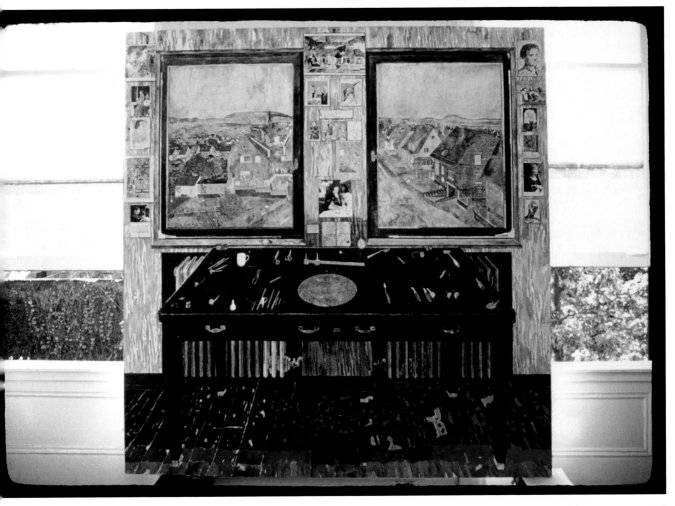

Carroll Street studio, Brooklyn, summer 1972

work we saw." The amount of money was substantial, enough for me to live on per month for the next two years, with just the addition of a part time job one evening a week. The offer was totally remarkable, but there was a condition. The condition was that the painting had to fit into the gallery. Staempfli Gallery was located at Seventy-Seventh Street and Madison Avenue on the second floor. As part of the condition, I was to build a cardboard dummy, a mock dummy of the middle panel and bring it up and make sure it fit. So I came up there with a piece of cardboard eighty by eighty inches. It didn't get in the elevator and it didn't go up the stairs. My heart was sinking. I was trying to think incredibly quickly as to how this picture would get in. I was sitting in a very fancy office and a whole direction to my life was ahead of me in one way and a whole direction was behind, tugging at me. George said, "Would you cut the painting?" And I said, "No, I'm not going to do that. It's on wood, so it can't be cut." (It could be cut but I didn't want to cut it.) Then I said to him, "What about the windows? You could take out the window and have it hoisted in through the window." He said that taking the window out would cost more than the painting. I was not sure if he was right. Anyway, I was trying to think as fast as I could. Somehow, I thought to ask, "Is there a service elevator?" He said, yes, there was. This man was like Mr. Casual, and he was probably born that way. His personality and my personality were so different. He said, "I can show you where it is." We went out the front door of the gallery, into the hall, and then through a door and there was an elevator. The cardboard dummy that I had brought up with me fit by about two or three inches. I was jumping up and down, really jumping up and down, and this man was cool as anything.

Every month he sent me a check. On the first of the month, like Swiss time—his family was Swiss—he sent me this check. It was an amazing period of time. It was so much pressure. It was wonderful, but we were terrified.

MP: Was that your first solo show in New York?

SD: Yes. I did this painting and two other paintings and there were a lot of drawings. But it felt eerie, like it was kind of like a story, like a children's story, or a fairy tale. So many things could have happened to *not* make this work: if George had gotten up on

the wrong side of the bed, if he had had a fight with his wife, if maybe some business downturn took place. Really remarkable. And this was, at the time, a major New York gallery and it was very well-respected.

MP: Do you know if Antonio López García saw the show?

SD: I don't know if he saw the show, but the catalogs that they printed—I should show you a catalog, they're very well done—they went all around the world, so he would have been sent the catalog. I had the good fortune of meeting Antonio López a few years after, and he only speaks Spanish, so we spoke through a translator. But he is a very interesting man. Had I not seen a reproduction in the newspaper of a sculpture of López's of a woman sleeping, which was written up, I would not have gone to that gallery, because that gallery was not particularly a gallery that was friendly to figurative art. In fact, López was the only figurative artist they showed at that time. All the rest of the work consisted of different types of abstraction or different directions. But I didn't know this. Harry Bertoia was there for a long time, as was George Rickey and Morton Kaish. And a Japanese sculptor, Masayuki Nagare. But it was not necessarily at that time a pro-figurative gallery. It changed after this period, and they brought in other Spanish realists such as Claudio Bravo, who showed there a lot.

MP: Interesting.

SD: It was very lucky. You know, it was lucky seeing the reproduction of López's work and it was lucky that I came to this crisis and it forced me to act. This was literally the first gallery I every approached. I mean, you know, there are people who spend years doing this. I suppose an artist needs an incredible eye or vision.

MP: And, with this in mind, maybe you could talk a little bit about your theory of the flying eyeball.

SD: Well, when I did this painting I saw the movie *The Man Who Fell To Earth*. It's a movie where David Bowie plays an extraterrestrial who is absolutely wonderful-looking but really a total space cadet. There's a scene in the movie where he goes into an apartment house, but before he goes into the house he sees a plant in front of the house. The camera shows him looking at the plant and then, amazingly, he takes his eyeball out and puts it into the plant. Then he goes upstairs and he can tell who's coming into the house because the eyeball keeps feeding him the information. When I started the *Triptych* in Germany, I saw a very deep landscape out the windows. What appealed to me was the way that the landscape diminishes down to tiny pieces of visual information that are like a sixteenth or a thirty-secondth [of an inch] in size. Each one of those "dots," when juxtaposed with the figures, appears almost smaller than they are. I almost had this feeling that when I looked out on the landscape I could send my eye *out there*, all the way out, and the eye would look down and send back the information to me and then I would record the information the eye was sending. That's my theory.

MP: Well, it's interesting too, when I started thinking about it, the windows here in the central panel create a binocular vision into the landscape and we often forget that we actually see with two eyes and not one. We see in a binocular fashion. And, the way the landscape is rendered is so clear, there's no atmospheric perspective, there's no sort of fading off into the distance. It's not like you're looking at something in an eidetic kind of way. It's crystal clear. It's there, in front of you.

SD: I think the difference is the diminution in size. I would say it's not a painterly diminution, it's a graphic diminution.

MP: I wasn't quite clear on what you meant [in your e-mail] by *seeing* versus *perceiving* or *looking* versus *seeing*.

SD: In the painting, there's an image on my side of two men. Many of the images in

the *Triptych* came to me from newspapers. The story about those two faces is that a year or two before I began this painting, one of these men was arrested in New York City for committing rape. It was a trial that was covered in the news and got a lot of attention. This person was arrested and he was a very quiet, maybe even somewhat nerdy individual. He claimed that it was not him. He was *positively* identified by the victim. It was in the early seventies, a period of time when there was lots of crime in New York. A few months later, another man was picked up on some other charge and ended up confessing to the rape. The newspapers show these two heads together and they differ slightly, but they are very close. I think that's the difference between seeing and perceiving and looking versus seeing, because if you take students of mine, they will tell me that after we focus on a portrait, the eye, the nose, or the mouth, they start seeing things so differently. They'll tell me that people they see in the subway, or their families, or loved ones, lovers, husbands, wives, that now they're really seeing their eyes—the glow in their eyes, the shape, the movement. And we don't really *see*, we just sort of look in a casual way. I think that's one of the themes in the painting—really looking at something, and through that intense looking we are becoming who we are. We are becoming ourselves. We are becoming the best of ourselves that we can be.

MP: I think only a few people really are even aware of that or think about really seeing things. Most people just go along and look at the world in a very superficial way. I think for artists, because of the training, because of what artists do, they inherently look at things much more closely and see things.

SD: Giacometti would be a great example of that. If you read some of the things he says about perception and seeing, they're remarkably insightful. Yes, I think it's incredible and a wonderful part of doing art. Especially a certain type of figurative art. And you could almost argue that the instruments on the table are a means of harnessing this seeing to make art.

MP: It may have been Robert McGrath who pointed out a number of similarities between the images on the wall and the figures in the painting. The Madonna and

Child figure by Donatello and Renée and Simone. There was even a reference to your beard being Assyrian, I think.

SD: And I think he talks about the hands, the gesture of the hands. Some of it I think is conscious and I would say a good deal of it is not conscious. I never thought of the gesture of the hands. I liked the Donatello sculpture. It's not that I was trying to say this is the echo of Renée and Simone, I just liked it. Maybe I liked it for the same reason I liked Renée and Simone. It's kind of hard to say.

MP: And the Holbein portrait is at the center of the painting.

SD: The Holbein painting is located in Berlin. That painting is wonderful; it really has to be seen in person. Holbein used colors that you would not think of in the Renaissance. Like a certain type of green that he used which is like an acidy moss green and you don't really see that color in Renaissance painting. What he's depicting there is a merchant, whose name is Georg Gisze. He's depicted with the accoutrements of business, notes to himself, or notes that other people have given him in terms of loans, jottings, all kinds of things. There's a tapestry that he is leaning on. It's painted with the immaculateness of Holbein's paintings. And I loved the painting and it somehow, in a reproduction, found itself on my wall. It was only afterwards that I thought "this is such an interesting thing to put there because it's kind of a paragon of the whole painting." In other words, the objects around us identify who we are. Just a bit above it there's this wonderful painting by Edwin Dickinson. It's not as expansive as the Holbein painting, yet it's really the artist in the artist's world. That also seems a bit of an analogue for the *Triptych*.

MP: It's almost as if it says something very similar but the language is just much different.

SD: Yes and that also has to do with the studio and the studio world. The painting by Holbein makes me think of the stories of Thomas Mann. And I think in *Tonio Kröger*

he describes himself as a *bourgeois manqué*. What he's saying is that he had all of the everyday mannerisms and effects of a member of the bourgeoisie. The regularity, the businesslike quality, the "at it" work ethic, *but* he is a writer, and in a sense, this depiction of Georg Gisze is for Holbein, his *Tonio Kröger*.

MP: It's also been noted that there is an altarpiece-like quality of the *Triptych* and I'm wondering if maybe you could say something about that.

SD: I'm very unreligious. I think I have a strong spiritual side, but I don't think I believe in heaven. I don't want to alarm you.

MP: No, no, I gathered that from our previous conversations, that's why I find it so interesting.

SD: The altarpiece would be an altar of study, or the study of art, or the study of the meaning behind things. I'm not a person who knows a lot about Kabbalah, but I think one of the cruxes of the study of Kabbalah is to find the hidden force, the hidden meaning, or struggle behind an object, below a table, behind a wall, and I must say I'm fascinated by that. So, it could be an altar to the hidden Kabbalah, I don't know, but if it is an altar it may be an altar to perception. I'm not sure I know how to put it.

MP: I know the importance of the painting in your overall body of work, and you've mentioned a "search for identity," and I'm wondering if by that you mean that this [painting] played an important part in simply your maturation as a person, not only an artist, but just as a human being.

SD: Yes, yes. But I guess I don't think of it for myself, I think of it . . . we all have things that we care about for different reasons, and sometimes the reasons aren't apparent. We could almost say that we are the sum total of the matrix of all those things that we care about. So, in my case, they are very visual, but some of them are not—some of them are written. So, you could almost argue that this visual baggage—all of

these pictures, all of these images—is an attempt to define who this artist is, who this person is. Just as in a weird way, if you went over to someone's house and looked at their office space and looked at the pictures they had up, or looked at their refrigerator and looked at what they put on it, or followed them around for a day and looked at what they clipped out of the newspaper, what was important to them—that may change over a period of time, but if you are a good detective, I think that it would say something about those people. We collect these things, that's how we deal with the world. We are making choices and those choices say who we are.

MP: Absolutely. We talked a little bit before about your desire to go to Spain initially, and you eventually ending up in Germany [on the Fulbright]. Maybe you could elaborate on living near Kassel and you mentioned wanting to be in a small town with an old-world character.

SD: I think both of these examples would be a good example of life being surprising, perhaps you could say "be careful what you wish for." I tried to go on a Fulbright grant to Spain, and I had written as my proposal, to study with Antonio López García, which seemed perfectly legitimate and heartfelt. I think that if I had gotten that grant to Spain, I could never have done anything as good as this *Triptych*. My second choice was Germany, and amazingly that came through. And I should add that I never thought I was even a fit candidate to apply for a Fulbright grant. An artist friend, Shirley Pulido, previously had a Fulbright grant to France. I had told her that I was interested in applying for one but I didn't think I was yet skilled or mature enough as an artist to apply. She really encouraged me to try for it. So, the application to Germany came through and I ended up being connected with the Hochschule für Bildende Künste in Kassel. We had a lot of difficulty finding a place to live. I remember we drove through a town which was called Rabelshausen. This was a totally intact 1500s town. The roofs of the buildings were thatched, the animals lived on the bottom floor and the people lived in the floors above. We looked at an apartment that was for rent. This apartment looked like Van Gogh's bedroom. It was unbelievable. I could have worked there in that apartment for years. Renée looked at this and said "No

way are we going to live here." We eventually found an apartment in another town where we looked at a building and saw windows with no shades or blinds. It was in a very nondescript town, called Hessisch Lichtenau. The apartment had no furniture, but the landlord, who was a little offbeat, said he would give us his garden furniture, which he did. We lived with his garden furniture all year. It was a big apartment and there was a room which was I think called the *Wohnzimmer*, which was the living room. There was the kitchen, and the kitchen had no appliances, no refrigerator, no nothing. We spent the year cooking on a hot plate. There were no beds and for the first few months we slept on the floor. The view out the window was so boring and the apartment was so boring. I said to Renée, "You know, I don't want to be here, this is so uninspiring." Because we had so much difficulty finding a place to live, Renée felt antsy and anxious about the apartment search and she said, "You know, this is a really nice apartment, you'll find your subject here." And I think that is an amazing example of . . . it's what you bring to life; it's what you bring to the subject . . . that counts.

MP: You could have had a much more beautiful view and ended up not making the painting because of it.

SD: That's right. Oftentimes it seems to me in life you have to feel vibrations. It may not happen right away, but if you can feel these vibrations, they'll tell you what to do. I can't remember, maybe it was one day I was working on something and I looked at the table and looked at the pictures on the wall and I looked back and looked at myself looking at them and I thought, wow, this could be something. Actually, just recently, I was trying to find something which I would like to have in this upcoming book. I could not find it. It's a photograph of Renée standing in front of the middle panel of the *Triptych*, and there is no color, it's all in Rapidograph, and there's Renée at the age of twenty-seven. And, Renée is just wonderful looking. And you see the wallpaper and some of the images on the wall.

MP: Do you want to talk about the theme of the artist's process, and incorporating influences of art?

SD: Actually, you said something toward the end of our last interview, which I don't think I really understood. You were using this idea of process or this idea of quest and bringing it back to today. I thought about this and thought it was a very interesting question, an interesting point that you made. When I first started doing art, I had particular artists I liked and particular artists I didn't relate to. Then, as the years went by, one artist got stronger, more profound and interesting and another artist got less so. That's just the way it is and we should be thankful that all of our thoughts are not recorded, because we might sound really stupid. The one artist that seemed to me to grow the most in all these years was Cézanne. I can think of a few others besides Cézanne, like Giacometti, Max Beckmann, or Bonnard, but I think mostly of Cézanne. When I was a student, I didn't really connect or understand his work and now I am totally impressed with his mind and voyage. So, it seems to me that some of these palette paintings that I've been doing are not just about depicting the idea of process, but actually using process literally as an accumulation of palettes and paint and verve to paint. I could see the connection with artists like Dubuffet, Kiefer, and Cézanne. I like the openness to modernism. I don't like to feel defensive. I like to feel that I can use all different materials and ideas without hesitation and it's still about the human condition. That's very important to me. So, I would not be in the figurative camp that would decry Dubuffet, Kiefer, and Cézanne. I think it's a much more open situation, and it's incredibly appealing to me.

MP: I think that the notion that modernism can be thought of in a variety of ways and especially or specifically as far as abstract art goes versus representational art, that both of them can encompass the human condition as equally as one another is a fairly recent notion. You've got institutions and organizations such as the Museum of Modern Art for example, that have historically been very dogmatic about how they think about this.

SD: This really calls to mind something that is connected to Antonio López García. When I saw his work I began to realize certain things about him. He was the first figurative artist that I encountered who showed his work with contemporary non-objective artists, in Spain. Now, the figurative artists I knew would have never, I mean never,

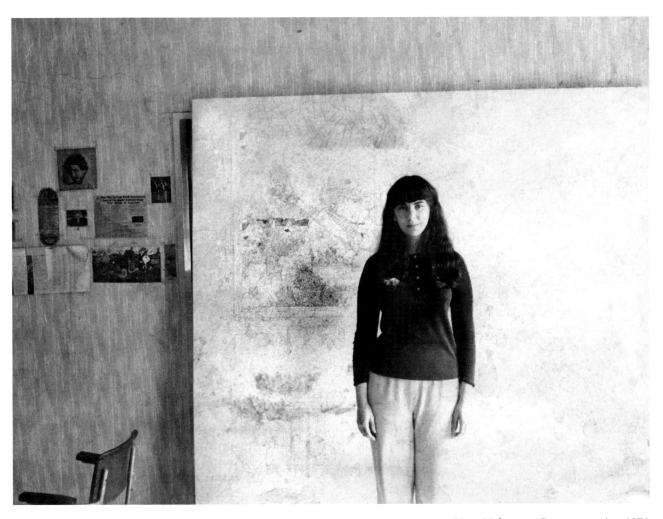

Hess. Lichtenau, Germany, spring 1971

shown their work with non-objective art. And what I liked about this point of view that López had was that he was basically saying that good art is good art. That good art is abstract, and that his art would project strongly wherever it's shown, whether it's [with] non-objective or figurative art. And he wasn't defensive about it. I thought that it was a way of coming at contemporary figurative art that was incredibly refreshing.

MP: Will Barnet said something to me once that I thought was interesting. When I had a studio visit with him, he had work from the seventies on the wall—you know, quintessential black-line figure, very stylized figures, as well as some earlier abstractions he had done in the sixties and some abstractions that he was working on then, this was maybe three years ago. And I looked at all of these together and I said to him, "There are so many similarities between these abstract paintings and that painting there with the figures in it." He looked at me and said "I don't make any difference between them. The compositions are similar and the same rules apply to both types of paintings."

SD: I remember seeing a show of de Kooning and there's a painting de Kooning did called *Excavation* that I think is totally stunning. I just was stopped in my tracks by that painting. If I was to do a figurative work on the level of that painting, I think I would be doing just fine.

MP: Maybe we could return to talking about the Courbet painting. Perhaps you could elaborate on what you said before.

SD: He's a very interesting artist and that is a painting I've always been attracted to. You're not the only person who's mentioned the connection between *The Artist's Studio* and my *Triptych*. The first time I saw that Courbet in person was when it was hung in the Louvre, in a long gallery near *The Raft of the Medusa*. Now they have the painting in the d'Orsay Museum. Actually, it's quite hard to see because of a lot of glare on it. I don't quite know why the curators don't see that. It's a very romantic painting and it's a romanticized image of the artist and the coterie of friends who are visiting

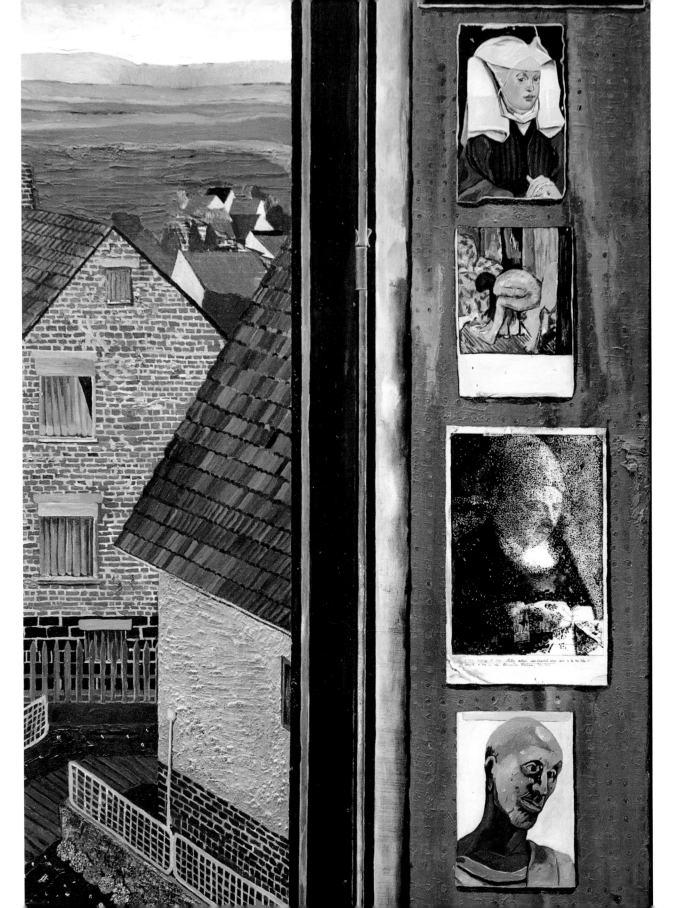

or schmoozing or whatever they're doing in the artist's studio. It's a wonderful image of an artist, the nude, who you might guess was the artist's muse, and a child sitting nearby. I guess the studio is a place of great wonderment and kind of a hymn to who we are and where we're going, and I think that Gauguin's title for one of his paintings, which I can't remember now, would be perfectly appropriate.

MP: Where do we come from? Who are we? Where are we going?

SD: Yeah, it's perfect.

MP: Linda Nochlin wrote a major iconographic analysis of that Courbet painting and she identified each one of the characters and how they were related to Courbet.

SD: I think the painting has had a curious history in that I think he rented an exhibition space to show the painting and it was one of these things that really got very little attention when it was first shown. There's not a little bit of ego in that painting. It has a certain kind of bravura about it.

You know, I'm going to go back to Penn State University with Renée, Simone, Simone's husband Jeremy, and their son Adrian, my grandson. Everyone is very keen on seeing the *Triptych* again. Art is amazing in that if you just move it slightly from one wall to the other it looks different. And if you don't see it for a while and you think about it, and go to see it, it also looks different. Both my wife and daughter have seen this painting a number of times, quite a number of times. Renée especially saw it from zero to the fruition of the painting. She is really interested in seeing it again. Art can be especially communicative, special, and tangible. Some people feel that art has that tangibility and some people, no matter what you can convey to them, they don't get it. I feel very fortunate because my daughter gets it, my wife gets it, my son-in-law, hopefully my grandson, and that's terrific.

MP: I know one of the things that you wanted to discuss was consciousness and the way that visual images provide a baggage that pushes a more and more acute con-

sciousness. Certainly the *Triptych* is filled with so much visual imagery, and different visual images assembled in a very specific way. Maybe you could elaborate on your thoughts on how visual images provide a certain type of baggage.

SD: I should preface this by saying that I didn't do a painting about consciousness, but consciousness is something that I'm very interested in and it must have somehow come through in the painting. I would like to think that human beings can live very fully, i.e., live with a high degree of consciousness. I mean that they are accepting great amounts of stimuli and are enjoying it, going with it, embracing it, riffing on it. Consciousness means that you're getting your money's worth. You've got your one shot and you're . . . the blues are bluer than blue, the reds are great, the yellows are wonderful and we are amalgamations of so many different things from grade C to grade A and from a van Eyck painting to a child's drawing of a dragon; from a spelling lesson to Wittgenstein. I think that's an important thing to be aware of.

MP: Do you think that . . . this may be veering off topic just a little bit, but do you think that there's so much overstimulation of imagery in our society today that the ability to achieve a higher consciousness has changed on some level or become more difficult for people? My feeling, at least, is that very few people operate in their lives with a higher . . . greater receptivity to being open or a greater consciousness operating on a higher level in some way. Many people just go through their lives without experiencing that.

SD: Your hunch is that very few people experience that?

MP: Yes.

SD: I agree with you, but I think it's a worthwhile goal. It's really the way to live. It's as though each day you received all this stimuli, ideas are bouncing around in your head, and you just can't contain yourself because there is so much that you were taking in. Earlier on we were talking about this book by Herman Hesse called *The Glass*

Bead Game. If I remember this right, I think those glass beads would be equivalent to the different images in my *Triptych* that could provide non sequitur responses to life.

MP: Movies have been very influential on your visual development, haven't they?

SD: Yes, I am a very big fan of cinema. In fact, I think that film has kind of replaced a certain direction in visual arts or has co-opted that place and it's a shame.

MP: The medium does something that static pictures can't do. They're moving, there's sound.

SD: I wasn't thinking about the moving part, I was thinking about the depth, the challenging subject matter. There's a modern element, but human and touching and dealing with our human condition. There seems to me to be less and less of that in the fine arts and more of that in film.

MP: Recently I've noticed a resurgence of interest in humanist content in contemporary work, especially with artists of my generation. I think on some level that's probably a response to the current cultural climate that we're facing. There's a bit of a crisis type . . . the same thing was true in the late sixties and early seventies in response to the Vietnam War. Maybe humanist content waxes and wanes as far as its popularity.

SD: I could agree with that.

MP: Another point that I know you wanted to discuss is your experience living abroad, both in Germany and then in Italy.

SD: I lived in Germany for a year and when we got back I really thought that was the limit of my good luck and good fortune. To my great amazement, a few years later, I received a Rome prize to study in Italy at the American Academy in Rome, so I was able to study or continue painting in both the north and south of Europe. Those are

very different experiences. Perhaps it would be interesting to write about that. There were people I encountered who didn't like living in Rome. But if one likes living in Rome as I did, it's the most beautiful place that you can imagine, ravishing, stunning. This was five years after we lived in Germany. Living in Germany was not the most beautiful place one could think of, but it was very thought-provoking, very engaging. Life offers great ironies and I guess one of the most supreme ironies is that we went to Germany with a certain amount of mixed feelings—my wife and I. Yet, I don't think that the painting that this book is the subject of could have been done anywhere else but in Germany. I guess it really speaks to surprise in life, and not being too sure of what you feel.

MP: The aesthetic tradition is very different in the South as opposed to the North.

SD: Yes, it is very different. Aesthetically I can easily identify with a certain German idea of what would be called plain statement. Exact plain statement. Which I think John Russell would have said if he wrote about Dürer and engraving and a certain kind of German character. I can easily identify with that. I think there are aspects of this painting that identify with that spirit. That's not what I'm talking about really, I'm talking about a political and moral side which . . . nowadays it's a different time period, but 1970 was simply twenty-five years after the Second World War. We had lots of questions about going there, but it was a period of great growth for us, really stunning.

MP: Do you think you grew as much during your time in Rome as you had in Germany—as an artist?

SD: I think I did, but there, what caused the growth was the people I kept meeting. These were very strong personalities that were at the American Academy in Rome, people that I would have never come across: a composer like Bob Beaser, a poet like Miller Williams, I would have never met them. Miller came from Arkansas, Bob had been to Yale and was either teaching at Yale or going to school there, and I had no connection with those two worlds. It was incredibly stimulating meeting someone like

Rudolf Arnheim. It was really challenging. The city of Rome wasn't challenging in that way. Rome was simply unbelievably beautiful, architecturally beautiful. It's not a city that you can argue with. The main phrase is *pazienza*. The city doesn't yield; you yield to the city.

MP: I'm embarrassed to admit I've never actually been to Rome. I've been through it a couple of times.

SD: There were lots of people who didn't like Rome but, for the people who did like it, Rome was like a dreamscape. I heard that many times over and over from people who have spent a period of time there and liked it, that it had a dreamscape quality, a dream city quality.

MP: You didn't feel that?

SD: I did, very much so—a real dreamscape. This is extremely fortunate, it's good luck times two—squared.

Appendix

The Fulbright Triptych: A Map

Simon Dinnerstein: A Retrospective

Looking at One's Own Artwork
Simon Dinnerstein

Artist's Biography

The Fulbright Triptych: A Map

The Fulbright Triptych: A Map

1. Roberto Ortiz (age 8)
2. Jan van Eyck, *Madonna in a Church*, c. 1437–1439. Staatliche Museen zu Berlin, Germany
3. Renée and her father, Sam Sudler
4. Phonogram card, Spalding Unified Phonics
5. Alfredo Quinones (age 6)
6. Jean Miele (age 10)
7. Subway booth photograph, Renée and Simon, 1965
8. Subway booth photograph, Renée and Simon, 1965
9. Dieric Bouts, *Mater Dolorosa* (Sorrowing Virgin), c. 1480-1500. Art Institute of Chicago
10. Barbara Ann O'Toole (age 6)
11. Child's drawing
12. Giovanni Bellini, *Saint Francis in Ecstasy*, c. 1480. Frick Collection, New York City
13. Ian Lewis (age 6)
14. Child's drawing
15. Jean-Auguste-Dominique Ingres, *Portrait of the Comtesse d'Haussonville*, c. 1845. Frick Collection, New York City
16. Photograph, Roxbury, Vermont, 1968
17. Hans Holbein the Younger, *Portrait of Jakob Meyer*, c. 1516. Kunstmuseum, Basel, Switzerland
18. Primitive fertility figure, Aegean/Cycladic
19. Persian miniature
20. Child's circles, Spalding Unified Phonics
21. Georges Seurat, *Woman Reading in the Studio*, c. 1887–1888. Fogg Art Museum, Harvard University, Cambridge, Mass.
22. Giovanni Bellini, *Sacred Allegory*, c. 1490–1500. Galleria degli Uffizi, Florence, Italy
23. Harvey Dinnerstein, *In the Kitchen,* 1960-1961
24. Edwin Dickinson, *Self-Portrait*, c. 1943. National Academy Museum, New York City
25. Gloria Mintz, "Solitude"
26. Käthe Kollwitz, *Pregnant Woman*, c. 1910
27. Georges Seurat, *Models*, c. 1887–1888. Barnes Foundation, Merion, Penn.
28. Johannes Vermeer, *The Art of Painting*, c. 1666. Kunsthistorisches Museum, Vienna, Austria
29. Jan van Eyck, *Eve* (detail), *Adoration of the Mystic Lamb*, c. 1432. Cathedral of Saint Bavon, Ghent, Belgium
30. Persian miniature
31. Hans Holbein the Younger, *Georg Gisze*, c. 1532. Staatliche Museen zu Berlin, Germany
32. Quote, Ludwig Wittgenstein, *Philosophical Investigations*
33. Letter, Renée to Simon Dinnerstein
34. Hans Holbein the Younger, *Portrait of a Leper*, c. 1523. Fogg Art Museum, Harvard University, Cambridge, Mass.
35. Enguerrand Quarton, *Avignon Piéta*, c. 1460. Musée du Louvre, Paris, France

36. Rogier van der Weyden, *Portrait of a Lady*, c. 1455. National Gallery of Art, Washington, D.C.

37. Edgar Degas, Pastel drawing, c. 1880s

38. Georges Seurat, *The Artist's Mother*, c. 1882–1883, The Getty Museum, Los Angeles

39. Donatello, *Habakkuk*, c. 1427–1436. Museo dell'Opera del Duomo, Florence, Italy

40. Child's drawing

41. Willowbrook photograph

42. Larry Clark, *Tulsa* series, c. 1971

43. Photograph, Hebert and Andrea Wenderoth, Germany, 1971

44. Jean Fouquet, *Portrait of Charles VII of France*, c. 1445–1450. Musée du Louvre, Paris, France

45. Assyrian relief

46. Photograph, late 1960s, *The New York Times*

47. Jan van Eyck, *The Last Judgment* (detail), c. 1425–1430. Metropolitan Museum of Art, New York City

48. Subway booth photograph, Simone, Renée, and Simon, 1974

49. Jan van Eyck, *Baudoin de Lannoy*, c. 1437. Staatliche Museen zu Berlin, Germany

50. Subway booth photograph, Simone, Renée, and Simon, 1974

51. Photograph, Renée and Lucky, Roxbury, Vermont, 1968

52. Soviet exit visa

53. Andrea Wenderoth (age 6), Portrait of the Dinnerstein family

54. Quote, Herman Melville, *Moby-Dick*

55. Edgar Degas, *Woman with Chrysanthemums*, 1865. The Metropolitan Museum of Art, New York City

56. Donatello, *Madonna and Child*, c. 1446. Basilica of Saint Anthony, Padua, Italy

57. Sumerian figure, from the Square Temple of Tell Asmar, modern day Iraq

58. View from the Dinnersteins' apartment, Germany

59. View from the Dinnersteins' apartment, Germany

60. Lens

61. Circular mat cutter

62. Stopwatch

63. Sycamore frond

64. Burnisher

65. Scraper

66. Burin

67. Dried out potato

68. Engraving plate

69. Leather pad

70. Steel table plate with artist's signature and date of painting

71. Pencil stubs

Simon Dinnerstein: A Retrospective

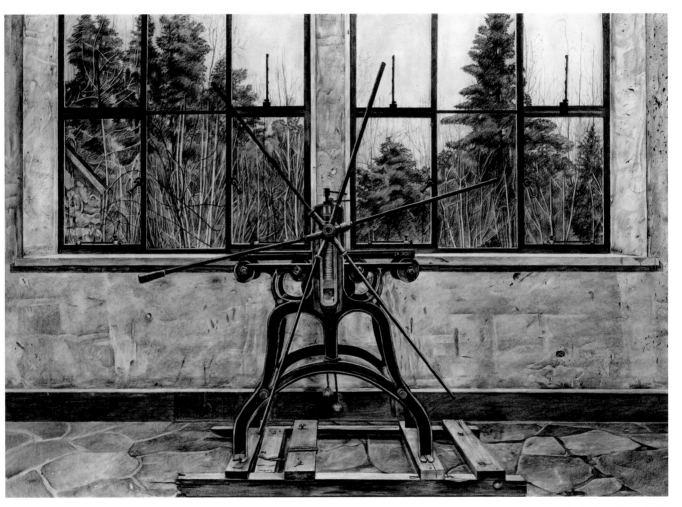

The Kelton Press, 1969

An early influence on Dinnerstein is the tradition of northern European realism, with its stress on a graphic naturalism, formal concerns, and what the art critic, John Russell, described as "the ancient German tradition of exact plain statement."

In Dinnerstein's drawing of his wife's uncle, Arnold, born Abraham Lincoln Friedman, the subject is represented in intricate detail, with every line, pebble, hair, shoelace, grain of wood, crease, and check delineated. As Dinnerstein recollects, "The day became for Arnold a kind of ritual: the posing, the conversation, the dinner, and the car ride back to Jamaica, Queens."

Arnold, 1972
Charcoal, conté crayon, lithographic crayon
84 x 36 in.
National Academy of Design, New York
Robert Dale Jones in loving memory of Mary Catherine Gray Jones

See:
Guy Davenport, p. 51
Marshall Price, p. 258

◄ *The Kelton Press,* charcoal, 25 ½ x 39 ½ in., 1969, Collection of Howard and Harriet Zuckerman

Arnold, 1972 ➤

In progress while Dinnerstein was painting *The Fulbright Triptych*, this drawing explores the relationship between past and present in the respective lives of artist and subject. As the Dinnersteins' next-door neighbor in Hessisch Lichtenau, Germany, Marie Bilderl lived alone in a one-room apartment; her main company the haunting pictures on her wall, images of children and family members no longer living. "Other than quick weekly visits from a son who brought her food for the week," Dinnerstein recalls, "her primary contact with the world seemed to be limited to her interchange with these photos, her radio, and her sessions posing for my drawing."

Well into his Fulbright year, Dinnerstein asked Marie to pose for him. In her late eighties, she would pose for five minutes, then sit for the remainder of the hour. While she rested, Dinnerstein continued to draw and chat, with each session lasting for roughly three hours.

The picture still wasn't complete when the Dinnersteins left Germany. Marie gave Dinnerstein a number of items to help him complete the drawing: her apron, bedspread, and a ceramic heart.

Recalling *Marie Bilderl*, Dinnerstein explains:

Portraiture is an important theme in my work. In his essay, "Why the Novel Matters," D. H. Lawrence compares the novel to a human being: "the novel as a tremulation can make the whole man alive tremble." I suppose he meant that the full, rounded depiction, or portrait, found its analogy in the form and complexity of a novel. In my portrait of Marie Bilderl, it is this fullness of form that I strove for. While reflecting on *Marie Bilderl*, the drawing and the portrait, I realized that the little red heart she gave me hangs by a string on the left side of my desk . . . a curious thing to see after all these years.

Marie Bilderl, 1971
Charcoal, conté crayon
41 ½ x 49 ½ in.
Minnesota Museum of Art, St. Paul, Minnesota

Marie Bilderl, 1971

Five years after returning from Germany, Dinnerstein was offered the opportunity to study at the American Academy in Rome (1976-1979). Modeled after the flower market in the Campo dei Fiori in central Rome, *Flower Market, Rome* is a celebration of the habits and haunts of Dinnerstein's life in Italy, as well as the city itself. As Dinnerstein remembers, "The flowers, glowing in Rome's warm light, were mesmerizing. The stands were integrated into the city's design. Viewed from across a street, they were dazzling."

Over many months, Dinnerstein recreated this stand in his studio, bringing in numerous bouquets from his city strolls, or visits to the wholesale flower market on Tuesday mornings.

Flower Market, Rome, 1977–78
Oil on canvas
76 x 121 in.
Collection of Kirby Westheimer, Princeton, New Jersey

See:
Richard T. Arndt, pp. 184, 187
Rudolf Arnheim, p. 37
Albert Boime, pp. 238-239
Guy Davenport, p. 52
Gabriela Lena Frank, p. 211

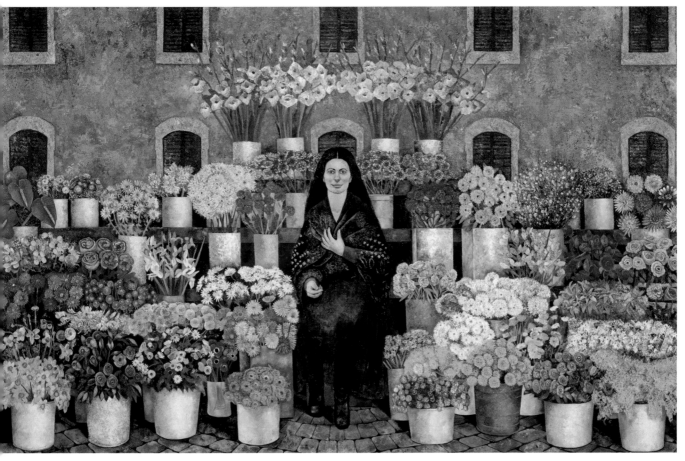

Flower Market, Rome, 1977-78

Through the influence of Rome's dazzling light, architecture, and sensuality, Dinnerstein's previously graphic work began to include a new sense of air and atmosphere. *Mid-Summer* explores the play of light, as well as the underlying energy present in all things. "Students of the kabbalah claim that there is a spirit located below the surface," Dinnerstein explains. "I suppose the artist searches for this essence and attempts to caress it."

Mid-Summer, 1987
Conté crayon, colored pencil, pastel
36 ½ x 51 ¾ in.
Collection of Isaac Erlich, New York

Mid-Summer, 1987

In the 1980s, Dinnerstein worked on a series of drawings of Cheryl Yorke, a student at New York City Technical College in Brooklyn. One day Cheryl came into Dinnerstein's class with small, delicate shells braided into her hair. "Her beauty and grace had me totally transfixed," Dinnerstein recalls, "and I asked her if she would pose for me."

Beginning with *Late Afternoon*, the series continued with *January Light*. While working on *January Light*, Dinnerstein had an image of Cheryl asleep, with the moon somehow present. As she posed, she shared stories of her childhood in St. Vincent, inspiring Dinnerstein to recreate the scenes in the drawing. As Dinnerstein explains, "The drawing proceeded with such ease that at times it almost seemed as if someone was drawing along with me or guiding my hand."

During an exhibition at Gallery 1199 in New York (1985), *In Sleep* inspired discussion about the overall meaning of the work and its references. Various interpretations were offered, from plantation scene to migrant workers, William Blake to Gothic entombments, Caribbean mysticism to Mexican realism. "Since all these ideas were interesting but at great variance with my vision," Dinnerstein says, "I can't help but wonder how much the artist really knows about what he or she has created."

In Sleep, 1983
Conté crayon, colored pencil, pastel
33 ½ x 59 ⅛ in.
National Museum of American Art, the Smithsonian Institution, Washington, D.C.
Gift of the Sara Roby Foundation

See:
Albert Boime, pp. 232-234

In Sleep, 1983

The last in the series of four drawings of Cheryl Yorke, *The Quiet Woman* juxtaposes the subject with a thick, leafy tetrastigma plant. "Something of the texture of the plant and the model's sensuality seem to mirror each other," Dinnerstein recalls. *The Quiet Woman* explores the tradition of combining the floral or still life with portraiture, "two elements [that] almost seem in conversation."

The Quiet Woman, 1988
Conté crayon, colored pencil, pastel
30 ⅛ x 43 ½ in.
Collection of Laurence Fishburne, New York

See:
Albert Boime, p. 232

The Quiet Woman, 1988

Inspired by a class play in his wife's pre-kindergarten classroom, *Night* explores the intersection of emotions, from energy and excitement to impatience and anxiety. While viewing the performance, Dinnerstein felt that "the elemental force and anima of these four-year-olds were palpable. The children were impatient to put the masks on, but once inside them they grew nervous and were quick to take them off."

Emulating a child's crayon-scratching to represent the hauntings and fears of childhood, *Night* depicts skeletons, witches, bats, masks, and most importantly, the El. To Dinnerstein, growing up in Brownsville, Brooklyn, "the El seemed to mysteriously disappear under the street, intriguing and frightening me throughout my childhood." By using a child's drawing technique tempered by adult sophistication, *Night* merges a child's reality with the world of fine art, evoking the spirits of Chagall, Ryder, Breughel, Gillespie, and Kiefer.

Night, 1985
Conté crayon, colored pencil, pastel
36 ½ x 76 ⅜ in.
Arnot Art Museum, Elmira, New York
Gift of Robert Dale Jones

See:
Albert Boime, pp. 239-242
Guy Davenport, p. 52
Thalia Vrachopolous, p. 94
Richard Waller, pp. 136-137

Night, 1985

After viewing an evocative photo of Iranian Shiites at a mosque in Damascus in the *New York Times*, Dinnerstein pinned the photo to his bulletin board and waited. As he says, "I felt that at some moment in the future, the rays and vibrations would bounce out of the photo, and I would know how to compose my picture."

While working, Dinnerstein felt he "was dreaming and drawing at the same time." Depicting important people from Dinnerstein's life, in and out of time, alive and no longer living, older and younger, *A Dream Play* evokes the dream state where irrationality has a certain eerie order. As in the words of the poet Wisława Szymborska, "Memory's finally found what it was after."

A Dream Play, 1986
Conté crayon, colored pencil, pastel
38 ¼ x 82 ½ in.

See:
Albert Boime, pp. 228, 231-234
Thalia Vrachopoulos, p. 94

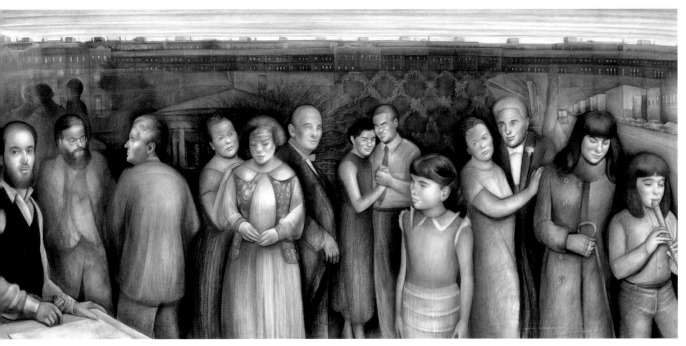

A Dream Play, 1986

When Dinnerstein began *Purple Haze*, he imagined a woman floating over New York City. Choosing a view from the nineteenth floor of a building at Fourteenth Street and Seventh Avenue, facing New Jersey and the World Trade Center, *Purple Haze* became a kind of collage, juxtaposing the woman and the city.

Shortly after Dinnerstein completed *Purple Haze*, three friends visited his studio. One of the visitors asked if Dinnerstein had ever read *The Master and Margarita* by Mikhail Bulgakov. When he later began reading the novel, Dinnerstein wondered about the reason for the recommendation. As Dinnerstein recalls, however, about a third of the way through,

> I read a section that made the hair on my neck stand on end. My drawing could literally have been a visual interpretation of a key scene described in Bulgakov's book. I can only consider the connection between such a major work of literature and my picture as a great compliment. It speaks, also, to the mysteries of art.

Purple Haze, 1991
Conté crayon, colored pencil, pastel, wax crayon, oil pastel
25 ¼ x 63 ¼ in.

See:
Gabriela Lena Frank, p. 211

Purple Haze, 1991

Reflecting Dinnerstein's study of the nude by such diverse artists as Degas, Klimt, Schiele, Freud, and Balthus, *Passage of the Moon* explores the dialogue between Western and Eastern traditions. After completing the drawing *Passage,* Dinnerstein and his wife traveled to Italy, where they had lived eighteen years earlier. An exhibition of Japanese art on display at the Palazzo delle Esposizioni included folding screens, one of which stopped the artist in his tracks. As Dinnerstein explains, "I immediately imagined my recently completed nude reclining in front of it!"

Burnishing, scratching, and scraping the surface, Dinnerstein used an intense red and vermillion underpainting to recreate the richness of the screen, combining gold leaf with oil paint.

Passage of the Moon, 1998
Oil and gold leaf on wood panel
47 ½ x 67 ½ in.
Collection of Henry Justin

See:
Gabriela Lena Frank, p. 210
Marshall Price, p. 255

Passage of the Moon, 1998

During his stay at the American Academy in Rome (1976–1979), Dinnerstein began saving his palettes, becoming intrigued by "the small sculptural blocks representing the daily residue of paint." He recently returned to these palettes, using them as foundations to explore texture, sensuality, and the signature of the artist. Representing the dialogue between the nude and the artist's palette, *At the Still Point* explores the being and becoming of a work of art.

As Dinnerstein recounted,

> While working on the study I remembered seeing the play *The Dybbuk*. This is a story of a young, beautiful and haunted woman who speaks with the deep, melancholy voice of her rejected suitor. My palette seemed to be occupied by a spirit or dybbuk. It is at this point where the nude, in the throes of some process of artistic realization, fights to breathe and become alive. Her corporeality and the sensuality of the paint formed a mysterious conversation. One wonders who is in charge: the artist manipulating the paint or the image demanding to be born.

At the Still Point, 2004-06
Oil on wood panel
72 x 79 x 3 ¾ in.
Collection of Robin Quivers

At the Still Point, 2004–06

Dinnerstein has a particular routine for setting up the colors on his palette, every other day adding fresh paint on top of the already existing, dried colors. As he explains,

> I began to take notice of what was happening to my palette. It had become a kind of found object, fossilized and affected by time, endowed with a purposeful randomness. Looking intensely at this object, I began imagining, and then painting, a self-portrait, my face, peering out of the small void in the center of swirls of built up color. As I painted, the palette seemed to revolve and rotate, with paint appearing as if it had its own force surging through it. The surface looked like a topographical map, bringing forth traces of oceans, landforms and continents. I found myself adding botanical forms as they appeared to me.

Solaris, 2003
Oil on Plexiglass palette
20 x 18 x 3 in.

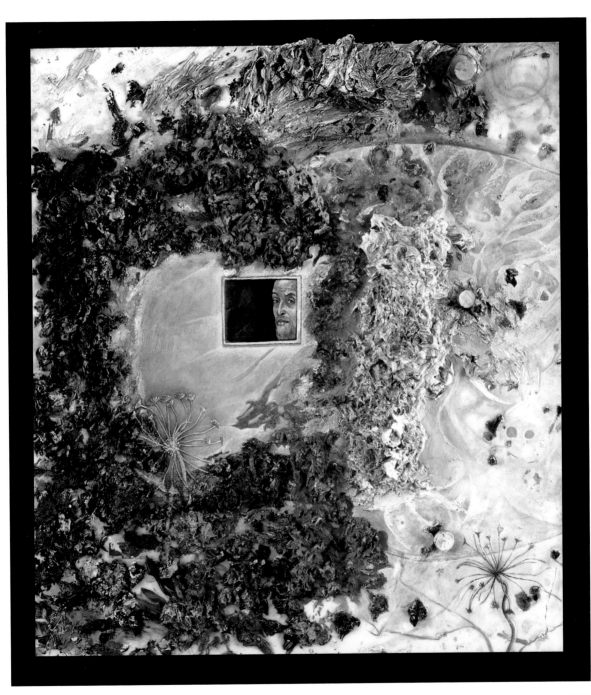

Solaris, 2003

Looking at One's Own Artwork
1986

Simon Dinnerstein

In April and May of 1985, I was occupied with a large solo exhibit of my work at Gallery 1199 in the Martin Luther King Jr. Labor Center in New York City. The gallery is adjacent to the lobby of Local 1199, the Hospital and Health Care Employees Union. My father, Louis Dinnerstein, had been an active member of this union. I usually exhibit at Staempfli Gallery in New York City, but when this opportunity presented itself, especially with the large space available, I eagerly jumped at it.

Gallery 1199 is a nonprofit space, so almost all of the preparations for the show were done by myself and an enthusiastic cadre of my students. Works arrived from various locations—private collectors; Pennsylvania State University; the law firm of Paul, Weiss, Rifkind, Wharton, and Garrison; and the Sara Roby Foundation—on April 2, the day the show was to be hung. There were thirty-five pieces representing a fourteen-year span from 1971 through 1985. As one can imagine, the scene at the gallery when the works arrived was chaotic and most intense. Although I had produced the works, I had never really seen them all together.

In designing the show, I wanted to somehow separate the older work, mainly paintings, from the more recent series of drawings that had occupied me for the past four years. I was concerned with how the exhibit would hold together, since my work had changed during the fourteen years. Yet, even though my hand and eye had grown more sophisticated, there seemed to be a connective thread running through much of the work. A theme kept emerging: the interest in people—in the individual and in the dreams and mysteries, the visual information and enthusiasms that define human beings. I guess I am interested in art that attempts to get at the full measure of a person. Something about D. H. Lawrence's statement that "the novel as a tremulation can make the whole man alive tremble" has always appealed to me.

The earliest painting in the show, *The Fulbright Triptych*, was begun in 1971 in Hessisch Lichtenau, near Kassel, Germany, where I had been living on a Fulbright fellowship. At the time, I was quite interested in northern European art, and the influence

of such artists as Holbein, van Eyck, and Bellini is certainly there. Before going to Germany, I was mainly drawing, and the *Triptych* actually depicts the studio of a graphic artist. In the center panel, a copperplate is shown on a table, surrounded by tools for engraving—burins, scrapers, burnishers, etc. It is an enormous painting—about fourteen feet wide, counting the spacing between the panels—that shows the workshop of an artist involved in printmaking and drawing.

As with other images, I try to bring together some combination of abstract and design elements and the figure in an expressionistic context. Also, I like working with naturalistic images as a starting point. Elements of the *Triptych* did exist—the table, the views from the windows, and some of the pictures and instruments. These incidental and real elements became stepping-off points for a more abstracted conception.

Many times artists work by instinct and "feel," and there are lines, elements, and themes that weave their way through a work of art in some secret and inexplicable way. The *Triptych* has a number of themes, some that I was not fully aware of until much later. On its most primary level, the painting deals with the artist and his world and family. The studio is shown, and underlying it are ideas of how perception and visual stimuli define us and give us our "axis," or understanding of the world. Images abound in this diverse, mysterious, playful, and irrational universe—reproductions of Holbein's *Portrait of Georg Gisze;* Seurat's drawing of his mother; Ludwig Wittgenstein's "forms of life"; a letter from my wife concerning an anxiety dream. The left panel shows my wife and daughter and various references to my wife's work as a teacher: children's drawings; a first day's writing assignment; a page of *Os* repeated many times; a fifth-grader's rendition of the effects of pollution on our environment; a big black letter *y* islanded on white paper. The right panel deals with my own associations—from a detail of van Eyck's *Last Judgment* to a Soviet exit visa to a fire-spewing dinosaur. How amazing that so many associations having seemingly nothing to do with one another become part of one's consciousness.

As I looked around at my exhibit, I realized how strange and varied inspiration can be to an artist or, for that matter, how widely it may differ between artists. For example, the imagery for *The Fulbright Triptych* came to me in its totality. There was only one study—in gold leaf for the copperplate on the table, since I was unfamiliar with the

process of gilding. Many times, though, numerous studies preceded a large work of art, and in this show, I was able to display some of these studies, especially for the recent series of drawings.

Before discussing these latter works, it might be interesting to say something about the origins of the group. After completing the *Triptych* in 1974, I had my first solo exhibit (in 1975, at Staempfli Gallery in New York City). During the following year, I was very fortunate to have received the Rome Prize Fellowship. I lived in Rome at the American Academy with my family from 1976 until early 1979. Returning to Brooklyn, I began teaching at both the New School for Social Research/Parsons School of Design and New York City Technical College. One of the classes that was especially interesting was Life Drawing—the Figure and the Portrait. I had particular ideas for the class—about how it should be run and about the relationship between tradition and innovation. My drawings up to this point had been almost entirely in black-and-white mediums. But as I taught the class, I became fascinated with the students' use of conté crayon in the warm brown colors, colored pencils, and pastels. It was really strange—one usually thinks of the teacher being in charge, but in this case, I watched the students work with mediums I had never worked with and learned from them.

For the recent group of drawings, I mainly worked with Rives BFK paper, which I used either by the sheet or mounted onto one hundred-percent rag board. To me, the appeal of the paper has to do with a number of its characteristics: it is very white; has a bit of "tooth"; is fairly heavy and can be given a good work over; and it is a woven paper and therefore more anonymous, having no pronounced texture or grain or line running through it. I am interested in a range of values in drawing, from the white of the paper to the rich, velvety, deep dark of the conté crayon. The use of the colored pencils (Cumberland-Derwent series) to give the luster and glow of oil is very appealing to me. Also, the pencils are not altogether different from those that my thirteen-year-old daughter draws with—an idea that appeals greatly to me.

The earliest of these drawings is *Nocturne for a Polish Worker* (1982), and here again the individual is depicted in his personal world. The man I was working with and what I wanted to communicate became so complex that somehow the broken space,

or collaged reality, seemed natural, especially as a way of dealing with the subject's memory and dreams. In considering this drawing, I wondered about the "baggage" we take with us—in terms of associations with the past, loyalties to some location or dream, irrational pushes and pulls, and secret ambiguous longings. I want certain of my pictures, when the situation is right and natural, to address these thoughts and feelings. The same might be said for a drawing of my daughter called *About Strange Lands and People*. Somehow the dream imagery within the picture worked and was real, and thus enhanced the mood. The images seemed to pull out the "roundness" and "weight" of the person, just as the reproductions in the *Triptych* had done in a more naturalistic way.

Three of the most important recent works in this exhibit were of a young woman, Cheryl Yorke, who was a student of mine in an art appreciation class at New York City Technical College. This was an invigorating and challenging class, and it gave me a chance to talk about various periods and styles of art to young art students. One day, I noticed that one of the black students had come into class with small, delicate shells braided into her hair. Her beauty and grace had me totally transfixed. I enjoy using friends or chance acquaintances as models rather than professionals, so I asked her if she would pose for a portrait class. She agreed and modeled for my classes a number of times. It was advantageous and helpful for me to observe her, and it gave me a point of view. I started the series with *Late Afternoon* and continued it with *January Light*. She was wonderful to work with, having an abundance of inner peace and a depth and a glow, and yet also an extraordinary outer, formal beauty. While working on the second piece, an image came to me of her asleep, with the moon somehow present. Incredibly to me, my preparatory studies for such a complicated work took five minutes. The drawing proceeded with such ease that at times it almost seemed to me that someone was drawing along with me or guiding my hand. In the Gallery 1199 exhibit, there was a great deal of comment about these three works, especially the last, *In Sleep*. Much of the discussion centered around the meaning of this work and the various interpretations that were offered—from plantation scene to migrant workers, to William Blake and Gothic entombments, to Caribbean mysticism and Mexican realism. Since all these ideas were interesting but at great variance with my

vision, it made me wonder about how much the artist really knows about what he or she has created.

A large show such as that one had completely cleared my studio. As I sat in the empty room with light patterning itself on the bare walls, I mused about my new direction. I thought of how much I admired artists such as Balthus, Lucian Freud, and Antonio López García, and about the way that both tradition and the avant-garde exist naturally and beautifully in their work. This combination is what I strove for— along with an art that was accessible in different layers and complicated images to a variety of viewers: to the people in my neighborhood, to the mailman, an art gallery director, an art historian, a writer. I saw lots of possibilities in the direction those recent drawings might take me. Being an artist is a kind of learning experience, an unconscious autobiography. I was eager, a little nervous, and most excited to see how the next few pages of my diary would unfold.

Artist's Biography

Simon Dinnerstein has had twenty-two solo exhibitions. He has also been awarded a Fulbright Fellowship to Germany, the Rome Prize for living and working in Italy at the American Academy in Rome, a Louis Comfort Tiffany Grant, the Ingram Merrill Award for Painting, a New York State Foundation for the Arts Grant, and three Childe Hassam Purchase Awards from the American Academy of Arts and Letters. In 1999 and 2000, a retrospective of his work toured the country, sponsored in part by a grant from the Robert Lehman Foundation. Two monographs, *The Art of Simon Dinnerstein* (University of Arkansas Press, 1990) and *Simon Dinnerstein: Paintings and Drawings* (Hudson Hills Press, 2000), have been published on his work.

For the past thirty years, Mr. Dinnerstein, a member of the National Academy of Design, has been represented in New York by Staempfli Gallery and ACA Galleries. He resides in Park Slope, Brooklyn.

Notes

Notes to " 'Time Suspension' and *The Fulbright Triptych*"

1. François Villon, "Ballade (of the Ladies of Ancient Times)," c. 1461, Translation: © Robin Shirley.

Notes to "The Theology of Art"

1. Simon Dinnerstein, e-mail message to author, April 21, 2009.

Notes to "A view? Oh, a view! How delightful a view is!"

1. E.M. Forster, *A Room with a View* (Penguin Modern Classics reprint, 1969), 8.

Notes to "Simon Dinnerstein's Conceptual Painting: *The Fulbright Triptych*"

1. James Snyder, *Northern Renaissance Art: Painting, Sculpture, the Graphic Arts from 1350-1575* (Englewood Cliffs, New Jersey: Prentice Hall, Inc., 1985), 318.

2. Class dialogue with Simon Dinnerstein, Parsons School of Design, New York, 1985.

Notes to "Painting Pointing Past Itself: Heterogeneity and Contingency in *The Fulbright Triptych*"

1. Robert L. McGrath, "To See and Be Seen: *The Fulbright Triptych* of Simon Dinnerstein," in *Simon Dinnerstein: Paintings and Drawings* (New York: Hudson Hills Press, 1999), 11-16.

2. Ibid., 13.

3. Roland Barthes, *S/Z* (London: Cape, 1974), 7.

4. McGrath, "To See and Be Seen," 13.

5. Ibid., 12.

6. Ibid., 12.

7. Ibid., 13. See also Peter J. Schwartz's analysis of the portrait of Gisze within a different but not entirely unrelated scholarly context. Peter J. Schwartz, "The Void at the Center of Things: Figures of Identity in Michael Haneke's Glaciation Trilogy," in *A Companion to Michael Haneke,* ed. Roy Grundmann, (Malden, Mass. and London: Wiley-Blackwell, 2010), 323-336.

8. Jürgen Habermas, *The Structural Transformation of the Public Sphere: An Inquiry into a Category of Bourgeois Society,* trans. Thomas Burger and Frederick Lawrence (Cambridge, Mass.: MIT Press, 1989).

9. I am of course aware that some of the objects on display are mass cultural artifacts that were simply

not available to the early bourgeois culture on which Habermas bases his theory, due to their dependence on technological reproducibility. Yet some of them, such as the children's drawings and magazine clippings, as well as early postcards, would have been part of this private sphere. And while paintings were certainly part of the private sphere of salons, their thematic and biographic connotations could, as the portrait of Gisze shows, invoke connotations of commerce.

10. Jean-Francois Lyotard, *The Différend: Phrases in Dispute,* trans. Georges Van Den Abbeele (Minneapolis: University of Minnesota Press, 1988).

11. Ibid., 3–4.

12. On the communicative ethics debate, see Seyla Benhabib and Fred Dallmayr, eds., *The Communicative Ethics Controversy* (Cambridge, Mass.: MIT Press, 1990), 1–22. I am particularly indebted to Fred Dallmayr's introduction, which brings a valuable context to Habermasian thought and its critics. On Habermas's concept of the public sphere, see Craig Calhoun, ed., *Habermas and the Public Sphere* (Cambridge, Mass.: MIT Press, 1992), 1–50. Calhoun's introduction provides a useful overview of Habermas's thinking up to and beyond the development of his theory of the public sphere.

13. Dallmayr, "Introduction," 2.

14. Calhoun, "Introduction," 2–3.

15. Dallmayr, "Introduction," 8.

16. Ibid., 8.

17. Pace Barthes, one might argue that the very figurativeness of an image is an indication of a certain universalism, because the denotative plane suggests that something can be perceived "as such" before it needs to be interpreted. However, this charge may be neutralized by following Barthes's insight that denotation trumps connotation. The figurative nature of any image may be offset by the potentially infinite connotations it generates. Ultimately, universalism is thus an ideological trap waiting to be debunked.

18. See Jürgen Habermas, *The Structural Transformation of the Public Sphere: An Inquiry into a Category of Bourgeois Society.* Habermas's groundbreaking book was not translated until 1989, but published in German in 1962 as *Strukturwandel der Öffentlichkeit* (Hermann Luchterhand Verlag: Darmstadt and Neuwied).

19. For West Germany these two concepts were not merely cultural responses to the ignominious legacy of fascism and dictatorship, but foundational values for the country's federal political structure.

20. See Juliane Rebentisch, *Ästhetik der Installation* (Frankfurt: Suhrkamp Verlag, 2003). Rebentisch develops a radical theoretical departure from work-centered hermeneutics via her reading of high modernist art theory and systems theory (Greenberg, Fried, Luhmann). While her argument is constructed with regard to high modernist arguments about abstract and minimalist art, she extends her thinking to

mimetic art, time-based art, and performance-based art. Indeed, it constitutes a defense of the principles of theatricality and figuration. I have thus chosen to apply her reasoning to figurative painting as well.

Notes to "Two Roads Converge . . . "

1. Two volumes of Fulbright memoirs have appeared, *The Fulbright Experience: 1946-1986* and *The Fulbright Difference: 1948-1992* (Transaction, 1987 and 1993). Intended as an ongoing series, further volumes planned by the program's U.S. alumni have sadly fallen victim to entropy.

2. I am indebted for this pertinent citation to Peter Ginna, preface to *American Places: Encounters with History (In Commemoration of Sheldon Meyer)*, ed. William E. Leuchtenburg (Oxford: Oxford University Press, 2000).

Notes to "To See and Be Seen: *The Fulbright Triptych* of Simon Dinnerstein"

1. This notion has nothing to do with the modernist cult of originality. The belief, somewhat facetiously held, was that a photographic reproduction of a work of art was superior to the original; an engraved copy once or twice removed, better yet; and a line drawing after a no-longer-extant original, still better. The best-case scenario called for a line drawing after a work of art that had never existed. Much of art history's best fictions have adhered to this schema.

2. The quote reads: "And to the question which of our worlds will then be *the* world, there is no answer. For the answer would have to be given in a language, and a language must be rooted in some collection of forms of life, and every particular form of life could be other than it is."

3. Curiously enough, *The Fulbright Triptych* resonates strongly for me with Norman Rockwell's *Triple Self-Portrait* (Rockwell Museum, Stockbridge, Mass.), where the artist in the act of self-representation surrounds his canvas with cheap color reproductions of great European painters ranging from Rembrandt to Picasso. A form of homage to the grand tradition, these reproductions also denote the distance, even exile of American artists from that tradition and its consolations.

Contributors

Juliette Aristides is an artist and the director of the Classical Atelier program at the Gage Academy of Fine Art in Seattle, Washington. She is the author of *Classical Drawing Atelier* (Watson-Guptill, 2006) and *Classical Painting Atelier* (Watson-Guptill, 2008).

Richard T. Arndt spent twenty-four years in the U.S. foreign service, was cultural attaché in such cities as Paris, Rome, and Tehran, and served as president of Americans for UNESCO. He is the editor of *The Fulbright Difference: 1948-1992* (Transaction Press, 1993) and the author of *The First Resort of Kings: American Cultural Diplomacy in the Twentieth Century* (Potomac Books, 2005).

Rudolf Arnheim (1904-2007) was a professor of psychology of art at Harvard University and the author of numerous books, including *Art and Visual Perception: A Psychology of the Creative Eye* (University of California Press, 1954) and *Entropy and Art* (University of California Press, 1971).

Dan Beachy-Quick is the author of two nonfiction collections, *A Whaler's Dictionary* (Milkweed Editions, 2008) and *Wonderful Investigations: Essays, Meditations, Tales* (Milkweed Editions, 2011), as well as four collections of poetry: *This Nest, Swift Passerine* (Tupelo, 2009), *Mulberry* (Tupelo Press, 2006), *Spell* (Ahsahta Press, 2004), and *North True South Bright* (Alice James Books, 2003).

Robert Beaser is a composer, former co-director of musical elements at New York City's 92nd Street Y, artistic director of the American Composer's Orchestra at Carnegie Hall, and professor and chairman of the Composition Department at the Juilliard School.

Albert Boime (1933-2008) was a writer, professor of art history at the University of California-Los Angeles, and author of the University of Chicago Press's *A Social History of Modern Art* series.

Virginia Bonito is an art historian, independent scholar, and founder and director of The Mnemosyne Foundation.

Phillip A. Bruno is the former co-director of Staempfli Gallery. He now works as a collector and benefactor to museum and university art galleries.

Nancy Ekholm Burkert is the illustrator of many celebrated books, including *James and the Giant Peach* (Knopf, 1961) and *Snow White and the Seven Dwarfs* (Farrar, 1972), which received the Caldecott Award in 1973.

George Crumb is the American composer of classic modernist works, including *Black Angels* (1970), *Eine Kleine Mitternachtmusik* (2002), and *Ancient Voices of Children* (1970).

Guy Davenport (1927-2005) was a Distinguished Alumni Professor of English at the University of Kentucky. He authored numerous books, including *The Geography of the Imagination* (David Godine, 1997) and *A Balthus Notebook* (Ecco Press, 1989).

Renée Dinnerstein is an educator, consultant, and lecturer in New York City public and private schools. She is the recipient of the Bank Street Early Childhood Educator Award.

Simone Dinnerstein is a classical pianist. She performs throughout the world, and her best-selling recordings include Bach's *Goldberg Variations* (Telarc), *The Berlin Concert* (Telarc), and *Bach: A Strange Beauty* (Sony).

Anthony Doerr is the author of *The Shell Collector* (Penguin, 2003), *Four Seasons in Rome* (Scribner, 2008), and *Memory Wall: Stories* (Scribner, 2010). He is the recipient of three O'Henry Prizes for short stories, a Guggenheim fellowship, and the Rome Prize Fellowship.

Colin Eisler is the Robert Lehman Professor of Fine Arts at the Institute of Fine Arts of New York University. He is also the author of numerous books, including *Masterworks in Berlin* (Little, Brown, 1996), *The Master of The Unicorn: The Life and Work of Jean Duvet* (Abaris Books, 1978), and *Dürer's Animals* (Smithsonian, 1991).

Alvin Epstein is an actor and director who has starred in many Beckett productions, including *Waiting for Godot* and *Endgame*. He is the former artistic director of the Guthrie Theatre in Minneapolis, and a founding member and former associate director of the Yale Repertory Theater.

Daniel Mark Epstein is a biographer, poet, and playwright, whose works have been widely published and performed. His recent books include *The Lincolns: Portrait of a Marriage* (Ballantine, 2008) and *The Glass House: New Poems* (Louisiana State University Press, 2009).

Gabriela Lena Frank is a Guggenheim Fellow and winner of a Latin Grammy for best classical composition in 2009, published by G. Schirmer, Inc. She has collaborated with artists such as Yo Yo Ma, Dawn Upshaw, the King's Sisters, the Kronos Quartet, and Nilo Cruz.

Brian W. Goesl is the executive director of the Texarkana Regional Arts and Humanities Center in Texarkana, Arkansas.

Maurizio Gregorini is an Italian poet and journalist. He is the author of *Il Male di Dario Bellezza* (Stampa Alternativa, 2006) and the novel *Neve e Sangue* (Albano Laziale, 2007). He conducts his own television and radio programs in Italy.

Philippe Grimbert is a psychoanalyst, author, and winner of the Prix Goncourt des Lycéens for his novel *Memory* (Simon & Schuster, 2008), which was made into Claude Miller's film, *A Secret*.

Roy Grundmann is an associate professor of film studies at Boston University and a contributing editor for *Cineaste Magazine*. His publications include *Andy Warhol's Blow Job* (Temple University Press, 2003) and *A Companion to Michael Haneke* (Wiley-Blackwell, 2010).

Michael Heller is a poet and essayist whose publications include *Speaking the Estranged: Essays on the Work of George Oppen* (Salt Publishing, 2008), *Eschaton* (Talisman House, 2009), and *Beckmann Variations & Other Poems* (Shearsman Books, 2010).

Kate Holden is the author of *In My Skin: A Memoir of Addiction* (Arcade Publishing, 2007). She writes a column for *The Age*, a newspaper in Melbourne, and has widely published reviews, essays, and short stories.

David Krakauer is a clarinetist, composer, and bandleader who tours internationally with his band, Klezmer Madness. He is one of the leading contemporary performers and creators of klezmer music.

Jhumpa Lahiri is the author of *The Namesake* (Mariner Books, 2004), *Unaccustomed Earth* (Vintage, 2009), and the Pulitzer-Prize-winning *Interpreter of Maladies* (Mariner Books, 1999).

Ulrich Littmann worked for the German Fulbright Commission for over forty years and served as its executive director between 1963 and 1994.

Robert L. McGrath is a professor emeritus of art history at Dartmouth College. He is the co-author of *Paul Sample: Painter of the American Scene* (Hood Museum of Art, Dartmouth College, 1988).

Louis Menashe is an associate editor at *Cineaste Magazine* and the author of *Moscow Believes in Tears: Russians and Their Movies* (New Academia Publishing, 2010). He is professor emeritus of history at Polytechnic Institute of New York University.

Thomas M. Messer is director emeritus of the Guggenheim Museum, having directed the museum for twenty-seven years. He is the author of *Edvard Munch (Masters of Art)* (Harry N. Abrams, 1986), *Egon Schiele* (Institute of Contemporary Art, 1960), and *Jean Dubuffet* (Solomon R. Guggenheim Foundation, 1973).

Mary Pope Osborne is the author of numerous novels, biographies, and picture books, including *The Magic Treehouse* series of children's books.

Marshall Price is the associate curator of Modern and Contemporary Art at the National Academy Museum, and former associate curator of the Santa Barbara Museum of Art.

John Russell (1919-2008) was a former senior art critic for the *New York Times* and the author of numerous monographs, including *Seurat* (Thames & Hudson, 1965), *Francis Bacon* (Thames & Hudson, 1993), and *Matisse: Father and Son* (Harry N. Abrams, 2001).

Valerie Sayers is a professor of creative writing at the University of Notre Dame and the author of the novels *Who Do You Love* (Doubleday, 1995) and *Brain Fever* (Doubleday, 1996).

Herb Schapiro is a playwright and author. His published work includes the plays *The Me Nobody Knows* (Samuel French, 1970) and *The Love Song of Saul Alinsky* (Samuel French, 2008), and *Elements of Drama: A Study Guide to "Hamlet"* (Holt, Rinehart & Winston, 1989).

Dinitia Smith is a former national culture correspondent for the *New York Times* and the author of the novels *A Hard Rain* (Doubleday, 1980), *Remember This* (Henry Holt & Company, Inc., 1989), and *The Illusionist* (Scribner, 1997).

George Staempfli (1910-1999) was a painter, writer, and the director of Staempfli Gallery for over thirty years, during which time he showed the work of a variety of

European and American artists, including Salvador Dali, Paul Delvaux, David Park, Elmer Bischoff, Joan Brown, and George Rickey.

Edward J. Sullivan is the dean for the humanities at New York University, a professor of art history at the Institute of Fine Arts of New York University, and the author of *Fernando Botero* (Rizzoli, 1993), *Antonio López García* (Rizzoli, 1990), and *Claudio Bravo* (Rizzoli, 2005).

George Tooker is one of America's pre-eminent painters. He was the subject of a retrospective exhibition at the National Academy Museum in 2008.

John Turturro is an actor, writer, and director whose filmography includes *Do the Right Thing* (1989) and *Barton Fink* (1991), for which he was honored as Best Actor at the Cannes Film Festival.

Thalia Vrachopoulos is the curator at the Tenri Cultural Institute, a professor of art history at John Jay College, and the author of *Hilla Rebay, Art Patroness and Founder of the Guggenheim Museum of Art* (Edwin Mellen Press, 2005).

Richard Waller is the executive director of University of Richmond museums, which include the Marsh Art Gallery, the Joel and Lila Harnett Print Study Center, and the Lora Robins Gallery of Design from Nature. Previously, he worked at the Brooklyn Museum of Art for nineteen years and taught at New York's Parsons School of Design.

Miller Williams is a poet, translator, and director emeritus of the University of Arkansas Press. He was President Clinton's 1997 inaugural poet, and his poems, stories, essays, and translations have been published widely and translated into several languages.

Acknowledgments

Many thanks to the generous financial contributors involved with this project: Richard T. Arndt, the Edith C. Blum Foundation, Laurence Fishburne, Henry Justin, Nicholas Polk King, Robin Quivers, Peter Scotese, The Spirit of the Lake Foundation, and Michael Steinhardt.

We would like to gratefully acknowledge the kind permission to reprint the following essays: Albert Boime, "Simon Dinnerstein's Family Romance," *The Art of Simon Dinnerstein* (Fayetteville, Ark.: University of Arkansas Press, 1990); John Russell, "In Dinnerstein's Painting, an Echo Chamber," *New York Times*, February 8, 1975, © by The New York Times Company; Rudolph Arnheim, "Pictures of the Lasting World," Guy Davenport, "The Art of Simon Dinnerstein," and Robert L. McGrath, "To See and Be Seen: *The Fulbright Triptych* of Simon Dinnerstein," in *Simon Dinnerstein: Paintings and Drawings* (New York: Hudson Hill Press, 2000).

Thank you to John Coghlan, for his excellent work as production designer, and to David Rosenthal and Peter Nevraumont for their invaluable assistance and advice. Appreciation to Kate Strickland for her deep commitment to this project. For translations, thank you to Philip Lasser and Michele Thomas (Philippe Grimbert), and Silvia Gilliotti and Stacy Mazzone (Maurizio Gregorini).

Thank you to Steven Tucker and Greg Korda for their photography of *The Fulbright Triptych* and its details, as well as to the staff of Loupe Digital in New York, specifically Chris Daciuk for his creation of the map of *The Fulbright Triptych* (p. 288).

Our appreciation also goes to the following individuals for the use of their photographs: Simon Dinnerstein (pp. 62, 99, 237, 269, 279), Ben Harms (pp. 49, 249), Bruce C. Jones (p. 149), Peter A. Juley and Sons (p. 297), Tony Nobile (p. 6), Adam Reich (pp. 313, 315, 317), Joel Rudnick (p. 122), Bev Sutley (pp. 10, 215), and Harry Tarzian (p. 324).

Milkweed Editions

Founded as a nonprofit organization in 1980, Milkweed Editions is an independent publisher. Our mission is to identify, nurture and publish transformative literature, and build an engaged community around it.

Join Us

In addition to revenue generated by the sales of books we publish, Milkweed Editions depends on the generosity of institutions and individuals like you. In an increasingly consolidated and bottom-line-driven publishing world, your support allows us to select and publish books on the basis of their literary quality and transformative potential. Please visit our Web site (www.milkweed.org) or contact us at (800) 520-6455 to learn more.

Milkweed Editions, a nonprofit publisher, gratefully acknowledges sustaining support from Amazon.com; Emilie and Henry Buchwald; the Bush Foundation; the Patrick and Aimee Butler Foundation; Timothy and Tara Clark; the Dougherty Family Foundation; Friesens; the General Mills Foundation; John and Joanne Gordon; Ellen Grace; William and Jeanne Grandy; the Jerome Foundation; the Lerner Foundation; Sanders and Tasha Marvin; the McKnight Foundation; Mid-Continent Engineering; the Minnesota State Arts Board, through an appropriation by the Minnesota State Legislature and a grant from the National Endowment for the Arts; Kelly Morrison and John Willoughby; the National Endowment for the Arts; the Navarre Corporation; Ann and Doug Ness; Jörg and Angie Pierach; the Carl and Eloise Pohlad Family Foundation; the RBC Foundation USA; the Target Foundation; the Travelers Foundation; Moira and John Turner; and Edward and Jenny Wahl.

NATIONAL
ENDOWMENT
FOR THE ARTS

A great nation
deserves great art.

THE McKNIGHT FOUNDATION

MINNESOTA
STATE ARTS BOARD